JOAN MIRÓ
Snail Woman Flower Star

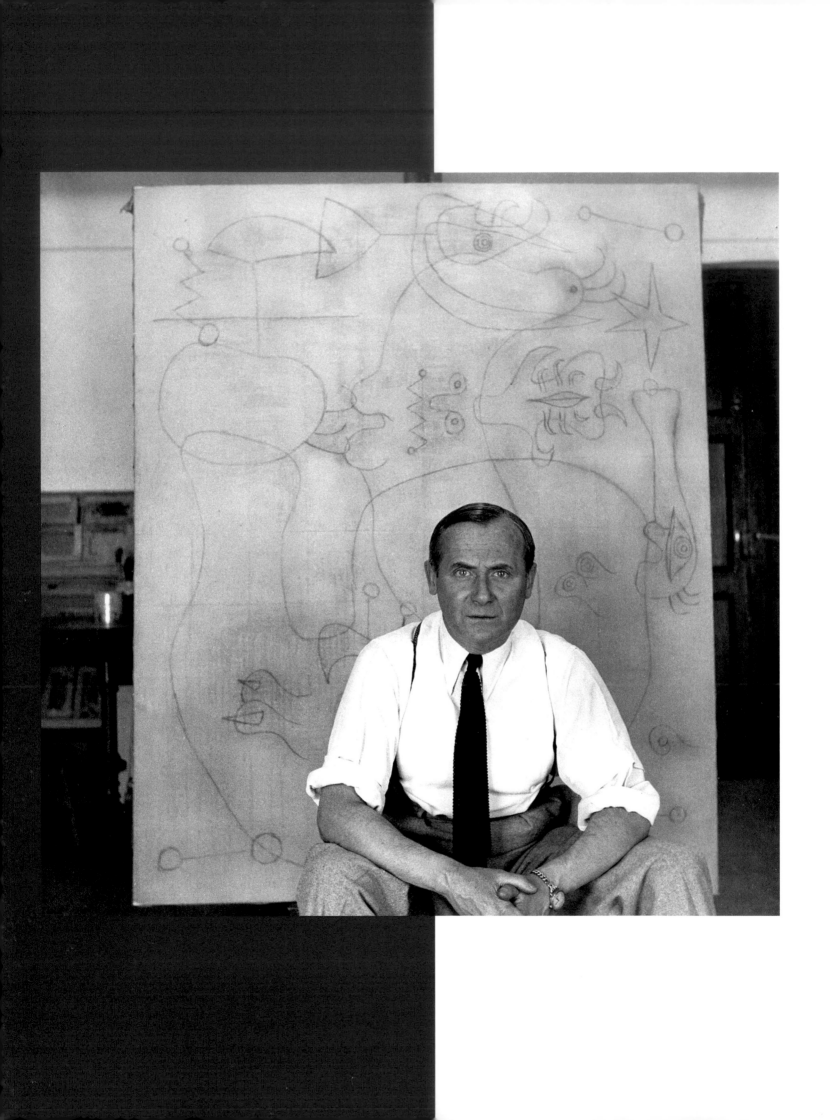

JOAN MIRÓ

Snail Woman Flower Star

EDITED BY STEPHAN VON WIESE

AND SYLVIA MARTIN

WITH ESSAYS BY

VICTORIA COMBALÍA, ANTJE VON GRAEVENITZ,

CHRISTA LICHTENSTERN, SYLVIA MARTIN

AND STEPHAN VON WIESE

PHOTOGRAPHS BY

JOAQUIM GOMIS

AND A FOREWORD

BY JEAN-HUBERT MARTIN

PRESTEL MUNICH · BERLIN · LONDON · NEW YORK

CONTENTS

JEAN-HUBERT MARTIN

FOREWORD

By exhibiting the work of Joan Miró, the museum kunst palast highlights classic modernism as an integral part of its exhibition programme. The show focuses primarily on works of the 1920s and 1930s, which might be considered the heyday of the artist's creative output.

Miró's roots lie in the cultural upsurge that was Barcelona around the turn of the 20th century. The art-minded *grande bourgeoisie* were receptive to unusual, creative thinking, and supported artists who explored new avenues. Symbolism and Art Nouveau had come up with ever more sophisticated styles and lent market credibility to the fashion of aestheticism and decadence. In his novel *A Rebours* (*Against the Grain*; 1884), Joris-Karl Huysmans impressively re-creates this world of artifice. The search for new ideas and extravagant effects produced a kind of artistic schizophrenia: a yearning for the utmost refinement was offset by a degree of enthusiasm for brutality in aesthetics, which was thought to have the potential of being further explored sensuously. Seen from afar, the buildings of Antoni Gaudí, for example the unfinished church of the Sagrada Família, manifest great elegance, but there is a deliberate roughness in the detail, as in the use of broken pottery for the mosaics in the Parc Güell. These—only apparently contradictory—principles form the key to understanding the work of Miró, who based his own original aesthetic on them.

Externally, Miró was a retiring man. When I made his acquaintance in the 1970s, he seemed rather like a country solicitor. Yet the exterior concealed an explosive temperament. Like all avant-garde artists, he wanted to refashion

the world. This is particularly evident in the grounds of his pictures. Miró was a superb technician, but set himself apart from academic conventions in a clear and purposeful way. He worked accurately, his drawings recalling those of Ingres and Matisse, but it was important to him that his laborious studies gave the impression of being light and spontaneous. What looks casual and improvised is calculated and prepared down to the last detail. When you look closely, it turns out, for example, that some of the sweeping outlines that appear to be drawn by an expansive, spontaneous gesture of the hand are in fact made up of numerous, small broken lines.

Like Picabia, Miró viewed modernism as a rejection of the *bon métier*, and again like him Miró developed strategies of provocation. Yet he was more cautious than Picabia, who took his experimentation with materials further, using marine paints, for example. When Miró employs sandpaper as a base, this of course evokes an earthy brownish soil, but at the same time its significance goes far beyond an interpretation linking it with his Catalan homeland. Miró was always trying out something new. He was constantly making discoveries, trying out new styles and investigating unexplored avenues. That applied particularly to his picture grounds, which often look dirty: paint splashes, spots, canvases left unsized. All these features can be examined for their sexual connotations for, as Georges Bataille concluded in his writings, dirt and sexuality are closely related. Miró's clear shapes and beautiful colour fields are often set against an undercoat of dirt that possesses revolutionary force.

At the time, there was a kind of secret sign language among Dadaists and Surrealists in matters of eroticism. Duchamp, for example, was a master at incorporating sexual allusions in his works so that they were picked up by the 'in' crowd and friends, but remained invisible to the middle-class public. Discussions then centred on formal values, but there was a second layer of interpretation for the artist. Miró actively took part in this game of codes, but often the allusions are so well concealed that it requires extensive detective work to identify them. The rebus technique was—at least in the 1920s—one of the fundamental principles underlying the structure of many of Miró's pictures.

It is not always easy to catch hold of the aggressive and sexual side of Miró, because our image of the artist is dominated by the striking character of his late works, which have become so popular. What the artist was really interested in during his most important period, the 1920s and 1930s, is evident above all in the picture grounds—linking beauty with its opposite.

It would not have been possible to present this view of Miró's work without the help of numerous lenders, whom we wish to thank here along with the people closely connected with Miró who have made substantial contributions to the exhibition. Our thanks go therefore to Jacques Dupin and Ariane Lelong-Mainaud for the extensive information they provided in determining the owners of works and for the many useful pointers; Miró's two grandsons Emilio Fernández Miró and Joan Punyet Miró for their co-operation and

readiness to help; Rosa Maria Malet of the Fundació Miró for making archive material from the drawing collection available for study and research; and Odette Gomis, who supplied her father's photographs. We are also indebted to Jean-Jacques Aillagon (chairman) and Alfred Pacquement (director) of the Centre Georges Pompidou, Musée National d'Art Moderne, for giving their permission to lend all three large *Bleu* canvases, which are among the finest ensembles of their collection.

At the museum kunst palast, the project was organised by Stephan von Wiese as curator of the exhibition and Sylvia Martin as project manager. My thanks are due to them, as well as to Victoria Combalía, director of the Centre Cultural Tecla Sala in Barcelona, who joined us as co-curator. Heidi Irmer assisted, while Anne-Marie Katins was responsible for editorial matters. Our gratitude goes to e.on as founder of the museum kunst palast and exclusive sponsor of this exhibition, and to members of the curatorial committee and all colleagues and helpers who took part. Together they have mounted a fascinating exhibition featuring the highlights of Joan Miró's oeuvre.

Jean-Hubert Martin
Director general

JOAQUIM GOMIS AND THE 'ATMOSFERA MIRÓ'

Thanks to the intensive photographic work of Joaquim Gomis (1902, Barcelona—1991, Barcelona), the surroundings in which Miró worked after his return from France to Barcelona, Mont-roig and Palma de Mallorca in 1940 were recorded in great detail. Gomis made the acquaintance of Miró through architect Josep Lluis Sert, soon becoming a close friend of the artist. His photographs are notable for their 'authentic eye'. They record subject matter that also inspired Miró in his work. In them, we see the world from the painter's perspective. Successive joint exhibitions lent Miró's implicit blessing to Gomis's photographic work—Miró's first exhibition at the Galerie Maeght in Paris in 1948 was accompanied, for example, by Gomis's photo series *Atmosfera Miró*, which was expanded in later years.

Gomis was nine years younger than Miró, but grew up in a similar milieu, in up-and-coming Barcelona. An artistic career was not a foregone conclusion—Gomis worked initially for his father's cotton-importing business, on behalf of which he spent lengthy periods in Britain and the United States (Houston and New York) in 1922/23, 1925 and 1928, where he was exposed to and fascinated by modern technology. It was there, too, that he took his first series of amateur photographs.

On his return to Barcelona in 1929, the city was wholly absorbed in the World Exhibition, which was generating a whirl of new activity. Gomis's photographic attention was drawn to the architectural work of Antoni Gaudí, while socially he became part of the circle around Sert and the hat merchant

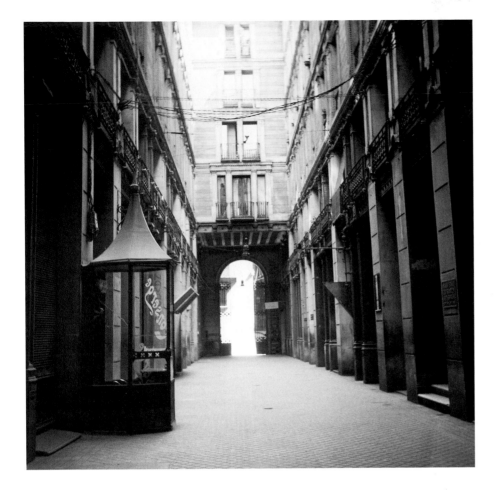

No. 4, Passatge del Crèdit, Barcelona, Miró's birthplace, c. 1944

and art publisher Joan Prats. In 1932, they jointly set up the Amics de l'Art Nou (ADLAN, Friends of New Art) at the Hotel Colon, whose aim was to support avant-garde art, especially Surrealism. Exhibitions of works by Pablo Picasso, Jean Arp and Alexander Calder, including the latter's *Circus*, followed, but the art of children and the mentally ill, Gomis's famous postcard collection and African art were likewise the subjects of shows. Though ADLAN had no official printed organ, it was involved in producing a celebrated special issue of the periodical *D'Ací d'Allà*, which provided a comprehensive survey of the latest trends. This was the occasion that led to the first close collaboration between Gomis and Miró, who contributed the title page and a pochoir to the issue.

Miró and Gomis both spent the Civil War in Paris, and were in constant contact. Encouraged in his photographic work by Brassaï and Henri Cartier-Bresson, Gomis's principal interest had become photography by the time he returned to Barcelona in 1939. Prats was instrumental in getting the photographer to work in series and sequences. The result was 'photoscopes', in which an individual object—the first was a eucalyptus tree—was examined conceptually as part of a 'photographic journey'. Gomis may have had these 'photoscopes' in mind when he did his sequential studies for the *Atmosfera Miró* from 1940.

The selection of 30 photographs presented here is divided into three sections. The first photographic enquiry in the *Atmosfera Miró* series (1942–47) records the surroundings of Miró's studio at the time, in the Passatge del Crèdit. We see the roof terrace with a view over the city, the *objets trouvés* on walls and in cupboards, *La Pinacoteca* with folk art on display in a cabinet, and Miró at work. Gomis also recorded the printing of the *Barcelona* series of lithographs in 1944. The second section of photographic work (1946–50) comprises photo sequences taken at the country estate in Mont-roig del Camp near Tarragona. They show both the intimate heart and origin of Miró's work. The luxuriant vegetation in the fields outside Tarragona—carob trees, olives, vines, cacti—traces a linear ornamentation in black and white, but the buildings and interior of the Masía, the Miró family estate, and the many small collector's items in the workshop building, radiate a special magic in their interplay of light and shadow. Happily, the coast and hilly countryside near Mont-roig feature as well. The settings and objects from which Miró evolved his system of symbols are presented here in their real-world context. Finally, the third section, covering 1956 to 1961, is devoted to the old stone house of Son Boter in Palma de Mallorca and its studio full of graffiti drawings.

In 1972, Gomis was one of the initiators and founders of the Fundació Joan Miró in Barcelona.

Joaquim Gomis's photographic style of recording things and even people in an objective yet magical way is undergoing a kind of renaissance, for his work is currently being reappraised and the photographer more widely acknowledged for having made a major contribution to modern Spanish photography.

Stephan von Wiese

11

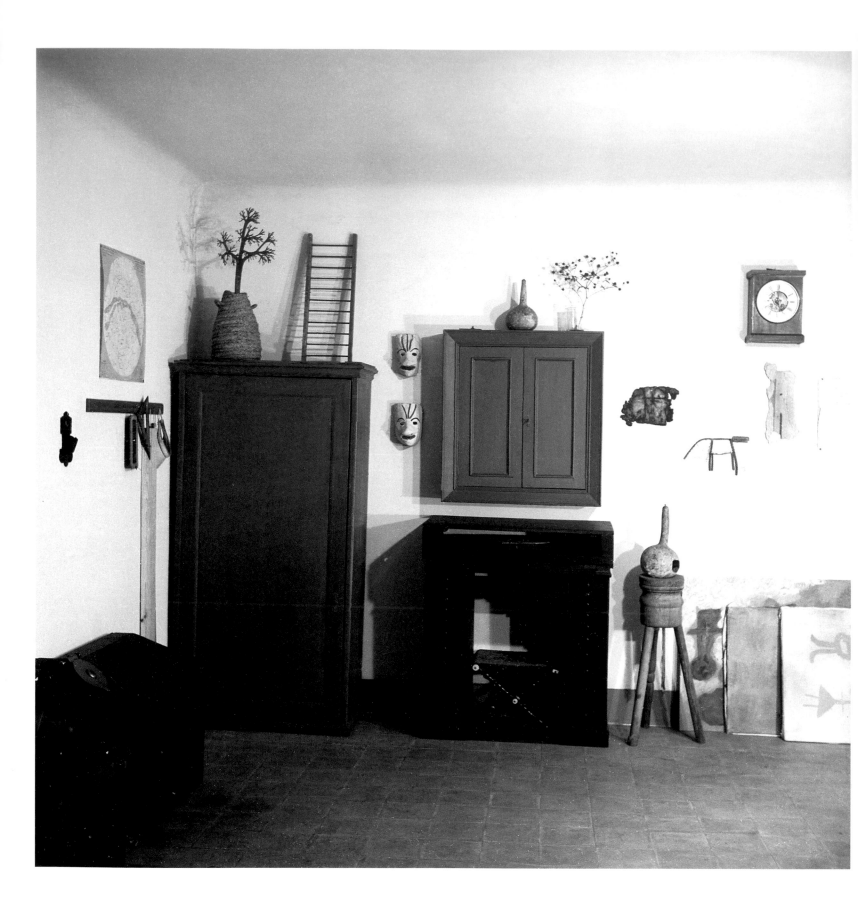

Studio in the Passatge del Crèdit, Barcelona, 1945

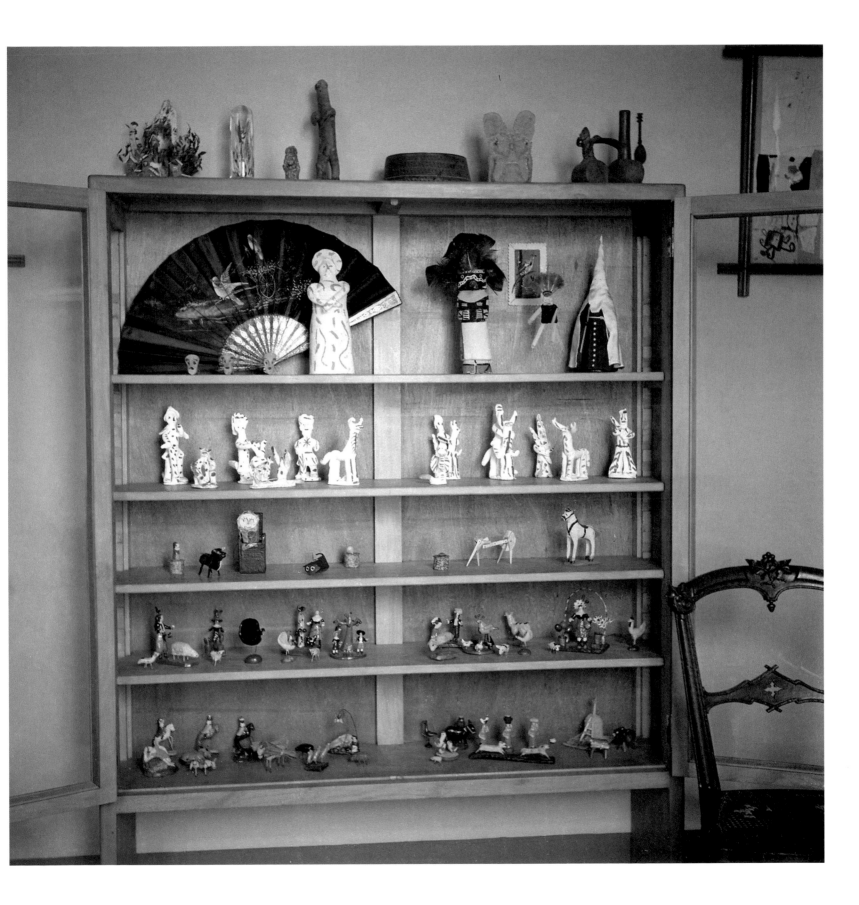

La Pinacoteca with Miró's collection of folk objects, Passatge del Crèdit, Barcelona, c. 1944

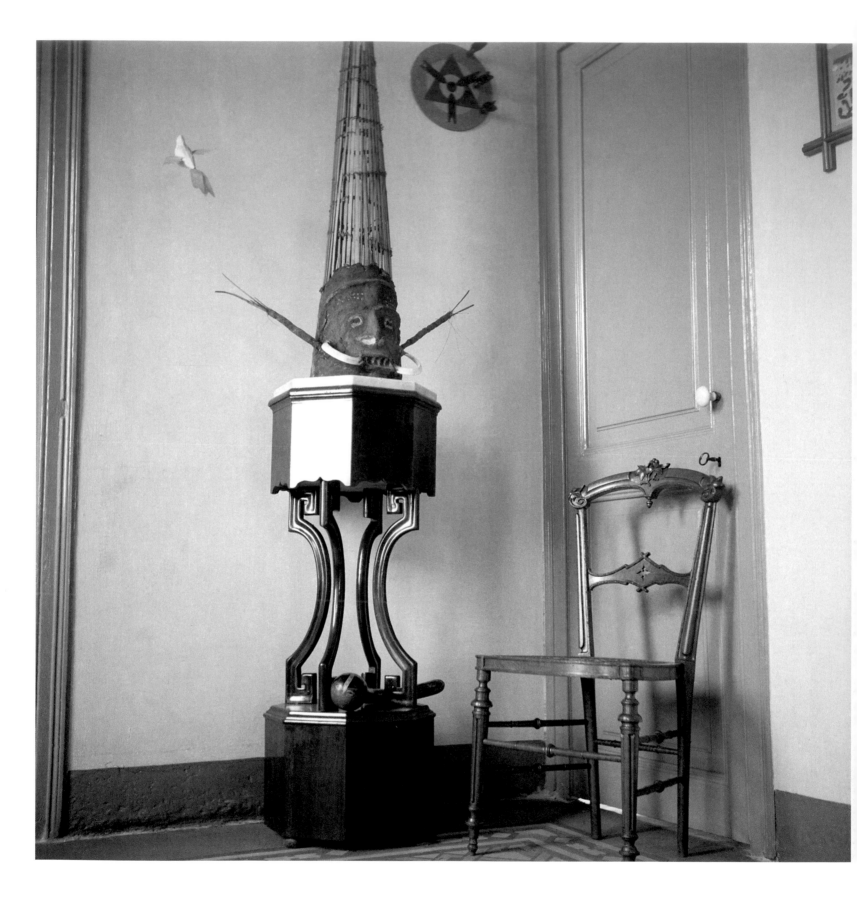

Mask from Vanuatu, Miró's studio, Barcelona, c. 1944

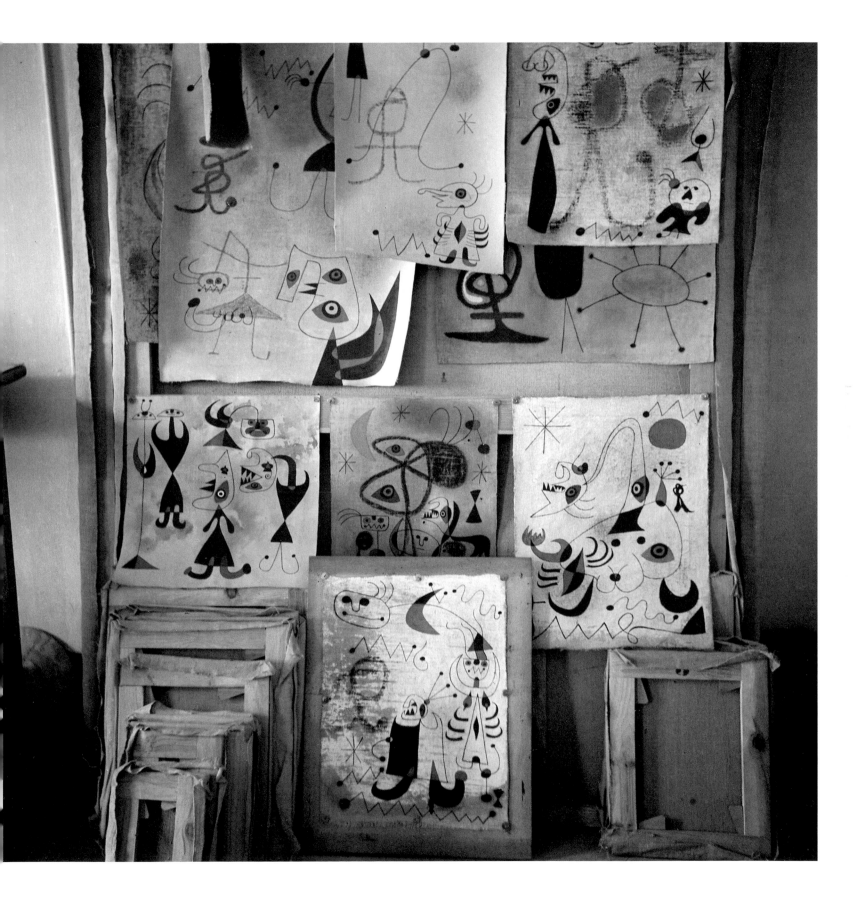

Miró's studio, Barcelona, 1944

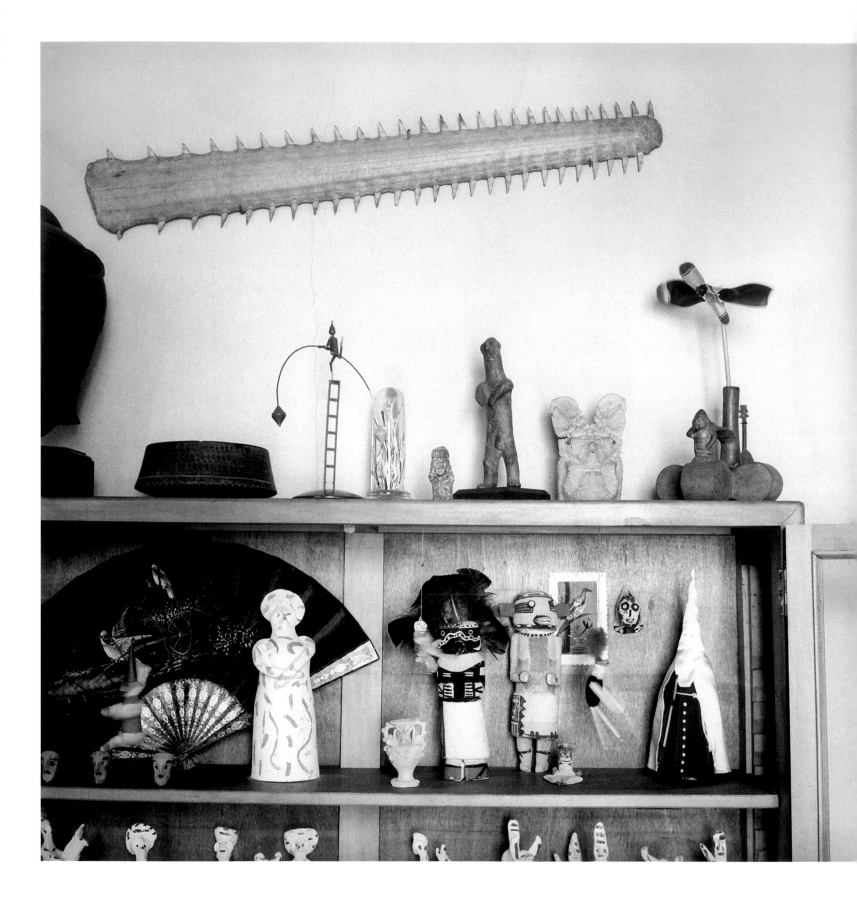

La Pinacoteca with Miró's collection of folk objects, Passatge del Crèdit, Barcelona, *c.* 1944

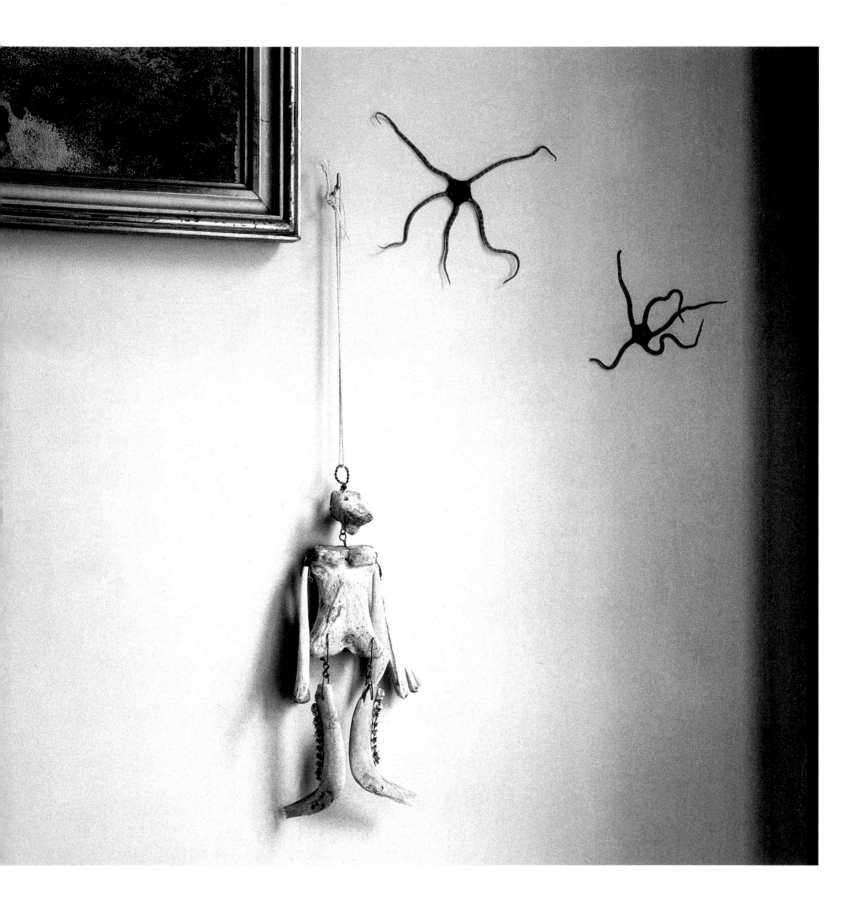

Alexander Calder's *Bone Man* in Miró's studio, Barcelona, c. 1944

Alexander Calder's *Wire Horse* in Miró's studio, Barcelona, 1944

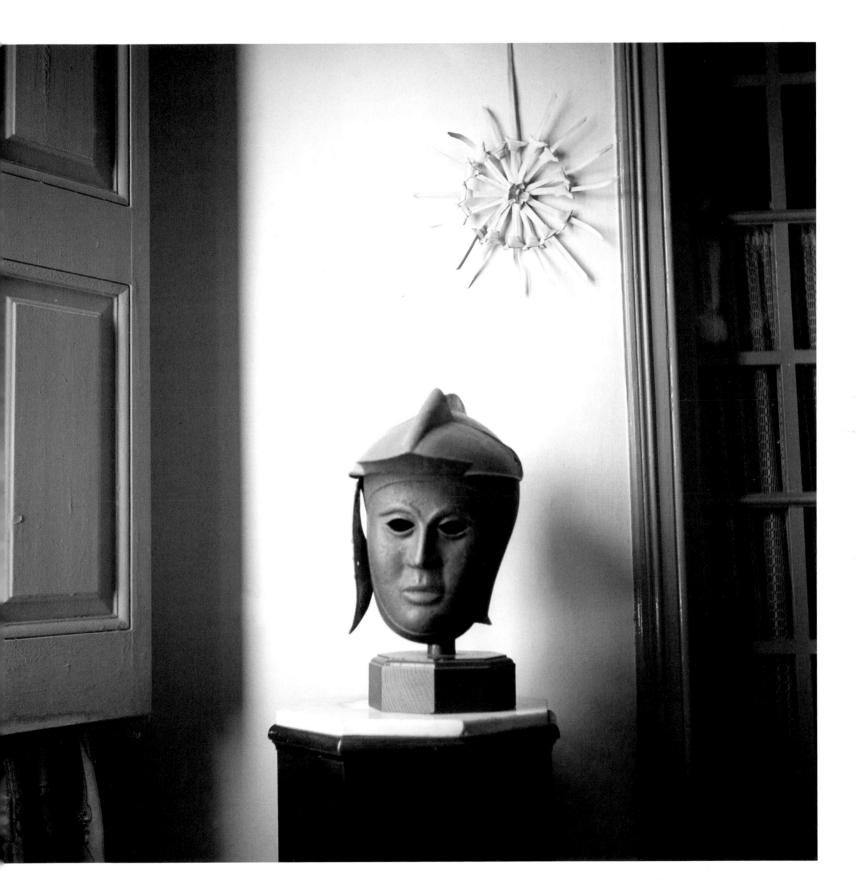

Mask of a Persian soldier in Miró's studio, Barcelona, c. 1944

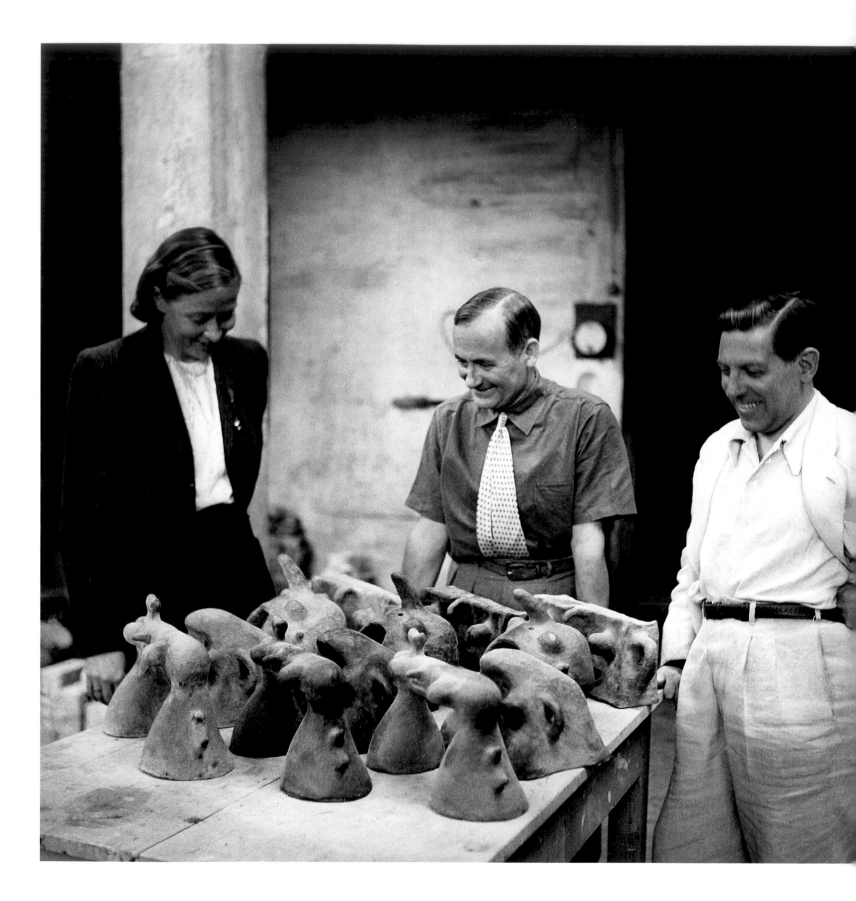

From left to right: Madame Matisse, Joan Miró, Josep Llorens Artigas in Artigas's studio, Barcelona, 1946

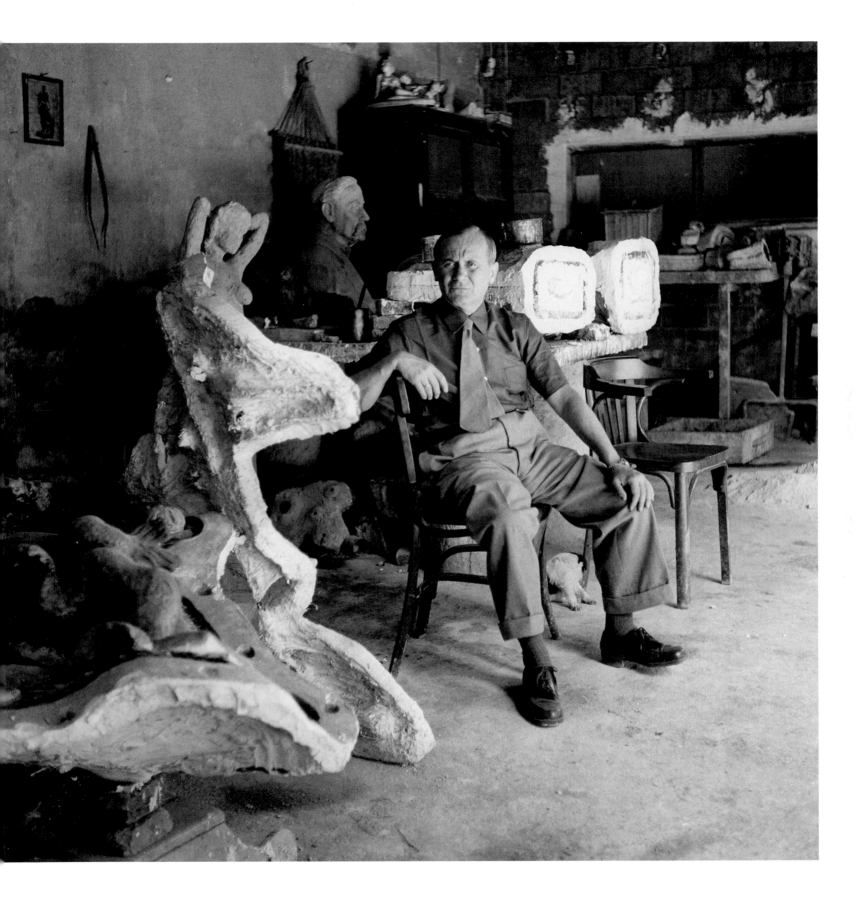

Miró at the Gimeno foundry, Barcelona, 1946

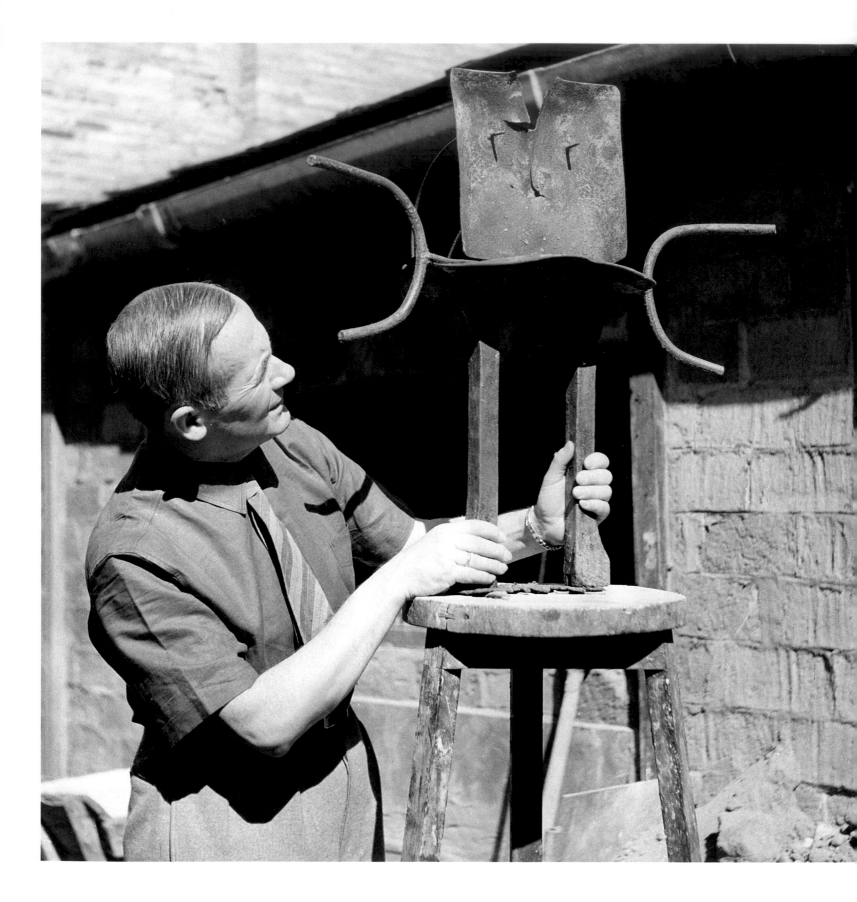

Miró at the Gimeno foundry, Barcelona, 1946

Sant Ramon Hermitage, Mont-roig del Camp

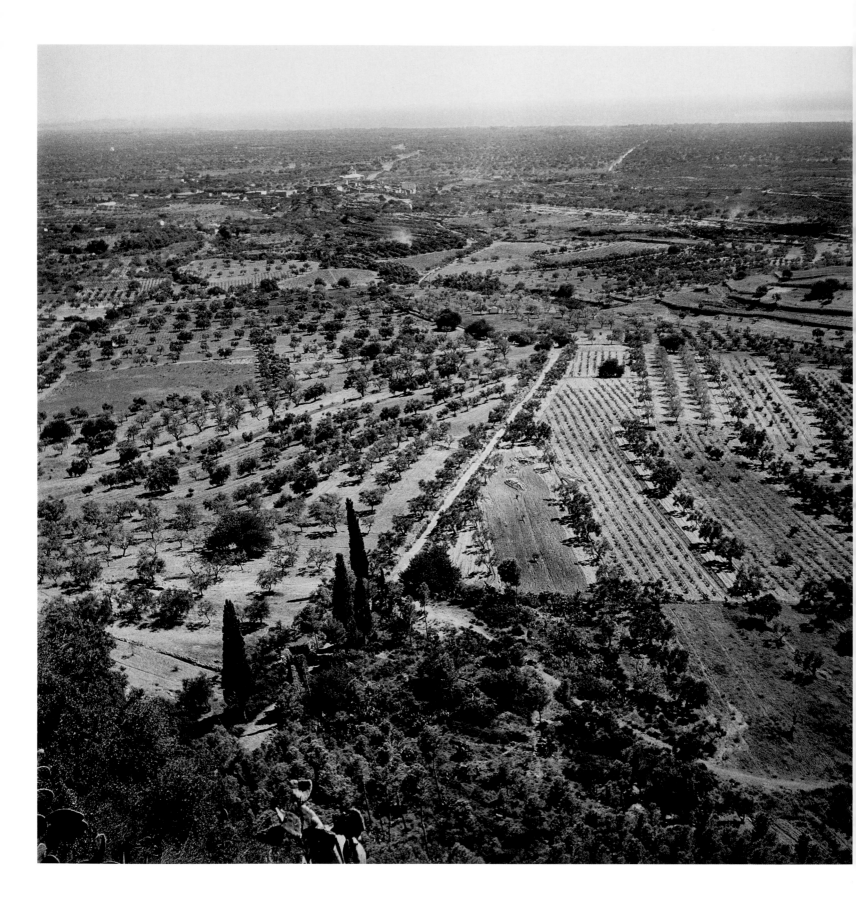

Fields near Mont-roig del Camp

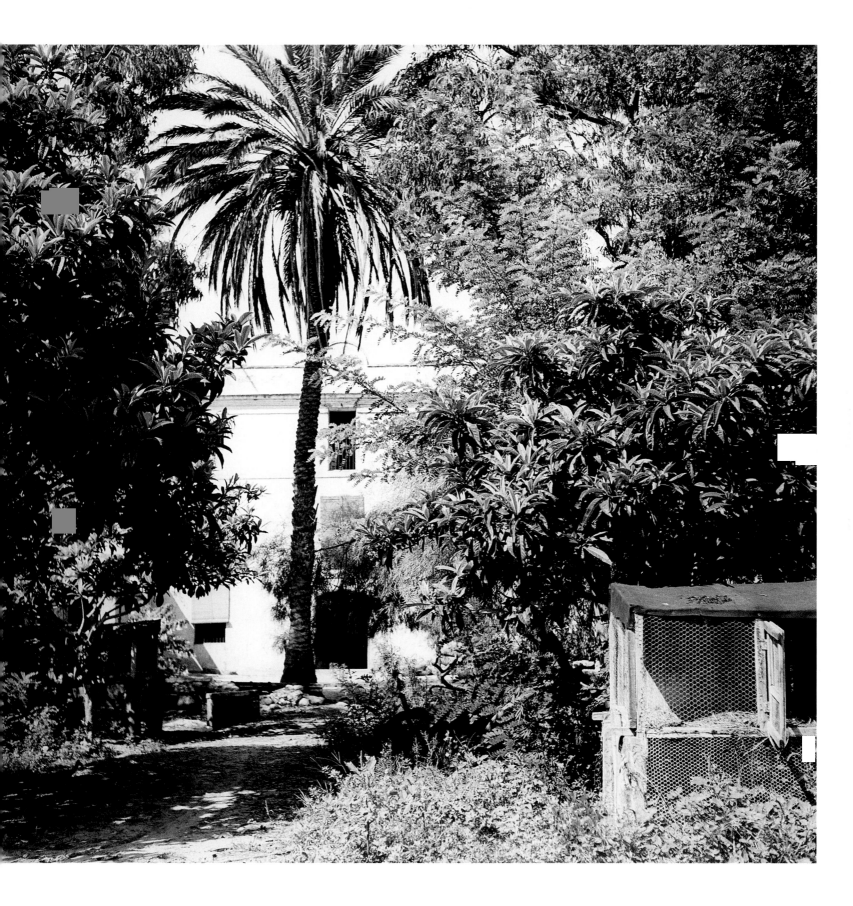

Romeu house, Mont-roig del Camp, 1946, the subject of *La Maison du palmier*, 1918

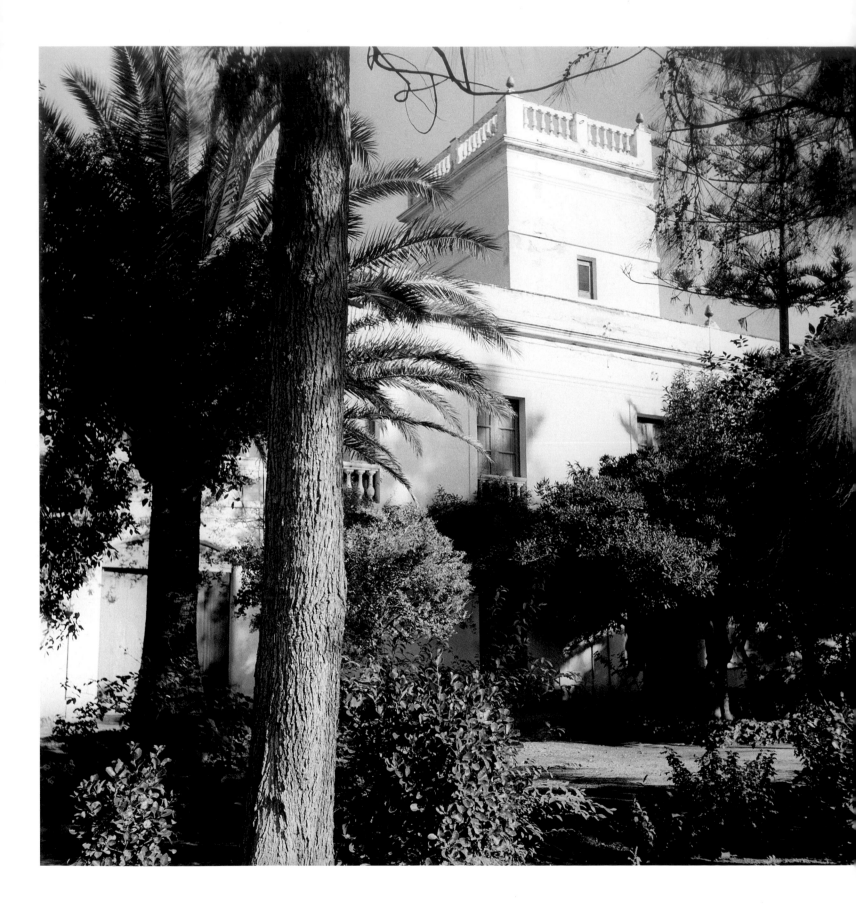

Miró's house in Mont-roig del Camp, 1946–50

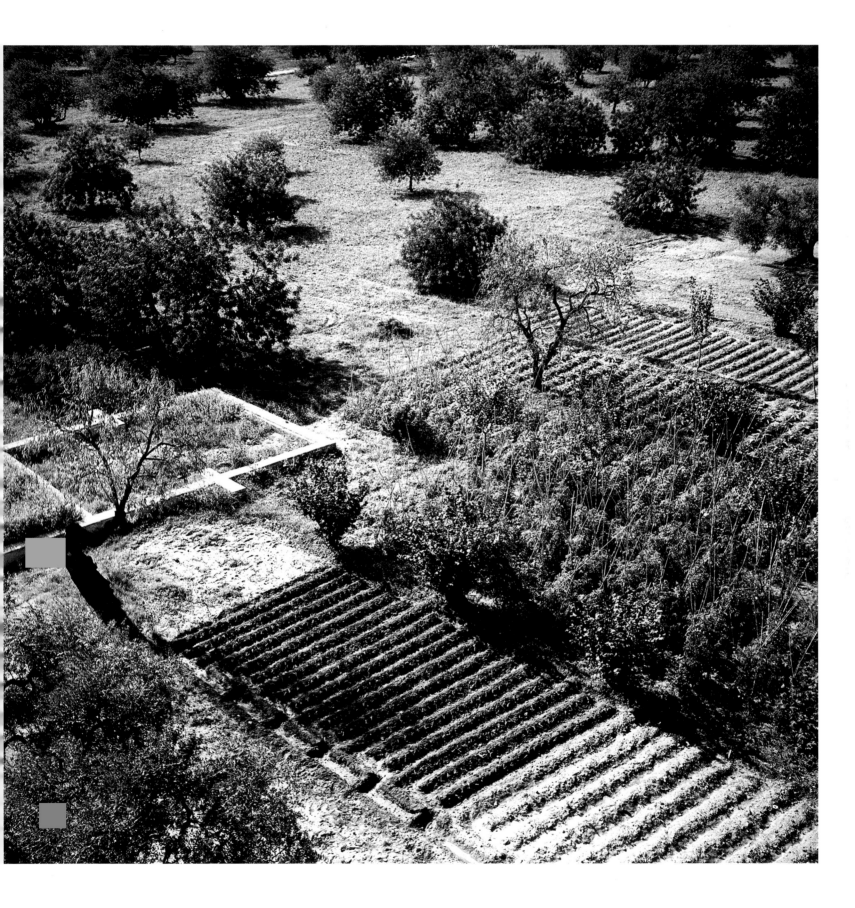

Fields near Mont-roig del Camp, 1946—50

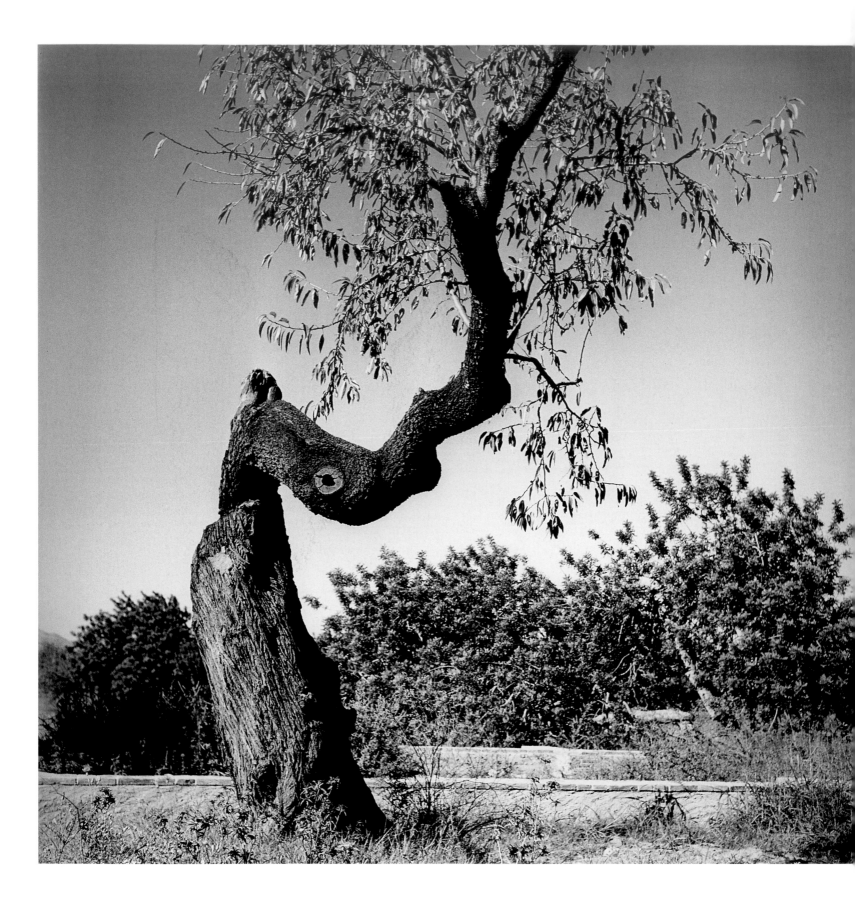

Olive tree near Mont-roig del Camp

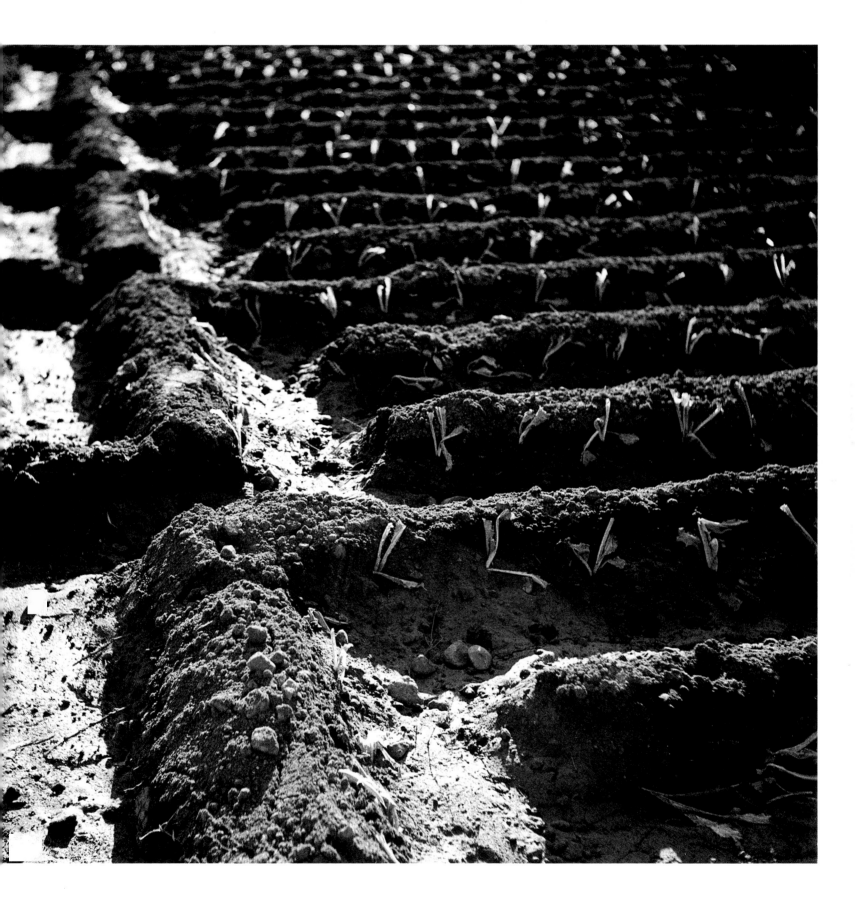

Furrows in fields near Mont-roig del Camp

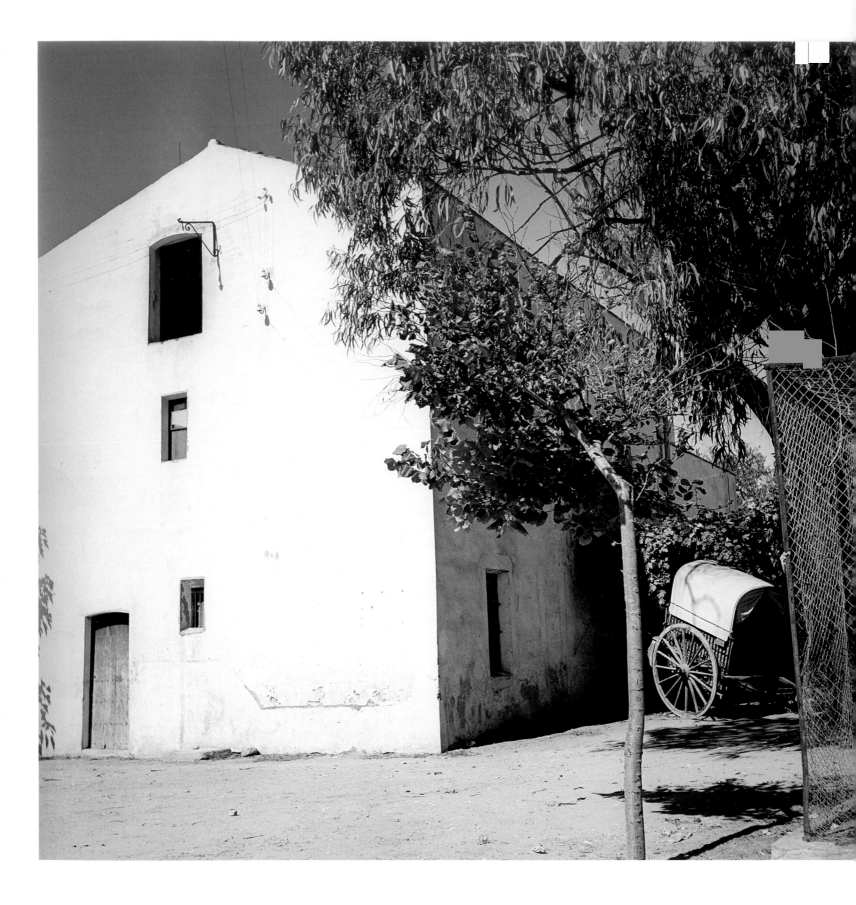

The Masía, Mont-roig del Camp, 1946

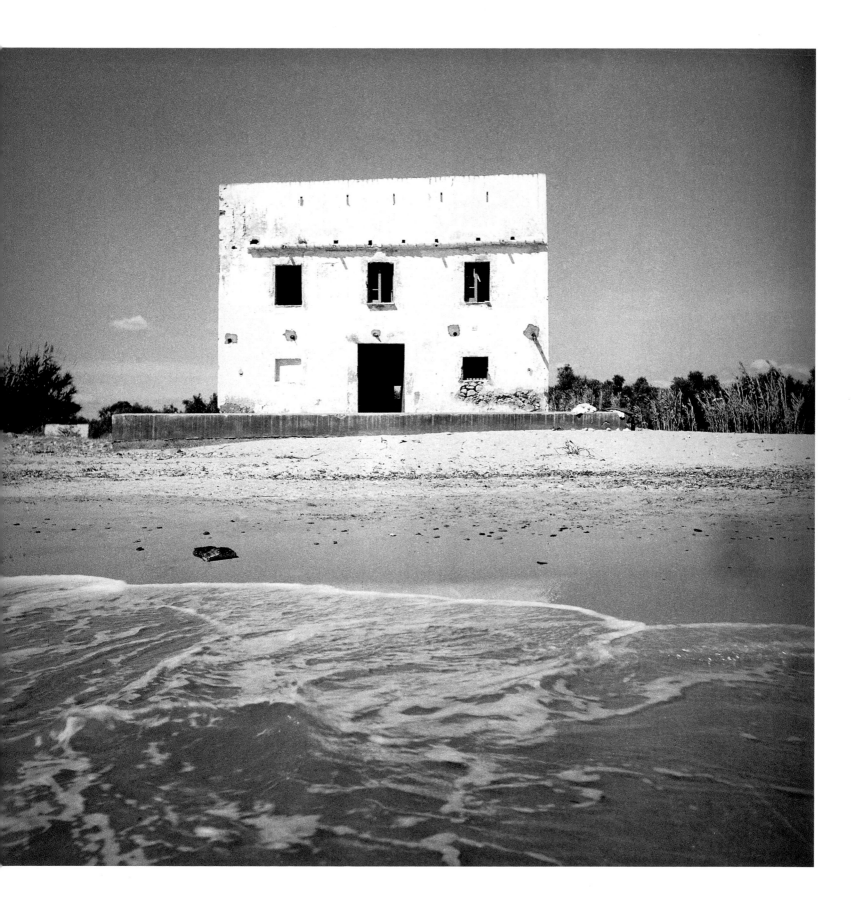

Customs officer's house on the Platja de Mont-roig, c. 1946

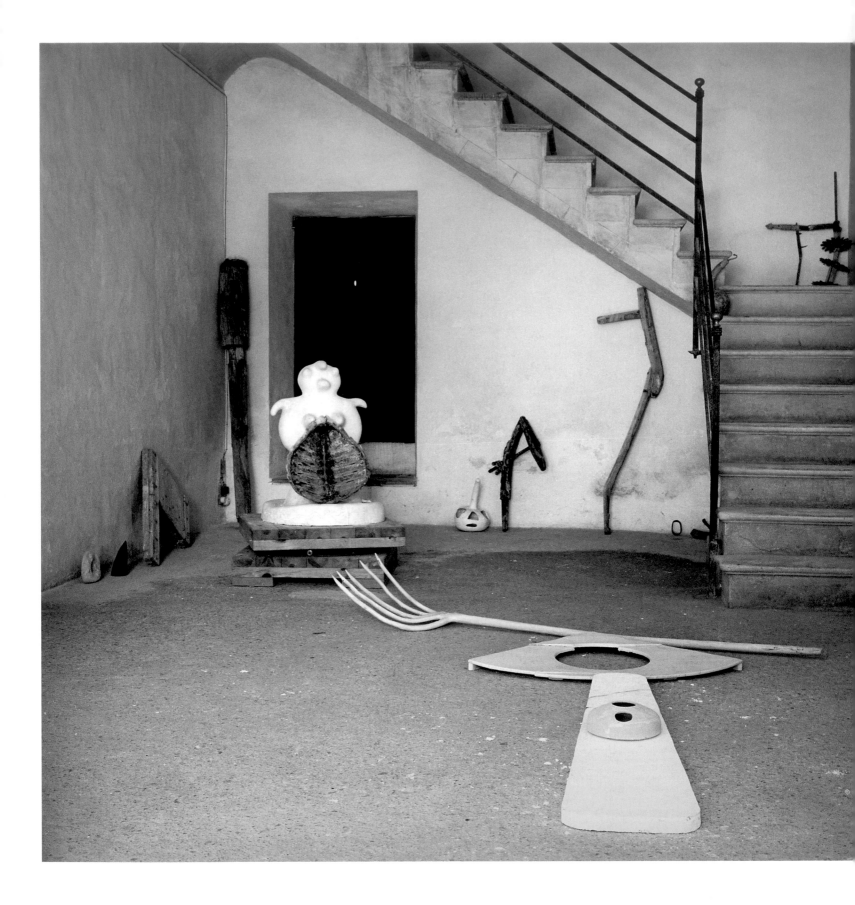

Maquette for *The Pitchfork* (*La Forca*), Son Boter, Cala Major, Majorca, 1961

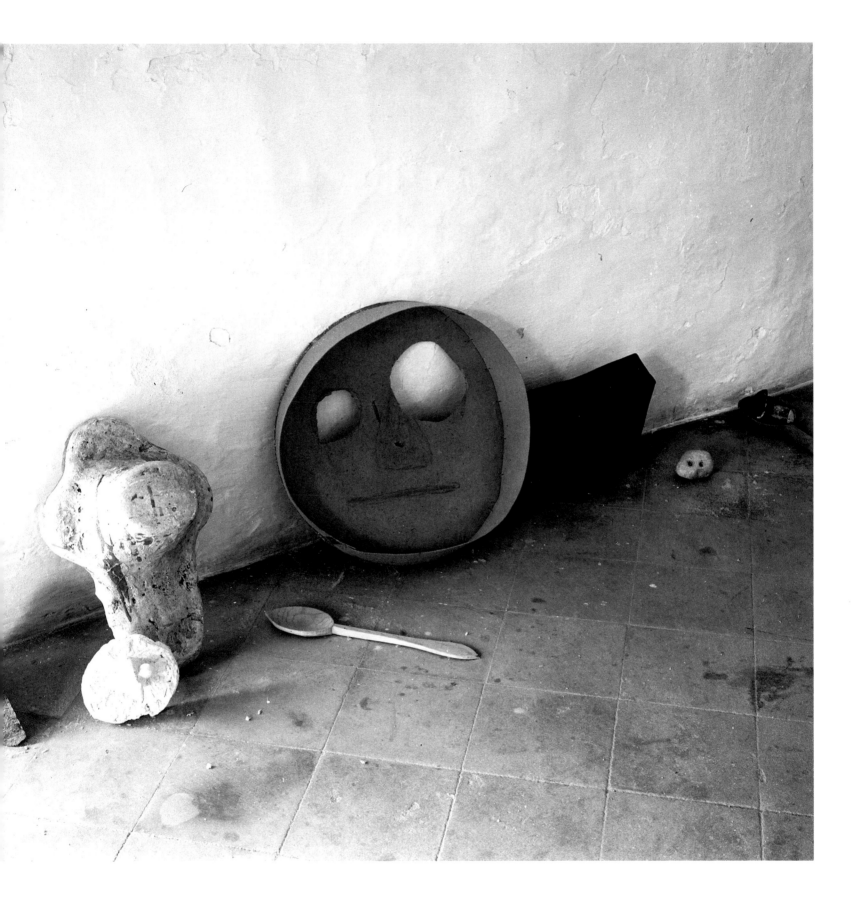

Son Boter studio, Cala Major, Majorca, 1961

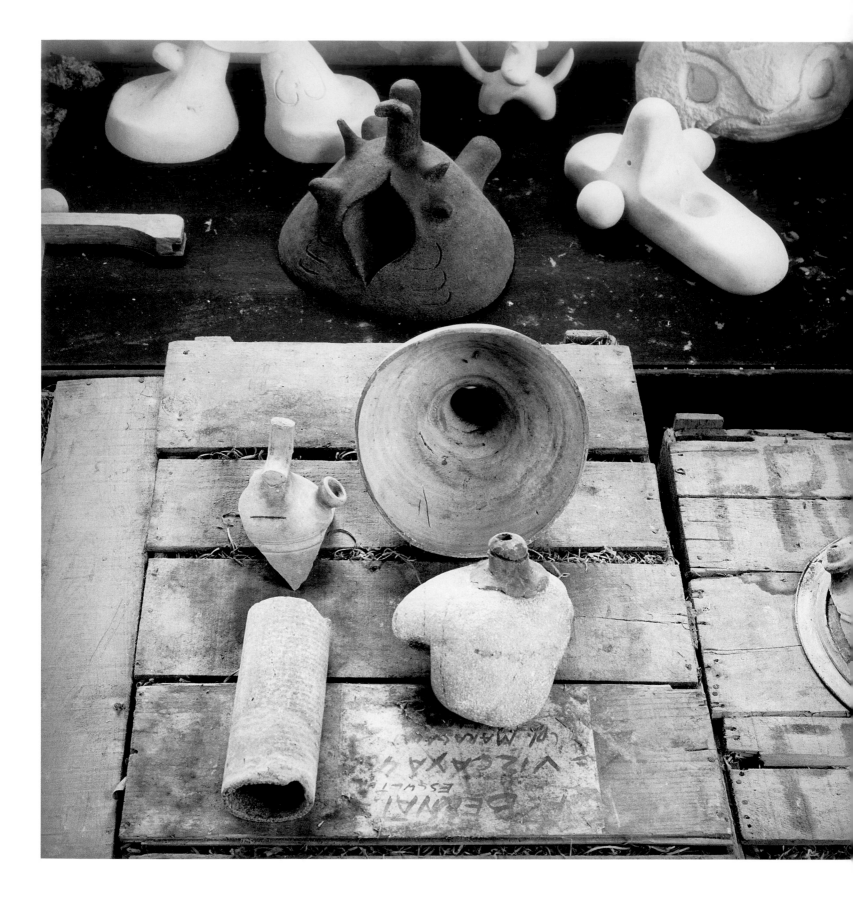

Son Boter studio, Cala Major, Majorca, 1961

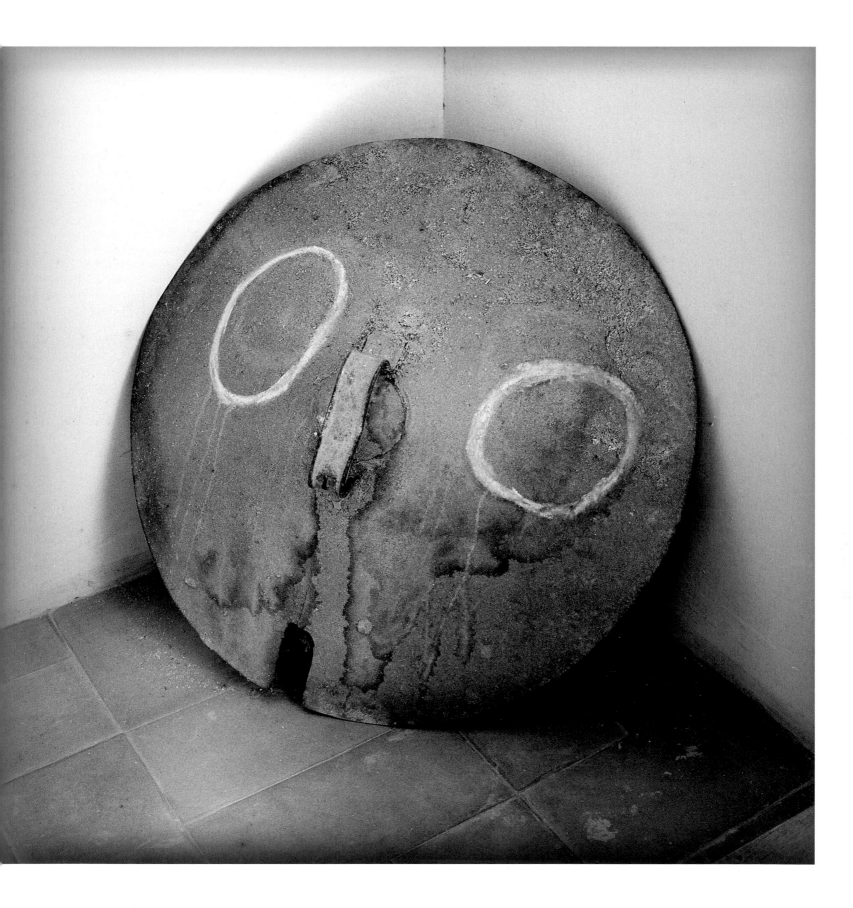

Son Boter studio, Cala Major, Majorca, 1961

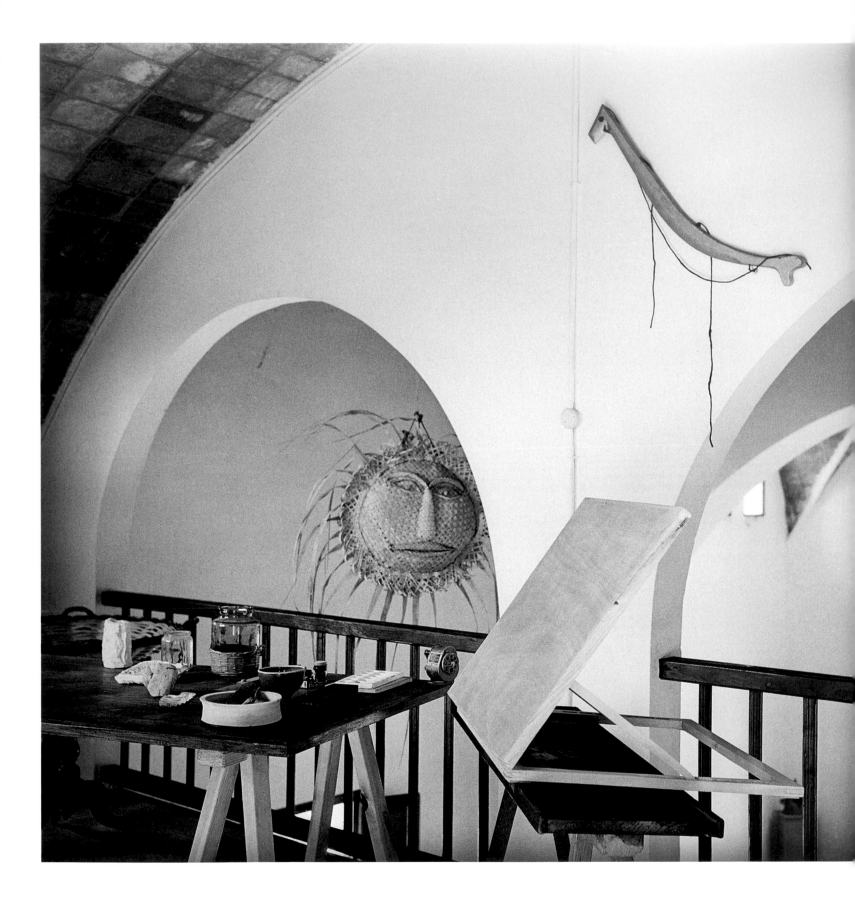

Son Boter studio, Cala Major, Majorca, 1961

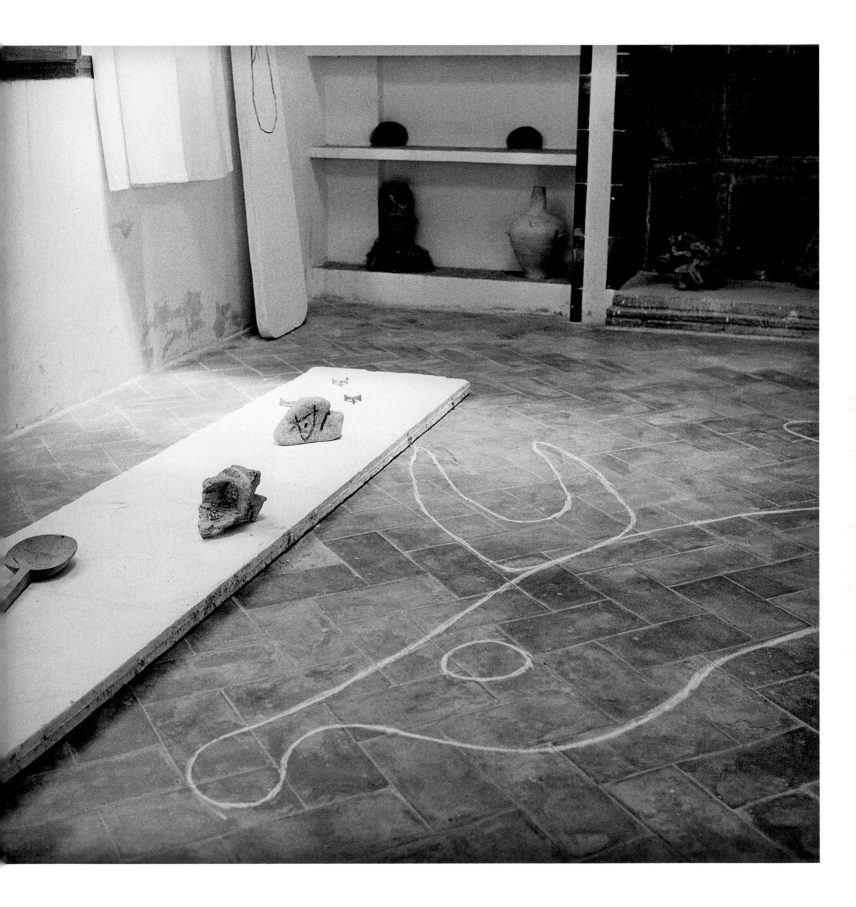

Son Boter studio, Cala Major, Majorca, 1961

VICTORIA COMBALÍA

MIRÓ'S STRATEGIES
REBELLIOUS IN BARCELONA, RETICENT IN PARIS

MIRÓ IN BARCELONA

'Here in Barcelona we lack courage.' Joan Miró

Who was this young Miró who caused a stir with his first solo exhibition at Barcelona's Dalmau Gallery in February 1918? What did he have to do with Catalonia? And what position did he occupy in Paris? The art critic Josep Maria Junoy announced this first exhibition in Barcelona by describing the painter as 'a small tin soldier' (Miró had just completed his military service) of whom 'much more would be heard'. Junoy also revealed something of the nationalistic orientation of Catalan cultural policy when he said: 'he is a painter who gobbles up new artistic trends from abroad with naïve voracity and generally digests them thoroughly without losing anything of his very special Catalan character.'[1]

Joan Miró came from a middle-class family in Barcelona. His father owned a large jeweller's shop in the city, while his grandfather on the distaff side of the family was a joiner. The family's artisan origins no doubt at least partly explain Miró's artistic inclinations and his love for what Catalans call 'a job well done'. Yet, as an upstanding bourgeois, his father refused to allow his son to devote himself to painting, forcing him to accept a job as a bookkeeper with Dalmau i Oliveres in Barcelona. Miró later recalled how his whole life after those 'two years of slavery' in the shop turned into a struggle for freedom. It was a traumatic experience: Miró suffered from severe de-

Fig. 1 Josep Maria Jujol, Interior decoration of Mañach's shop, 1911

Fig. 2 Josep Maria Jujol, Ceiling painting in the Casa Negre, Sant Joan Despí, Barcelona, 1915

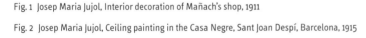

pression, and subsequently contracted typhoid, which kept him confined to bed at the Masía, the farm that his parents had just bought in Mont-roig. His father's lack of understanding, and the stark contrast between the pragmatic character of the father and the sensitivity of the son, contributed in Jacques Dupin's opinion to Miró developing into a taciturn, solitary person.

He received his artistic training in Barcelona at very different institutions. At La Llotja art academy (1907–10) his teachers were Josep Pascó, professor of applied art, and Modest Urgell, whose romantic landscapes, with their expansive, empty spaces and low horizons, no doubt influenced Miró's work.

Another school, the private academy of Francesc Galí, which the young Miró attended from 1912, was noted for its pedagogical innovations. The modern, elegant extrovert Galí ventured into the countryside around Barcelona with his pupils so that they could draw direct from nature. It was at this school that Miró would meet the two closest friends of his youth—Josep Francesc Ràfols (1889–1965) and Enric Cristòfol Ricart (1893–1960)—and their correspondence reveals the rebellious, non-conformist personality of the young Miró. Ricart tells us, for example, that the 18-year-old Miró was a 'pathological case'. 'He found it very difficult to represent the shape of an object, and he often had to explore a shape haptically before he could grasp it visually. He did not see at first glance whether the edge of a table was sharp or the handle of a jug was rounded. He had to go and touch the object. His perception of colour was no more accurate…. What an iron will-power, what rigorous discipline it

showed in one who two years later would go to the other extreme.'[2] Ricart was referring here to the highly detailed realism of the period that followed and the vivid colours that Miró used for it.

However, it was at a very traditional academy, the Circol Artístic de Sant Lluc in Barcelona, that Miró completed his training. There he drew from models and sat alongside the ageing Antoni Gaudí in drawing class. Miró was always impressed by Gaudí's creative vigour, with his vision of an organic architecture, which made his work unique. Miró was influenced not only by Gaudí—in my view, he was just as much impressed by Josep Maria Jujol, a collaborator of the architect, who was responsible for most of the ceramic designs in the Gaudí buildings and the ironwork balconies of the Casa Milà (La pedrera).

Jujol did the external and interior decoration of Mañach's, a shop selling safes at 57 Calle Ferràn in Barcelona (1911; Fig. 1), which no longer exists. The shop was very close to the Passatge del Crèdit, where Miró lived. Jujol likewise constructed the Casa Negre in Sant Joan Despí, Barcelona (1915; Fig. 2). In both places, the abstract, kidney-shaped forms—in ochre and blue in the Casa Negre—must have greatly impressed the young painter.

Some friends of his youth would remain in touch with Miró all their lives and play an important part in his career, such as Joan Prats, whom Miró got to known in Sant Lluc. Prats subsequently owned a hatter's shop, collected many avant-garde works (one of the few to do so in Catalonia) and was one of

the initiators of the Fundació Miró in Barcelona. Around 1912, Miró befriended the potter Josep Llorens Artigas, who later became famous as such, but was at first a young painter and occasional art critic. Artigas wrote several, not always positive articles about his friend. The contradictory relationship between Artigas and Miró changed after the Spanish Civil War. In the close and fruitful collaboration from 1942 onwards, Miró and he carried out numerous pottery and wall decoration commissions.

The young Miró in Catalonia was not the same reticent and shy young painter who later formed part of the Parisian group of Surrealists. In Barcelona, Miró was a restless young man with a highly critical attitude towards official culture. He went to every exhibition opening, and sharply criticised the nepotism in Catalan cultural politics and collectors' indifference. 'What will happen if we exhibit?' he wrote to Ricart. 'Apa [Feliu Elies, a conservative critic] will blow up (thank God). Some other gentlemen will praise us. No one will buy (people who claim they are admirers of ours and who have large fortunes will play dumb in order to see if we will give our work away or sell it for a pittance. I must tell you that if I have to live much longer in Barcelona I will be asphyxiated by the atmosphere—so stingy and such a backwater (artistically speaking).'[3]

In 1918, Miró did what many young people do. He joined forces with colleagues who wanted to create better opportunities to exhibit and to defend themselves more effectively against critics from the entrenched Catalan art establishment. He thus became a member of the Agrupació Courbet, to which Josep Llorens Artigas, Francesc Domingo, J.F. Ràfols, Enric C. Ricart and Rafael Sala also belonged (later members include Rafael Benet, Marià Espinal, Torres-García, Josep Obiols and Togores, who lived in Catalonia at the time). The local press made them out to be a radical avant-garde group, yet in 1918 the Agrupació Courbet was only cautiously modern: they showed the influence of Cézanne, Fauvism and Cubism, and rejected the sentimental art of *pompiers*. Their most obvious feature was the strong use of an intensive yellow colour, on account of which Miró proposed the name Saló Groc-Chrome for the group (*groc* meaning 'yellow' in Catalan).

In this circle of friends, Enric Cristòfol Ricart was, like Miró, a rebel in his youth, but unlike Miró his attitude to art gradually became conservative as he grew older. He was a leading light of the local periodical *Themis*, in issue 18 (20 March 1916) of which the *Manifesto of Futurist Woman* was published, much to the annoyance of peace-loving subscribers. He travelled a lot, but according to Ràfols was also a 'domestic soul', 'the most pious heart of our homeland'.[4] In these first years, he painted still lifes influenced by Fauvism, which resemble those of Miró of this date, but are clumsier in execution and less dynamic. Towards 1921, Ricart's painting manifested traits of Noucentisme, whereas in 1925 and 1926 a short phase of Cubist influence followed, though he soon gave this up. Particularly notable is the quality of his woodcuts. His recently published memoirs furnish an interesting record, for example his commentary on the Dada Festival, which was held in the Salle Gaveau in the rue de la

Boëtie in Paris, 26 May 1920. To Ricart, Dadaist pamphlets were 'full of innocence and pedantry'.

After his trip to Paris in 1920, Miró gradually distanced himself from Ricart, although he invited him to Mont-roig in 1927 and 1933. After a few brief, sporadic letters—on personal matters, such as a letter of condolence—Miró's final letter to his friend was in 1959, in which he thanked Ricart for keeping the correspondence of their youth, which would be very useful for the book that Jacques Dupin was writing at the time.

Another important friend of his youth, Josep Francesc Ràfols, was noted for his particularly good nature. He was apparently so kind-hearted that after he died a group of friends even proposed canonisation. Ràfols was a reasonable painter but a very good draughtsman, a meticulous architect and an excellent teacher, who wrote exceedingly well about art. He embodied the Noucentisme ideals of restraint, public-spiritedness and spirituality.

Another key figure in Miró's youth was the critic Sebastià Gasch, whom he got to know in Sant Lluc in 1918 or 1919. Gasch would prove the critic who would defend Miró with the greatest steadfastness, passion and shrewdness, and popularise his work in the rest of Spain via his articles in the *Gaceta Literaria*. The friendship between Miró and Gasch was of a highly intellectual nature. Miró sometimes criticised him rather sharply, but also manifested great trust in and appreciation of him. He and Gasch mutually supported each other. Miró kept Gasch informed about the French art scene and put him in touch with Jean Arp and Alberto Giacometti, whereas Gasch kept Miró up to date with the avant-garde art scene in Catalonia. Together they planned what Miró called 'offensives', one in painting, the other in art criticism.

The stylistic change from Catalan Art Nouveau to Noucentisme took place in the artistic circles in which Miró moved. Noucentisme was a cultural revival movement in Catalonia between 1906 and 1923. In art, it repudiated the individualism and romanticism of Art Nouveau and propagated a return to Neoclassicism, though not without introducing occasional modern features. Politically, Noucentisme was aligned with a conservative nationalism, which likewise contained modern features, such as the idea of an urban Catalonia driven by the industrial middle classes. The intensive support of schools, museums and libraries was a highly important initiative in the heart of a backward and undereducated Spain. Nationalism and public-spiritedness were tenets of Noucentisme that Miró always shared. However, the aesthetic limitations of the movement were one of the reasons why Miró would distance himself from his friends who clung to the styles of the past.

Noucentisme and its principal theoretician, Eugeni d'Ors (Xènius), advocated a return to order, balance and Neoclassicism. In the fine arts, this ideal was represented by the artist Joaquin Sunyer, whose Mediterranean and idyllic visions of rural Catalonia were enthusiastically received throughout the region. Miró's subject matter resembled Sunyer's—the Mediterranean, country life

and women—but Miró gives these traditional subjects a completely new meaning by means of a novel, abstract and synthetic language. This goal was achieved in *Ploughed Earth* of 1923–24 (illus. p. 59). To get there, Miró had to pass through various stages, going far beyond the qualified Cézannism of Sunyer. Between 1916 and 1918, he learnt from Vincent van Gogh, Henri Matisse, Robert Delaunay, German Expressionism and Cubism, and incorporated elements of them in his own work.

Robert S. Lubar, who has studied this period of Miró's work in depth, distinguishes between three aesthetic trends in the Catalan nationalism of the day: Eugeni d'Ors's Noucentisme, whose Neoclassicist streak was reflected in the painting of Neoclassicist painter Torres-García; Maragall's nationalism, spontaneous and romantic, manifested in exemplary fashion in the art of Sunyer; and, lastly, Junoy's aesthetic philosophy, an eclectic view of Mediterranean Neoclassicism that embraced Cubism as well as works by Torres-García, Sunyer and Manolo Hugué. For Lubar, Miró's art represents an 'archetypal view of a primitive Catalonia unchanged by time, industrialisation or political transformations'[5] that runs contrary to both d'Ors's Neoclassicist doctrine and the conservative politics of the Lliga Regionalista, and instead shares the idea of a cultural sensibility common to the Mediterranean peoples.

Other details support this view. Where being a champion of your own roots means an ideology that is basically traditional, Miró's defence of his native land entailed defending the primitive and the instinctive. As Miró himself put it in 1918, this attitude is not alien to Futurism, which he got to know through his friend Rafael Sala, who had associated with the Italian Futurists in Florence in 1914.

In a long letter to Ricart, Miró writes: 'I think that, after the magnificent Impressionist movement in France, ... we shall see a free art whose interest will be the *sound* of vibration, which is the result of the spirit. Instinct will triumph over everything, even against our very selves.... I am anxiously waiting to savor the Futurist writings against out-moded Rome and its moonlight nights: ... Down with weeping clouds! Let's be real men. Let's transplant the primitive man in ultramodern New York.... Here in Barcelona we lack courage. The critics most interested in modernism and Guillermo de Torre's movement Ultraísmo go weak at the knees when they see one of these eternal bygones and even say nice things about it. No one dares to say to the men that go to the Teatro Liceo [the opera], or the girls with ample décolletages who provoke but do not satisfy, that the operas of the Italian can-beltos are being prostituted.... No one dares say anything nasty about our museum!'[6]

Instinct and aggressiveness as a programme became recurrent motifs in Miró. Indeed, at the end of his life he said to Georges Raillard: 'All my life, I have preferred aggressiveness.... The older I get, the crazier, the more aggressive or, if you like, the nastier I become.' And when Raillard asked him: 'Do you have the feeling you're leaving a vision of your time behind

you?', Miró replied: 'I'm not so sure of that. Perhaps a time that can't see where it is going ... a return to our origins, to primitive violence.'[7]

The difference between Miró and his contemporaries in Catalan Noucentisme can be described as follows: his 'return to our origins' is by no means a return to an ideal Arcadia but to a concept of an instinct linked with life forces. Thus it was inevitable that the Surrealists would fascinate Miró as they did. Once, just to distance himself from a return to Neoclassicism such as Noucentisme advocated, at a gathering of Surrealists at which he was attacked by his friends, who were shouting 'À bas la France!' and 'À bas la Patrie!', Miró suddenly called out: 'À bas la Méditerranée!' In my view, he was criticising a super-annuated notion of the Mediterranean (which, as Jean Michel Gouthiertold to me, is the opposite of 'north', which Breton so admired) that could easily encompass Neoclassicism.

Miró's main lesson was to render the strengh of his roots universal. He drew his life force from a light, a landscape, its flora and fauna—and from the stars. Miró was an urban man who felt spiritually attached to rural life—not like an ecologist avant la lettre (he never discussed the matter in this way), but because he found examples of 'genuine' things in his rural surroundings. Over the years, Miró would develop a philosophy according to which man is at one with nature, part of a harmonious and egalitarian cosmos, in which an insect is as important as a mountain and a man as important as a tiny leaf. It was a holistic concept that prompted him to 'look for the noise hidden in silence, the movement in immobility, life in inanimate things, the infinite in the finite, forms in the void, and myself in anonymity', as he told Yvon Taillandier in 1959.[8] And we shall see how he reacted to the brilliant intellectualism of Paris after the provincial and intellectually dead Barcelona, but immediately discovered that he needed his roots to go on working. This awareness of his roots would become a leitmotif and distinguishing feature. His remarks about the importance of the land are quite well known, but let us recall them here: 'Trample the earth when painting, for strength enters through your feet.'[9] Or even the anecdote according to which he picked grass in the Bois de Boulogne in Paris and put it in an envelope to take home, so he could finish his picture of *The Farm* (illus. p. 125). He was so clear about it in his own mind that, having returned to Mont-roig from his first trip to Paris for one of his habitual summer stays in the country, he wrote to Ricart words that would sum up his plans for his whole life: 'Definitely, *never again Barcelona*. Paris and the country *until I die*.'[10] These alternating spells lasted from 1920 to 1940, and proved extraordinarily fruitful for his work.

However, for the time being Miró's first solo exhibition in Barcelona, at the Dalmau Gallery (16 February to 3 March 1918), caused a sensation. Miró exhibited 64 works in all, including *The Rose*, *Portrait of Vicens Nubiola* (illus. p. 122), *Nord-Sud* (illus. p. 55), *Prades, the Village* and *Siurana, the Path* (illus. p. 124). All these works show the influence of Paul Cézanne and Fauvism, and, as Jacques Dupin pointed out, exhibit 'a tangible rhythm, a visible flow of vitality and inner strength'.

Accompanying the exhibition was an acrostic incorporating the name 'Miró'. It was invented by Junoy, in praise of the painter's intense colours and dense surface treatment: 'forta pictòrica **M**atèria **I**mpregnada d'una **R**efractabilitat c**ó**ngestionant'. This did not in any way reduce the rage of numerous visitors who, incensed at Miró's radical visual idiom, destroyed a large proportion of the drawings exhibited. Miró also received several anonymous abusive letters, including one with another acrostic, forming the word 'merda'.[11] This event certainly contributed to Miró's relationship with Barcelona becoming problematic from then on, a sweet and sour mixture of partiality and resentment. Not surprisingly, the episode stuck in his mind for the rest of his life.

Although it may not have seemed so and the 'popular' antagonism was great, the reaction of the critics was not entirely negative. Almost all of them drew attention to Miró's courage and acknowledged his talent as a painter.

In summer 1918, Miró settled in Mont-roig. His work continued to feature scenes of rural life set in the Tarragona countryside, but it took the form of a hardened realism, in which the 'calligraphy of a tree or a rooftop' was described 'leaf by leaf, twig by twig, blade of grass by blade of grass, tile by tile'.[12] Miró drew inspiration from the Italian primitives and Japanese art. Eventually he reached what Ràfols called a 'detailist' style, which would culminate in his celebrated painting *The Farm* of 1921–22. But what seems like extreme realism was also a kind of perception recalling the mnemonic perception of children. You draw not only what you see but also what you 'know' of the given object. Of his friend, Ricart wrote in his memoirs: 'Miró was overcome by a kind of ecstasy over the shapes of things until he had managed to analyse the smallest details and evolved a well reasoned, decorative form for them. If it was, for example, a vine he was painting, he did not restrict himself to interpreting what we see from the ground up, but also depicted the roots.'[13]

THE ENCOUNTER WITH PARIS

In March 1920 Miró made his first trip to Paris. The impression that the city and its museums made on him was overwhelming. Miró had never previously been beyond Majorca or the environs of Tarragona (he had never even been to Madrid to see the Prado, though it was one of his great wishes), and in Paris he felt completely paralysed and unable to paint. He became familiar with and an admirer of the works of Pierre-Auguste Renoir, Van Gogh, Edouard Manet (whom he considered better than the Castilians Francisco de Goya and Diego Velázquez), Alfred Sisley, Camille Pissarro, Cézanne and Jean-Auguste Ingres. He wrote to Ràfols that Catalan artists surpassed French artists because the latter 'have an easy road and they paint to sell'. He added a thought about how hard circumstances were in Catalonia: 'When will Catalonia allow her pure artists to earn enough to eat and paint? Catalonia's rough way of treating spiritual things might be a Calvary of redemption.'[14] How differently the scene in Paris must have seemed to him compared with provincial Barcelona, where buyers of modern art could be counted almost on one hand. The French art scene induced a temporary breakdown in Miró, but within a few months he

had learnt how to cope with it and to draw the consequences. From then on, he began to develop his own unique strategy. He began to shroud his work and his person in a cloak of secrecy.

The strategy of silence was an idea of his Catalan art dealer Josep Dalmau. In a letter of 12 April 1920 Miró tells him about a visit to Picasso: 'I went to Picasso's again together with the Mompous. He was very welcoming and scolded me because I hadn't been more often. He shows a lot of interest in my things. I told him I had nothing, that I'd packed it all in boxes. I am following your instructions not to show anyone anything.'[15] Even if the reticence complied with a wish not to be copied and a desire—as he himself said—to gather his forces for a spectacular public premiere, this did not stop him looking for a suitable place to exhibit. He had agreed with Dalmau that the latter would find him a gallery in Paris. But Dalmau proved less reliable than his reputation. He did not answer Miró's letters and did not make the necessary preparations, even though Miró did him every favour, such as drawing up a comprehensive list of books about Cubism (Dalmau was considering opening a bookshop in Barcelona).

Maurice Raynal, the celebrated critic of *L'Intransigeant* and connoisseur of Cubism, did much more than Dalmau to help Miró with his first solo exhibition in Paris, at the Galerie La Licorne.[16] Raynal wrote the introduction to the catalogue, and was given the *House with Palm Tree* (1918; Fig. 3) in return.

Miró's other important mentor during this first stay in Paris was Picasso. Miró visited him in March, April and June. That is a lot if one remembers that Picasso was already famous by then, and shows the painter from Málaga's great generosity towards (and curiosity about) the Catalan. In the following year, Picasso endeavoured to interest his art dealer Paul Rosenberg, who ran one of the most respected galleries in Paris, in Miró's art. Picasso remarked to Miró that 'in Catalonia passion and heroism are needed.... Believe me, if you want to be a painter, do not stir out of Paris.'[17] In his first exhibition in Paris, Miró exhibited works such as his *Self-Portrait* (which he gave to Picasso; illus. p. 121), *The Table—Still Life with Rabbit* (1920; Fig. 4) and *Table with Glove* (1921), in which the stylistic approach of New Objectivity (Neue Sachlichkeit) and Cubism are reflected.

Although this first one-man show in Paris is represented as a failure by all Miró scholars and was even considered such by the painter himself, many people were interested in his work, especially *The Table*. This unusual painting did not escape the notice of contemporary art lovers. Most reviews were positive, like that of Florent Fels in *L'Information*: 'Real talent in Monsieur Miró's work'; René Jean in *Comoedia*: 'Works that display an undeniable gift for painting'; or André Salmon in *Europe Nouvelle*, who calls him a 'disciple of Picasso, but a disciple in a Cubist sense'. Most of the critics drew attention to a certain 'primitivism' in Miró's art, Raynal even talking of 'delicate ungainliness'.

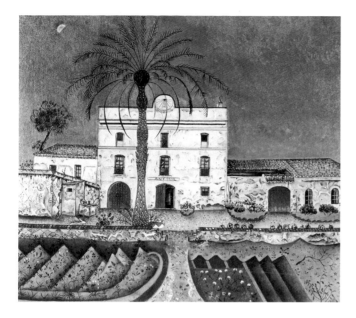

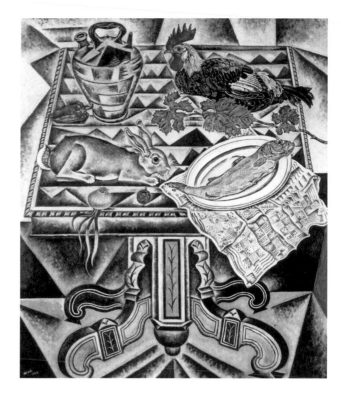

Fig. 3 Joan Miró, *House with Palm Tree*, **La Maison du palmier**, 1918,
oil on canvas, 65 × 73 cm, Museo Nacional, Centro de Arte Reina Sofia, Madrid

Fig. 4 Joan Miró, *The Table—Still Life with Rabbit*, **La Table—Nature morte au lapin**, 1920,
oil on canvas, 130 × 110 cm, private collection

As the attitude of some of the Catalan friends of his youth became more conservative despite their visits to Paris and knowledge of the latest art, Miró's relationships with them faded. His close friend Ricart, for example, thought Miró had been 'a lad with great qualifications for painting, but he is now beginning to fall victim to this band of bright sparks who run the scene in Paris'.[18] And he said this even before Miró had opened his exhibition at La Licorne. Ricart, the 'domestic soul', thought that in Paris Miró was becoming 'more reserved by the day, and I have heard more from the others than directly from him. Paris has obviously gone to his head a bit.'[19]

The encounter with writers of the order of Max Jacob or with the main figures of the nascent group of Surrealists meant an intellectual shock for Miró, to which he was certainly not immune.

In February (or March) of 1921, Miró had rented a studio at 45, rue Blomet, which belonged to the sculptor Gargallo. In the neighbouring studio was André Masson (with whom he had become acquainted through Max Jacob at the Café La Savoyarde). In Masson's studio, Miró met Michel Leiris, Roland Tual, Georges Limbour and Armand Salacrou—in short, the rue Blomet group. About this time he also made the acquaintance of Pierre Reverdy, director of the *Nord-Sud* newspaper, and Antonin Artaud. In the rue Blomet, Miró encountered an atmosphere of friendship and camaraderie that, as he said, he had never experienced in Catalonia. He got to know Jean Dubuffet, Robert Desnos and Paul Eluard, and occasionally visited members of the rue du Château group (the Prévert brothers, Yves Tanguy and Marcel Duhamel), especially Tanguy.

Miró noticed the great difference in intellectual tone in Paris immediately. He remembered the works of Arthur Rimbaud, Lautréamont, Friedrich Nietzsche and Fyodor Dostoyevsky being read in the rue Blomet. During the day, Miró painted in a neat and tidy studio in total quiet, while Masson painted at night to the accompaniment of music, and played cards and chess. These two diametrically opposed personalities explored the byways of automatism at the same time. And, with great diplomacy and intelligence, the discreet Miró, elegantly dressed and living an ascetic life, began to invite to his exhibitions the liveliest and most avant-garde figures the times could offer. On 30 June 1922 he told Ràfols that in Paris he had to make contact with people and become a 'man of the world'.[20] Life in Paris was indeed cosmopolitan. Patrons existed and the Surrealists moved in both the cafés and nightclubs of Montparnasse.

When Miró painted *The Farm*, he felt this was an important work, a conclusion to a creative phase. The painting was exhibited in the Salon d'Automne in 1922 but elicited only a few lines (from Maurice Raynal in *L'Intransigeant*) in the papers. Miró made an effort to invite as many personalities from French cultural life as possible, but without success. He exhibited the painting again in Montparnasse. On 7 April 1923, Tristan Tzara, for example, received a letter: 'Joan Miró présente ses meilleurs amitiés à M. Tzara et il est heureux

de lui faire part qu'il exposera la toile *La Ferme* au Caméléon (146, rue Montparnasse) à propos de la conférence que M. Schneeberger donnera le lundi 9 avril à 9h. du soir sur la Littérature Catalane.'[21] (Joan Miró sends his regards to Monsieur Tzara and is pleased to inform him that he will be showing the painting *The Farm* at the Caméléon [146, rue Montparnasse] on the occasion of the lecture on Catalan literature by Monsieur Schneeberger on Monday, 9 April at 9 p.m.) Except for Masson, the Surrealists were likewise not interested in *The Farm*, which was too realistic for them. In the end, Hemingway bought it for the princely sum of 5,000 francs, which plunged him into debt.

From 1922 to 1925, Miró concentrated exclusively on finding a new visual language by moving from the object to the sign. He succeeded with *Ploughed Earth*. The alternation between Paris and Mont-roig proved a very satisfactory approach to life and indeed the best thing for his work, as he had had the prescience to realise ('Definitely, never again Barcelona. Paris and the country …'). Miró did indeed spend every summer in Mont-roig, with shorter or longer stays in Barcelona. In the winter, he lived in Paris, though without entirely breaking his links with the Catalan art scene. Jacques Dupin, Miro's finest biographer, wondered how the artist found his way from extreme realism to his poetic ideograms that dispense with all detail, and commented: 'This radical transformation of forms did not take place in Paris…. It happened in Mont-roig, in the calm of a familiar landscape.'[22] My own view is that it was not just his 'slow and patient working method' (Dupin) and artistic development that brought him to this point, but also the radical thinking he had picked up from his colleagues in Paris and learnt to appreciate. The 'ascetic representation', to use Dupin's striking phrase, undoubtedly owed much to conversations with Leiris and Masson as well.

In summer 1922, Miró wrote to Roland Tual: 'During my off-hours I lead a primitive existence. More or less naked, I do exercises, run like a madman out in the sun, and jump rope. In the evening, after I've finished my work, I swim in the sea. I am convinced that one's serious work begins only in maturity, and to get to that point of development, we must lead a good life…. I see no one here, and my chastity is absolute. Quite a change from my busy social life in Paris, a fact that must not be overlooked either.'[23]

THE SECOND EXHIBITION IN PARIS
In 1941, André Breton recalled that Miró's accession to the Surrealist group had been 'tumultuous', and happened in '1924'. And yet Miró's position in the group was of a man apart. He neither appears in all the group photos nor signed the numerous manifestos. He does not appear in the tribute portrait to Germaine Berton in 1924, and in 1925 did not answer the survey on the subject of suicide. According to Dupin, for Miró the 'Surrealist meetings were like visits to the family on Sunday afternoons. They were a matter of form, even where rebellion was involved.'[24] I think Miró preferred to listen. He was too independent to submit to group discipline, and did not want any problems. Paris proved too intense and important for his career for him to allow a matter of opinion to give rise to conflict. He was pursuing his own struggle, which chiefly concerned painting.

Nonetheless, he persisted with his intelligent campaign of promotion, the result being that the invitations to his second solo exhibition in Paris, at the Galerie Pierre in 1925, were issued in the name of the Surrealists, not his own. How did he do it? Presumably with his extraordinary courtesy and obstinacy, coupled with the fact that his art obviously deserved the support. The exhibition, lasting from 12 to 27 June 1925, was opened by Benjamin Péret. The 'whole' of Paris, even Prince Eugene of Sweden, was present at the opening, around midnight at the rue Bonaparte.

Traditionally oriented critics (Vauxcelles, Florent Fels and Charensol) lamented the loss of a very promising painter. In *Les Nouvelles Littéraires* of 11 July 1925, Fels describes Miró as a 'Futurist torero', who paints 'furry rhomboids' and 'truncated cones with legs'. The 'success' or, 'noise', if you like, that Miró produced in Paris did not go unheeded in Catalonia. I do think that, henceforth, quite different horizons emerged in Miró's relationship with Catalonia. His previous positive critics Ràfols and Junoy had taken up more or wholly conservative attitudes and complained that the painter was 'done for'. Others, like the painter and critic Rafael Benet, behaved petty-mindedly: 'We are told the opening day of the exhibition cost him a lot of money because of the champagne, and this is to encourage bad habits in the local people.'[25] Then along came Gasch, the passionate and unconditional admirer, who rounded off his first article about Miró in *La Gaseta de les Arts* (15 December 1925) with a rousing statement: 'Miró is the most original representative of modern art after Picasso'.

In autumn that year, from 14 to 25 November, Miró took part in the extraordinarily important exhibition of 'La Peinture surréaliste', also at the Galerie Pierre, which was opened by André Breton and Robert Desnos. Other participants were Man Ray, Picasso, Arp, Paul Klee, Masson and Ernst. Miró's contribution included his celebrated *Harlequin's Carnival*. He wrote from the rue Blomet to Gasch: 'Excited by the storm I am making. That is our "speciality"…. As it is not a solo exhibition, I'd thought of sending only a few catalogues to Barcelona, but as I can see the current aggressiveness towards me, I'm proposing to flood the whole of Barcelona with catalogues.'[26] Thus Miró was still the 'rebel' in Catalonia, where his exile would awaken reactions of a distressing local patriotism. One journalist wrote: 'An art like that of Miró's is neither one of ours nor does it have anything to do with us. It is necessary for artists to learn, but look what Dunyac [a local sculptor] did when he returned to his homeland.'

THE 'BALLETS RUSSES', MIRÓ AND THE SURREALISTS: MIRÓ THE MAGICIAN
On 18 May 1926, the *Ballets Russes* premiered the ballet of *Romeo and Juliet* at the Sarah Bernhardt theatre in Paris. A note in the programme reads: 'Répétition sans décor en deux parties'. However, Max Ernst and Miró had been commissioned to do the sets. On this occasion it was the Surrealists

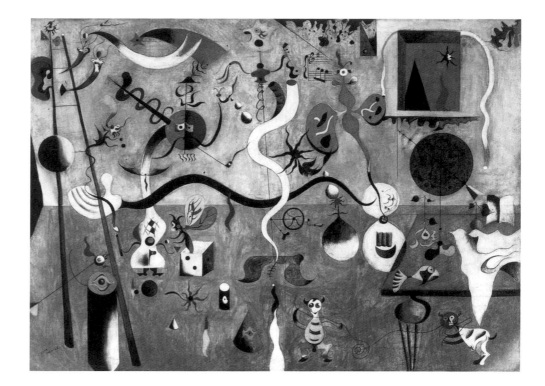

Fig. 5 Joan Miró, *Harlequin's Carnival*, **Carnaval d'Arlequin**, 1924–25, oil on canvas, 66 × 93 cm, Albright-Knox Art Gallery, Buffalo, Room of Contemporary Art Fund 1940

themselves who attacked Miró. At the first performance, around 50 people began to whistle and distribute leaflets signed by André Breton and Louis Aragon. The leaflets said: 'One should not allow one's thoughts to be ruled by money.' Serjei Diaghilev had revolutionised the ballet with his modern choreography and stage sets, which he commissioned initially from Russian artists Léon Bakst and Alexandre Benois, then later from Picasso (*Parade*), Sert et al. Anna Pavlova and Vaslav Nijinsky danced under him, while Stravinsky owed him, according to one commentator, 'almost all his fame'. He was nonetheless violently attacked by the French communist newspaper *L'Humanité* for his 'bourgeois education and his long sojourns in capitalist circles'. The 'orthodox' Surrealists in 1926 were of exactly the same mind.

But the scandalous events at the *Ballets Russes* enable us to measure Miró's international reputation. In the London *Vogue* of July 1926, he is described as 'one of the leaders of the Surrealist movement in Paris'. René Gaffé began to collect pictures by him, and in 1927 the painter first took part in the 'International Exhibition of Modern Art' organised by the Société Anonyme at the Brooklyn Museum in New York.

From 1925, the reviews of Miró's work underwent another fundamental and extraordinarily positive change. His work now became the object of commentaries by his Surrealist colleagues and friends, poets and writers. Undoubtedly these are the finest texts ever written about Miró (together with those by Jacques Dupin, the best authority on him). Special mention

must be made of the commentary on Miró in Breton's *Le Surréalisme et la peinture*, a book that appeared in 1928. Breton's assessment of the Catalan artist is ambivalent: 'Joan Miró cherishes perhaps one single desire—to give himself up utterly to painting, and to painting alone (which, for him, involves limiting himself to the one field in which we are confident that he has substantial means at his disposal), to that pure automatism which, for my part, I have never ceased to invoke, but whose profound value and significance Miró unaided has, I suspect, verified in a very summary fashion. It is true that that may be the very reason why he could perhaps pass for the most "surrealist" of us all.'[27] This is a judgement that at first glance hardly looks very positive, as it damns Miró as being no theoretician (which he was not) but 'only' a painter. Breton had an almost unerring eye for talent, but it was certainly Miró's lack of 'literature' that shocked him in the painter. But he also says that Miró is 'invincible in his field'. 'No one is as close as he is to associating the unassociatable.' And Breton adds: 'Delirium has nothing to do with it. Pure imagination is the sole mistress of what it seizes hold of every day, and Miró must not forget that he is only an instrument of it.'

Miró was indeed first and foremost a painter. He himself spoke out against painters whose work was just a visual expression of a theoretical programme: 'I do not believe in those who are trying to invent new schools.—I detest all painters who want to theorize. The great Impressionists worked brilliantly in front of light.—By impulse—Cézanne impulsively—Picasso impulsively. The only path of the chosen few—swept along by the impetus of the great

45

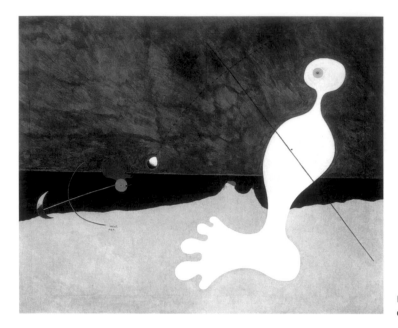

Fig. 6 Joan Miró, *Figure Throwing a Stone at a Bird*, **Personnage lançant une pierre à un oiseau**, 1926, oil on canvas, 73 × 92 cm, The Museum of Modern Art, New York

spiritual motor.'[28] He had a different relationship to literature. There was a complete harmony between Miró and the Surrealist poets. Not only did they write superbly about Miró, he became the favourite illustrator among poets, such as Tristan Tzara, Paul Eluard and René Char. Right from its foundation, the periodical *La Révolution Surréaliste* illustrated several of Miró's works. *The Trap* (1924), for example, in which we see a tree-man urinating on the beach in the presence of a rabbit and a cock, accompanies a text by Benjamin Péret (*Ces Animaux de la famille*) (no. 5, October 1925). In the same issue, *Ploughed Earth* (1923–24) illustrates the dreams of Michel Leiris and Max Morise. *Harlequin's Carnival* (1924–25; Fig. 5) appeared in no. 8 (December 1926) and *Figure Throwing a Stone at a Bird* (1926; Fig. 6) in no. 9–10 (October 1927). In Spain, on the other hand, there were virtually no reproductions of Miró's most recent works.

Robert Desnos, Michel Leiris et al. transferred Miró's visual poetry to literature. In *Little Review* (spring/summer 1926), Leiris wrote: 'Sometimes of mankind there remains only the mark of a foot on the wet sand ... and the spermatic fusion of the sexes is translated only by a thread.' The poet captures the ability of Miró's forms to achieve synthesis, which is close to mnemonic drawing, and associates them with primitive art and magic practices in which part of an object represents the whole (in Miró, he says, 'the bird is represented by a feather, the swift arrow of his flight or the mark of his talons'). 'Formerly', he adds, 'the anxious tribes of men would bury their nail-peelings and their fallen hairs in fear of sorcery; for they believed that

these particles of themselves contained their whole vital spirit.... Today, there is a new race of men who, from the double world of flesh and spirit, retain only the traces, vestiges of structures which a valueless intelligence can never render firm.... There is no question of proving, constructing. The state of mind is a new fetishism, which demands nothing but the perfect adhesion to the heart to any sort of object, free of symbol, but reflecting like the tiniest cell the infinite harmony of all the universe. A man like Miró belongs to that sorcerer race whose feats seem often ridiculous because of their bizarre tone and their air of coming from somewhere else.'[29]

This is the first indication that Miró was seen as a magician, even before the widespread cliché that he was a child. This magical aspect of Miró's art was also seized upon by the critics. For example, in 1928 Waldemar George wrote that 'Miró gave back to modern painting those great magic virtues that it had lost even a recollection of.'[30]

In his long article of 1929, 'Miró and the Resurrected Miracle',[31] George extended this concept of magic virtue to include that of a secret language that would nonetheless be accessible to 'children, lunatics, sleepwalkers, miracle-workers and the inspired', that is, a language for everyone who 'shatters the close confinement of reason, that prison of the spirit'. Miró's language is 'irrational, mythical and fantastic', and he adds that it is a 'poetic ex-voto', as if remembering the original idea of Leiris.

Fig. 7 Joan Miró, *Spanish Dancer*, **Danseuse espagnole**, 1928, private collection

Leiris and George speak of magic or secret codes, but Desnos and others, including Leiris, put forward the idea of purity and the innocent gaze. In a review of the Surrealist exhibition held in Zurich in 1929, Desnos writes: 'Everything is simple, just like so many complicated things are simple for the virginal and fertile imagination of children.... Miró's painting is undoubtedly the purest in the world, just as its creator is one of the purest spirits of this age.' And Desnos links the illogical and irrational with purity of gaze, which unites true poets with children, a favourite leitmotif of the avant-garde.[32]

Dalí, who joined the Surrealists in 1929, also wrote an article about Miró, establishing a link with primitive art and talking of 'his purest and most elementary magic opportunities' and Miró's 'pure inspiration and religious instinct'.[33] Dalí was prompted to write about his colleague out of admiration and gratitude. Not only did Miró introduce him into the Surrealist group but did his best as a mentor for him with his art dealer Pierre Loeb.

Leiris wrote again about Miró in *Documents*.[34] In this important article, he first discusses the concept of the void, linking it with Eastern thought. For Leiris, this void was a moral and metaphysical emptiness, not a 'negative term for nothingness but ... the absolute'. The poet confirms at the same time that behind the apparent cheerfulness and humour in Miró's work there lies a long period of 'emptying' the self until 'a state like childhood' was reached by the artist. It was thus a completely thought-out innocence or simplicity. He describes the paintings as 'stained rather than painted, as shabby as ruined buildings, as seductive as bleached walls', which recalls the late poetry of another Catalan, Antoni Tàpies.

CATALONIA, THE ASSASSINATION OF PAINTING, THE EXHIBITION AT BERNHEIM'S

Miró's position was visibly improving. After the international success of 1926, his name was on everyone's lips. In 1925, he had signed a contract with Jacques Viot, Pierre Loeb's former bookkeeper, and his financial situation stabilised at last. Miró moved to the Cité des Fusains (22, rue Tourlaque), in which his neighbours were now Max Ernst, Jean Arp, Max Morise and the art dealer Goemans. In 1926, he remarked in a letter to Gasch that he was not particularly interested in what was happening in Catalonia. But his lack of interest was clearly related only to the provincial, mediocre Catalan art scene. Miró never broke off contact with the real intellectuals and leading lights of the literary avant-garde in Catalonia. In 1927, for example, he illustrated the poet J. V. Foix's book *Gertrudis*.

At the same time, and very sure of himself as he did so, he did not give up his strategy of raising expectations. On 24 February 1927, he wrote to Gasch: 'In the name of the friendship that links us, I ask you to stop talking about me in Paris.... I work hard, very rarely see people.... No one has yet seen what I have done this summer nor what I'm doing now.... I don't allow anyone to talk about me.... On the other hand, there is a great panic around me, and I observe that my name keeps cropping up everywhere.' Again, on 4 March

1927: 'You know the horror that success represents to me and how I despise fashion. They are huge dangers in Paris. Just look what's left of the previous generation!... It is now thought here that everyone who comes from Barcelona has to destroy everything. Think of Picasso, who came from Barcelona, of the unknown dimension I represent to them, and I come from Barcelona as well. At the moment, there are great expectations of everything that comes from Barcelona.'[35]

Another concept that surfaces in the writings of those years is the 'assassination of painting', a phrase coined by Miró around 1927.[36] Indeed, between 1925 and 1927, Miró underwent one of the purest periods of his entire artistic career, and perhaps the most 'conceptual', which Dupin described as 'dream painting'. With the radical post-Dada collages of the *Spanish Dancers* in 1928 and 1929, a new, powerful, radical approach or *tabula rasa* emerges in his art. The dancer from André Breton's collection (now deposited at the Centre Georges Pompidou in Paris; Fig. 7) depicts merely a hatpin, a cork and a feather. Another consists of a drawn triangle on sandpaper and a photo of a flamenco dancer's shoe. Both can be described as visual poetry, as they consist solely of pictures without anything having been drawn.

Of course, Miró's 'assassination of painting' was a provocative phrase—but an important one. It meant opposing one's craft, rejecting the technicalities of painting and going one step further, above all to explore new materials. At any rate, the idea of 'assassinating' painting served as a basis for the *Groc Manifesto*, which Dalí and the critics Gasch and Montayà signed in 1928, in which the signatories committed themselves to boxing, the cinema, photography and an 'immovable ear on a small, straight pillar of smoke'—a clear allusion to two of Miró's motifs.

In 1928 came, one might say, Miró's Parisian *succès d'estime* and commercial success, with an exhibition at the Galerie Georges Bernheim. Everything was sold, and it was almost unanimously well received among the critics. The Catalan periodical *L'Amic de les Arts*, founded by Gasch in 1926 and to which Dalí and the critic Magí Cassanyes also contributed, reproduced numerous works by Miró in issue 26, dated 13 May 1928. At the same time, Gasch could hardly contain himself, and rejoiced in Miró's commercial triumph in an act of justified verbal 'revenge': 'May all the fools in this patch of the woods who considered Miró an idiot allow me to notch up one point in my favour.'[37]

Miró appreciated the favourable attitude of his Catalan friends, but as he did so remembered that 'his friends from here who lived in Paris treated me with the most infamous cruelty.'[38] Mariette Llorens Artigas, daughter of the potter, reported that various Catalan artists in Paris made jokes about Miró's genius by insinuating that he positively radiated an 'aura'.

Following his success, the journalist Francesc Trabal published a long interview with Miró in the Catalan newspaper *La Publicitat* (14 July 1928). In it, Miró emphasised the importance of his homeland and what he called 'offensive [i.e. outward-looking] nationalism', that is, he had become an international Catalan. He railed against nationalist victimisation and sentimentality, attacked 'local geniuses', such as Feliu Elies, Togores and Sunyer, and above all he defended risk-taking and adventure in the face of the bourgeois notion of 'future'.[39]

1929 AND BEYOND

1929 was an important year in Miró's professional and personal development. On a local level the periodical *Hélix* in Vilafranca del Penedés published two articles in defence of Miró in its issue number 1 (February 1929). On an international level, the Belgian periodical *Cahiers de Belgique* dedicated an issue to him in June, with articles by Gasch, Dalí and Desnos. The famous North American collector Eugene Gallatin bought two of his pictures. One of these was *Dog Barking at the Moon* (1926), which found its way thence into the Philadelphia Museum of Art. In France, this was the year when Breton published his second Surrealist manifesto. In its June issue, the periodical *Variétés* published 'À Suivre: Petite Contribution au dossier de certains intellectuels à tendances révolutionnaires'. We find there answers by writers and artists to the question Breton raised on 12 February as to whether their activity should be restricted to an individual nature or not. Miró had not taken part in Breton and Eluard's statement on Communism in 1926, had watched the exclusion of Artaud and Soupault from the Party (in November 1926) and had likewise not taken part in other collective statements, like that in the defence of Charles Chaplin in 1926 or the survey on sexuality in 1928. Yet, surprisingly, he answered. His answer was very much like that of his friend Robert Desnos, who said he was not against joint action per se but rejected discipline. Miró answered: 'Launching a campaign always requires a common effort. Yet I think that individuals with an ailing, strong or excessive personality ... could never submit to barracks discipline that requires joint action at any price.'[40] Miró continued to be a reticent and watchful observer, who rebelled only through painting, and defended the independence of the creative spirit. He did not take part in partisan matters that would lead to members being excluded. His approach was quite distinct from that of Dalí, likewise Catalan, who joined the group the same year and under similarly tumultuous circumstances. A good measure of the esteem in which the other Surrealists held Miró's work, especially his radical collages, was the reproduction of two of his *Spanish Dancers* in the same issue of *Variétés* (June 1929).

In 1929, Miró married, finally settling in Paris, where he became an established success. His pictures were to be found in the most important art collections of the avant-garde worldwide, such as those of René Gaffé, the Vicomtesse de Noailles, Jacques Doucet, Marie Cuttoli, Eugene Gallatin and Paul Rosenberg. In the 1930s, he exhibited regularly at the Galerie Pierre and at Goemans's and Bernheim's. From 1932, Pierre Matisse exhibited his work in New York. Robert Desnos and Georges Hugnet wrote about him. He illustrated books by Lise Deharme (1928), Tristan Tzara (1930), Georges Hugnet (1933), Paul Eluard (1938) and Benjamin Péret (1938). This fruitful collaboration broke off with the German invasion in 1940. In a dilemma as to whether he should

emigrate to the United States or return to Spain, he decided, at the urging of his family, to return to his own country, where he suffocated culturally and politically under the Franco dictatorship. In Spain, he lived in seclusion and almost unknown until far into the 1960s. Having spoken out unequivocally against the Franco regime in the Spanish Republic's pavilion at the Paris World Exhibition in 1937, Miró opted for inner exile. His daughter, Dolors, confirms that besides the pressure of her mother to return to Spain, the pull of his native land was also a decisive factor in Miró's resolve to return. 'In North America, he would not have had the Mediterranean', she added.[41]

NOTES

1 Josep Maria Junoy, 'Joan Miró', *La Veu de Catalunya*, 4 January 1918.

2 Enric Cristòfol Ricart, *Memòries* (Barcelona, 1995), p. 22.

3 Letter 460, 4 August 1918, quoted from *Joan Miró: Selected Writings and Interviews*, ed. Margit Rowell (London, 1987), p. 56.

4 Quoted from Victoria Combalía, *El descubrimiento de Miró: Miró y sus críticos 1918–1929* (Barcelona, 1990), p. 33.

5 Robert S. Lubar, 'El Mediterráneo de Miró: Concepciones de una identidad cultural', in *Paris–Barcelona*, exh. cat. (Paris: Galeries nationales du Grand Palais, 2001; Barcelona: Museu Picasso, 2002), pp. 401–12.

6 Letter 42, February 1918, Ricart Archive, Biblioteca-Museu Balaguer, Vilanova i Geltrú, Barcelona.

7 Georges Raillard, *Joan Miró: Ceci est la couleur de mes rêves* (Paris, 1977).

8 Yvon Taillandier, 'Je travaille comme un jardinier', interview with Joan Miró, *XXe Siècle Mensuel* 1, no. 1 (Feb. 1959); quoted from Rowell (note 3), p. 253.

9 Jacques Dupin, *Joan Miró: Life and Work* (London, 1962), p. 34.

10 Letter 483, 18 July 1920, Ricart Archive, Biblioteca-Museu Balaguer, Vilanova i Geltrú, Barcelona; quoted from Rowell (note 3), p. 73.

11 Lubar shows how Junoy dampened any criticism of Miró's avant-gardism by referring to his 'very special Catalan' qualities in his article for *La Veu de Catalunya*; cf. Lubar (note 5), p. 406.

12 As he explained to Ricart in a letter, quoted from Rowell (note 3), p. 54, and in Robert S. Lubar, 'Joan Miró before *The Farm*, 1915–1922', Ph.D. diss. (New York University, 1988), p. 128.

13 Ricart (note 2), p. 23.

14 Letter from March 1920, Ràfols Archive, Biblioteca de Cataluña, Barcelona; quoted from Rowell (note 3), p. 72.

15 Rafael Santos Torroella, *35 años de Miró* (Barcelona, 1994), p. 67.

16 Letter of 5–10 March 1921, Archivo Histórico del Colegio de Arquitectos de Cataluña, Barcelona.

17 According to Miró in a letter to Ràfols, quoted from Amadeu Soberanas and Francesc Fontbona (eds.), *Cartes a J. F. Ràfols, 1917–1958* (Barcelona, 1993), p. 45.

18 Letter from Ricart to Ràfols, 17–18 March 1921; quoted from Lubar (note 11), p. 207.

19 Ricart (note 2), p. 84.

20 Quoted from Soberanas and Fontbona (note 17), p. 59.

21 Letter from Miró to Tzara, Bibliothèque Littéraire Jacques Doucet; quoted from Combalía (note 4), p. 65.

22 Jacques Dupin, 'The Birth of Signs', in *Joan Miró: A Retrospective*, exh. cat. (New York: Solomon R. Guggenheim Museum, 1987), p. 33.

23 Letter of 31 July 1922; quoted from Rowell (note 3), pp. 79–80.

24 Jacques Dupin, *Joan Miró* (Paris, 1993), p. 116.

25 Rafael Benet, 'Cròniques d'Art a Paris: Els artistes catalans residents aquí', *La Veu de Catalunya*, 23 June 1925.

26 Letter of 15 November 1925; quoted from Combalía (note 4), p. 76.

27 André Breton, 'Surrealism and Painting' (1928), in idem, *Surrealism and Painting*, trans. Simon Watson Taylor (London, 1972), p. 36.

28 Letter from Miró to Ràfols, Mont-roig, 11 August 1918, Ràfols Archive; quoted from Rowell (note 3), p. 57, and partly cited in Lubar (note 5), p. 130.

29 Michel Leiris, "Joan Miró", trans. Malcolm Cowley, *Little Review* (spring/summer 1926): 8–9.

30 *Presse*, 16 May 1928; quoted from Combalía (note 4), pp. 194–95.

31 Waldemar George, 'Miró et le miracle ressucité', *Le Centaure*, no. 8 (May 1929); quoted from Combalía (note 4), pp. 226–27.

32 Robert Desnos, *Züricher Zeitung*, 25 October 1929; quoted from Combalía (note 4), p. 265. C. Green investigated the subject in 'Picasso and Miró' (1930), in *El mago, el niño y el artista*, Leccions Alfons Roig, IVAM (Valencia, 1991).

33 Salvador Dalí, *L'Amic de les Arts*, no. 26 (June 1928); quoted from Combalía (note 4), pp. 200–201.

34 Michel Leiris, 'Joan Miró', *Documents*, no. 5 (October 1929); cited in Combalía (note 4), pp. 257–61.

35 Quoted from Combalía (note 4), p. 88.

36 'Je veux assassiner la peinture', quoted from William Jeffett, *Impactes: Joan Miró, 1929–1941*, exh. cat. (Barcelona, 1989); Jeffett refers to the quote in Maurice Raynal, *Anthologie de la peinture en France, de 1906 à nos jours* (Paris, 1927), p. 34; also quoted by Adolphe Basler in *Marges*, 15 February 1927.

37 Quoted from Combalía (note 4), p. 89.

38 Letter from Miró to Francesc Trabal, 8 August 1928; quoted from Combalía (note 4), p. 93.

39 Interview quoted from Combalía (note 4), pp. 206–13.

40 *Variétés* (June 1929).

41 Conversation with the author, 11 March 1990.

STEPHAN VON WIESE

PAINTING AS UNIVERSAL POETRY
THE CONNECTION BETWEEN PICTURE AND WORD IN MIRÓ

The painting *Snail woman flower star* of 1934 (illus. p. 177) was designed and painted as a cartoon for a tapestry. It juxtaposes and combines two fundamentally different (eidetic and phonetic) communication systems—writing and images. The title is inscribed as a looping, handwritten calligramme between the largely abstract figures, and thus becomes part of the picture system. The sweeping loops of the writing are like an echo or a paraphrase of the organic forms, recalling choreographic or musical notation containing the melody for the ecstatic, archaic dance of the totem-like, mask-headed figures.

However, the title is not just a picture; it is also a poem in which alliteration and assonance (i.e. a concordance of emphasised vowels) are skilfully combined. The title reads like an oracle. One sees it as a line, with its suggestive ring in one's ear. As Michel Foucault has noted in another context (interpreting a work by Magritte), calligrammes as an artistic form tautologously reconcile an ancient fundamental polarity: 'Calligrammes make use of the old characteristic of letters: they constitute both linear elements you can arrange in space and signs that have to be played as a defined chain of sounds. Letters are signs that can also represent an object figuratively. Calligrammes set about playfully erasing the oldest antitheses in our alphabetic civilisation—showing and naming; representing figuratively and saying; reproducing and articulating; imitating and signifying; seeing and reading.'[1] This synthesis of opposites is a feature of poetry. That is why in his Miró monograph, *Der magische Gärtner*, Hubertus Gassner judges the calligrammes of Guillaume Apollinaire—the collected volume appeared in 1918 under the title *Calligrammes*—as 'the

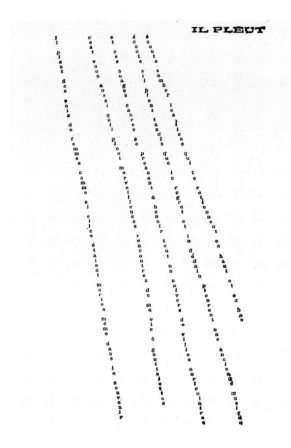

Fig. 1 Guillaume Apollinaire, *Il pleut*, calligramme

Fig. 2 Guillaume Apollinaire, *Montparnasse*, calligramme

most modern art form of the day', i.e. the 'combination of word and image, the liberation of painting relying on purely visual means into a cross-genre poetry that blended poetry and image [Figs. 1, 2].'[2] This was Miró's artistic goal as well.

Miró's expanded repertoire of pictorial elements, which included syllables, words and phrases, is thus not a marginal phenomenon in his work but of fundamental importance. He wanted to be more than a painter. As a *peintre-poète*, he wanted to take painting to a higher level, where it would unite with poetry. This intention was stressed time and again in Miró's conversations with James Johnson Sweeney and Georges Raillard, and in reports by contemporary witnesses and friends, in particular André Masson. In an interview with Georges Duthuit Miró commented: 'I make no distinction between painting and poetry. I have sometimes illustrated my canvases with poetic phrases, and vice versa. The Chinese, those great lords of the spirit—isn't that what they did?'[3] According to Masson: 'It was obvious that for Miró and myself, poetry (in the broadest sense of the term) was of capital importance. Our ambition was to be a painter-poet ... [we were] painters purporting to work from poetic necessity.'[4] Or again Miró: 'I saw a lot of poets that year [1924], because I thought it was necessary to go beyond the "plastic fact" and arrive at poetry.'[5] Only after his stay in Varengeville-sur-Mer in 1939 and life in isolation during World War II was the initiating role of poetry gradually taken over by that of music. Once again, this brought about a change in the structure of his work, with mystic contemplation replacing poetic spiritual inspiration: 'I felt a deep desire to escape. I closed myself within myself purposely ... and now music in this period began to take the role poetry had played in the early twenties.'[6]

THE WILL OF THE POET CAN TOLERATE NO LAW ABOVE ITSELF

This 'extension' of painting corresponds to a basic tenet in the radical artistic thought of Early German Romanticism, which expected poetry to be 'universal poetry', to use Friedrich Schlegel's term in his key *Athenäum* piece no. 116 of 1798, anticipating the modernist view: 'Romantic poetry is progressive, universal poetry. Its aim isn't merely to reunite all the separate species of poetry and put poetry in touch with philosophy and rhetoric. It tries to and should mix and fuse poetry and prose ... and make poetry lively and sociable, and life and society poetical.... It alone is infinite, just as it alone is free; and it recognizes as its first commandment that the will of the poet can tolerate no law above itself.'[7] Painting as 'poetry' in this sense breaks down all barriers and conventions and determines its own laws. More than all Surrealist manifestos, such an early creed of radical art theory was the equivalent intellectual background for Miró. 'Miró was devouring the great rebels of poetry—Novalis, Lautréamont, Rimbaud, and Jarry—and they profoundly influenced his imagination,' observed Jacques Dupin sagely in his monograph on the artist.[8] The mention of Novalis also suggests a connection with the radical thought of his like-minded poet-friend Friedrich Schlegel.[9] Always open to analogous and associative short cuts between all spheres of nature and art, Miró did indeed establish a law of his own. This explains not least the many surprising turns in his artistic development. We are witnesses to an increasing

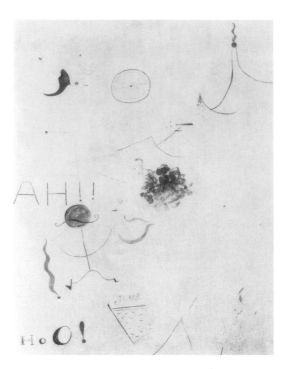

Fig. 3 Invitation to the 'Joan Miró' exhibition, Galerie Pierre, Paris, 1925

poeticisation of the canvas, from which ultimately a personal symbolic idiom emerged, a kind of meta-language that embraced both text and image. Miró's pictorial alphabet, evolved from the artist's own intellectual environment, is universally readable despite, or perhaps because of, its idiosyncratic coding, and is indeed the epitome of *peinture-poésie*.

The two-way relationship between image and script in Miró's work will be outlined in this essay, which is based on much illuminating work in previous studies. The work of Margit Rowell is pioneering in this respect—particularly in *Joan Miró: Magnetic Fields*, a catalogue accompanying the eponymous exhibition that she and Rosalind Krauss curated at the Solomon R. Guggenheim Museum in New York in 1972.[10] Instead of the image of a supposedly 'naïve' outsider of modernism, Miró's pioneering achievement in this development was at last acknowledged. In the foreword to her book *Joan Miró: Peinture = Poésie*, Margit Rowell quotes by way of introduction the artist's poetological avowal that 'painting and poetry are done the same way you make love; it's an exchange of blood, a total embrace—without caution, without any thought of protecting yourself.'[11]

SECRETS THAT DO NOT FEAR BROAD DAYLIGHT
'The Surrealists put me in touch with poetry', Miró emphatically confirmed in his conversations with Georges Raillard.[12] From 1921 to 1926, the artist lived and worked (with half-yearly intermissions during which he returned to Catalonia) as a neighbour of the painter André Masson in his studio at 45,

rue Blomet. There, in Montparnasse, a 'magnetic field' of friendship developed. A productive exchange of thought among like-minded literati and painters got underway. According to Miró: 'Masson was always a great reader and full of ideas. Among his friends were practically all the young poets of the day. Through Masson I met them. Through them I heard poetry discussed. The poets Masson introduced me to interested me more than the painters I had met in Paris.... I gorged myself on it all night long—poetry principally in the tradition of Jarry's *Surmâle*.'[13]

The anarchic spirit of Dadaism still prevailed, as was manifest in a particularly spectacular way at the Dada Festival in the Salle Gaveau in Paris in May 1920.[14] A new textual and visual language developed in empathetic, parallel exploration: 'He was not alone in his dilemma—painters, poets, and writers were all passing through the same crisis. What they all had to do was to "wipe the slate clean"—this was the sense of Dada's total revolt—and start to live and work afresh. If they were to take their place in history, they would have to invent entirely new modes of expression, in accordance with their own thought and sensibility. No. 45 rue Blomet was then one of the avant-garde laboratories, where the new language was being forged.... He [Miró] familiarized himself with the methods poets were evolving to regain access to the domain of the imagination.'[15]

The inner circle included not only Masson and Miró but also the poets Georges Limbour and Armand Salacrou.[16] Inspiration came from various sources:

Fig. 4 Joan Miró, *The Reversal*, **Le Renversement**, 1924, oil, pencil, chalk and tempera on canvas, 92 × 73 cm, Yale University Art Gallery, New Haven

Salacrou wrote plays and translated Byron; Limbour read out, for example, poems by the Breton mystic Saint-Pol Roux and texts by Jarry, the author of the play *Ubu Roi* and spiritual father of the Theatre of the Absurd. From 1922, the writer and later ethnologist Michel Leiris, author of dream reports and a glossary of euphonious word associations, came and went every day —he remained a lifelong friend of Miró, and became one his most important inspirers and interpreters. The startling chains of visual and mental ideas Leiris conjured up were a poetological model for Miró, who included Leiris's Christian name in the title of a *tableau-poème* he did in 1927—*Michel, Bataille et moi*. Poet Roland Tual, whose work would never be published and who worked in obscurity, was closely linked to the group. Antonin Artaud, actor and poet, who handily kept the group supplied with theatre tickets for current productions, was a regular—later he and Vitrac would found the Théâtre Alfred Jarry, closely associated with the Theatre of Cruelty. Visitors came from the studio community associated with Duhamel and Tanguy in the rue du Château, including the collage poet Jacques Prévert, who would later write a whole cycle of poems about Miró and his pictorial language.[17] Picasso and Tristan Tzara, co-founders of Dadaism, were more than occasional guests. The first envoys also came from the group of proto-Surrealist poets associated with Breton. In time, the north-south metro line became the most important link between Montmartre, where the 'founding fathers' of Surrealism (Breton, Eluard, Soupault and Aragon) resided, and the rue Blomet, where most of the later dissidents—the 'backward artists' (Miró)[18]—were at home.

The Surrealists, informally constituting a group from 1923, notably included Robert Desnos, the journalist and poet who later became artistically very closely linked with Miró.[19] At the seances chez Breton in the rue Fontaine, where accounts of dreams were read out, he stood out—like Crevel—for his readings of cryptic texts gasped out under hypnosis or in sleep. Following in Freud's footsteps, they discovered the hidden world of the unconscious. Breton wished to bind Freud's insights to Marxist doctrines in order to change people and the world. Even as a neurologist at the military hospital of Nantes, he had used patients to experiment with automatic writing, a method that was supposed to articulate the unconscious. In 1919, Breton and Soupault had jointly written the first Surrealist text—*Les Champs magnétiques*—with contributions written down without involving the use of reason. The title deliberately alluded to electro-magnetic processes: 'The physical and spiritual universe is only a force field in constant vibration in which all "wireless" things interfere and communicate with each other.'[20] In Breton's first Surrealist manifesto (1924), the central message was: 'I believe in the future resolution of these two states, dream and reality, which are seemingly so contradictory, into a kind of absolute reality, a *surreality*, if one may so speak.'[21] Admittedly, Breton did not visit Miró's studio in the rue Blomet until 1924, and then reacted without understanding.[22]

Miró's second solo show in Paris was opened at midnight on 12 June 1925, at the Galerie Pierre in 13, rue Bonaparte. The invitation card turned into a kind of second founding document of Surrealism (Fig. 3). The card bears the

signatures of 25 poets and painters, uniting the separate coteries from the rue Blomet and Breton's circle for the first time. The card itself resembles a calligramme, forming, as it were, a written group portrait, and is thus a latent allusion to the new pictorial form, the picture-poem (*tableau-poème*)[23] in Miró's oeuvre, in which images and words are combined, whether in the form of integrated poetic titles such as in the paintings '*Smile of my blonde*', 1924, and '*The happiness of loving my brunette*', 1925 (illus. p. 134), or in visual declamations as in the apocalyptic *Reversal* (Fig. 4) and Chaplinesque *Gentleman* (illus. p. 133), both of 1924, the former with the double startled exclamation 'AH!! HoO!', the latter with the handwritten, pompous 'Yes'. Another form is the close imitation of calligrammes in the painting-poems with inscriptions: *Etoiles en des sexes d'escargot* and *Photo—This is the Colour of my Dreams* (Fig. 11), both of 1925.

The list of 25 signatories comprised virtually the entire group of Surrealists, and included nearly all the writers listed by Breton in his first Surrealist manifesto (of the 18 mentioned there—Aragon, Baron, Boiffard, Breton, Crevel, Delteil, Desnos, Eluard, Gérard, Limbour, Malkine, Morise, Naville, Noll, Péret, Picon, Soupault and Vitrac—only Delteil is missing here). The list was now extended to include the group of painters—Ernst and Masson—who remained a small minority, plus the poets from the rue Blomet—Leiris, Artaud and Tual—and individual marginal artists such as Lübeck, Fraenkel, Canive and Bousquet.

This graphic bouquet of signatures is not only a gesture of personal support. It is in the iconographic tradition of friendship pictures and is in particular a follow-up of a painting by Max Ernst two and a half years earlier entitled *Au Rendez-vous des amis*. It linked a young group of intellectuals with various spiritual antecedents (Dostoyevsky, Freud, Raphael). Of the 14 contemporaries depicted in it, ten—Aragon, Breton, Crevel, Desnos, Eluard, Ernst, Fraenkel, Morise, Péret and Soupault—were on the invitation card for the Miró exhibition. The Galerie Pierre was also the location of the first exhibition of Surrealist painting ever, in November 1925.

Breton's own attitude to Miró's work was rather reserved. In a serialised article entitled 'Le Surréalisme et la peinture', appearing in four instalments in *La Révolution Surréaliste*, he does not mention him.[24] Nevertheless, after Miró's solo exhibition at the Galerie Pierre, reproductions of Miró's works appeared time and again in this principal organ of Surrealism, beginning with *Motherhood* (illus. p. 115) and *Catalan Landscape (The Hunter)* (illus. p. 127) in issue no. 4, 15 July 1925.[25] In the book version of the above article, published in 1928, Breton discusses Miró for the first time, describing him (in respect of automatism) as perhaps 'the most "surrealist" of us all', but nonetheless he is full of qualifications: 'In place of the innumerable problems which do not concern him in the least despite the fact that human character is moulded for them, Joan Miró cherishes perhaps one single desire—to give himself up utterly to painting, and to painting alone (which, for him, involves limiting himself to the one field in which we are confident that he has substantial

means at his disposal), to that pure automatism.'[26] For Miró, automatism was indeed more than just a method to fathom the unconscious. In fact, it opened up for him the field of poetic freedom without restriction. The first empathetic appreciation of Miró came characteristically not from Breton but from the pen of the Surrealist dissident Michel Leiris in his periodical *Documents*, founded in 1929 with a broader spectrum of subjects in view (teaching, archaeology, fine arts, ethnography). In contrast to Breton's obsession with the reality of dreams and the unconscious, Leiris came up with a new interpretation of Miró that went to the heart of the matter: 'Though his pictures are still exciting secrets, they are secrets that do not fear broad daylight, and they are all the more confusing as no cockcrow will put them to flight.'[27]

MAY OUR BRUSHES KEEP TIME WITH OUR VIBRATIONS!

Miró's special sensitivity to the new poetry among the group of literati in the rue Blomet was not incidental. Even in Barcelona he had followed current literary trends with keen interest. The cover images he contributed to the Catalan literary periodicals *Arc-voltaic* (Electric Arc) in February 1918 and *Trossos* (Fragments) in March 1918 and the poster for the French Catalan periodical *L'Instant* in 1919 show his active participation in the literary life of his homeland. References to contemporary literature also crop up in the paintings, for example in the pictures *Nord-Sud* (a French newspaper), 1917 (Fig. 5), and *The Horse, the Pipe and the Red Flower*, 1920 (Fig. 6).

Spain remained neutral during World War I, and as a result a number of French artists sought refuge from the war in Barcelona. In conversation with Georges Raillard, Miró himself named artists Marie Laurencin (a former girlfriend of Apollinaire), Otho Lloyd and his brother, Dadaist Arthur Cravan, who both painted and boxed, Olga Sakharoff and Albert Gleizes.[28] The group also included the poet Maximilien Gauthier, Nicole Groult (sister of couturier Paul Poiret), the painter Charchoune, the two Delaunays (on their way to Lisbon) and last but not least Francis Picabia, who arrived with Gabrielle Buffet from New York in summer 1916. In the Catalan capital, Picabia would find in Josep Dalmau, the gallery owner in the Calle Portaferissa who sympathised with the new artistic developments, a publisher for this first four issues of his periodical *391*. The first issue appeared in January 1917 and bore Picabia's mechanical drawing *Novia* on the cover.[29] Since his Cubist exhibition of 1912, Dalmau had been the champion of the French avant-garde in Barcelona[30] —Miró himself owed Dalmau his first solo show (16 February to 3 March 1918), and indeed it was through Dalmau that he made contact with pioneering international artists and became an '*International Catalan*'.[31]

The periodical *391* and its editor, Picabia—whom he had met—drew Miró's attention to the Dadaist movement. Picabia's title pages caused a stir because they challenged traditional aesthetics. They included his machine pictures such as *Miroir de l'apparence* on the cover of issue no. 2. No less unusual was the colour reproduction of Apollinaire's calligramme *L'Horloge de demain* in issue no. 4. A calligramme—as defined by Rosalind Krauss—is a poem that shows a picture both visually and verbally.[32] How struck Miró had been

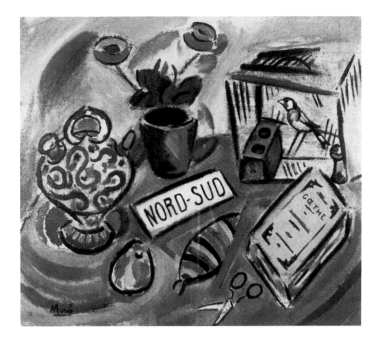

Fig. 5 Joan Miró, **Nord-Sud**, 1917, oil on canvas, 62 x 70 cm, Galerie Maeght, Paris

Fig. 6 Joan Miró, *The Horse, the Pipe and the Red Flower*, **Le Cheval, la pipe et la fleur rouge**, 1920, oil on canvas, 82.5 × 75 cm, Philadelphia Museum of Art, Philadelphia

by this *poème-image* he emphasised decades later in conversation with Raillard.[33] But earlier calligrammes (e.g. *Lettre-océan*), initially called ideogrammes, that Apollinaire published in *Les Soirées de Paris* from issue no. 25, June 1914, could also have reached Barcelona. At any rate, a veritable 'calligraphy fever' swept over avant-garde writers,[34] to which the cover page of Miró's first exhibition catalogue at Dalmau's also bears witness. Catalan poet Josep Maria Junoy, founder of the periodical *Troços*, and a champion of Miró, arranged the letters of the artist's name in bold capitals in a vertical strip and included it in a calligramme that lauded Miró's painting and strong coloration combined with formal firmness, as follows: 'forta pictòrica **M**atèria/**I**mpregnada/d'una **R**efractibilitat/c**ó**ngestionant' (strong pictorial matter and firm form mutually reinforce each other) (Fig. 7).[35]

In a few cases, Miró had already used words and thus references to poetry in his pictures, even by 1918. The best known example is *Nord-Sud*, a painting dating from 1917. The title relates to a literary newspaper founded in Paris in the same year (which was issued 16 times, from March 1917 to October 1918). The systematic literary programme of its editor, Pierre Reverdy, made it a forerunner of Surrealism. Breton singles it out in the first Surrealist manifesto and—like Apollinaire, Aragon, Soupault, Max Jacob and Tristan Tzara—himself wrote for the paper more than once. Illustrations were supplied by Georges Braque and Fernand Léger. On his own admission, Miró was an avid reader of *Nord-Sud*,[36] and may well have been particularly convinced by Reverdy's concept of 'poetic pictures', which stressed the

wondrous side of everyday life. In March 1918, Reverdy notably stated in *Nord-Sud*: 'The image is a pure creation of the mind. It cannot be born of comparison but of a juxtaposition of two more or less distant realities. The more the relationship between the two juxtaposed realities is distant and true, the stronger the image will be—the greater its emotional power and poetic reality.'[37]

Reverdy was thus one of the discoverers of the artistic method of confronted montage. What is normally separate and irreconcilable is brought together dissociatively, which merely intensifies the emotional effect. For Surrealism, and Miró as well, this artistic method would acquire vital importance. Reverdy's basic conviction that pictures are pure creations of the spirit will have met with Miró's complete approval. If bearing this in mind we return to Miró's *Nord-Sud* of 1917, the volume of Goethe beside the title of Reverdy's newspaper immediately becomes meaningful. Here, too, dissociative motifs are brought together. During World War I, German and French literature was officially separate, indeed antagonistic intellectual worlds. Politics and blind patriotism had dug a deep ditch here, which could be overcome in neutral Catalonia. Moreover, Miró had a personal knowledge of Goethe, as a letter he wrote to his fellow student Enric Cristòfol Ricart quoting from *Faust* in 1915 reveals: 'He who always looks ahead may sometimes falter, but he then returns with new strength to his task.'[38] Here Miró was thinking of the artist's activity. 'Working hard' was his maxim for success, as is likewise evident from the letters to Ricart.[39]

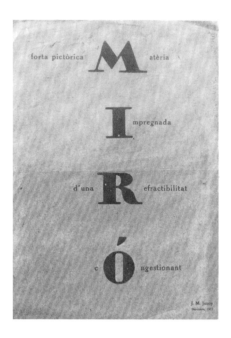

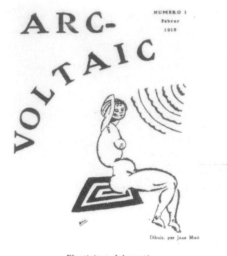

Fig. 7 Exhibition catalogue *Joan Miró*, Dalmau Gallery, Barcelona, 1918, with a calligramme by Josep Maria Junoy

Fig. 8 Cover of the periodical *Arc-voltaic*, no. 1 (February 1918), designed by Joan Miró

Whereas in 1917 the title of an avant-garde French literary periodical was the subject in the picture *Nord-Sud*, in early 1918 Miró contributed two cover images for Catalan periodicals. At the same time the solo exhibition at Dalmau's was underway, so the spotlight was on Miró as a newcomer. The two covers were very different. *Troços* was initially orientated more towards Paris, but after being taken over by poet Josep Vicenc Foix under the re-spelt title *Trossos* it became more Catalan-orientated. The March issue (the fourth out of a total of five) reproduced Miró's Cubist-Futurist pastel and Indian ink drawing from the previous year, *Calle de Pedralbes*.[40]

The design for the cover of *Arc-voltaic* was altogether bolder and more forward-looking. This was the sole issue of the periodical to appear under the joint editorship of the poet Joan Salva-Papasseit and the painter Joaquim Torres-Garcia and Miró (Fig. 8). Whereas Torres-Garcia's manifesto *Art-Evolució* was reproduced inside the magazine in French, the design of the cover was left to Miró. He used the opportunity for a paratactic juxtaposition of three different pictorial levels as a *poème-dessin*. The title line plays with the word 'arc' typographically, whose motif is echoed in the arching line. Moreover, the nude female figure appears to sit in a magnetic field. Everything seems to be switched on. The four artistic postulates of the periodical, in which Miró must at least have had a hand—they do not coincide with Torres-Garcia's manifesto[41]—conceptually link the vibration of the soul with electro-magnetic oscillation, rather like the Dadaist machine pictures of Picabia. The overarching concept of 'vibration'—in both a mechanical and emotional sense—

appears time and again as an artistic objective in Miró. On the cover, the following subjects are listed: 'Plasticitat del vertic—Formes en emoció i evolució—Vibracionisme de idees—Poemes en ondes Hertzianes' (plasticity of vertigo—forms in emotion and evolution—vibrationism of ideas—poems in Hertz wavelengths). 'After the contemporary liberation of the arts we will see artists under no flag emerge with the strings of their spirits vibrating to different kinds of music.... May our brushes keep time with our vibrations', Miró wrote to Ràfols in 1917.[42]

LEAF BY LEAF, TWIG BY TWIG, TILE BY TILE

'Right now what interests me most is the calligraphy of a tree or rooftop, leaf by leaf, twig by twig, blade of grass by blade of grass, tile by tile,' Miró wrote a few months later from Mont-roig to his painter friend Ricart on 16 July 1918.[43] This 'calligraphic realism'—Dupin calls it 'poetic realism',[44] Rowell 'phantasmatic realism'[45]—seeks artistic draughtsmanship in nature that is to be read almost like a page of writing, like a book. Calligraphic realism left its mark on the following years, culminating in the key work *The Farm* of 1921–22 (illus. p. 125).

However, a prior glance needs to be taken at an informative direct literary quote in the previous picture *The Horse, the Pipe and the Red Flower* of 1920 (Fig. 6). Like *The Farm*, but in a different way, this painting is also a kind of inventory. We see several domestic utensils from his parents' country house in Mont-roig laid out.[46] The objects are arranged as in a still life so as to in-

clude two artistic references—one to painting, the other to poetry. An oval painting in Miró's style shows the immediate external world—the reddish brown fields around Mont-roig. The book was bought by Miró in Paris. The open page with the line drawing of the cock identifies it as the poem *Le Coq et l'arlequin* by Cocteau, illustrated by Picasso.[47] As was already the case in *Nord-Sud* the picture incorporates discrete, indeed contrasting worlds: painting and poetry, traditional Catalan homeland and new experimental Parisian setting. The real world and the imaginative world of poetry, the frontiers between which are increasingly blurred, are placed side by side.

Miró's 'poetic realism' first emerged in 1918 with the Tarragona landscapes he did in Mont-roig, in which the spring of narrative joy pours forth in abundance. *The Vegetable Garden and Donkey* (*Le Potager à l'âne*) was as much subject matter in 1918 as the marks of a cart on an overgrown track—*L'Ornière*—or the reddish brown fields with vines and olive trees set against the backdrop of a chain of mountains in the distance—*Montroig, vignes et oliviers*. This realism is poetic, both in subject matter (the solemn representation of unspoilt landscape in meticulous detail) and in form (the calligraphic and rhythmic arrangement of objects). Nature itself seems poetic—for example in the way the branches stand out calligraphically against the sky. The painter poet Miró merely follows its example.

With *The Farm*, this phase of creation reaches its culmination and conclusion. It is a key painting in his early work and features an authentic representation of the barn and hen house at the family farm, the Masía, which served as a refuge for Miró and is where he drew inspiration time and again.[48] In a newspaper interview of 1928, Miró says of this work: '*The Farm* was a résumé of my entire life in the country. I wanted to put everything I loved about the country into that canvas—from a huge tree down to a tiny little snail. I don't think it makes sense to give more importance to a mountain than an ant ... and that's why I didn't hesitate to spend hours and hours making the ant come alive. During the nine months I worked on *The Farm* I was working seven or eight hours a day.'[49] In the middle of the picture is once again a calligraphic motif, the large carob tree so typical of Catalonia, with its dense boughs and foliage.[50] The individual aspects of rural life unfold with lexicological clarity, whether animals, plants, mountains, objects or people (we see only a maid by the well with a small child squatting to relieve itself)—it is all reproduced with the same intensity. Distance and foreground, the largeness and smallness of things no longer play a role in weighing up poetic relevance. All the objects are equally clearly and sharply delineated. A magical-poetic field unfolds, set out on the grid of a strict ordering system as a kind of substratum.[51] The macrostructure of the pictorial field is divided into numerous clearly articulated individual areas in which details stand out conspicuously. The spiritual structuring with its dense arrangement of details gives rise to pictorial symbols. The furrows of the fields manifest a free linear patterning —the calligraphy of the nature motifs almost acquires the character of Islamic ornamentation. In the picture, the moment in time appears suspended, like the shadowless hour of Pan. Calm and immobility reign. The subject would

appear to be the eternal law of farming life, were it not for the front page of a Paris newspaper—*L'Intransigeant*—painted into the picture as a foreign body. Again—as with the Cocteau book—the quotation is a reference to Miró's new inspiring environment, among the Parisian poets. Miró's eye probes the traditional image of his homeland for new, unexpected references, in accordance with Reverdy's principle that miracles should take place in everyday settings. Thus in Miró's picture the columns of the newspaper are aligned with the motif of the watering can, so that the dissociative pair of motifs becomes a metaphor: the new kind of poetry—represented by the newspaper columns from Paris—waters the parched soil, leading to an intellectual renaissance.[52] Clearly Miró, despite all re-orientation, also wanted to retain a solid link with the great cultural achievements of the past. It is no accident that the flat pictorial surface, many stereometric details and the coloration evoke the celebrated Romanesque frescoes of Catalonia, such as those in Taüll. At the time, the country was rediscovering these as part of its national heritage, and a major restoration programme was launched to rescue them.[53] 'Miró thus calls attention to a bygone age of Catalonian history that is now to be reawakened to new life.'[54]

Robert S. Lubar speaks of a 'poetic conception' of the Tarragona countryside in Miró's works, and 'archetypal images of simple life'.[55] In *The Farm*, with its new pictorial approach, liberated from the constraints of perspective and the ordering principle of relative size, he had made a first step towards freeing his imagination. Painting became a poetic space, the artist's world of imaginary images replacing those of the real world.

THE SHORTEST ROUTE FROM ONE PUZZLE TO THE NEXT

In Mont-roig in summer 1923, Miró started work on three paintings with a particularly inventive repertoire of signs—*Ploughed Earth* (Fig. 9), *Pastorale* (illus. p. 126) and *Catalan Landscape (The Hunter)* (illus. p. 127). Various objects appear very familiar from the previous picture *The Farm*, especially in *Ploughed Earth*. Once again there is a large tree (this time schematised into a pine tree), the agave, the furrowed land, various animals such as a snail and a chicken, even the motif of a newspaper stuck in the ground. However, the formerly realistic setting is torn apart, the objects appear arbitrarily scattered over the canvas and they look different. The meaning of the picture is hermetically sealed. We appear to be looking at a magic rebus. 'Miró's painting is the shortest route from one puzzle to the next,' was the striking formulation of Miró's contemporary, the poet Roland Tual.[56] If Breton, as mentioned, emphasises the 'automatism' of pictorial structure that contradicts any rational experience, we should no doubt go along with the idea initially, even if—as with the phantasmagoria of Hieronymus Bosch—we are reluctant to abandon the search for a secret pictorial meaning. [However,] on 26 September 1923, Miró wrote to Ràfols from Mont-roig: 'I have already managed to break absolutely free of nature and the landscapes have nothing whatsoever to do with outer reality. Nevertheless, they are more *Montroig* than had they been painted *from nature*.' Miró speaks of pictures seen 'completely from within his inward being'.[57] [Thus] Breton's

view of that time, that Miró's works developed unthinkingly and uncontrolled, i.e. 'automatically', is disproved even if we look merely at how the pictures originated. It involved a highly reflective process that took numerous detailed studies and sketches to develop.[58] Admittedly, the intentionally hermetical representation has resulted in many details remaining inexplicable to this day, and this was the artist's intention. The objective was to compress reality. The vision represents an inner truth, incorporating 'more' Mont-roig than its deceptive actual appearance. Only the law of poetry now applies.

The three pictures begun in summer 1923 form an artistic trio. Step by step, the new pictorial structure was coming to a climax, freed of the laws of the outer world and taken to the frontiers of comprehensibility. Pictorial objects dissolve and appear to be consumed. The signs become more and more abbreviated. They lose their substance, become diagrammatic, geometrical figures, dotted outlines, until finally they float on threads like weightless mobiles. Painting becomes writing, melody, sound. In accordance with Schlegel's universal principle of poetry, the frontiers of genres of expression dissolve and merge. Clearly, the trio of paintings represented a developmental process. A cosmic event takes place in the Mont-roig countryside. Following a remark by Miró, William Rubin suggested in passing that the *Catalan Landscape (The Hunter)* should be seen as a representation of the four elements.[59] But it seems reasonable to apply this statement to the series as a whole, as the aspect of reality treated is fundamentally differently in each work. A picture of the earth—*Ploughed Earth*—is followed by the collision of fire and water in *Catalan Landscape (The Hunter)* and the dissolution of picture signs in the form of air and sound in *Pastorale*.

As the title suggests, *Ploughed Earth* focuses on the element earth. On the line of the horizon we see an archaic-looking silhouette of a farmer ploughing the earth with the help of an ox. Ploughed strips of land are discernible, with furrows running horizontally or undulating like a brook. This ancient motif appeared in cave paintings, to which allusion is made here.[60] The basic activity of turning the soil and ploughing up the field—and thus, in a metaphorical sense, the picture—is the key to the rest, even if the process is shown at the margins. New animal life grows from the tilled soil, and to this extent the painting is also a depiction of the Creation myth.[61] The substance earth generates the cycle of life. This applies to all creatures, not just the plants rooted in the soil, i.e. agave, fig tree, pine tree. It applies also to the animals, which, with their powerful hooves, claws, legs and talons, seem to stand on terra firma. Even the fish is stuck in the ground. The snail, fish and chicken are clustered round two small mounds of earth, which as the embodiment of sexual organs are metaphors for the eternal procreative urge.[62] It is not just a matter of the continued material existence of life, however. Matter is imbued with forces, currents and juices; the entire living cosmos is engaged in wireless intercommunication. We know from his covers for *Trossos* in 1918, for example, that Miró was interested in the physics of vibration and electromagnetic waves. In the picture of the ploughed land, virtually all the creatures have their ears or feelers on the alert. The hairs of the mare's

mane, for example, are standing on end, as are the dog's fur and the chicken's comb. The snail's feelers are outstretched, the agave is unfurling its spines. The crown of the pine tree has symbolic rays emanating from it, and the tree is endowed with a staring eye and an outsize listening ear. The flagpole and the newspaper are also mere continuations of this elementary osmotic communication, as cultural superstructure phenomena. The cryptic pictorial world reduces this elementary event to the fabulous sign language of poetry. The poetic picture becomes a second creation of earthly nature.[63]

However, Margit Rowell takes the motif of the lizard with the conical hat —the traditional hat of magicians—as a starting point for interpreting the picture as a free paraphrase of Apollinaire's poetic dialogue *L'Enchanteur pourrissant* (The Decaying Magician). The scene is an enchanted forest, as in Apollinaire's work. With this in mind, one might say it was not really compatible with Miró's basic poetological attitude to stick so closely to a single literary source. Apollinaire's may have provided the first inspiration for subject matter and supplied a kind of basic scenario, but the further treatment was derived from the logic and alogic of Miró's picture.

In the *Catalan Landscape (The Hunter)*, the poeticisation of the pictorial structure is taken a considerable step further. The individual pictorial motifs are reduced to script-like signs, but this serves only to reduce their comprehensibility still more and reinforce the hermetic sealing of the pictorial meaning. Yet, decades after its creation, Miró offered in this case (and no other) a precise deciphering of the pictorial motifs and authorised a diagrammatic rendering in the form of an 'iconographic map' based on this information.[64] Yet this very deciphering of the external pictorial meaning ultimately renders the viewer still more helpless. He or she is provided with a relatively inconsequential inventory of pictorial objects and a trivial story as basic information. The poetic enigma of the work, the strange transformation of formal motifs and their origin and the cohesive structure of the script-picture are far from being fathomed. Indeed, knowledge of the pictorial story might lead one down the wrong path with such fundamental questions left open.

The story of the picture is quickly told: a hunter has shot a rabbit and lights his pipe. The grill on which to cook the rabbit is prepared on the right-hand side. Rudiments of various other motifs frolic about the rest of the yellow and pink space (the sea and fiery land). A bird plane circles in the sky, letting down a ladder. A single leaf is growing on a cross-section slice of a carob tree, a sun egg with spidery legs and an eye hover above the scene, a conical boat flying a Spanish flag drifts across the sea, while on land lies a giant sardine reduced to a few lines representing bones, with the pictorial form being rudimentarily echoed by a bold, florid 'sard' written beside it. Script-like abbreviations of various other motifs are distributed around like flotsam. But why this mixture of a few realistic details, numerous stenogrammatic lines and a number of geometric signs? What process was the pictorial sign system subjected to? Here, the idea of seeing a depiction of the four elements in it seems to take us furthest. Miró himself referred to fire as the dominant

Fig. 9 Joan Miró, *Ploughed Earth*, **La Terre labourée**, 1923–24, oil on canvas, 66 × 94 cm, The Solomon R. Guggenheim Museum, New York

element of the picture.[65] Little flames are springing up all over the picture. The shapes of objects burn in the fire and are reduced to diagrams. On the other side, water dissolves the motifs, which get mixed into new constellations and combinations. The two colour areas could also be allocated to the elements, red for fire, yellow for water, or even vice versa, since in this picture all sign language systems come together. Burning, dissolving and mixing is clearly the poetological principle of this cosmic landscape of Mont-roig, in which pictorial signs are transformed into script signs for the first time in the artist's painted oeuvre.

In August 1924, Miró wrote to Michel Leiris: 'The R.R. from the song of a cricket, for example, or the isolated sound of a consonant or vowel, any sound, be it nasal or labial. This can create a surprising metaphysical state in you poets.'[66] This song of the cricket would appear to be written in small letters on the right-hand side of *Pastorale*. There are numerous clues in support of interpreting this last landscape picture of the trio as a representation of the element air. The objects almost throughout consist only of outlines. They are completely transparent and blown through by the wind. The pronounced emptiness and weightlessness of the almost colourless painting is the first impression. We recognise a bull, a one-legged, goblin-like figure balanced on the pointed head of a vase or genital-shaped female figure, the triangle of an agave, a brook, a blazing fire, a rainbow, a frog.[67] The picture appears to be divided by two horizontal lines like staff lines, creating the impression of a musical score. Beside the 'R.R.' of the cricket appears a vowel 'a' and 'so'.

The picture is not just about air, it is also about sound. A kind of pastoral concert appears to be taking place, though explicit references to the Catalan landscape are now faded out. Miró's pictorial world was becoming more and more generalised. The painting was one of Miró's first experiments in combining image, text and sound in the same work.

The letters quoted above make it clear once again that Miró always made use of his exchanges with poets, especially Leiris. The modifications and mutations of his pictorial signs, which run through whole chains of symbols in slightly amended form—the sun becomes an eye becomes a spider becomes a vagina, a triangle becomes a head becomes a mountain, a human becomes a tree, a cone becomes a hat becomes a weapon becomes a boat, crossed lines become a human figure, a vase becomes a woman—can be understood as associations based on shape. The established appearance of matter and the fixed order of the world get out of sync in the process; all objects and their relationships become fluid and dissolve, charged with spiritual energy that radiates beyond the canvas.

Michel Leiris conducted similar experiments and operations in the field of literature. The phenomenon of internal sound changes and shifts of meaning turned language into a material detached from all experience of reality. In two issues of the periodical *La Révolution Surréaliste* (from April 1925) Leiris published his *Glossaire* (Fig. 10),[68] with its witty, barbed speech manipulations and transformations: *ingénu* (naïve, harmless) becomes *le génie nu* (the naked

GLOSSAIRE : J'Y SERRE MES GLOSES

A

AMERTUME — *la mer s'abreuve d'écume. Je hume la mer.*

ANNEAU — *l'angoisse pend à nos naseaux.*

C

CADAVRE — *le cadenas s'ouvre : c'est le havre, cadastre de nos lèvres.*

CALICE — *un cilice de pétales.*

CHEVELURE, *huche des vœux voleurs de chair.*

CIEL — *si elle ? où elle ? ré-elle ou irré-elle ?*

CLOISON — *le cloître ou la prison, une loi.*

CUISSES — *acuité des ciseaux nus, lisses.*

D

DÉCIMER — *détruire les cimes.*

DÉFINIR, *c'est disperser. Dilemme de la démence.*

DENSITÉ — *dents serrées : les pierres de la cité. Dans quel site serons-nous ressuscités ?*

DOMINER : *délire dérisoire, dédale déchiré.*

E

ECLIPSE — *ellipse de clarté.*

ECLOSION — *écluses rompues, si nous osions !*

ENIGME — *je gis dans la géhenne. Est-ce une digue ou une dîne ?*

ENSEVÉLI — *serai-je bientôt lié dans les sèves ?*

ENTRAILLES — *l'antre du corps, et ses broussailles.*

EPAVES — *elles pavent la mer.*

ERE — *l'air que nous respirons, notre aire d'action.*

ETAU — *les ais, sans le couteau.*

ETINCELLE — *éteinte et célée sitôt ailée.*

EVASION — *hors du vase, vers Eve ou Sion !*

F

FANTOME — *enfanté par les heaumes.*

FÉCONDER — *profondeur des fées, te seconder et te sonder...*

FIANCÉE — *au fil des ans défi lancé.*

FIÈVRE — *la sève monte, je me défie de ses lèvres.*

FILIGRANE — *les fils de nos organes nous lient, granules.*

FLAMME — *l'âme s'effile comme une lame.*

FLEUVE — *fleur neuve des rives.*

FLORAISON, *hors des raisons flétries, le flot de braise...*

FOUDRE — *le feu en poudre, quant va-t-il sourdre ?*

FROID — *fixe et roide.*

G

GLACE — *mirage qui craque. Il nous enlace.*

H

HORLOGE — *hors du cadran l'heure abrogée.*

HUMAIN — *la main humide, moite. L'as-tu connue, cette main ?*

I

INGÉNU — *le génie nu.*

J

JEU — *le feu de joie, la joie du feu.*

L

LANGAGE — *bagage lent de l'esprit.*

LANGUE — *la gangue des ailes, comme la lampe en est la hampe.*

LÉGENDAIRE — *j'entasse les pierres d'antan, dures ou légères.*

LUCIDE — *Lucifer de l'épée, quel suicide ?*

LUXURE — *l'usure du luxe charnu erre.*

M

MARBRE, — *arbre immuable des veines.*

MÉTAMORPHOSES — *maladie métaphysique des morts.*

MIGRATION — *migraine des oiseaux.*

MINERAL — *nerf durci par les râles, pierre terminale.*

MURAILLES — *mûres, elles se marquent de failles et de craquelures.*

N

NOMBRE — *l'ombre niée.*

O

ORBE — *courbure, l'aube des ovaires.*

ORIGINEL — *les os rigides naissent : je les hèle.*

OSSATURE — *eaux-mères saturées, déposez les structures !*

P

PERSPECTIVE — *l'œil perce, lumière active.*

R

RACINES — *sinuosités originaires des races.*

RAVIN — *V entr'ouvre son raVin, sa ValVe ou son Vagin.*

RÉVOLUTION — *solution de tout rêve.*

ROSAIRE — *l'érosion des prières.*

RUMEUR — *brume des bruits qui meurent au fond des rues.*

RUSE — *elle rase les murs, elle est ma muse.*

Fig. 10 Michel Leiris, *Glossaire* in *La Révolution Surréaliste* (1925)

Fig. 11 Joan Miró, *Photo— This is the Colour of my Dreams*, **Photo—ceci est la couleur de mes rêves**, 1925,
oil on canvas, 97 × 130 cm, private collection

Fig. 12 Guillaume Apollinaire, *Case d'Armons*, calligramme, 1916

genius), *langage* (language) becomes *bagage lent de l'esprit* (dull baggage of the mind), *flamme* becomes *l'âme s'effile comme une lame* (the soul tapers like a blade). In these chains of association the original meaning of the word gets lost and new, unlikely collocations of meaning are revealed. The heading *J'y serre mes gloses* (....) is explained by Leiris in his 1925 glossary: 'The normal and etymological meanings of a word do not teach us about ourselves because they represent the collective part of the language.... Only when we dissect the words we love without worrying about the etymology or agreed meaning do we discover their deepest veiled virtues, the secret ramifications that run through every language and are channelled by the association of sounds, forms and ideas. Language is then transformed into an oracle, and we possess ... a thread to guide us into the Babel of our mind.'[69] The alchemy of images in Miró corresponds to the alchemy of words in Leiris.[70]

PHOTO—CECI EST LA COULEUR DE MES RÊVES

Perhaps the most enigmatic example among the paintings from the *Tableaux-poèmes* series of 1925 is the one inscribed *Photo—ceci est la couleur de mes rêves* (Photo—this is the colour of my dreams) (Fig. 11). It is taken here as an example of the pictorial type as a whole. Reference has been made several times to Apollinaire's inspirational role in the connections between word and picture, and this is confirmed once again. Of course, in Miró's works words and figures are not identical as in Apollinaire's calligrammes but interweave or form parallel figures, for example in the graffiti-like painting-poems *oh! un de ces messieurs qui a fait tout ça* and *le corps de ma brune puisque je*

l'aime comme ma chatte habillée en vert salade comme de la grêle c'est pareil, both from the same year, 1925.

Beside these pictures with their expressive, rough-stained brown grounds, *Photo—ceci est la couleur de mes rêves* looks empty. We are faced with a virtually white picture. Only the blob of blue and the two patches of text written with the precise script of a calligrapher are left as traces of signs. The picture is the text, the text the picture, which is the heart of the dilemma, because the work cannot be deciphered either as text or picture. Even though it appears clearly arranged, the correct interpretation of the dissociative elements of script, white canvas and paint (blue blob) remains a pictorial puzzle.

Even the promise of the large, beautifully written word 'Photo' is not kept. No photo is in evidence, its visualisation being left to the imagination. Here again a work by Apollinaire may have served as a model. In the wartime collection of calligrammes *Case d'Armons* (1916), we find on page 12 beneath the heading *Dans le village arabe* a souvenir of a poet who is left unnamed —*Bonjour mon poëte*. Instead of the *photographie tant attendu* (keenly awaited photo) as promised in the caption there is just a calligraphically framed cross (Fig. 12).[71] The photographic image is left to the viewer to supply. Like the visualisation of the photo, the representation of the painter's dreams, as promised in the second bit of text in Miró's painting, remains just a shapeless sample of its apparent colour, blue. In view of the Surrealist inflation of

dream accounts and hallucinative photos, Miró's painting *Photo— This is the Colour of my Dreams* must be taken as a gesture of downright ostentatious refusal.

All mimetic elements have been withdrawn from the work. The only clue to deciphering the painting is the presence of the blue blob, the only painted motif. It has the appearance of a blue petal collaged on the canvas, and is thus an allusion to a key symbol of Romanticism. The blob in supposedly material substance could just as well suggest a patch of blue sky. At any rate, it initiates a constant flow of associations between the energy fields of image and word, matter and sign. Mallarmé's poetic world, his ideal of the 'white page', his sublime concept of azure, his poem *Un coup de dès* have been cited as models for Miró's conceptual procedure.[72] Michel Leiris also referred to the Tantric exercises of Tibetan ascetics, the 'knowledge of the void', with which Miró was said to be complying: from a precise mental image, e.g. that of a garden, you remove all the details one by one, 'finally even the sky and the ground ... an ultimate absence that enables the mind really to see and contemplate the void. Only then do you reassemble the garden piece by piece.'[73] According to Leiris, among contemporaries Miró had taken this experiment furthest.

In a few years, starting from his highly detailed poetic realism, Miró had reduced his visual world to a repertoire of mutable signs and generated canvases governed by an artistic law of his own, which only open themselves to the viewer in search of the poetic key, by participation.

NOTES

1 Michel Foucault, *Ceci n'est pas une pipe* (Montpellier, 1973), p. 21f. ('Le calligramme, lui, se sert de cette propriété des lettres de valoir à la fois comme des éléments linéaires qu'on peut disposer dans l'espace et comme des signes qu'on doit dérouler selon la chaîne unique de la substance sonore. Signe, la lettre permet de figurer la chose. Ainsi le calligramme prétend-il effacer ludiquement les plus vieilles oppositions de notre civilisation alphabétique: montrer et nommer; figurer et dire; reproduire et articuler; imiter et signifier; regarder et lire.') The reference to Foucault occurs in Rosalind E. Krauss, *Joan Miró: Magnetic Fields*, exh. cat. (New York: The Solomon R. Guggenheim Museum, 1972), p. 23.

2 Hubertus Gassner, *Joan Miró: Der magische Gärtner* (Cologne, 1994), p. 23f.

3 'Où allez-vous Miró?', conversation with Georges Duthuit, *Cahiers d'art*, no. 8–10 (1936); quoted from *Joan Miró: Selected Writings and Interviews*, ed. Margit Rowell (London, 1987): 151.

4 André Masson in a letter to Margit Rowell; quoted from Rowell, 'Miró, Apollinaire and L'Enchanteur pourissant', *Art News* 71, no. 6 (October 1972): 65.

5 Joan Miró, 'Je rêve d'un grand atelier', *XXe siècle* (May 1938); quoted from Rowell (note 3), p. 161.

6 James Johnson Sweeney, 'Joan Miró: Comment and Interview', *Partisan Review* (Feb. 1948); quoted from Rowell (note3), p. 209.

7 Quoted from *Friedrich Schlegel's "Lucinde" and the Fragments*, trans. Peter Firchow (University of Minnesota Press, Minneapolis, 1971), p. 175.

8 Jacques Dupin, *Joan Miró: Life and Work* (London, 1962), p. 157.

9 For the correspondence between F. Schlegel and Novalis, see *Friedrich Schlegel und Novalis: Biographie einer Romantikerfreundschaft in ihren Briefen*, ed. Max Preitz (Darmstadt, 1957).

10 See Krauss (note 1), idem, 'Magnetic Fields: The Structure', p. 11, and Margit Rowell, 'Magnetic Fields: The Poetics', p. 39. Krauss elaborated her views in a later article, 'Michel, Bataille et moi', in *October 68* (spring 1994): 3–20.

11 Margit Rowell, *Joan Miró: Peinture = Poésie* (Paris, 1976), p. 5 (Peinture ou poésie se font comme on fait l'amour; un échange de sang, une étreinte totale, sans aucune prudence, sans nulle protection); English translation quoted from Rowell (note 3), p. 152. The book includes the essays 'Miró' (1970) and 'Magnetic Fields: The Poetics' (1972).

12 ('Les surréalistes m'ont mis en rapport avec la poésie.'): *Joan Miró: Ceci est la couleur de mes rêves: Entretiens avec Georges Raillard* (Paris, 1977), p. 49.

13 Interview with James Johnson Sweeney, *Partisan Review* (Feb. 1948); quoted from Rowell (note 3), p. 208.

14 See Marc Dachy, *Dada & les Dadaïsmes: Rapport sur l'anéantissement de l'ancienne beauté* (Paris, 1994), p. 228.

15 Dupin (note 8), p. 137.

16 See Joan Miró, 'Souvenir de la rue Blomet' (1977; transcribed by Jacques Dupin); quoted in Rowell (note 3), pp. 99–104.

17 Jacques Prévert, 'Joan Miró', in Jacques Prévert and Georges Ribemont-Dessaignes, *Joan Miró* (Paris, 1956).

18 ('les attardés de Montparnasse'): Miró, 'Souvenir de la rue Blomet'; quoted from Rowell (note 3), p. 101.

19 See Miró's drawings for Desnos's book entitled *Les Pénalités de l'enfer ou les Nouvelles Hébrides* of 1925 (cat. nos. 76–78). The joint book project was not realised at the time, and the text remained unpublished until the cassette with Miró's lithographs appeared long after the poet's death. (See Renée Riese Hubert, *Surrealism and the Book* [Berkeley, Los Angeles and Oxford, 1992], p. 297.) Miró also did illustrations for Tristan Tzara (*Parler seul*, 1950) and Paul Eluard (*A Toute Epreuve*, 1958). In 1959, André Breton wrote his 22 prose poems to accompany Miró's *Constellations* series of gouaches (1939/41).

20 Philippe Audoin, foreword in André Breton and Philippe Soupault, *Les Champs magnétiques* (Paris, 1992), p. 11.

21 André Breton, *Manifestoes of Surrealism*, trans. Richard Seaver and Helen R. Lane (Ann Arbor: University of Michigan Press, 1969), p. 14.

22 See Rowell (note 4), p. 64. According to Masson, who had drawn Breton's attention to Miró, Breton asked after visiting his studio: 'How come you find him [Miró] an interesting painter? What do you see in the painter of these childish pictures? I don't understand.'

23 See William Rubin, *Dada and Surrealist Art* (New York, 1969), p. 150, and Rowell (note 11), pp. 129, 141.

24 The first instalment of the article appeared in issue no. 4 (15 July 1925) of *La Révolution Surréaliste*, and the rest in nos. 6, 7, 9–10. The periodical was discontinued after the second Surrealist manifesto by Breton appeared in issue no. 12 (15 Dec. 1929).

25 No. 5 (15 Oct. 1925): *Le Piège* and *Terre labourée*; no. 8 (1 Dec. 1926): *Carnaval d'arlequin*; no. 9/10 (1 Oct. 1927): *Personnage jetant [sic] une pierre à un oiseau*; no. 11 (15 March 1928): *La Sauterelle*; no. 12 (15 Dec. 1929): untitled drawing (*Les Amants*, 1928).

26 André Breton, 'Surrealism and Painting' (1928), *Surrealism and Painting*, trans. Simon Watson Taylor (London, 1972), p. 36.

27 Michel Leiris, 'Joan Miró', *Documents* 1, no. 5 (1929): 263–69; quoted from *Elan Vital oder Das Auge des Eros: Kandinsky, Klee, Arp, Miró, Calder*, ed. Hubertus Gassner, exh. cat. (Munich: Haus der Kunst, 1994), p. 477. For more on this subject, see Krauss, 'Michel, Bataille et moi' (note 10).

28 *Joan Miró* (note 12), p. 17.

29 See Michel Sanouillet, *Francis Picabia et* 391, vol. 2 (Paris, 1966), p. 43.

30 See Pascal Rousseau, 'La Galerie Dalmau: L'Introduction de l'abstraction en Catalogne et l'avant-garde parisienne durant la Première Guerre mondiale', in *Paris—Barcelone de Gaudí à Miró*, exh. cat. (Paris, 2002), p. 327ff.

31 Letter from Miró to E.C. Ricart, Mont-roig, 18 July 1920; quoted from Rowell (note 3), p. 73.

32 See Krauss (note 1).

33 See *Joan Miró* (note 12), p. 19.

34 See Gassner (note 2), p. 21.

35 See on this subject Robert S. Lubar, 'La Méditerranée de Miró: Conceptions d'une identité culturelle', in *Paris—Barcelone* (note 30), p. 406.

36 See Miró, 'Souvenir de la rue Blomet' (1977); quoted in Rowell (note 3), p. 101.

37 Patrick Waldberg, *Surrealism* (London, 1965), p. 20, and *Dada and Surrealism Reviewed*, ed. Dawn Ades, Council of Great Britain, exh. cat. (London: Hayward Art Gallery, 1978), p. 22.

38 Letter from Miró to E.C. Ricart, Caldetas, 31 January 1915; quoted from Rowell (note 3), p. 48.

39 See, for example, the letter to E.C. Ricart, Mont-roig, 14 September 1919; quoted in Rowell (note 3), p. 64.

40 See Robert S. Lubar, 'Miró Before *The Farm*: A Cultural Perspective', in *Joan Miró: A Retrospective*, exh. cat. (New York: The Solomon R. Guggenheim Museum, 1987), p. 17, and Rosa Maria Malet, 'El surrealisme entre l'afinitat i la divergència', in *Surrealisme a Catalunya 1924–1936*, exh. cat. (Barcelona, 1988), p. 18.

41 J. Torres-Garcia does not introduce the concept of 'emotion' into his manifesto *Art-Evolució*. The manifesto speaks only of the necessary 'evolutionary' artistic approach and concludes: 'Nostra divisa tindria d'ésser: individualisme, presentisme, internationalisme.' Quoted from Jaime Brihuega, *Manifiestos, proclamas, panfletos y textos doctrinales: Las vanguardias artísticas en España, 1910–1931* (Madrid, 1982), p. 97.

42 Letter from Miró to J.F. Ràfols, Mont-roig, 13 September 1917; quoted from Rowell (note 3), p. 51. See also the edition of the correspondence published in the original Catalan: *Joan Miró: Cartes a J.F. Ràfols (1917/1958)* (Barcelona, 1993), p. 20 (Que.l nostre pincell marqui les nostres vibracions!).

43 Letter from Miró to E.C. Ricart, Mont-roig, 16 July 1918; quoted from Rowell (note 3), p. 54.

44 See Dupin (note 8), p. 81ff.

45 See Rowell (note 11), p. 13.

46 See Margit Rowell, 'Miró at the Museum: Works in the Philadelphia Museum of Art', *Bulletin: Philadelphia Museum of Art* 83, no. 356/357 (autumn 1987): 4.

47 Lubar (note 40), p. 25.

48 The oasis-like magic that radiates from the Masía is currently being destroyed by the construction of a high-speed railway nearby.

49 'Entretien avec Francesc Trabal', *La Publicitat*, 14 July 1928; quoted from Rowell (note 3), p. 93.

50 The carob tree, whose pods are being fed to the donkey, was Miró's favourite tree; see Joan Punyet Miró and Gloria Lolivier, *Miró: Le Peintre aux étoiles* (Paris, 1993), p. 27.

51 Carolyn Lanchner, 'Peinture-Poésie: Its Logic and Logistics', in *Joan Miró*, exh. cat. (New York: The Museum of Modern Art, 1993), p. 20f.

52 See Gassner (note 2), p. 45. Gassner also sees in this, as in other motifs, some of the first sexual connotations, later explicitly developed in other works.

53 See *Agnus Die: L'art romànic i els artistes del segle XX*, exh. cat. (Barcelona: Museu Nacional d'Art de Catalunya, 1995–96), pp. 58–61.

54 Gassner (note 2), p. 43f.

55 Lubar (note 35), p. 410.

56 ('La peinture de Miró est le plus court chemin d'un mystère à un autre.'): Roland Tual, remark of 4 June 1925; quoted from Michel Leiris, *Journal, 1922–1989*, ed. Jean Jamin (Paris, 1992), p. 119.

57 Letter from Miró to J.F. Ràfols, Mont-roig, 26 September 1923; quoted from Rowell (note 3), p. 82.

58 See the catalogue raisonné *Obra de Joan Miró: Dibuixos, pintura, escultura, ceràmica, tèxtils* (Barcelona: Fundació Joan Miró, 1988), and Pere Gimferrer, *Joan Miró: Auf den Spuren seiner Kunst* (Stuttgart, 1993).

59 *Miró in the Collection of the Museum of Modern Art*, ed. William Rubin, exh. cat. (New York: The Museum of Modern Art, 1973), p. 25f. The element of fire in *Catalan Landscape*—Miró told Rubin—'completes the alchemy of the picture'. Rubin adds: '... with the earth, air, and water ...' He then points out that the first picture of Masson that drew Breton's attention to him was called *The Four Elements*. Rubin concluded that Miró's iconographical interest in metaphysics and alchemy developed in the 1920s parallel to his fascination with the Surrealist movement.

60 Sidra Stich, 'Joan Miró: The Development of a Sign Language', in *Miró*, exh. cat. (St. Louis: Gallery of Art, Washington University, 1980), p. 11ff. Reproductions of the cave paintings in Altamira in Barcelona's Museo Arqueològico Provincial made a deep impression on the young Miró.

61 See Gassner (note 2), p. 52, according to whom the writings of Jakob Böhme, especially his title page engravings, were the decisive source in this 'Surrealist cosmogony'.

62 Gassner (note 2), p. 58.

63 See Rowell (note 4), pp. 64–67.

64 Rubin (note 59), p. 21. The diagram is on p. 22.

65 Miró's observation as recorded by Rubin was: 'At the time, both Masson and I were very much engaged with images of flames', Rubin (note 59), p. 25.

66 Letter from Miró to Michel Leiris, Mont-roig, 10 August 1924; quoted from Rowell (note 3), p. 86.

67 In a pencil study for the picture, Miró also inscribed the word 'grenouille'; see the illustration and discussion in Gassner (note 2), p. 130f.

68 Michel Leiris, *La Révolution Surréaliste*, no. 3 (15 April 1925): 6f.; no. 6 (1 March 1926): 20f.

69 Michel Leiris, *La Révolution Surréaliste*, no. 3 (15 April 1925): 7.

70 Miró's attitude to alchemy is described by Gassner in idem (note 2), p. 145ff.

71 Michel Décaudin, *Guillaume Apollinaire* (Paris, 1986), p. 129f.; see also Francis Picabia's collage *La Veuve Joyeuse* of 1921 in which a photograph of the artist on the steering-wheel of a car is juxtaposed with a drawing of the photograph. *Francis Picabia*, ed. Jean-Hubert Martin and Hélène Seckel, exh.cat. (Paris, 1976), Fig. 95.

72 See Roland Penrose, *Miró* (London, 1970), p. 197f., and Rowell 'Magnetic Fields: The Poetics', in Krauss (note 1), p. 61.

73 Michel Leiris, 'Joan Miró', *Documents* 1, no. 5 (1929): 263; quoted from *Elan Vital* (note 27), p. 476. See also on this subject Krauss, 'Michel, Bataille et moi' (note 10), p. 4.

SYLVIA MARTIN

ON THE READABILITY OF SIGNS
MIRÓ'S PATH FROM MYSTERIOUS TO COMIC PICTORIAL SIGNS IN THE 1920s AND 1930s

Symbols, figures, labels, abbreviations in word and image are these days a self-evident part of everyday life. The flood of verbal and non-verbal sign systems is both frowned upon as an excessive stimulus overload on human perception and valued as a boost to the global communication network. Art with its creativity and aesthetics has long been interested in the shorthand of everyday language and is at once a producer, a source, indeed a quarry of ideas. This quality distinguishes the work of many artists and artistic movements whose aim it is to bring together art and everyday life. Joan Miró is one such artist. As a Catalan, he was deeply bound up in the life of his homeland, and, as an artist moving in Surrealist circles in Paris, he was infected by the intellectual revolution that sought to fuse art and life. In 1922/23, following a 'poetic-realist' phase, Miró turned towards a pictorial idiom based on signs and codes. It was an artistic style he would never abandon, and indeed constantly re-invented by means of various strategies. By 1940 Miró had developed an aesthetic language of signs that was quite distinct from the enigmatic works of the early 1920s and is so clearly formulated that anyone can read it. He combines elementary contractions with an obviously comic tone, which together constitute the particular charm of these works and made the artist and his work part of the fabric of everyday human life. I should like first to compare two works—one from the early 1920s, the other from the mid-1940s—to show how different the artist's language of signs was in these periods.

In the *Catalan Landscape (The Hunter)* of 1923–24 (illus. p. 127), myriad apparently arbitrary objects and figures reduced to mere signs populate an

abstract landscape. They include the hunter (top left corner), plants and animals, such as the over-large skeletal sardine in the foreground, and heavenly bodies. They appear as richly decorated abbreviations, enigmatic symbols born of an unbridled creativity that are intended to sweep the viewer into the world of the artist's imagination. Every detail can be decoded, yet only through the synthesis of numerous individual elements do meaningful figures emerge.[1]

In *Figures and Birds in front of the Sun* of 1946 (illus. p. 200), we are no longer witnesses to a surreal meeting of heterogeneous abbreviations. The picture now becomes a field of communicative signs. The artist places a few motifs, given the general designations of 'figures', 'birds' and 'sun', on a spatially undefined colour ground. Every pictorial sign stands for itself, and is notable for an assured linear sense combined with carefully positioned patches of bright colour. As no three-dimensionality is suggested, unlike in the early works, the components look like signs of a simple visual code. Because of their elementary nature (star, bird, woman) and recognisable shape, the individual figures are readily intelligible and claim universal validity. If we compare the figure of the hunter in *Catalan Landscape (The Hunter)*, for example, with the prancing figure in the top left corner of *Figures and Birds in front of the Sun*, it becomes clear that the 'figure' abbreviation is more readable in the later work. A variety of details and decorative additions surround the figure of the hunter: he smokes a pipe, body parts such as the head in the shape of a triangle, an ear, an eye, the penis and the heart can be made out. Yet much is left unclear. What do the flame-shaped rays on the head and heart signify, or the wavy line transecting the line that represents the hunter's body? The viewer must laboriously piece together the figure of the hunter. Owing to its complexity, it emerges only gradually, like a picture puzzle. In the end, the idea of a few lines representing a man with a heart and pipe is both mysterious and funny. But the visual humour is rather cryptic in the early works. It is initially concealed by the enigmatic nature of the symbols, and is grasped by the viewer only after some delay and with intellectual effort. In *Figures and Birds in front of the Sun*, the witty, humorous tenor of the picture is palpable owing to the readily intelligible signs. The head of the figure in the top left corner—clearly visible as such—sways on a trunk with outspread arms that is trying to balance. The figure in the bottom right corner, on the other hand, consists only of a head and neck, such that the creature's nose is much too long and comically distorted. Three tiny curved hairs represent a whole head of hair. This simplification or even compression into signs, the distortions and displacements of familiar shapes and the omissions are what largely constitute the funny or witty character of the visual signs and figures in the works from the late 1930s.

Miró thus markedly changed his sign language in the 1920s and 1930s. He retained many signs (woman, bird, stars, eye, sun, etc.), but his style changed from being enigmatic and symbolic to simple and humorous, whereby he arranged the elements of an ideographic system in playful fashion. A figure now appears to be just a figure, no more.[2]

The question then arises how he came by this particular form of visual language, and whether there were developments in the vibrant, fertile environment of Paris in the 1920s and 1930s that correspond to the changes in Miró's work.

PRIMITIVISM, ETHNOLOGY AND ART

Along with the reclusive work in his Catalan homeland, which was of decisive importance for the artist all his life because that is where he found peace and security, Miró sought inspiration time and again in the cultural life of Paris. When he moved into a studio at 45, rue Blomet at the end of 1920, the artist found himself amidst the nascent Surrealist movement. Working in the neighbouring studio was the painter André Masson. The latter's studio was where poets and writers such as Michel Leiris, Robert Desnos, Antonin Artaud and Georges Limbour used to gather to discuss socio-political issues and argue about contemporary forms of artistic expression. In Desnos's description of the group, a casual, friendly atmosphere is evident, but at the same time he addresses one of its central concerns: 'The courtyard was unusual for Paris, consisting of a grass-covered enclosure planted with lilac trees which must still bloom every year. There had been a vine, but the landlord has aesthetic ideas and ordered it to be torn down, for "it made the place look lousy". This was where I met Miró. *The Farm* [illus. p. 125] was the first of his paintings I ever saw. It lit up the whole white-washed studio.... In one corner of the studio was a table covered with Balearic toys, little plaster gnomes, and strange animals painted in bright colors. The little creatures seemed to have come right out of *The Farm*. They gave the studio a festive, fairy-tale air, and I found myself trying very hard to remember something I had long forgotten, and still could recall only a ghost, a flavor: something from a story for children, in which animated mushrooms played the principal parts.'[3] This ghost, a condition of life believed lost and therefore better in Surrealist eyes, needed to be rediscovered in order to provide an alternative to reality, with its inadequacies and fossilised ways of seeing.

In the early 1920s, the yearning for an alternative reality linked the group of friends from the rue Blomet with the ideas of André Breton, the theoretical voice of Surrealism. In 1924, Breton published the first Surrealist manifesto, in which he proclaimed 'absolute reality'. 'I believe in the future resolution of these two states, dream and reality, which are seemingly so contradictory, into a kind of absolute reality, a *surreality*, if one my so speak.'[4] As the realm of unconscious processes, dreams would become a central source for Surreal existential and ultimately pictorial concepts. Other areas in which, according to the Surrealists, the unconscious is articulated are childhood, the behaviour and expression of the mentally ill, the soul of the people and folk art. In addition to this, the Surrealists were interested in tribal artefacts and the rites of indigenous peoples.

That the Surrealist movement should turn to the art and culture of primitive peoples as a field of reference is understandable given the long, deep-rooted interest in the exotic and the foreign.[5] Around 1910, Cubist artists, particularly

Fig. 1 Joan Miró, *Painting*, **Peinture**, 1930, oil on canvas, 230 × 150 cm, Fondation Beyeler, Riehen, Basle

Picasso, explored the formal repertoire of African domestic and cult objects. They filled their studios with figures, masks and other tribal objects. They were principally interested in the formal and aesthetic solutions of African sculpture—possessing a robust, three-dimensional formal idiom—in which they saw analogies to their own sculptural ambitions.[6]

Primitivism underwent a change in the hands of the Surrealists, who had new artistic objectives. Artists such as Max Ernst, André Masson and Victor Brauner propagated a new Surreal notion of art that they were aiming at in their works and sought artistic solutions that would be capable of incorporating fantastic, magical and dream-like elements. They found what they were looking for in the tribal objects of Oceanian peoples, the Indians of the north-west coast of America and the Eskimos, whose art featured in Parisian collections, galleries and exhibitions in the 1920s.[7] Even if, because of the ethnic fragmentation of these regions—especially in Oceania—the cultural spectrum is extremely broad, a number of common features stand out: flat painting, fluid and interlinking forms, the aleatoric use of natural materials, an 'X-ray' style[8] and a grotesque aspect. Objects produced by these formal means possess a fantastic and mystic aura, which tallied with the artistic ideas of the Surrealists.

We know that around 1944 Miró's studio contained objects from Oceanian peoples and Native Americans, which tends to suggest that, at least initially, he shared the Surrealist taste for the art of these exotic regions. But they were not all that numerous. Miró set up a mask with a fearsome, teeth-baring mouth on a substructure consisting of long, curved wooden legs surmounting a low table, like on an altar (illus. p. 14). Small *katchinas*, carved wooden and painted dolls, representing the ancestral spirits of the Hopi Indians of Arizona and New Mexico filled the showcases in the studio (illus. p. 13). Apart from tribal art, there was also a Persian soldier's mask as well as a straw sun such as is sold in the Rambla de Catalunya in Barcelona on Palm Sunday (illus. p. 19). *Siurells* from Majorca (small clay figures), small folk-art figures (illus. p. 13)—including Manger figures—and masks from Miró's Catalan homeland (illus. p. 12) dotted the workshop along with various natural *objets trouvés* (illus. p. 17) and a wire circus horse made by his friend Alexander Calder (illus. p. 18). In 1929, Calder made a complete circus troupe, and put on performances with them. The origin and dates when any individual object was added to the collection, and even the authenticity of many of the objects, are uncertain.[9] Miró's long-desired large workshop in Majorca, which his friend architect Josep Lluis Sert designed and the artist moved into in 1956, still houses these unique artefacts of popular and tribal culture.

The importance of the tribal artefacts and the art of primitive peoples for Miró's art is therefore difficult to determine solely from the context of the collection. The objects in the workshop seem rather like a random accumulation. A glance at Picasso's collection of African sculptures or Max Ernst's collection of *katchinas* shows that Miró did not wish to specialise, nor did he

Fig. 2 Plate from Carl Einstein's book entitled *Negerplastik*, Leipzig, 1915, p. 66

strive for completeness.[10] Yet the individual elements of his *pinacoteca* were indispensable—the artist needed visual stimuli to activate his creative processes. Miró himself commented: 'I begin my work under the effect of shock, which I can sense and which gets me on the run from reality.... In any case, I need a starting point, even if it's just a speck of dust or a gleam of light.'[11] Or again: 'I work on a picture for a long time, sometimes years. But during this time there are moments—sometimes very long ones—when I am not working on the piece. The decisive thing for me is that the starting point is recognisable, the shock that brought it about.'[12] Accordingly, there would have to be echoes of tribal culture in Miró's pictures. But a glance at his oeuvre is discouraging in this respect. It does not seem plausible to link individual elements of pictures of the early 1920s with objects of Eskimo art or the skeletal fish in *Catalan Landscape (The Hunter)* with the Oceanian 'X-ray' style, as has been discussed in the literature, for Miró was not familiar with such objects at this early date.[13] A noteworthy detail that is evident throughout his entire oeuvre is nonetheless the emphasis on genitals, whether female or male (illus. pp. 169, 170). The fold-like bulge of the vagina and projection of the penis have their counterpart in indigenous African and Oceanian cultures, and allude to the desire for and conjuring up of fertility.[14] *Painting* of 1930 (Fig. 1) appears to reproduce the prototypical African sculpture, such as that illustrated in Carl Einstein's book entitled *Negerplastik* of 1915 (Fig. 2). An elongated neck surmounted by a large, round head, the projecting breasts of the female figure and the representation of a woman and a man as a pair are related features. Yet *Painting* is an exception in Miró's work.

Other sources of 'shock' from the realm of primitive sculpture can only be presumed. *Two Women* of 1935 (illus. pp. 190−91) resembles a chamber of horrors, in which a woman with an outsize head and wide-open eye who is reduced to her female sexual organ is placed opposite a second shapeless figure with sharp, protruding teeth. With its dangerous-looking carnassials, this figure is reminiscent of the mask from Vanuatu (illus. p. 14) that graced Miró's Parisian studio. From 1933, Miró produced a number of works in various materials in which the figures consist of naturally flowing, linear shapes (illus. pp. 168, 177, 185). When, in 1930, Miró began to doubt the expressive capacity of painting as a medium, he examined a wide range of materials at length for their aesthetic quality. This pleasure in experimentation was something he had learnt from the Dadaists, with whom he had come into contact even in Barcelona in 1917. But it is also a distinguishing feature of the artists of Melanesia, who would look over any article or material they found for its potential as a medium and in this way would come up with a great variety of objects, ranging from the droll to the fantastic.[15] Slender proportions are characteristic of statuettes from the cultural sphere of Easter Island, of which André Breton possessed two examples (Fig. 3).[16]

In formal or aesthetic terms, it remains a matter of speculation to discern traces or definitive echoes of exotic cultures in Miro's works, such as those evident in the works of Max Ernst. Moreover, the few clues suggest that, whatever Miró's interest in primitive peoples was, it was not confined to Oceanian and Native American cult objects or Eskimo art.

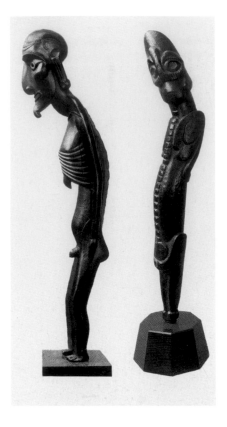

Fig. 3 Easter Island statuettes from the André Breton Collection, from *Cahiers d'art*, no. 2–3 (1929): 108

Fig. 4 Tepano Jaussen, 'Signes idéographiques de l'écriture de l'Ile de Pâques', from *Cahiers d'art*, no. 2–3 (1929): 116–19

That there was nonetheless some link with the world of primitive peoples is clear from an interview with Georges Duthuit in 1936: '... wherever you are, you can find the sun, a blade of grass, the spirals of the dragonfly. Courage consists of staying at home, close to nature, which could not care less about our disasters. Each grain of dust contains the soul of something marvelous. But in order to understand it, we have to recover the religious and magical sense of things that belong to primitive peoples.'[17] In his personal notion of a physical world endowed with souls, Miró sees a parallel to the way primitive peoples live and see the world. What mattered to him was to reach —by means of a procedure similar to that used by the indigenous peoples— a subjectively determined, unspoilt state that acknowledges the value of every object and living creature. The artist had no intention of adapting behavioural patterns of primitive peoples. At most, it involved a similar spiritual attitude.

Indeed, like many Surrealists, Miró was fascinated by the thought patterns that give rise to myths, magic, dreams and totemism. With such allusions, these artists adopt an almost sociological stance, though without asserting any claim to scientific precision. As to Oceanian masks, it is interesting to note that during ritual ceremonies the mask transformed its wearer into the ancestor it depicted. For Surrealist artists, the process of transformation has priority over matters of form—which was still primary for the Cubists—and meticulous scientific analysis.

The background against which this shift in art—from focusing on formal or aesthetic considerations to those concerning content—took place was one of scientific advancements in the fields of sociology and psychology from the turn of the century. Although researchers still obtained much of their knowledge of living conditions and functional connections in indigenous cultures by filtering it out of literary tradition, their conclusions nonetheless considerably enriched the European notion of life among primitive peoples. For example, in *The Golden Bough*, published in two volumes in 1890 and 12 volumes in 1911/15, Sir James Frazer investigated dreams as an important component of everyday life in primitive societies—a subject very dear to the Surrealists. In 1912, Freud published *Totem and Taboo*, in which he compared the psychology of primitive peoples with that of neurotics. In the same year, the French sociologist Emile Durkheim published his treatise *Les Formes élémentaires de la vie religieuse*, whereas in 1923–24 his nephew, sociologist Marcel Mauss, wrote *Essai sur le don*, in which he investigated the socio-economic structures of gift-exchanges among Melanesians and Native Americans.[18]

These few examples give an impression of the wealth of publications that artists such as Breton, Ernst, Leiris, Tzara and Miró himself not only registered but also energetically discussed. An article entitled 'L'Art nègre et l'art océan' by André Clouzot and René Level appeared in 1919, on the occasion of one of the first exhibitions of African and Oceanian art to be held in Paris.[19] It was followed by numerous other articles on Oceanian and Native American art

Detail of Fig. 4

Fig. 5 Joan Miró, *Seated Woman I*, **Femme assise I**, 1938, oil on canvas, 163.4 × 131 cm, The Museum of Modern Art, New York

and objects from Eskimo culture, not only in *Cahiers d'art*, one of the leading art and cultural periodicals of the day, but also in such other organs as *Documents* (1929–34) and *Minotaure* (1933–39), which were founded by members of the Surrealist movement and written and read by them. In 1929, the abundant literature about Oceanian folk art reached a new high in the March-April issue of *Cahiers d'art*, which Christian Zervos dedicated specially to the subject. The articles discuss regional features and delve into psychoanalytical and religious aspects. Numerous pictures of tribal objects, including those from André Breton's extensive collection, bore witness to the expressive capacity of indigenous peoples.[20]

What may have prompted Miró to develop his idiosyncratic sign language based on simple pictures—an approach that clearly distinguishes him from other Surrealist artists, such as Max Ernst or Salvador Dalí—is an article written by Tepano Jaussen that appeared in *Cahiers d'art*.[21] In it Jaussen discusses the culture of Easter Island and, in particular, Rapanui, the language found only in this part of Polynesia. In its written form this language consists of pictographs—which have been discovered on wooden poles, hair ornaments and other objects—of which an interpretation has so far been only moderately successful. Jaussen endeavoured to decode the pictographs by turning to experts and natives, and summed up his discoveries in a table called the 'Signes idéographiques de l'écriture de l'Ile de Pâques' containing 500 signs divided into 14 categories (Fig. 4). Jaussen also established that many signs, such as that for 'man', 'bird' or 'fish', were easy to identify because

they represent only themselves.[22] From the end of the 1930s, 'woman', 'bird', 'star', 'figure' etc. likewise constituted the repertoire of elementary signs in Miró's works. Here as well, they stood primarily for themselves. An ideogram for a seated woman in Jaussen's table bears an astonishing resemblance to the main motif in Miró's similarly named *Seated Woman I* of 1938 (Fig. 5). If we take a look at Miró's works from 1933 and 1934 with this in mind (illus. pp. 177, 180), motifs of amoebic creatures and objects reveal further parallels to the ideographs of Easter Island. However, in subsequent years Miró pared down these pictorial signs, and by 1940 had developed figures representing 'human beings' or 'animals' that shared only clear readability with the ideographic signs of Easter Island.

Jaussen's article indicates in exemplary fashion that an interest in the purely aesthetic contemplation of tribal objects can turn into an interest in the context in which they arose and in their systematic study. His table with its list of coded pictorial signs marks the transition to such a methodical approach.

That artists from the Surrealist movement were also involved in this nascent ethno-methodology is proven by the example of poet and writer Michel Leiris. Leiris first avowed his proclivity for studying exotic cultures in an article entitled 'The Eye of the Ethnographer', which he wrote in 1930 for the periodical *Documents*, which he had founded with Georges Bataille and Carl Einstein. Leiris considered ethnography an admirable science as it placed all social forms on the same level, without distinction. In his article, he announced

Fig. 6 Alfred Jarry, *Véritable Portrait de Monsieur Ubu*, 1896

a research trip led by Marcel Griaule that he would be joining along with Paul Rivet and Georges-Henri Rivière from the Musée d'Ethnographie. Their itinerary (from 1931 to 1933) would take them from Dakar across Central Africa to Djibouti.[23] Once back home, in 1933, Leiris wrote several articles for *Minotaure*, reporting his experiences on this journey. His accounts, which were in part diary notes, focused on the Dogon tribe living in the French Sudan (present-day Mali). They explained to interested Europeans the functional connections of ritual objects, particularly those of the splendid and popular masks, and the ritual structure of the Dogon cult of the dead. Numerous documentary photos showing natives dancing with masks and performing rituals conveyed a new, supposedly authentic picture of an exotic culture.[24] Yet during the preparations for the trip, Leiris was aware that his observations could not be objective, and that the adventure was in fact the realisation of various childhood dreams, a 'battle with ageing and death' and a desire to 'step out of the river of time'.[25] His kind of fieldwork is what Hans-Jürgen Heinrichs dismisses as 'ethno-poetic experience', adding that 'Leiris is an ethnologist of the self and others—his system is the overarching symbolic system of cultures and the worlds of the imagination.'[26]

There was thus a paradox in the life and work of Michel Leiris, and a similar ambivalence was also true of Miró and his art. Miró was likewise an artist and equally keenly interested in the great wide world, yet he never felt the urge to go on adventurous expeditions to distant lands. He quenched his thirst for information from his immediate environment, which included numerous

publications, such as *Minotaure*, for which he did a series of drawings on the subject of the Minotaur for issue 3–4.[27] Moreover, as the work *Musique Seine Michel, Bataille et moi* of 1927 reminds us, Miró was closely associated with the intellectual revolutionaries mentioned in its title.[28] In their ideas, Miró encountered a methodological approach that encouraged, even inspired him to conceive a systematic visual language such as appeared at the end of the 1930s. Surrealistic notions of dreams, automatism and the unspoilt combined with the growing desire for systematisation, typologising and coding—a step that André Breton, who clung firmly to the purely fetishist power of tribal objects, did not take, in contrast to Leiris, Miró and Bataille.

COMICS, CHILDREN AND GRAFFITI

'Later Viot and Pierre arranged an exhibition of Surrealists at the Galerie Pierre, and I had two things in the show: *The Dialogue of Insects* and *Harlequin's Carnival*. After that, Viot disappeared—nobody knows where—and Pierre himself offered me a formal contract—Pierre, who actually admitted that when he first saw my work he started telling everyone that a new kind of comic painting had appeared on the scene and was splitting his sides laughing!'[29]

The comic element mentioned by Miró himself is a constant in his visual worlds, and turns up time and again in various styles and disguises. An early, prime example of this special form of expression is *The Gentleman* of 1924

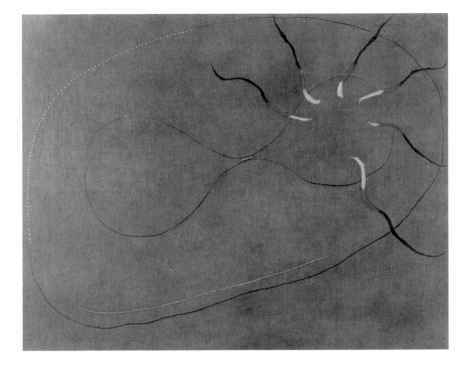

Fig. 7 Felix, from *Cahiers d'art* 5, no. 6 (1930): 336

Fig. 8 Joan Miró, *The Kiss*, **Le Baiser**, 1924, oil on canvas, 73 × 92 cm, private collection

(illus. p. 133). The figure in it harks back to Père Ubu in the play *Ubu roi* by French writer Alfred Jarry (1873–1907), which developed from a farce he wrote at the age of 15. It was first staged in 1896. Miró turns the crude humour of the violent and cowardly Ubu inside out by transforming this revolting individual, who keeps shouting 'green snot', into a distinguished gentleman endowed with inappropriate accessories, such as a cigarette stuck in his behind. Jarry's plays, particularly *Le Surmâle* (*The Supermale*) as well as *Ubu roi*, were favourite reading in Surrealist circles because of their grotesque and fantastic elements. In his attachment to Jarry, Miró went so far as to copy a drawing by the writer (Fig. 6), but added letters, an almost realistic foot and other unusual features, to turn it into something surreal. Characteristic of Miró's figure of Ubu is that it is defined by a clear outline that at the same time distorts the body—an outline similar to those featuring in the artist's later works. No diaphanous or fraying areas (illus. p. 148) destabilise the figuration. The eruptive delight in narrative detail of the early years (illus. p. 129) has already given way to a tentative concentration of shape.[30]

Similar formal features characterise *The Kiss* of 1924 (Fig. 8). A simple line circumscribes two circles—representing heads—which are linked by bubble-like extensions—representing two mouths meeting. Tentacle-like feelers emerge from the right circle—a symbolic shorthand that Miró continually used to indicate female figures. Interestingly, there is a correspondence in both form and content to the American cartoon film *Felix*, which was shown in Paris cinemas by 1930 at the latest. In this, there is a scene in which the protagonist of the film, Felix the cat, gives the female cat a hearty buss (Fig. 7).[31] Whether and when Miró might have seen this cartoon is not known. However, the Surrealists' own films and film reviews, such as Leiris's article on Buster Keaton, published in *Documents* in 1930, testify to their interest in the cinema.[32] Cartoon films and comics, moreover, provided fertile ground for the Surrealists, whose unbridled imaginations created clever images and storylines to match. Ultimately the cartoonists in the first comics, revelling in the incredible experiences of their heroes, rogues and street urchins, rebelled against social norms.

Picasso's enthusiasm for comics is well known. He was provided with cartoon strips from American daily and Sunday newspapers by the Cone sisters Claribel and Etta, with whom he had become acquainted before World War I. Picasso had adopted the narrative structure of comics—the sequence of individual scenes in registers—in 1937 in his series of prints entitled 'The Dream and Lies of Franco', in which the artist protested against Franco's putsch.[33] Parallel to this, Miró drew a series of gouaches informed by a similar impulse. They unite cruelty and brutality—which must be considered a reflection of the political unrest of the time—with the comical. Critic Clement Greenberg recognised the co-existence of these incompatible opposites in Miró's work and drew attention to the phenomenon in a picture that manifests the basic elements of comics. In *Figures Pursued by a Bird* of 1938 (Fig. 9), three figures and a bird clash in a narrative space that is nearly perspectival. A fourth figure is seen making off, only its large head visible at the bottom right edge of

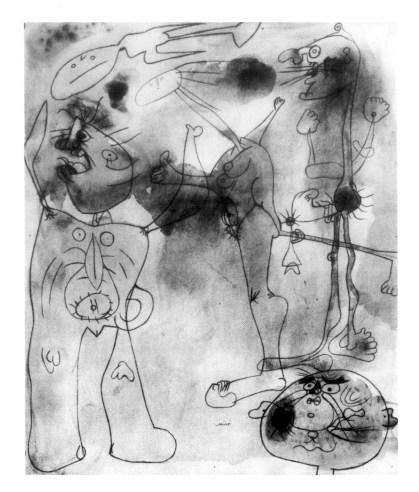

Fig. 9 Joan Miró, *Figures Pursued by a Bird*, **Personnages, suivis par un oiseau**, 1938, black and brown chalk, watercolour on paper, 41 × 33 cm, The Art Institute of Chicago, Peter B. Bensinger Charitable Trust

the picture. Movement is suggested by the striding female figure in the middle and by the speedlines (the elongated shape of the bird, the hair of the woman, the mouths opened to speak and the lines issuing from the mouth of the man on the right).[34] In contrast to other pictures in which figures and elements are isolated from each other and appear in an undefined colour space, in this gouache an utterly realistic interaction between severely deformed figures is taking place that has earned the label of 'tragic realism' for this series of works. Even though the device of a continuous picture sequence is not used, parallels to comics can be discerned particularly in this phase of the artist's work. Miró himself never made any suggestion of such a link, yet there was in his estate a printed page of unknown origin called *Auca de 'Les Set Portes'* (Fig. 11), which reproduces a rich sequence of comic scenes from the Set Portes restaurant in Barcelona in typical comic handwriting. Each picture has a short, three-line caption beneath it, explaining the punch-line of the respective scene.[35] The page can be dated to *c.* 1961 and therefore could not have directly influenced Miró's development in the 1920s and 1930s. Yet, the style of draughtsmanship that has gone into *Auca de 'Les Set Portes'*, the dark lines on a light ground, the simple but trenchant outlines and the few solid areas are also found in some early Spanish comics. An example of this is the figure of Macaco, whom K-Hito (pseudonym of cartoonist Ricardo García López) created in 1928 for the weekly periodical of the same name (Fig. 10). Macaco is an inoffensive little man who is constantly getting involved in absurd goings-on and surreal situations.[36] We also find a similar kind of compression and exaggeration with comic excesses in such works as

The Snake with Red Poppies Moving through a Field of Violets Inhabited by Lizards in Mourning of 1947 (illus. p. 197), which Miró filled with simple, comical figures. Both Miró and the cartoonists who worked for daily newspapers wanted to appeal to a broad public, and both adopted a readily intelligible, comical pictorial idiom.

That Miró believed in a closer, more profound relationship between art and the broad public is evident in a comment made by the artist: 'The people are always the same, in fact, and everywhere—spontaneously—they create marvelous things. This is the reason for my attraction to anonymous things, graffiti, the art of common people, the expressions and gestures that leap out at you…. But you have to have kept yourself pure enough in order to be moved. To lose contact with the people is to lose yourself.'[37] Comics were aimed directly at the man on the street. If a series did not accord with the 'tastes' of the masses, it was set aside without further ado.

But Miró emphasises quite specifically in the above quote another kind of 'street art', namely graffiti. Even in the 1920s and 1930s, the walls of buildings, piers of bridges, fences etc. were scribbled over with writing, signs and brands, and not just in Paris and Barcelona. Walls and asphalt have always been an interface between subject and society, private and public, the individual and the coded. 'Things like that [graffiti] belong to everyone and no one,' said Picasso in conversation with the photographer Brassaï, who had recorded the numerous scratched or chalk-painted figures on the walls of Paris with his camera

Fig. 10 K-Hito, Macaco, *fotógrafo*, from *Macaco*, no. 54 (February 1929)

Fig. 11 *Auca de 'Les Set Portes'*, c. 1961, Estate of Joan Miró, Fundació Joan Miró, Barcelona

from the early 1930s.[38] Many of these graffiti were made by children, and told of their small worlds from an unspoilt, pre-logical viewpoint. In a study that appeared in 1913 called *Les Dessins d'un enfant*, the French philosopher G. H. Luquet illustrated and analysed many children's drawings from public spaces in Paris. How close such formulations are to the works of Miró, such as *Painting (The Sum)* of 1925 (illus. p. 137), is shown by pictures in which children outline 'head figures' with a simple line (Fig. 12).[39] Perhaps it was such relationships that moved André Breton to criticise Miró's work: 'The only drawback to Miro's natural aptitude was a certain arrested development of the personality at the childhood stage which afforded him a poor protection against unevenness, profusion and looseness and, intellectually, set certain limits to the scope of his testimony.'[40] Unevenness, profusion and looseness are genuine characteristics of children, though not acknowledged here by Breton as positive ones. He sees no nourishment for art in these aspects of childish behaviour. Once again—as already indicated in connection with artefacts of primitive peoples—Breton's exclusive (i.e. he allows only subjectively selected areas to count) and therefore doctrinaire view of a central area of reference for Surrealism comes to the fore. Yet, in his first manifesto, Breton depicted childhood as a time filled with magic and endowed with every kind of freedom, which the artist was to rediscover in a parallel existence. 'The mind which plunges into Surrealism re-lives with glowing excitement the best part of its childhood.'[41]

Once again it was Leiris who bound the essence of Surrealism to reality by uniting first-hand accounts and scientific studies with ideals. He tells of graffiti

that children had drawn on the walls of churches in the Abyssinian province of Gojjam, which ethnologists Griaule and Larget discovered on an expedition in 1928–29. They are simple line drawings—in some cases very tentative—of heads, figures, dancers, animals etc. These childlike graffiti are strikingly similar to the ideographs from Easter Island in their typology and use of compression, omission and simplification to convey their message. 'Graffiti,' says Leiris, 'have existed since the earliest days of prehistory, for cave paintings are no different, and even today you come across them in all parts of the world, among people of all races and in all climatic conditions. They are either symbolic drawings with a religious meaning or they take the form of pure ideograms, which then represent a script in the actual sense.'[42] If we study Miró's studio in Paris in the 1940s with its numerous drawings pinned up on the walls (illus. p. 15), it is easy to establish a connection between the children's graffiti, the sign language of Easter Island, the symbolic and the comical. As in *Women and Birds in front of the Sun* of 1942 (illus. p. 195), Miró's pictorial syntax consists of elementary signs and figures, which on a wall-like colour ground look as if scribbled on to it.

However, his works around 1940 show not just a formal relationship with indigenous pictorial signs and children's graffiti. The strategies that lie behind such pictorial devices recur in Miró as well: the ideographs of Easter Island are aimed at communication, whereas the drawings of children have to do with game strategies, that is, creating and using signs in play. They are similar in the comprehensibility of the signs and the apparently arbitrary arrangement

Fig. 12 Graffiti, Plate XVIII from G.-H. Luquet, *Les Dessins d'un enfant*, psychological studies, Paris, 1913

of the abbreviated forms. Miró thus opens up his pictorial worlds to a broad public, which does not—unlike in the case of Dalí, for example—need particular information to decode the works. Using the scarce information (star, bird, woman) to hand, it is in fact left to the viewer to interpret Miró's works.

'DOCUMENTS', FREUD AND JOKES

As to Miró's artistic development in the 1920s and especially the 1930s, Michel Leiris and his colleagues from the rue Blomet turned out to be kindred souls. '[Leiris's] ideal is to attain a total understanding, through ethnology and poetry, of what we live in.'[43] Leiris's ability and strength lay in combining scientific discovery—through methodical fieldwork—with artistic vision. Some of his ideas drew nourishment from doctrinaire Surrealism as represented by Breton. The relationship between Breton and the small group in the rue Blomet was therefore notable for similar objectives on the one hand and mutual disapproval on the other.

Breton liked Miró's work very much. The work Miró had done from 1924 he certainly considered as Surrealist art. 'From then on, his output displayed an innocence and freedom that have not been surpassed.'[44] Yet almost in the same breath, Breton comes up with a harsh criticism of what he saw as an intellectually limited notion of art. Likewise, though he had viewed many writers from the rue Blomet as comrades-in-arms in his first Surrealist manifesto (1924), in the second Surrealist manifesto (1930) he attacked artists such as André Masson, Antonin Artaud and Georges Limbour because they

would not accept the revolutionary aims of Surrealism unconditionally.[45] Leiris and Miró were not specifically mentioned by Breton in either manifesto. Yet Leiris records in his diary on 13 May 1929 that he had officially broken with Surrealism on 19 February the same year, which implies that he was previously a member. In fact, like Masson, Tual, Limbour, Soupault and others, he had refused to sign a circular letter on 12 February 1929 committing supporters of Surrealism to a joint, ideologically motivated campaign. In an interview in 1931 Miró also explicitly distanced himself, expressing a critical attitude to doctrinaire Surrealism.[46]

The founding of the periodical *Documents* provided both Leiris and Georges Bataille, who likewise moved away from the doctrinaire theories of Breton, a platform to put their views across to the public. The very structure of the periodical is indicative: along with numerous articles on individual artists, ethnology, nature, medieval art and society, a section was reserved for the *Dictionnaire*. Under the encyclopaedic heading of the *Dictionnaire*, the three founders of the periodical, Bataille, Einstein and Leiris, as well as other writers took key terms, such as 'eye', 'metamorphosis' and 'mouth', as the starting points for chains of associations intended to describe the whole heterogeneous spectrum of existence. With his discursion on spittle (*crachat*), Leiris supplies a succinct example of this procedure: 'So that the mouth can now recover its full mythological destiny, there is love on the one hand (because what is the mouth if not a warm, moist cavern decked out with teeth like stalactites, behind which the guardian dragon of the tongue conceals

God knows what treasures). On the other hand there is spittle in there too: at a stroke, it bears the mouth down to the lowest step of the organ ladder, degrading it to an expectoral hole, which is far more disgusting than its role in the ingestion of nourishment.'[47] By means of an ordinary substance, in this case spittle, the sublime and the everyday, the beautiful and the ugly, the natural and the artificial, become the subject of discussion and the essence of existence. This form of dialectic—that the awfulness of the world has an obverse in the comic—is reflected in *Documents*. Its contributors recognised that the childish-cum-comical side of life found artistic expression in the work of Paul Klee, Jean Arp and Miró.[48]

It was Leiris who succinctly summed up the irreconcilable in Miró's work: 'It may seem surprising at first glance to talk of asceticism in Miró. The burlesque aspect of his pictures, the astonishing joy that is emitted from within, would seem to make nonsense of the idea. However, if you look more closely, you can see that as a painter he must have achieved a tabula rasa in himself in order to find his way back to such a childlike quality, which is both so serious and yet so madcap, shot through by a wholly primordial mythology based on the metamorphoses of stones, plants and animals, a little like the fairy tales of untamed peoples, in which all elements of the Earth undergo such improbable transformations.'[49] Here, Leiris manages to address all aspects of Miró's work in a single paragraph. The childlike character also identified by Breton, which is closely linked to the comic components of the works, now appears in an altogether different light. For Leiris, it is a key, indeed indispensable factor in Miró's pictures in conveying a view of a holistic existence. A background of this kind makes works such as *Figure* of 1934 (illus. p. 188) or *Two Women* of 1935 (illus. pp. 190–91), which are regarded as part of the artist's 'wild' period in which grotesque elements were juxtaposed with comical ones, more or less intelligible.

For Surrealist artists, regardless of their internal disagreements, Sigmund Freud's psychoanalytical work is one of the key sources of explanatory models for their investigations into the unconscious. The unconscious features as a primal, non-conditioned state. For Freud, it surfaces in dreams or in the psyche of indigenous primitive peoples. But Freud also recognised its role in jokes and humour. In 1905 he published, initially in German, his study of *Jokes and their Relationship to the Unconscious*. Taking a selection of jokes as his starting point, he investigated the techniques and intentions of jokes, their mechanisms in the psyche and society, the unconscious as a common factor in jokes and dreams, and the relationship between jokes and humour.[50] Freud's insights can be applied to a remarkable extent to the droll pictorial symbols in Miró's work around 1940. Freud discovered, for example, that the decisive factor of a joke is condensation or compression. As a first example of this method, he cites a joke by the poet Heinrich Heine, which he had incorporated in one of his articles. As the joke goes, the lottery collector and corn operator Hirsch-Hyacinth boasted to a third person about his friendship with the rich Baron Rothschild, saying: 'And, as true as God shall grant me all good things, Doctor, I sat beside Salomon Rothschild and he treated me

quite as his equal—quite famillionairely.'[51] The malapropism 'famillionairely' comes from the compression of 'familiar' and 'millionaire' into a single word, which makes the joke. Other possible methods Freud mentions are inventing hybrid words, modification, double entendre etc. All these techniques are based on types of compression or, as Freud says, economy with words.[52] Compression in the form of simplification is a fundamental feature of works such as *Figures and Birds in front of the Sun* of 1946 (illus. p. 200) described earlier. In the picture, signs, human and animal bodies are reduced to stick figures; elongated and curved or pointed noses are produced by means of compression; whereas the technique of simplification generates a dual coding for the figure in the bottom right-hand corner. Who can say whether this is man or beast? Each individual pictorial element is intelligible *and* eccentric, and because of this at once funny. According to Freud, humour is created by the economy or avoidance of psychic effort. The effect is to relieve the psyche, and because the joke is readily intelligible, it does not tax the intellect. The eruption of laughter at humorous compression, maintained Freud, releases bottled up and inhibiting energy and thus causes relief.[53] In his works around 1940, Miró sets out the figures in his works in a simple and recognisable manner so that no particular intellectual effort is required to decode them or understand the joke. He avoids taking compression so far that intelligibility is no longer possible.

In *Jokes and their Relationship to the Unconscious*, Freud also writes: 'The psychogenesis of jokes has taught us that the pleasure in a joke is derived from play with words or from the liberation of nonsense, and that the meaning of the joke is merely intended to protect that pleasure from being done away with by criticism.'[54] Playing with words is something people do best in their earliest childhood, when the unconscious is still in control. Jokes, childishness and the unconscious produce, according to Freud, a functional unit, which is enjoyed in play.[55] Once again there is thus a correspondence between Miró's means of communication and play on the basis of an ideographically conditioned visual language. The artist links both aspects with simple humour, making his pictures readily intelligible to the public. Freud sagely remarked that 'a dream is a completely asocial mental product', whereas 'a joke ... is the most social of all mental functions that aim at a yield of pleasure'.[56] Seen in this light, the works Miró produced around 1940 in a uniquely communicative and at the same time humorous language of pictorial signs become icons of a notion of art anchored in the unconscious.

Between 1922/23 and 1940, Miró's sign language changed fundamentally. With the aid of formal compression, the artist moved from a narrative, enigmatic symbolism to simple pictorial signs that are unmistakably comic in tenor. He thus moved away from a coding determined by the subject to attain a universally valid communicative coding, which does not however exclude constantly recurring symbols such as ladders, vaginas, stars etc. being interpreted associatively at a deeper level. The readability of the signs, their playful composition and the shift of abbreviation towards comedy are aimed ultimately at a collective unconscious. Miró was able to continue his

/ [mll ho Toplier]

aesthetic game with these signs ad infinitum without it ever failing to fulfil its purpose. At the same time, with a pictorial language that moved into the realm of generality Miró steered a course along the fine line between 'high' and 'trivial' art—a dichotomy that the artist himself never acknowledged as such throughout his life. The context described here in which the artist moved in the 1920s and 1930s reveals the inherent strength of a view of art that sought comprehensibility in its public face without the art ever losing its lyrical qualities. Michel Leiris and the others from the rue Blomet can be seen as kindred thinkers with similar objectives—much more even than André Breton. Miró was a master at establishing a balance between intellectual virtuosity and general comprehensibility, between high and low, between the demanding and the playful. In an interview in 1931, he gave a striking and at the same time poetic image of his understanding of art: 'I'm only interested in anonymous art, the kind that springs from the collective unconscious. I paint the way I walk along the street.'[57]

NOTES

1 See *Miró in the Collection of the Museum of Modern Art*, ed. William Rubin, exh. cat. (New York: The Museum of Modern Art, 1973), pp. 20–26.

2 In 1968, Miró finally defined an alphabet of 20 signs in the *L'Œil-Oiseau* series of drawings. See Carme Escudero and Teresa Montaner, 'Joan Miró: Desfilada d'obsessions', in *Joan Miró: Desfilada d'obsessions*, exh. cat. (Barcelona: Fundació Joan Miró, 2001), pp. 11–26, cat. no. 2, p. 130. See also Sidra Stich, *Joan Miró: The Development of a Sign Language* (St. Louis: Washington University, 1980).

3 Robert Desnos, quoted from Jacques Dupin, *Joan Miró: Life and Work* (London, 1962), p. 138.

4 André Breton, *Manifestoes of Surrealism*, trans. Richard Seaver and Helen R. Lane (Ann Arbor: University of Michigan Press, 1969), p. 14. In his first manifesto, Breton considers Robert Desnos, Georges Limbour and Antonin Artaud champions of Surrealism.

5 For the history of primitivism—the inspiration modern artists derived from the art and culture of primitive peoples—see *'Primitivism' in 20th Century Art: Affinity of the Tribal and the Modern*, ed. William Rubin (New York: The Museum of Modern Art, 1984).

6 Jean-Louis Paudrat, 'From Africa', in ibid., vol. I, pp. 125–75, and William Rubin, 'Picasso', in ibid., vol. I, pp. 241–343.

7 See Evan Maurer, 'Dada and Surrealismus', in ibid., vol. II, pp. 535–93.

8 The term 'X-ray style' denotes a design in which empty areas alternate with solid ones, as in a medical X-ray. This rhythmic appearance of positive and negative areas occurs in both the paintings and the objects of Oceanic peoples.

9 For the objects in Miró's studio, see Escudero and Montaner (note 2) and Pablo J. Rico, 'Joan Miró territorios creativos', in *Joan Miró: Territorios creativos*, exh. cat. (Palma de Mallorca: Fundació Pilar i Joan Miró, 1996), pp. 15–42. See also *Joan Miró: L'Arrel i l'indret*, exh. cat. (Barcelona: Sala d'exposicions Portal de Santa Madrona, 1993), pp. 64–67.

10 See Rubin (note 5), p. 327 (P. Picasso) and p. 568 (M. Ernst).

11 *Palma territori Miró*, exh. cat. (Palma de Mallorca: Fundació Pilar i Joan Miró, 1996), p. 43.

12 Ibid., p. 49.

13 See Maurer (note 7), pp. 592–93, who disproves Elizabeth Cowling's comparison with Eskimo masks.

14 See Rubin (note 5), passim.

15 Waldemar Stöhr, *Kunst und Kultur aus der Südsee* (Cologne, 1987), p. 17.

16 The photograph of the two statuettes appeared in *Cahiers d'art* in an article about Easter Island; see *Cahiers d'art*, no. 2–3 (1929): 108, Figs. 171 and 172. The Breton Collection was auctioned in Paris in 1931 together with that of Paul Eluard.

17 'Où allez-vous, Miró?', conversation with Georges Duthuit, *Cahiers d'art*, no. 8–10 (1936): 257; quoted from *Joan Miró: Selected Writings and Interviews*, ed. Margit Rowell (London, 1987), p. 153.

18 On the subject of ethnology and Surrealism, see Mary Drach McInnes, *Taboo and Transgression: The Subversive Aesthetics of Georges Bataille and Documents* (Boston, 1994), pp. 9–25.

19 See Maurer (note 7), n. 10, 18.

20 *Cahiers d'art*, no. 2–3 (1929).

21 Tepano Jaussen, 'L'Ile de Pâques', *Cahiers d'art*, no. 2–3 (1929): 108–19. Miró hung a number of pictures of cult objects from Easter Island on the walls of his studio in Majorca, notably the monumental heads of the Maori, so that we can assume he took a special interest in this culture. See Rico (note 9).

22 'Un grand nombre de signes: homme, oiseau, poisson, etc. présentent d'eux-mêmes un sens clair et facile pour les yeux', in ibid., p. 115.

23 Michel Leiris, 'L'Œil de l'ethnographe', *Documents* 2, no. 7 (1930): 404–14.

24 *Minotaure* 1, no. 2 (1933). Michel Leiris, 'Objets Rituels Dogon', in ibid., pp. 26–30, 45–51; idem, 'Danses funéraires Dogon', ibid., pp. 73–76.

25 Leiris (note 23), quoted from *Elan vital oder das Auge des Eros*, exh. cat. (Munich: Haus der Kunst, 1994), p. 513.

26 See Hans-Jürgen Heinrichs, *Ein Leben als Künstler und Ethnologe: Über Michel Leiris* (Frankfurt, 1992), pp. 77 and 81.

27 *Minotaure*, no. 3–4 (1933): 12. This issue also includes Paul Eluard, 'Les Plus Belles cartes postales' (pp. 85–100) and Tristan Tzara, 'D'Un Certain Automatisme du Goût' (pp. 81–84). Both topics discussed here, postcards and hats, are directly reflected in Miró's collages (illus. pp. 162, 167) made the same year, which suggests Miró took a keen interest in the periodical.

28 *Joan Miró: Catalogue raisonné, Paintings*, ed. Jacques Dupin and Ariane Lelong-Mainaud, vol. I: 1908–1930 (Paris, 1999), no. 260. See also Rosalind E. Krauss, 'Michel, Bataille et moi', *October 68* (1994): 3–20.

29 Francesc Trabal, 'A Conversation with Joan Miró', *La Publicitat*, 14 July 1928; quoted from Rowell (note 17), p. 96.

30 For Alfred Jarry, see also *UBU: Cent ans de règne*, exh. cat. (Musée-Galerie de la Seita, 1989), passim. Alfred Jarry, *Ubu Roi*, trans. Barbara Wright, A New Directions Book (Norfolk, CT, 1961).

Miró worked on the subject again in later years, for example in 1966, when he did 13 lithographs to illustrate *Ubu roi*. See Eva Beate Bode, 'Miró's Illustrationen zu Ubu roi', in *Miró: Mein Atelier ist mein Garten*, exh. cat. (Ludwigshafen am Rhein: Wilhelm-Hack-Museum; Ostfildern-Ruit, 2000), pp. 166–67.

31 Jacques Bernard Brunius, 'L'Humour et l'amour chez les animaux', *Cahiers d'art*, no. 6 (1930): 333–36. In his article, Brunius mentions a number of cartoons that were on show in Paris, e.g., *Coco the Clown, Matou Krazy Kat, Mickey Mouse* etc. The cartoon figure of Felix was launched by Pat Sullivan in 1917, and from 1923 was the star of a daily cartoon. The figure was invented by graphic artist Otto Messmer.

32 Michel Leiris, 'Keaton (Buster)', *Documents* 2, no. 4 (1930): 236.

33 See Günter Metken, *Comics* (Frankfurt and Hamburg, 1970), pp. 174–77.

34 Clement Greenberg, *Joan Miró* (New York, 1948), pp. 39–44, illus. p. 39.

35 F.J.M., 43.3 × 31.6 cm, c. 1961, Fundació Joan Miró, Barcelona. Miró kept this page together with a model for *Ubu roi* in a folder. I am grateful to Teresa Montaner of the Fundació Joan Miró in Barcelona for her helpful information about this page.

36 I should like to thank the Strip documentarci centre in Rotterdam for information and material concerning the history of Spanish comics in the 1920s and 1930s. See also *High and Low: Modern Art and Popular Culture*, exh. cat. (New York: The Museum of Modern Art, etc., 1990). In this exhibition, Miró's surreal landscapes from around 1926 were contrasted with George Herriman's *Krazy Kat* comic strip from 1910 onwards, pp. 168–82.

37 See Rowell (note 17), p. 153.

38 Pablo Picasso 1945, quoted from *Brassaï Graffiti: Zwei Gespräche mit Picasso* (Stuttgart, Berlin and Zurich, 1960). See Brassaï, 'Du mur des cavernes au mur d'usine', *Minotaure*, no. 3–4 (1933): 6–7.

39 See Christopher Green, 'The Infant in the Adult: Joan Miró and the Infantile Image', in *Discovering Child Art: Essays on Childhood, Primitivism and Modernism*, ed. Jonathan Fineberg (Princeton, NJ, 1998), pp. 210–34.

40 André Breton, 'Genesis and Perspective of Surrealism in the Plastic Arts' (1941), in idem, *What is Surrealism? Selected Writings*, ed. and intro. Franklin Rosemont (London, 1978), p. 225.

41 See Breton (note 4), p. 39.

42 Michel Leiris, 'Graffiti abyssin', *Arts et métiers graphiques*, no. 44 (1934): 56–57; quoted from *Michel Leiris: Die eigene und die fremde Kultur*, ed. Hans-Jürgen Heinrichs, Ethnologische Schriften, vol. 1 (Frankfurt, 1985), p. 128.

43 See Heinrichs (note 26), p. 76, Krauss, 'Michel, Bataille et moi', *October 68* (1994): 3–20, and Christa Lichtenstern, 'Metamorphosemodelle bei Michel Leiris, Georges Bataille und Carl Einstein' and 'André Breton und seine Gruppe', in idem, *Metamorphose in der Kunst des 19. und 20. Jahrhunderts*, vol. 2: *Vom Mythos zum Prozessdenken* (Weinheim, 1992), pp. 126–49.

44 See Breton (note 40).

45 See Breton (note 4), pp. 129–34.

46 Michel Leiris, *Journal, 1922–1989*, ed. Jean Jamin (Paris, 1992), p. 119. For Miró, see Francisco Melgar, 'Los artistas españoles en Paris: Juan Miró', *Ahora*, 24 January 1931, in Rowell (note 17), pp. 114–17.

47 Michel Leiris, 'Crachat: L'Eau à la bouche', *Documents* 1, no. 7 (1929): 381–82, quoted from *Elan vital* (note 25), p. 533. Interestingly, Margit Rowell endeavours to illustrate the world of symbols in Miró's works in the form of a *dictionnaire*. See *Joan Miró: Campo de Estrellas*, exh. cat. (Madrid: Museo Nacional Centro de Arte Reina Sofia Madrid, 1993), pp. 42–53.

48 Georges Limbour, 'Paul Klee', *Documents* 1, no. 1 (1929): 53–54; Michel Leiris, 'Joan Miró', *Documents* 1, no. 5 (1929): 263–69; idem, 'Exposition Hans Arp (Galerie Goemans)', *Documents* 1, no. 6 (1929): 340–42.

49 See Leiris, 'Joan Miró', ibid.; quoted from *Elan vital* (note 25), p. 477.

50 *The Standard Edition of the Complete Psychological Works of Sigmund Freud*, trans. and ed. James Strachey in collaboration with Anna Freud, vol. VIII: *Jokes and their Relation to the Unconscious* (1905) (London, 1964). A more precise differentiation between jokes, comedy, humour etc. as explained by Freud appears irrelevant to a discussion of Miró's works.

51 Ibid., p. 16.

52 Ibid., pp. 42–43.

53 Ibid., pp. 127, 147–53, 157.

54 Ibid., p. 131.

55 Ibid., p. 170.

56 Ibid., p. 179.

57 'Artistes espagnols à Paris: Juan Miró', *Ahora*, 24 January 1931; quoted from Rowell (note 17), p. 117.

CHRISTA LICHTENSTERN

FROM THE PLAYFUL TO A DENUNCIATION OF VIOLENCE
MIRÓ'S DEFORMATIONS OF THE 1920s AND 1930s

The image of witty, playful Miró that has taken root in public consciousness and in the meantime cheaply fills the framing and picture departments of stores—the notion of the carefree Catalan who gets his 'puppets' dancing in the Mediterranean light of sun, moon and stars—is deceptive. Anyone who really wants to get to know the major painter-poet that he was, must also sound out the depths of his terrifying experiences. Deploying tricks in the way the Surrealists exended familiar figures, Miró summons up an armoury to respond to the shock tactics of fascism and 'compose' himself as a man and artist. To understand the development of this self-fortification and its inherent tensions, a glance at the early Miró and his image of humanity seems appropriate. The following handful of examples may show by way of introduction how his first steps were shaped by an innate classicism that he had to absorb before he could break out with self-assurance under the auspices of Surrealism.

Even the great *Standing Nude* of 1918 makes one sit up.[1] In this painting, Miró depicts a massive female nude in a suggestive contrapposto stance, recalling one of Courbet's heavy female bodies cut in the sharp-edged prism of Cubism. The bright animal ornamentation of the splendid curtain behind the nude and the flowers on the carpet under her feet all appear to pay homage to the powerful, well-proportioned body. Miró's choice of the classical pose did not come from nowhere. Behind it lies a programme, which the 25-year-old artist had unmistakably introduced into his still life *Nord-Sud* as early as 1917 (illus. p. 55). The composition is marked by a balanced harmony of colour

Fig. 1 Joan Miró, *The Farmer's Wife*, **La Fermière**, 1922–23, oil on canvas, 81 × 65 cm, Musée National d'Art Moderne, Centre Georges Pompidou, Paris

and form that revolves within itself. Robert Delaunay's early *Formes circulaires* would seem to have been the inspiration for the coloration.[2] Various important objects from Miró's everyday life are grouped around the main motif, a folded copy of the newspaper *Nord-Sud*. None of the seven surrounding objects—the Catalan jug, the flower vase, the birdcage, the opulent book emblazoned with the title *Goethe*, the scissors, the fruit—overlaps the other. Every object appears lovingly enclosed in its own plasticity.

Undoubtedly the conspicuous positioning of *Nord-Sud* must be seen as Miró's declaration of belief in French avant-garde art, i.e. Van Gogh, Cézanne, Matisse, Picasso and Juan Gris. In the intellectual circles of Barcelona, where Miró was living at the time, just as among the staff of the Parisian *Nord-Sud*, it was the general view that modernism and classicism must of necessity come together as part of a new Mediterranean order. Miró would thus have read an article by Paul Dermée in the first issue of *Nord-Sud*, on 15 March 1917, in which the latter outlined a programme for contemporary French art, and proclaimed principles for it, such as 'concentration', 'composition' and 'purity'.[3]

The young Miró may have shared this view, putting *Nord-Sud* in a context with the token Spanish *latinità*, the jug and, opposite it, the German classicism of Goethe.

Miró had always been a devotee of literature. In 1916, he read poetry by Apollinaire and the texts of the Italian Futurists with great enthusiasm.

After he came to Paris in 1920, he associated mainly with literary figures, such as Michel Leiris, Georges Limbour, Roland Tual, Armand Salacrou, Robert Desnos, Paul Eluard, Benjamin Péret and Antonin Artaud.

Remarkably, Miró's native realism is consistent with the perspective of Goethe presented in the *Nord-Sud* still life. The Catalan remained faithful to his realism all his life. On 31 August 1919, he wrote to his friend Enric Cristòfol Ricard: 'Everything is contained in reality as long as you grub deep enough for it.'[4] It is a philosophy not far removed from Goethe's principle: 'There is no sense in looking for something behind phenomena. They *are* theory.'[5] Other evidence speaks for itself. In a conversation with Georges Duthuit, the painter said on the subject of abstraction: 'Not with intellectuals who have no responsibilities.... Let them chew on their abstractions if they can't find any real food or real rhythm or human facts. Have you ever heard of anything more stupid than "abstraction-abstraction"? And they ask me into their deserted house, as if the marks I put on a canvas did not correspond to a concrete representation of my mind, did not possess a profound reality, were not a part of the real itself!'[6]

After the war, Miró confirmed his philosophy to Walter Erben: 'Everything you see in my pictures exists.' Or: 'Nothing is invented, it's all there.'[7] This empirical foundation accords with Miró's early conviction that a picture must be precisely calculated to a fraction of an inch and *balanced*. A related combination of classical order, harmony and precision streams in warm, alert

Fig. 2 Joan Miró, *The Statue*, **La Statue**, 1926, pencil on paper,
24 × 18 cm, The Museum of Modern Art, New York

colours from Miró's *Self-Portrait* of 1919 (illus. p. 121). Symmetry, balanced proportions and calm are imparted to the viewer despite the insistent, enquiring gaze.[8]

Disruption first breaks into this order in *The Farmer's Wife* of 1922–23 (Fig. 1), which introduces a new kind of tension. The heavy object quality of the woman is visually supported by the geometry of the bucket and beam. Immediately noticeable about the figure are its disproportionately large feet. As he often said, within his all-embracing realism Miró wanted to 'get through to the soul'. Could that mean in this case that the farmer's wife, who is about to kill a hare, will do this only with inward reluctance? Does Miró possibly want to show this reluctance by making her legs over-heavy? At any rate, her anxious, distant, grave look speaks for itself. If this is indeed the case, her deformed feet could indicate to us a state of trance and therein the state of her unconscious mind.

In the following years, Miró increasingly tried to do justice to this unconscious. His imagination ranged ever more widely, while his inner adherence to reality became all the more tenacious. A new cosmos of experience was opening up for him thanks to the proximity of his studio to those of André Masson and Michel Leiris (*c.* 1921–23), his acquaintance with Georges Bataille, Carl Einstein, Henry Miller, Ezra Pound and Ernest Hemingway, his solo exhibition in 1925 at the Galerie Pierre and afterwards joint events with the Surrealists (especially André Breton, Paul Eluard and Louis Aragon), such as his participa-

tion in the major Surrealist group exhibition 'La Peinture surréaliste', and finally the collaboration with Max Ernst on the stage sets for the ballet *Romeo and Juliet* under Serjei Diaghilev's aegis in 1926. He began to expand his colour areas. Objects became permeable and, stripped to their outlines, oscillated together rhythmically. Everywhere, lines acquired a hitherto unknown grace.

In the midst of this reshaping process, which I should like to paraphrase as *élévation*, Miró developed a figure typology that matched the new lightness. He first introduced it in 1924–25, in *Harlequin's Carnival* (illus. p. 45).[9] In this, the three principal protagonists, Harlequin, the singing guitar-player and the insectoid creature, appear to consist of tubular, vermiculate or aerated elements looking pumped up. Invented by Arp, biomorphism now made its confusing but delightful entry into Miró's work.

In the avant-garde art of the 1920s and 1930s, biomorphism involved an approach to design that first appeared in Arp's wood reliefs of 1915 and seemed to be shaped by the forces of natural life.[10] With the abundant, massive yet sinewy, constantly changing elements, associations with the unarticulated, shapeless and amoebic became possible, or even the spherical shapes of germination and embryos. All attempt at portrayal was now secondary. Everything was now only suggested and approximate. The latent potential for motion in biomorphic shapes led to the formation and re-organisation of organisms to the point of intentional 'liquefaction'.[11] The much older aesthetic

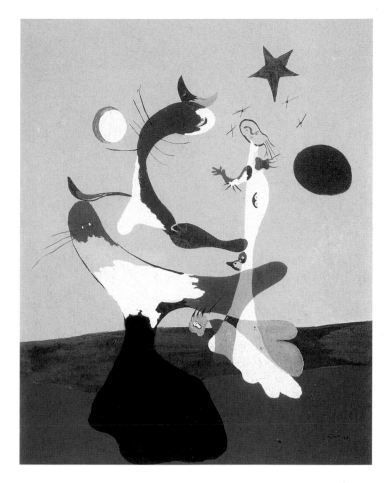

Fig. 3 Joan Miró, *Composition (Small Universe)*, **Composition (Petit univers)**, 1933, gouache on card, 39.5 × 31.5 cm, Fondation Beyeler, Riehen, Basle

concept of deformation is contained in modern biomorphism, if not subsumed in it. In terms of conceptual history, Miró's expressive and increasingly autonomous, distorted shapes belong to the realm of a general aesthetic of deformation that is characteristic of modernism. For Diderot, deformation was still a form of *laideur*, ugliness, and therefore the opposite of the normative and beautiful. In contrast, the Romantic writer Victor Hugo saw deformation, released from all obligations of rules, as a result of the 'grotesque': 'Le grotesque ... crée le difforme', he wrote in 1827 in his famous *Préface de Cromwell*. Hugo thus includes deformation in the Romantic antithesis of the grotesque, characteristic and individual on the one hand and sublime on the other. The Romantic writer sought to comprehend 'le réel', absolute reality, in these irreconcilable opposites, i.e. deformation becomes here indirectly an organon for experiencing the world. Miró's expressive deformations ultimately force us back to these Romantic roots. The other, no less future-influencing source of this reading of the deformation concept is the Symbolist Maurice Denis. For Denis, deformation was an ingredient of the formal act of design. For him, as creations of the spirit, visual works were based on its 'nouvel ordre classique' balanced between a 'déformation subjective' and a 'déformation objective.'[12]

That functional view of deformation as a vehicle of visual autonomy contains the germ of the modern form-related view of deformation. This is what Daniel-Henri Kahnweiler was talking about when he stressed that the Cubists had to distort the objects they were depicting to create compositions governed by their own rules. In acknowledging deformation as a positive aesthetic value in the renunciation of imitative representation, he was continuing Maurice Denis's train of thought.

The development of modern shape-related deformation, which in its content retains its Romantic roots in the grotesque and characteristic, was taken forward in respect of the human figure by Miró contemporarily with Picasso but also with Ives Tanguy, Masson and Salvador Dalí.

After *Harlequin's Carnival* we find invented biomorphic shapes in Miró that are formally more disciplined and as such come across as largely serene. An example is *'The happiness of loving my brunette'* (illus. p. 134). Here the maximum undulation, i.e. sentimentality, is bestowed upon the beloved. She leans head to head against her paramour, who with his bottle-like body and geometricised straddled stance manifests less 'biomorphic' undulation.

In the pencil drawing of *The Statue* (Fig. 2), which is adapted from a 1925 painting of the same name, Miró's biomorphism spills over into intentional comedy.[13] In this case, the artist is no longer content with an allusion in loop heads but depicts a statue-figure surrealistically brought to life and endowed with a moustache, nose and eye, who moves around in space and takes itself very seriously. Its right hand is outstretched invitingly to the viewer, and this and the immensely enlarged left foot give the figure a

Fig. 4 Joan Miró, *Woman*, **Femme**, 1934, pastel on velvet paper, 107 × 72 cm, Richard Zeisler Collection, New York

disproportionate, twisted look. The deformation draws life from the hollow pathos of a gesticulating statue rejoicing in a raised foot—a male one, of course, as can easily be seen from the leg hair. *The Statue* is deliberately placed in the corner of the square room so that its irregularity stands out.

In a thoughtful essay, William Rubin has put the New York picture in the context of contemporary works by Picasso: 'The massive right hand and left leg are examples of a type of distortion rooted in what may be called the "internal" image of the self: the way a part of the body *feels* as opposed to the way it looks. Such exaggeration would soon become central in Picasso's imagery, and it was, to be sure, in precisely the same year that Miró painted *The Statue* that Picasso's figures began to be radically distorted, although in a comparatively convulsive, expressionistic manner (as exemplified by his revolutionary *Three Dancers*).'[14]

Rubin's early identification of the hiatus depicted between the inner image of the self and the external, physical appearance that causes the deformation as such, needs stressing. It concerns not just the comparability of the works of Miró and Picasso but—more broadly—Surrealist attempts to express extreme emotions such as obsession, fear, rage and lust, by means of distortion and disproportionate figures.

The devices of distortion, destabilisation and disproportion used by Miró in *The Statue* were taken up by Dalí in an early Surrealist work, *Le Jeu lugubre*.[15]

Once again, it involves a statue coming to life in the background, on which a perverse desire is made evident by means of an immensely enlarged hand.

In the following years, Miró's organoid, distended figures became increasingly more abstract, as is evident, for example, in the *Portrait of Mrs Mills in 1759 (after Constable)* and its associated studies.[16] Occasionally Miró took Picasso's 'biomorphic structures'[17] as his point of departure. From 1927 up to the early 1930s a whole arsenal of bone-like figure inventions comes together. Miró for his part turns their metamorphic, insect-like fiendishness into something lighter and more cheerful. An extreme example of this is the series of airy, outline figures entitled *La Légende du Minotaure* (illus. p. 113), published in the December 1933 issue of *Minotaure*. Miró's collection of drawings brings nine scenes together. In them, the monster goes about his sexual desires uninhibited and with great variety until the unusual happy end is reached (bottom right) in the presence of sun, moon and stars. The same happy, cosmic connotation is stressed in a painted version of the Minotaur series called *Composition (Small Universe)* (Fig. 3). Everything here is radiant. The Minotaur holds up his young female victim clad in white, who does not seem in the least averse, triumphantly against the golden yellow sky over the blue sea.

Miró would seem to be cruelly driven out of this carefree world by the political events in his homeland. The artist was living in Barcelona when the autonomous left-wing government was forced to stand down in summer

Fig. 5 Pablo Picasso, *Woman in a Red Chair*, **Femme au fauteuil rouge**, 1932, oil on canvas, 130 × 97 cm, Musée National Picasso, Paris

Fig. 6 Joan Miró, *Head of a Man*, **Tête d'homme**, 1935, oil on card, 106 × 75 cm, Musée National d'Art Moderne, Centre Georges Pompidou, Paris

Fig. 7 Pablo Picasso, *Head of a Woman*, **Tête de femme**, 1932, bronze, 85 × 37 × 45.5 cm, Städelsches Kunstinstitut, Frankfurt

1933 by the revolts of the anarchists and the attempted coups of the army and the Guardia Civil. The country was overcome by terror. Churches were burnt down, and opposition figures arrested and murdered. In new elections in November 1933, the right-wing parties gained a majority. Various uprisings were the consequence. In October 1934, strikes broke out in the coal mines of Asturia. Catalan nationalists joined the rebels. The attempted revolution was brutally suppressed by Franco's troops, with more than 3,000 deaths and 30,000–40,000 thrown into prison. Brute force reigned in Barcelona. Like many of his fellow citizens, Miró was in a state of shock, and responded to the events with figures both subjected to violence and ready to inflict it. Nothing is secondhand in his pictures. As Miró himself said: 'Thinking about death led me to create monsters that both attracted and repelled me.'[18]

Indeed, in October 1934, Miró did 15 large-format pastels in which he captured monstrous creatures on flock paper. In the disconcerting juxtaposition of their 'lovely' coloration and repulsive physicality they appear to oscillate, torn to and fro between agility and brutality, impersonal intangibility and a menacing presence.

In a formal respect, Miró's monsters of hate and fear coincide with Picasso's 'biomorphic structures'. The closest comparison is between the 1934 pastel entitled *Woman* (Fig. 4) and Picasso's *Woman in a Red Chair* of 27 January 1932 (Fig. 5).

Even though Picasso adhered more closely to a definite syntax of spheres and bulges, which he had worked out for himself as a sculptor in Boisgeloup,[19] we encounter a similar parcelling up process in Miró as well, indeed a decomposition into individual body parts. Miró resorts to expression through symbols more strongly than Picasso. The monstrous vagina of the woman looks, for example, like an outsize loaf.[20]

In these works, which Miró himself called his 'wild pictures', heralded from 1933 in his 'drawings with collages' and pastels, the artist surprisingly incorporates grotesque figures developed in the round. This modelling of mass is unusual for him and underlines the menace of certain features of his apotropaic world of figures, such as the exaggerated organoid volumes, the aggressive sexuality and the emphasis on bones. All this is again reminiscent of Picasso.

The extent to which Miró was interested in Picasso's ongoing sculptural fantasy portraits—freely based on Marie-Thérèse Walter—is evident in *Head of a Man* (Fig. 6).[21] This was painted on 2 January 1935. If we compare it with a side view of Picasso's bronze *Head of a Woman* (Fig. 7), details such as the eyeball, the forehead, the shape of the nose and the contrasting part of the cheek suggest a knowledge of Picasso's third large-scale head sculpture (even if obtained via the first *Minotaure* issue of 1933).[22] Compared with Picasso, Miró intensifies the expressiveness of the head into a lurking, gnome-like physicality.

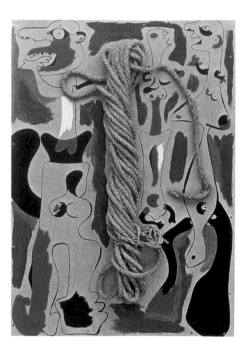

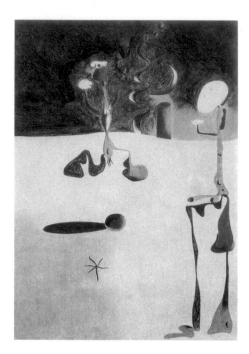

Fig. 8 Joan Miró, *Rope and Figures*, **Corde et personnages**, 1935, oil and rope on card on wood, 106 × 75 cm, The Museum of Modern Art, New York.

Fig. 9 Joan Miró, *Nocturne*, 1935, oil on copper, 42 × 30 cm, The Cleveland Museum of Art

Jacques Dupin remarks on this very strained phase of creation: 'It was no longer possible to be unaware of the deadly noose slowly tightening around the throat of mankind. Still, we may legitimately be surprised that, beginning as early as 1934, certain works of Miró were already bearing witness, not just to some vague malaise or anxiety (everyone felt this), but to a veritable panic terror, a recognition of the human tragedy in its most brutal, least bearable forms …'[23]

How Miró was able to intensify his 'wild' visual idiom in this time of trouble is evident from *Rope and Figures* (Fig. 8) dated March 1935. William Rubin and, in his wake, Hubertus Gassner have already discussed at length the picture in the context of the horrible torture methods used in the Spanish Civil War.[24] The rope as a crude symbol for strangulation and torture juxtaposed with three women and one man, speaks for itself. The writers justly draw attention to the latent aggression evident in the man. Violence is not just external but also innate, is what Miró appears to be saying. The convulsive figures look strife-torn in their physicality, and the composition blotched and crowded.

Miró attempted time and again to cope with 'tragedy in its most brutal form'. A separate sally in this direction was a group of six small oil paintings on copper and six tempera paintings on plywood (Masonite board) done between 23 October 1935 and 22 May 1936 — just a few days and weeks before the Spanish Civil War would break out, in July 1936, and Miró and his family would seek refuge in Paris. All works mentioned are imprinted with the reality

of the Catalan landscape and the terror he experienced. In *Nocturne* (Fig. 9), Miró develops strikingly fluid figures 'wasted to the bone' whose hideousness is reinforced by the exaggeration of the sexual organs — in slow, detailed work, as copper as a support requires — as if he wanted to exorcise them. Male and female are no longer able to come together even at night. Everyone is busy trying to avert the threatening evil. Just as social consorting appears disrupted, the colours appear jarring and as if poisoned.[25] In *Figures and Mountains* (*Personnages et montaignes*) the moving Earth appears to be repelling screaming monster people and atrophied animals everywhere.[26] Particularly in this picture, it becomes evident how his curious 'will-o'-the-wisps' anticipate the menacing scenario in Miró's chef d'oeuvre of the war years, *Still Life with Old Shoe* (Fig. 10) of January–May 1937. For the background of this outstanding picture, the following utterances by Miró seem informative: 'When the war came in July 1936, it forced me to interrupt my work, it thrust itself deep in my soul, what I had lost that summer and the necessity to find solid ground in realism came to light in Paris.'[27] From Paris, he told his art dealer Pierre Matisse in New York on 7 March 1937: 'The recent events have etched themselves deep in my soul, they were a hard and cutting lesson in matters of what it is to be human.'[28]

The *Still Life with Old Shoe*, which Miró worked on for five months as if possessed, passes on the 'hard and cutting lesson' to the viewer unedited: an apple (with a fork stuck in it), a bottle of gin, bread and an old shoe are exposed in an open field against an eerie sky shot through with flickering

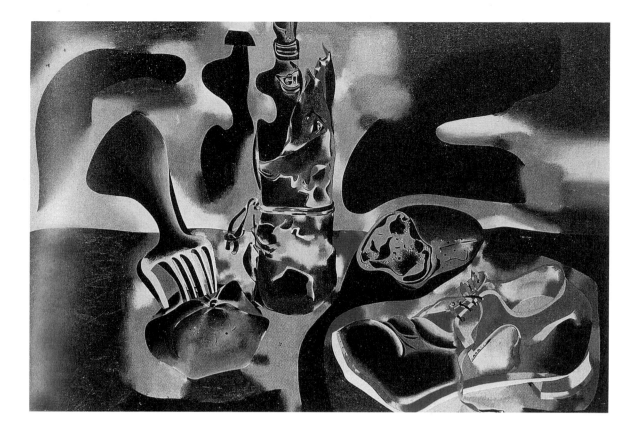

Fig. 10 Joan Miró, *Still Life with Old Shoe*, **Nature morte au vieux soulier**, 1937, oil on canvas, 81 × 116 cm, The Museum of Modern Art, New York

black shadows. They stand in the middle on bare earth as pars pro toto for the farmers, who put up the most stubborn resistance in the Spanish Civil War and suffered most. Although embraced by the menacing black shapes, each object appears in its vibrating individual coloration. Every object has an inherent radiant force and a striking inner dynamism.

The view that the simple folk of his homeland had a great innate potential for creation lies behind Miró's contemporary anti-war poster *Aidez l'Espagne* (Fig. 11). Miró here tries to emphasise its positiveness by means of a newly reinforced colour symbolism: the deep, pure blue, the saturated yellow and the few but unerringly placed spots of red, along with the balanced co-existence of black and white, combine to make a clear colour appeal of conviction and hope. The poster was distributed and sold by *Cahiers d'art*.[29] One franc per copy sold went to war victims. On the colour original, Miró wrote beneath the raised fist of the worker with the Catalan barretina: ' Dans la lutte actuelle, je vois du côté fasciste les forces périmées, de l'autre côté le peuple dont les immenses resources créatrices donneront à l'Espagne un élan qui étonnera le monde.'[30] (In the current struggle, I see the superannuated forces of the Fascist side, on the other side the people, whose immense creative resources will give Spain a vigour that will astonish the world.) This hope, grandiose in its desperate defiance, of a Spain one day revived in its creative potential that would redeem recent history, also informed Miró's official mural *The Reaper: Catalan Peasant in Revolt* (*El segador*, Fig. 12) made for the stairwell of the Spanish Republic's pavilion at the 1937 World Exhibition in Paris. The lost mural—regrettably,

as far as I know never reproduced in colour—was six metres wide and about eight metres high. In Paris, it was called *Le Faucheur* or *Paysan catalan en révolte*. Six celotex plates acted as a support. The picture showed a Catalan peasant *en révolte*, i.e. rebelling. Hubertus Gassner says of his appearance: 'With a face as chunky as a boulder, sharp teeth in a snarling mouth like a beast's, a knob-like phallic nose and projecting wispy beard, this peasant figure has all the physiognomic features of the monstrous figures in the pictures of the preceding years. Yet in contrast to the reserved reticence of those figures, this reaper looks quite extrovert and ready for action. Even the red barretina of the Catalan peasant is reproduced like a bent arm with clenched fist—the symbol of the Republic freedom fighters.'[31]

Both in its title and subject matter, Miró's painting alluded to the Catalan national anthem *The Reapers* (*Els segadors*) (as Hubertus Gassner briefly mentioned). The national anthem goes:

Catalunya, triumphant,
You will return to riches and greatness.
Behind these people
so worthy and so splendid.

A good swing of the hook!
A good swing of the hook, defenders of the land,
A good swing of the hook!

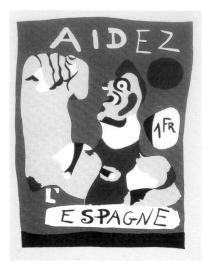

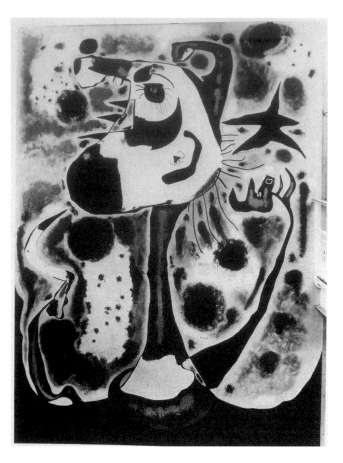

Fig. 11 Joan Miró, *Help Spain*, **Aidez l'Espagne**, 1937, poster, 25 × 19 cm,
Fundació Joan Miró, Barcelona

Fig. 12 Joan Miró, *The Reaper: Catalan Peasant in Revolt*,
Le Faucheur: Paysan catalan en révolte, 1937, oil on celotex, 550 × 365 cm (now lost)

Now's the hour, reapers,
now's the hour to be alert.
Come another June,
we'll whet our blades

A good swing of the hook ...

Let the foe tremble
to see our flag unfurl.
As we cut down the golden corn,
when it befits we'll cleave our chains.

A good swing of the hook[32]

Taking the Catalan national anthem as a whole, it is evident that Miró stuck faithfully to the text. With his arm raised in a classical accusative gesture, the half-length figure of the peasant towers in broad frontal view to monumental dimensions. His right hand holds the sickle. His appearance must strike fear, if the foe is to 'tremble'. The reaper is denouncing repression (or maybe urging 'Now's the time to be alert'?) and threatening (see second strophe) with the blade of the reaping hook, which is both his tool and weapon. He calls upon the cosmos to be his shield, as it were. Being astromantic, Miró marks the figure with his characteristic star, as if to say, the cosmos is on the side of the just, i.e. my fellow countrymen.[33]

With *The Reaper*—in 1937, it was displayed near Picasso's *Guernica*, Julio González's iron sculpture *Montserrat*, a peasant woman with a sickle (*sic*), and Alexander Calder's *Mercury* fountain—Miró's biomorphic deformation acquires an extreme political colouring. Under the pressure of the events of war, which made the artist almost sick with fear,[34] the denunciation of violence in his idiom comes through at its loudest and clearest. His resort to the Catalan national anthem also gives cause for thought. *The Reapers* was originally written as a historical romance after the peasant revolt of 1640 under Philip IV. Its present text was the work of Emili Guanyavents in 1891, and the musical setting was provided by Francesc Alió in 1892. Between 1931 and 1939, the anthem could be sung in Catalonia with various textual versions. It was banned by Franco until 1975, just like Catalan itself. In 1994, it was officially approved by statute as the Catalan national anthem. For almost 400 years, the song of the heroic reapers embodied the repeatedly and savagely curtailed endeavour of Miró's homeland to preserve its identity. The mural was thus part of a long-established tradition—in contrast to and as an appropriate complement of Picasso's *Guernica*, which was based on a recent war event.

The road from the sublimation and sexual playfulness of early biomorphic pictorial narratives to the historical partiality of his hypertrophic forms was marked out to Miró by the train of events. In this process, he remained consciously committed to his principle of realism. 'What matters,' he wrote on 18 December 1936 to Pierre Matisse, 'is the expression of the human spirit, the baring of his soul.'[35]

NOTES

1 *Joan Miró: Catalogue raisonné, Paintings*, ed. Jacques Dupin and Ariane Lelong-Mainaud, vol. I (Paris, 1999), no. 87, p. 78f.

2 See Hajo Düchtung, 'Das ist die Farbe meiner Träume: Zur Bedeutung der Farbe bei Miró', in *Joan Miró*, exh. cat. (Zurich: Kunsthaus, etc., 1986), pp. 91–102.

3 See Robert S. Lubar, 'Mirós katalanische Anfänge' in ibid., p. 26.

4 Ibid., p. 21.

5 Johann Wolfgang Goethe, *Wisdom and Experience*, trans. and ed. Hermann J. Wiegand (London, 1949), p. 94.

6 'Où allez-vous Miró?', conversation with Georges Duthuit, *Cahiers d'art*, no. 8–10 (1936); quoted from *Joan Miró: Selected Writings and Interviews*, ed. Margit Rowell (London, 1987), pp. 150–51.

7 Walter Erben, *Joan Miró* (Munich, 1959), pp. 21, 44.

8 In his commendable biography of Miró, Hubertus Gassner adds to the many interpretations of this picture the conjecture that in this portrait, which was so important in establishing Miró's style, the artist drew formally on a major work of Romanesque wall-painting in his homeland, namely the representation of the enthroned Pantocrator in the apse of San Clemente in Taüll (Tahull) dating from 1123. See Hubertus Gassner, *Joan Miró: Der magische Gärtner* (Cologne, 1994), p. 16ff. In conversation with Walter Haubrich during his great retrospective in Madrid in 1978, Miró said that, besides Monet, Renoir and Matisse, he was mainly influenced in his youth by the 'paintings in the Romanesque Museum in Barcelona, which he frequently visited'. See Walter Haubrich, 'Optimismus: Miró in Madrid', *Frankfurter Allgemeine Zeitung*, 6 May 1978.

9 See Dupin and Lelong-Mainaud (note 1), vol. 1, no. 115, p. 104f.

10 See Christa Lichtenstern, 'Biomorphism', in *The Dictionary of Art*, ed. Jane Turner, vol. IV (London, 1996), p. 74f.; idem, *Metamorphose in der Kunst des 19. und 20. Jahrhunderts*, vol. II: *Vom Mythos zum Prozessdenken, Ovid-Rezeption, Surrealistische Ästhetik, Verwandlungs-thematik der Nachkriegskunst* (Weinheim, 1992), p. 167ff. (in Part II, 'Metamorphose in Theorie und Praxis des Surrealismus', the chapter 'Metamorphose als Gestaltungsprinzip').

11 In his article about Miró that appeared in *Documents* in 1929, Michel Leiris had distinguished three phases in his friend's Surrealist work up to that date, classifying them under the broad titles of 'Metamorphosis', 1924–27; 'Void', 1925–27; and 'Liquefaction', from 1927. For more on this, see Gassner (note 8), p. 226ff. See also Christa Lichtenstern, 'Metamorphosemodelle bei Michel Leiris, Georges Bataille und Carl Einstein: Ekstase und Identifkationsproblem', in *Metamorphose*, ibid., pp. 126–32.

12 Maurice Denis, *Théories: Du Symbolisme au Classicisme* (Paris, 1912), chap. III.

13 See William Rubin's illuminating comments in *Miró in the Collection of the Museum of Modern Art*, ed. William Rubin, exh. cat. (New York: The Museum of Modern Art, 1973), p. 34.

14 Ibid.

15 See Karin von Maur, in *Salvador Dalí 1904–1989*, exh. cat. (Stuttgart: Staatsgalerie, 1989), Fig. 56, pp. 68–71. See also on this point Christa Lichtenstern, 'Zwischen Magie und Parodie: Zur Bedeutung der Statue bei Giorgio de Chirico und den Surrealisten', in *Jahresring 81–82: Jahrbuch für Kunst und Literatur* (Stuttgart, 1981), pp. 187–219, esp. p. 208ff. (for Dalí).

16 Rubin (note 13), p. 48ff.

17 For Picasso's biomorphic morphology, see Christa Lichtenstern (note 10), pp. 173–86. For Miró's *Légende du Minotaure* and the Surrealist re-interpretation of the Minotaur myth, see Lichtenstern (note 10), pp. 140–43. The concept of 'biomorphic construction' derives from Alfred Barr; see A.H. Barr, *Cubism and Abstract Art* (New York, 1966), p. 190.

18 Interview with Denys Chevalier, *Aujourd'hui: Art et architecture* (Nov. 1962); quoted from Rowell (note 6), p. 267.

19 See Christa Lichtenstern, *Picasso Tête de femme: Zwischen Klassik und Surrealismus* (Frankfurt: Städelsches Kunstinstitut und Städtische Galerie, 1980), pp. 6–72.

20 Another pastel drawing by Miró, *L'Homme à la pipe*, likewise recalls works by Picasso, notably his *Bathers* series of summer 1927 in Cannes. See Dupin and Lelong-Mainaud (note 1), vol. 2, no. 467, p. 111, and Christian Zervos, *Pablo Picasso, 1926–1932*, vol. 7: 1 (Paris, 1955), Fig. 104, p. 45.

21 Ibid., p. 60f.

22 See André Breton, 'Picasso dans son élément', *Minotaure* 1, no. 1 (1933): 3–29. Breton first presented Picasso's works in this essay, with excellent photos being supplied by Brassaï.

23 Jacques Dupin, *Joan Miró: Life and Work* (London, 1962), p. 264.

24 Rubin (note 13), p. 68; Gassner (note 8), p. 282f.

25 See Gassner's interpretation (note 8), p. 284. I am unable to comprehend the interpretation expressed by the author here. I can see neither a volcano nor a heap of excrement in *Nocturne*, though there is a menacing sphere in the middle of the picture, which throws a long shadow.

26 Dupin and Lelong-Mainaud (note 1), vol. 2, no. 509, p. 143.

27 Quoted from Gassner (note 8), p. 292.

28 Ibid.

29 *Cahiers d'art* 12, no. 4–5 (1937).

30 Illustrated in Rubin (note 13), p. 72.

31 Gassner (note 8), p. 287f.

32 I am grateful to Stephan von Wiese for the original text of the Catalan national anthem.

ELS SEGADORS
Catalunya, triomfant,
tornarà a ser rica i plena!
Endarrera aquesta gent
Tan ufana i tan superba!

Bon cop de falç!
Bon cop de falç, defensors de la terra
Bon cop de falç!

Ara és hora, segadors
Ara és hora d'estar alerta!
Per quan vingui un altre juny
Esmolem ben bé les eines!

Bon cop de falç ...

Que tremoli l'enemic
En veient la nostra ensenya
Com fem caure espigues d'or,
Quan convé seguem cadenes!

Bon cop de falç! ...

The author would like to acknowledge the help of Victor Sevillano, University of the Saarland, and Regina Hillert, who put me in touch with him. As a Catalan who has researched his country's recent history, he was able to provide invaluable information about the text of the anthem and its background.

33 Gassner's idea of 'poisoned heavenly bodies' is I think a misconception. See Gassner (note 8), p. 288. Such an interpretation seems to me justified neither by the heroic content of the anthem nor Miró's essentially positive use of the star metaphor.

34 Dupin (note 23), p. 356.

35 Quoted from Gassner (note 8), p. 291.

THE 'BARCELONA' SERIES
FIFTY LITHOGRAPHS, 1939–1944

From the early 1930s, prints were a major part of Miró's output beside the paintings, and the *Barcelona* suite was a first culmination in this medium. The series consists of 50 black-and-white sheets, which the artist drew on duplicator copying paper in Mont-roig in 1939 and had proofed and run off by Miralles in Barcelona in 1944 in an edition of only five copies. This work reflects like no other Miró's experiences in the Spanish Civil War of 1936.

The first major change in Miró's formal idiom, in 1934, was clearly a reaction to the unrest in his homeland, and is particularly notable in the large, now lost mural *The Reaper*. This picture was exhibited in the Spanish Pavilion at the 1937 World Exhibition in Paris, directly next to Picasso's *Guernica*. In contrast to Picasso's work, which is about the bombing of the Basque capital Guernica by General Franco's German allies, Miró's work does not represent an actual war scene. Miró depicts a peasant with a scythe, which is both an expression of his rural homeland in Catalonia and a symbol of the struggle for freedom. The selection of aggressive colours and the contorted figure make this peasant an apocalyptic figure, which reappears in Miró's *Aidez l'Espagne* (illus. p. 86), an appeal for support in *Cahiers d'art*, and on sheet 19 of the Barcelona series, recalling the arms of the Reaper raised in rebellion (illus. p. 86).

The whole *Barcelona* series of 1939 revives the 'wild' formal language of the series of paintings known as the 'monster pictures' (1934–38). The limbs of the figures are mutilated, deformed, contorted and reassembled by association and transposition. The crescent-shaped feet have no earthbound quality any more (sheet 16), arms are deprived of their hands or equipped with teeth (sheet 28), genitals appear to have lost their fertility and, together with eyes, may take the place of mouths (sheet 19). Because of these metaphorical displacements and the dark, smoke-like blobs that constantly recur in the sheets, the figures look both disjointed and injured as well as aggressive. Owing to the graphic style and the—untypical—renunciation of coloration, Miró's stock of symbols in the *Barcelona* series powerfully evokes the atrocities of war.

Yet we can also discern the changes in Miró that resulted from the years of exile in France. His preoccupation with constellations (see the eponymous series of paintings) gave rise in his work to clear forms and balanced compositions, to a veritable cosmos of erotic symbolism. In the *Barcelona* series, it is likewise a cosmos he conceives. The disparate grotesque figures are no longer isolated; they are surrounded by stellar symbols (sheet 23). In his pictures Miró confers a new, comprehensive dimension on the terrors of war.

Heidi Irmer

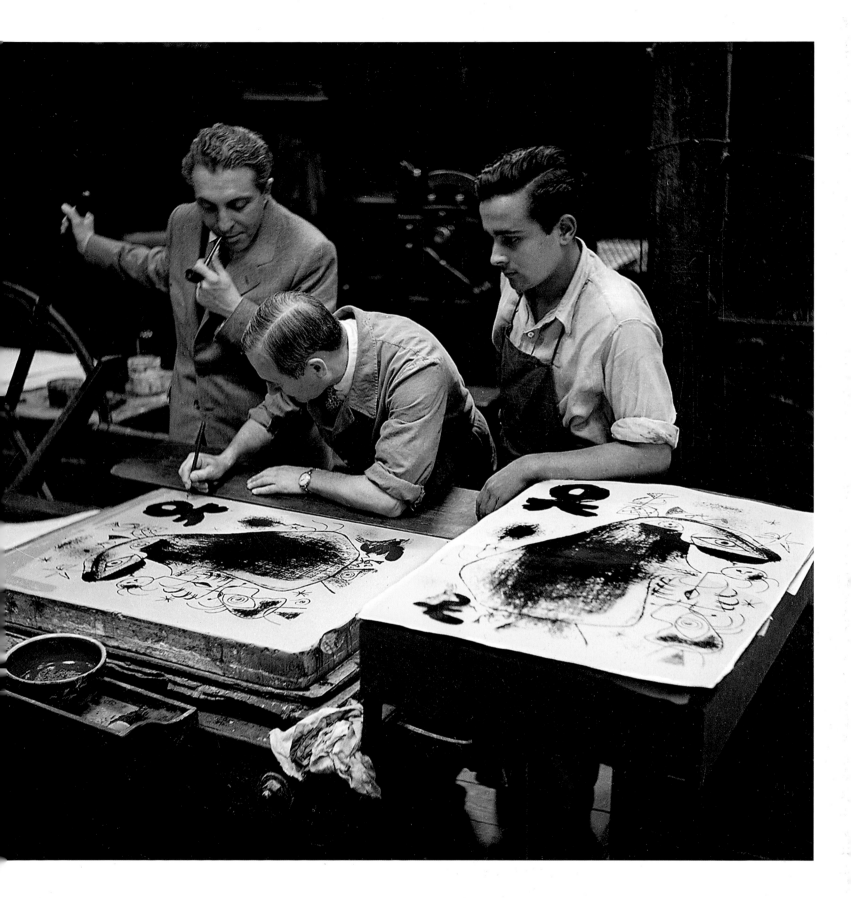

Miralles's workshop, Barcelona, 1944

Printing the *Barcelona* series of lithographs: (from left to right) Joan Prats, Joan Miró and Miralles

1

3

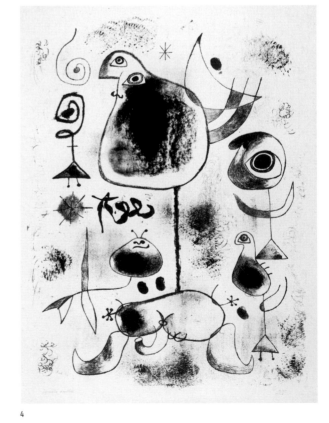

4

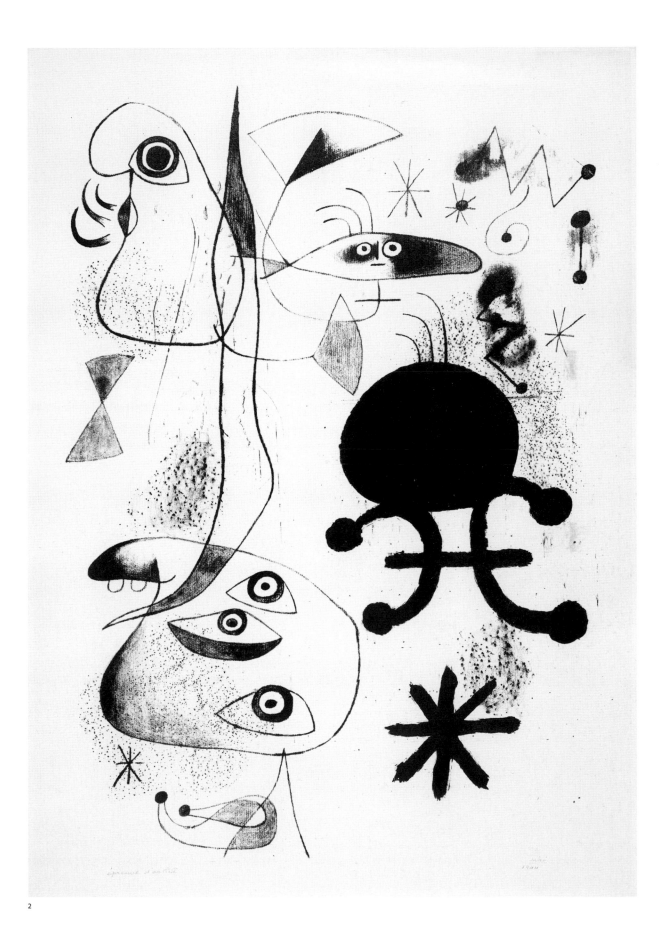

2

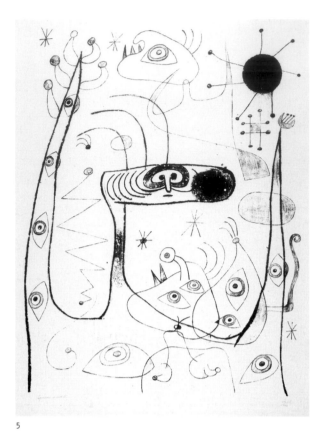

5

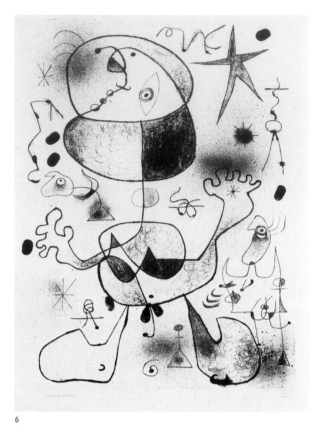

6

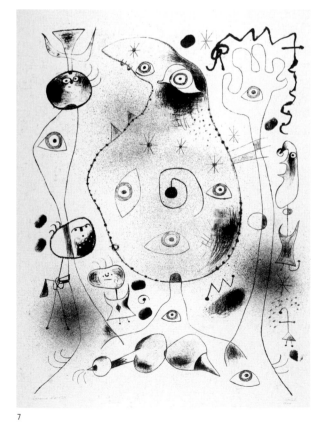

7

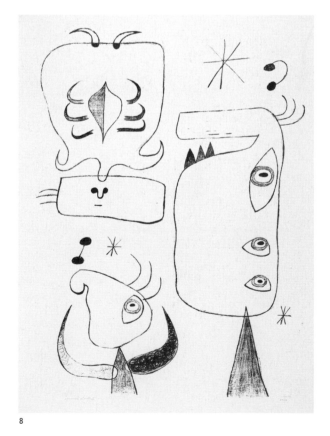

8

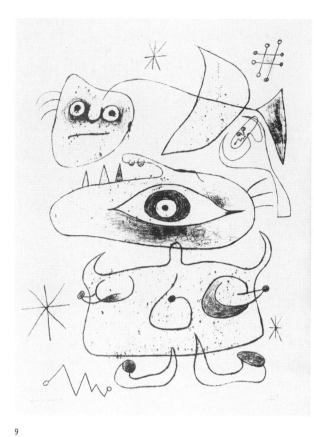

9

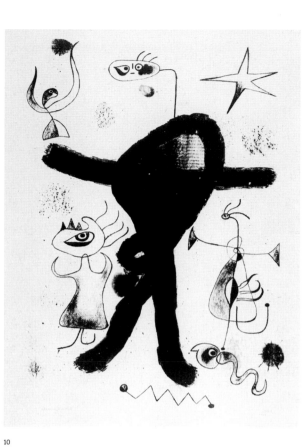

10

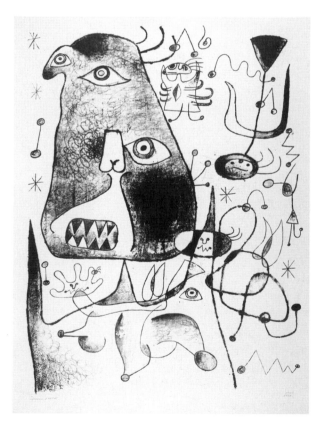

11

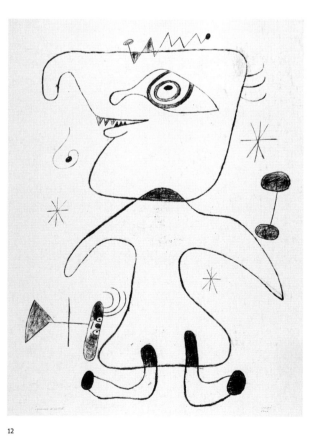

12

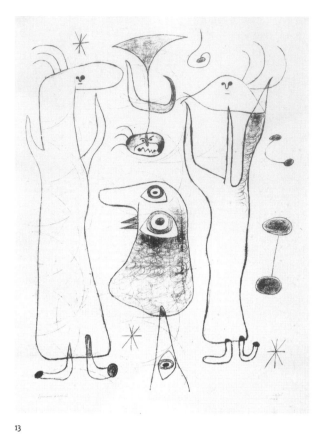

13

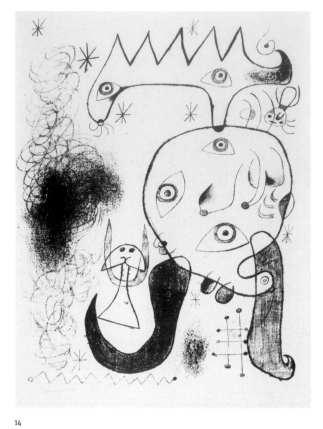

14

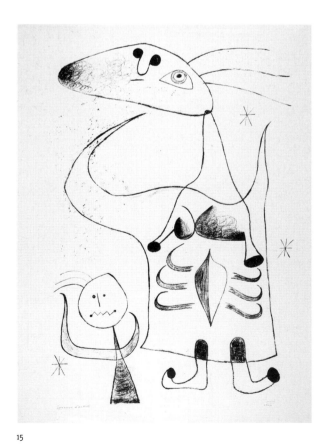

15

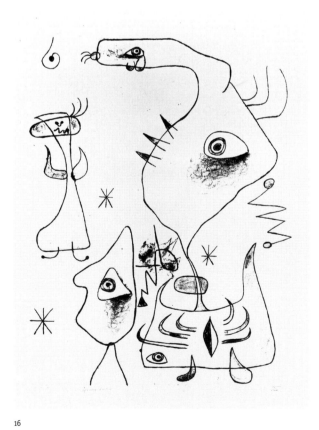

16

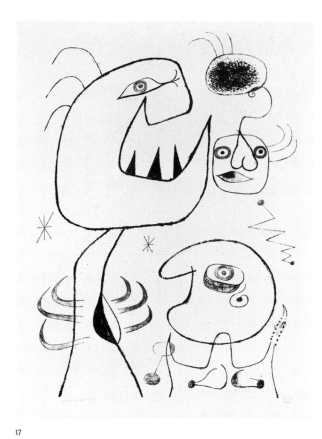

17

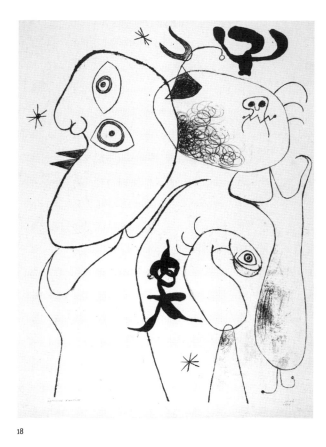

18

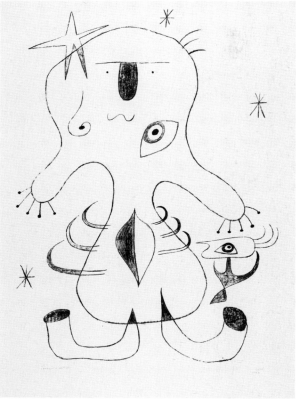

20

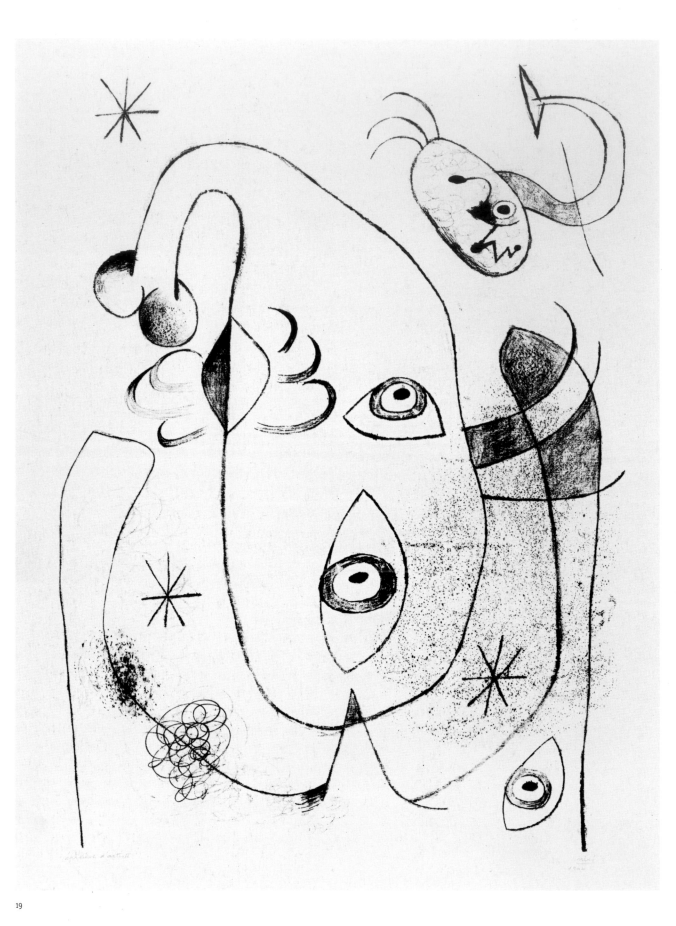

19

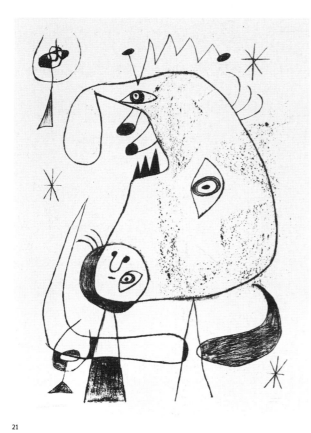

21

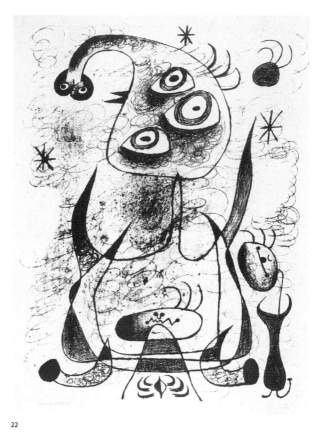

22

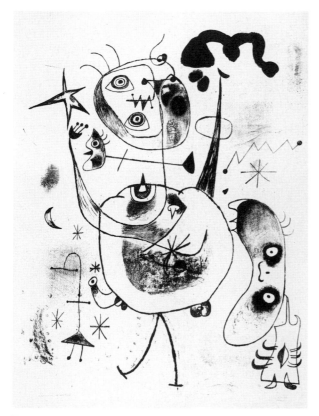

23

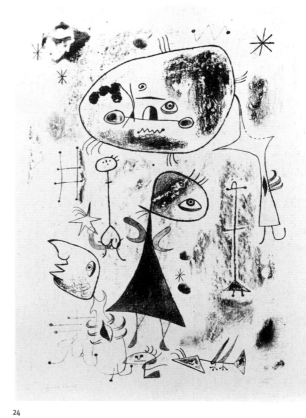

24

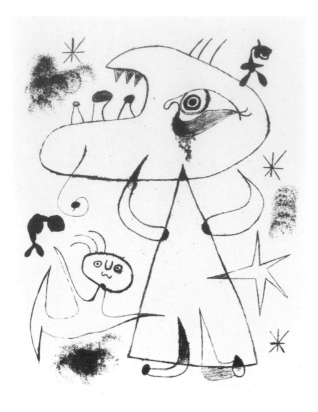

25

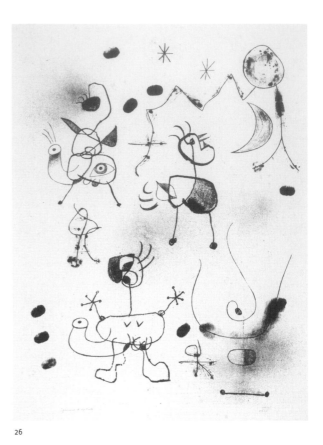

26

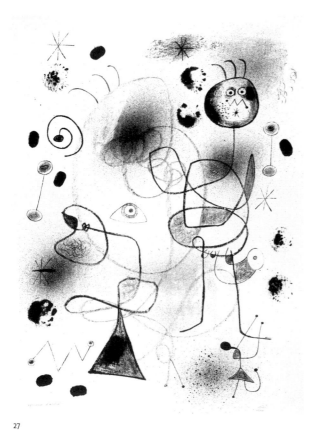

27

28

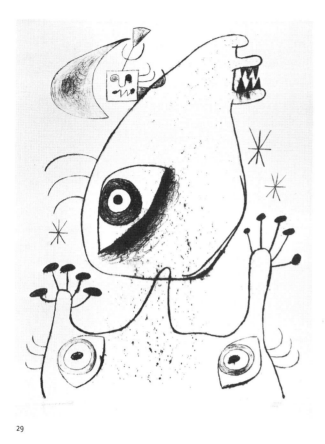

29

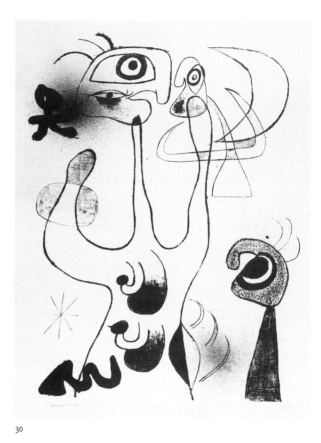

30

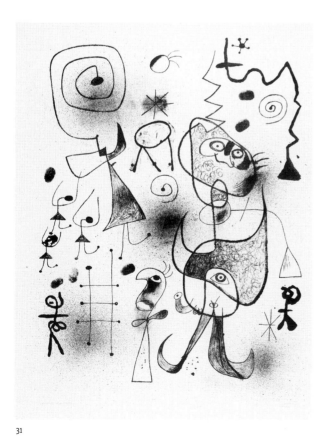

31

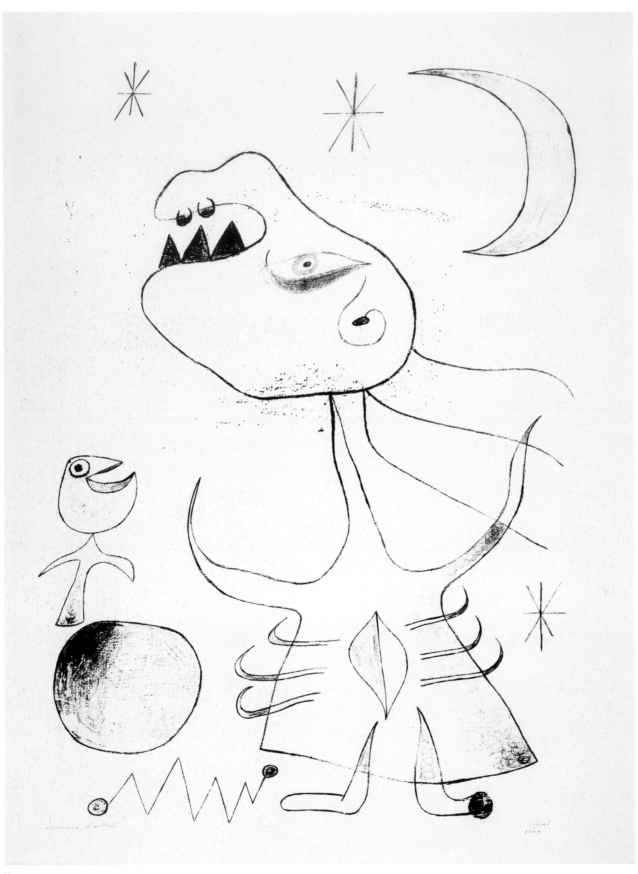

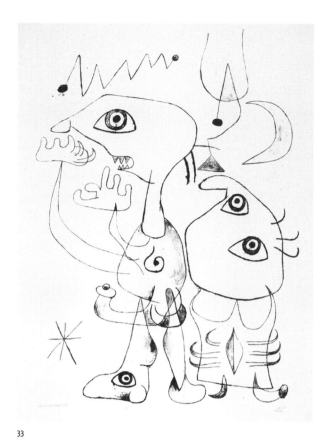

33

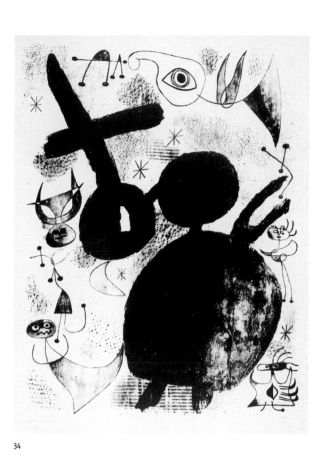

34

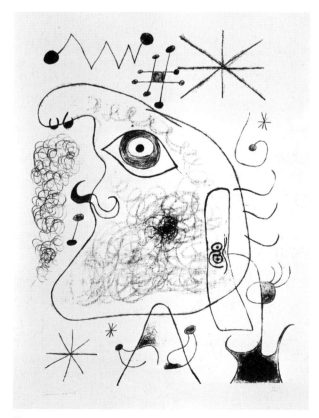

35

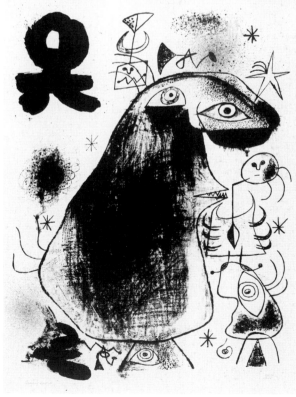

36

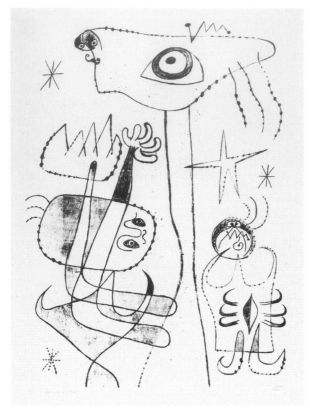

37

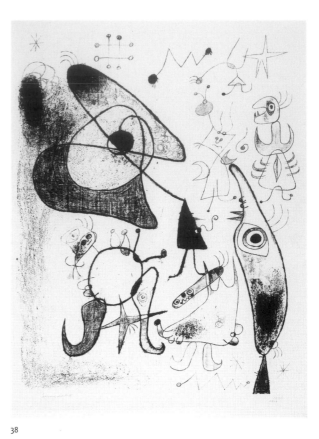

38

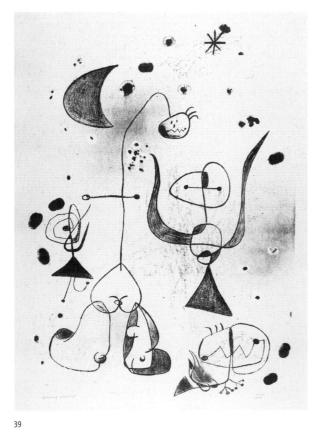

39

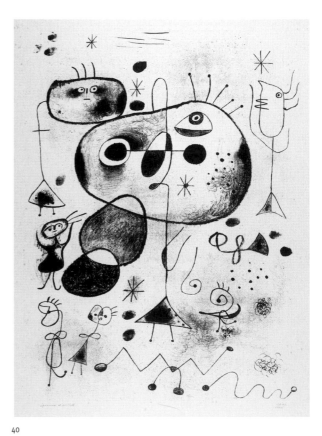

40

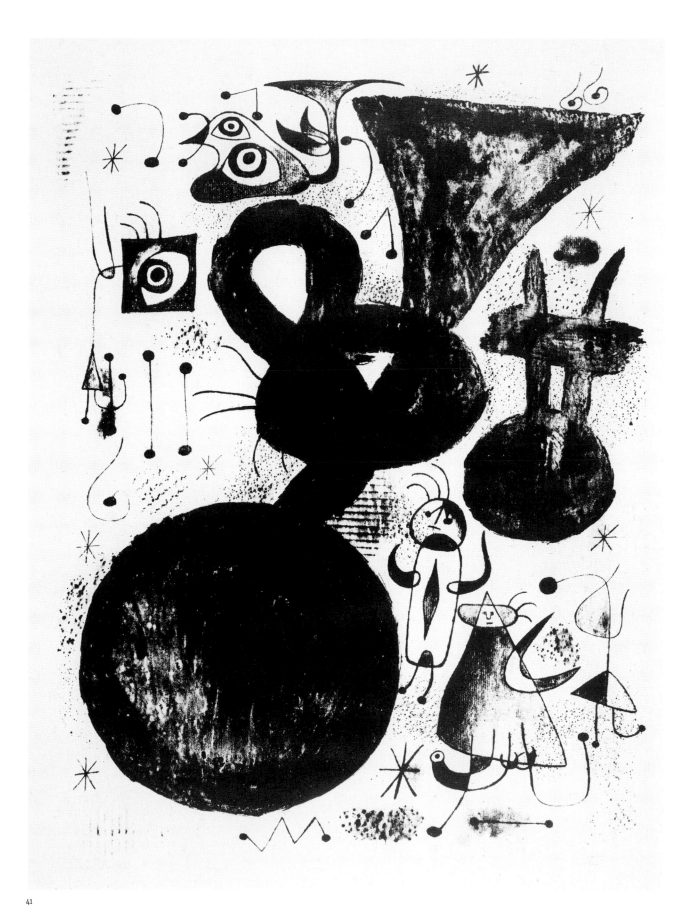

41

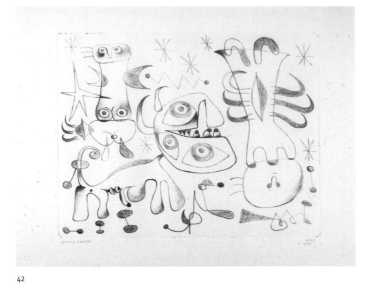

42

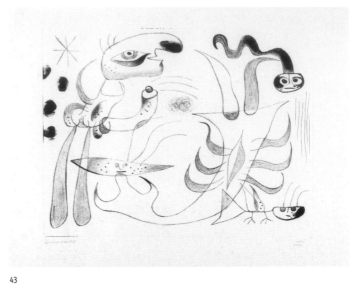

43

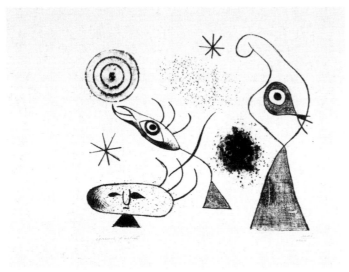

44

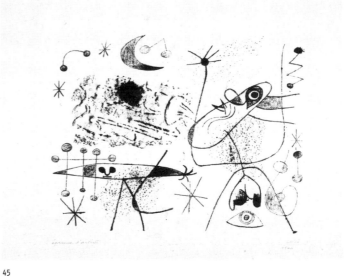

45

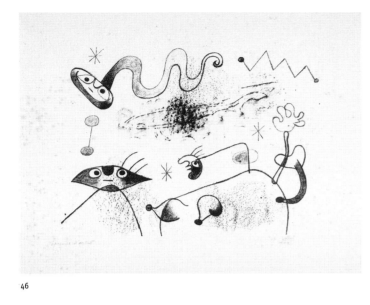

46

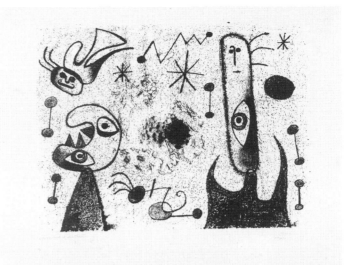

47

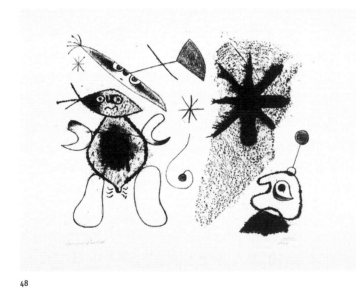

48

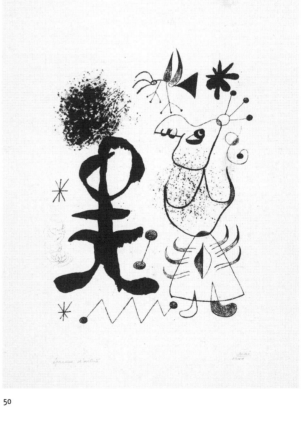

50

49

ANTJE VON GRAEVENITZ

A LABYRINTH BY JOAN MIRÓ

Like many traditional concepts, labyrinths were subjected to new interpretations in the 20th century. Miró, for example, altered it in both form and function. He enables those who venture into the labyrinth to answer an old question—namely, where's the exit?—in a new way.

Many people who stand and look at Miró's pictures are reminded of mazes, seeing droll cosmic figures in them and all kinds of weird and wonderful creatures. As no light source or firm terrain underfoot 'fixes' the settings of figures in his pictures, it is difficult to specify an 'environment' in which they exist. Their setting is often just a patch of colour or an approximated space. Before long, the notion of dreams inevitably surfaces, evoked by similar arrangements of colourful motifs in typical Surrealist visions from 1923/24 onwards. But as every picture in Miró's oeuvre offers an apparently different constellation to lead you astray, it is not much help to say simply that his stock of motifs is Surrealistic. Associations and attempts at narration are likely to be more helpful in charting the way out of Miró's painted mazes.

At first it was quite easy. One of the artist's landscapes of 1917 is stylised, but it at least features a realistically rendered track leading through the Spanish hills (illus. p. 124). By 1926, in Miró's *Landscape* (illus. p. 139), for example, such references to reality are completely absent. Here, three areas of colour combine to form an abstract landscape, while a ladder sketched in with a few strokes—and leading appropriately upwards—links the three areas. The ladder here is a kind of vertical path that would seem to lead into the

Fig. 1 Sketch for *Labyrinth*, 1965

open air. The viewer can cope with concepts of this sort. The painting '*Snail woman flower star*' of 1934 (illus. p. 177), on the other hand, is quite a different matter, even though the title suggests figures in a landscape. You start hunting, only to find faces, breasts and ossiform limbs, single eyes and an elongated hand with outspread fingers, which seems to come towards you like a path. Miró wrote four words into his picture in florid script, ensuring our confusion. Do the 'escargot femme fleur étoile' relate to the figures surrounding them, or do they indicate invisible figures that have been omitted and left to our imaginations? Who was asking? Henceforth, labyrinthine features were no longer a novelty to any viewers of Miró's pictures. Admittedly, the term 'labyrinthine' is just shorthand for the difficulty of making sense of the pictures. It's not a big step from there to the idea of a 'magic garden full of symbols'.[1]

A painting by the artist titled *Labyrinth* plain and simple would seem not to exist. Miró apparently reserved this title for the specially designed sculpture garden he created, which he indeed called *Le Labyrinthe*.

Yet although the 'labyrinth' in the garden of the Fondation Maeght in Saint-Paul-de-Vence on the Côte d'Azur dating from 1962–64 is among the greatest sculptural ensembles by Miró—it was an idea first developed in the war years of 1944–45—it has rarely been illustrated. Some authors mention it in passing, Julien Clay, Roland Penrose and Jean-Louis Prat being the exceptions.[2] Even in monographs focusing on Miró's sculptural work, the *Labyrinth* is largely ignored.[3] Whether it was appropriate to dismiss this sculptural ensemble

tacitly as an artistic byway remains to be seen. The first question is how to interpret the individual six figures of the labyrinth as well as the work as a whole, both symbolically and practically.

Miró's *Labyrinth*, located in the garden of the private museum designed for the Fondation Maeght by architect Josep Lluís Sert, was officially opened in 1964 by the client—collector and art dealer Aimé Maeght (1906–1981) and his wife Marguerite Devaye. Low walls of undressed, light-coloured rubble —like the stone walls one sees in the Spanish, French and English countryside—mark off the separate areas of the park. Between these walls, winding this way and that across the slope of the hill on which the Fondation Maeght stands between pines looking out to the Mediterranean, Miró laid out a few steps and small terraces to create a varied experience for the visitor wandering round the park. When in the park, you are surrounded by walls, but you can see over the walls to other parts of it and to other sculptures. This circumstance lends credence to a first thesis: the labyrinth is apparently supposed to be experienced as both individual sculptural works and as an overall concept. This thesis suggests what to do next: first, examine the individual works in the labyrinth, and only then ponder on a possible overarching concept for the whole, like a journey through the labyrinth.

The design involved three stages: around 1963–64 Miró envisaged just a few figures on a single path, which he then had laid out like the Stations of the Cross. A published plan from 1965 is even marked with arrows, which

Fig. 2 Joan Miró, *Stag Beetle*, **Cerf-volant**, 1963, ceramic, 360 × 120 cm, Fondation Maeght, Saint-Paul-de-Vence

Fig. 3 Joan Miró, *Salamander*, **Le Lézard**, 1963, ceramic, height 270 cm, Fondation Maeght, Saint-Paul-de-Vence

clearly show the earlier concept of a route through a labyrinth (Fig. 1).[4] This plan is the decisive, tangible evidence of Miró's concept of a fixed itinerary through the labyrinth and is the point of departure for this analysis. A further argument in support of the labyrinth plan is that in 1933 and 1944 Miró had drawn the first figures and agreed on a joint scheme with potter Josep Llorens Artigas. The collaboration was expanded in 1953 to include the latter's son Joan Gardy Artigas. In 1963, Miró acknowledged the dual author-ship of all joint pottery works exhibited that year in the Galerie Maeght in Paris. Both artists signed 'Miró-Artigas'. When the labyrinth opened in Saint-Paul-de-Vence, on 28 July 1964, the collaboration of the trio was once again made explicit.[5] Their first step was to make eight small maquettes of the planned arch along with flat models made from cardboard, to test the effect on the spot.[6]

By the time Miró died, in 1983, other figures had been incorporated into the garden in a second phase of development, in some cases with the first figures being moved around to other locations. Julien Clay has already given an account of the first additions made.[7]

In a third and final phase, the museum administration itself rearranged the figures. Some original works were brought indoors to protect them from weathering, while a second reason for change was that the labyrinth was now seen solely as a collection of arbitrarily assembled pictorial figures in a beautifully designed park. In support of this view, the museum cites Miró's

treatment of the sculpture garden in its second phase of development, when the artist introduced further works. Visitors could enter the garden wherever they liked, and a set sequence was now inconceivable.[8] Even so, Jean-Louis Prat's view is challenged here because Miró clearly called his work at the Fondation Maeght *Le Labyrinthe*. This argument is supported by the afore-mentioned plan and Miró's first sculptural studies of 1933, illustrated in *Minotaure*,[9] and around 1944 (now in the Fundació Joan Miró, Barcelona).

Our subject will thus not be the 'labyrinthine' in general, which would include the second and third creative phases, but exclusively the 'labyrinth' from the years of planning and the first phase of implementation, from 1944 to 1964.[10]

THE ITINERARY

The path from the museum leads into the park. The threshold phase begins. The first of the six figures is a flat relief fixed to the museum wall immediately beside the door to the park. Titled *Stag Beetle* (Fig. 2), it crawls, as it were, diagonally up the wall. In the inner part of the crackled, gaily dappled plaque you find at the top a faceless human figure with a yellow and red head and a tenuously delineated body consisting of long black lines.[11] The figure of a giant-sized insect or possibly a dragon (dragonfly?) is striving upwards. It resembles the human being. Opposite it—on a wall of the low library building that encloses the park at the side—the *Salamander* (Fig. 3) crawls up a natural stone wall. It does not in fact look like a salamander at all, any more than the stag beetle resembles a beetle. It looks much more

Fig. 4 Joan Miró, *Arch*, **L'Arc**, 1963, concrete,
580 × 615 × 215 cm, Fondation Maeght,
Saint-Paul-de-Vence

like some special kind of grey worm rearing up in the middle and presenting the viewer a smiling face consisting of dots, a comma and a line, like in a child's drawing, though its actual head would seem to be the two stumps of arms further up, which appear to be waving to the viewer. This creature also seems related to the human being. Miró's fingerprints lend the grey skin a distinctive character.

The visitor now leaves the area with the two creatures and moves on between the low walls to a kind of gateway—the *Arch* (Fig. 4).[12] Because of the bulges on it—and despite the light-coloured cement used to build it—the work looks less like a piece of architecture than an organic entity that might have been shaped out of clay, like a piece of African or Indian architectural sculpture. With its pointed projections at the side and the ossiform or crescent-shaped protuberance and a single breast shape with a hollow nipple on the transverse piece on top, the 'arch' looks more like a composite creature—half animal, half woman. On the right support, an engraved star can be seen beside a long snake and an inlaid red stone evoking a heavenly body. The other support is likewise decorated on the side and back, with brightly coloured stones and a blue marble shard.

The path now leads on via a short flight of steps to a brownish, lead-coloured egg that has its own domain, standing upright in a pond. This *Egg* (Fig. 5) is adorned with stars, snakes and an eclipsed sun. Near it is the *Goddess* (Fig. 6), resembling an upside down bell. The downward-pointing, stumpy arms make

it appear both dramatic and helpless. In the middle of the belly, a white shell-like leaf issues from a vaginal cavity as if being born. Between the protruding buttocks of the monstrous goddess, Miró painted a black dot in a black circle, recalling an anus or a blind eye.

Whereas the figures mentioned so far were made of painted ceramics, the next figure is of wrought and sectioned iron. Additional steps between the walls now lead to the lofty *Pitchfork* (Fig. 7). Its oversize base runs conically upwards, on which small bulges—like small heaps of clay applied by hand—produce a childlike, simple decorative effect. At the top sits a triangular plaque, the underside of which is rounded off into an arc and the centre of which is pierced with a large circle, which is in turn surmounted by the pitchfork. This is suspended above the arc like a large feather. In fact, the end of its handle could be taken for the upper part of a beak and the circular hole for the eye of a bird, as if a lapwing were sporting an outsize crest on its head. Miró placed this flat-topped iron figure on the extreme edge of the wall against the backdrop of a panorama of distant hills. Its outline acts as a sort of repoussoir figure against the soft landscape behind it.

THE LABYRINTH

The ensemble tends to create a cheerful, fairy-tale impression in which the figures in a story of creepy-crawlies, birds and women or a goddess, egg and stars are suggestively presented. What do these figures have to do with a labyrinth? And what could Miró have understood thereby?

Fig. 5 Joan Miró, *Egg*, **L'Œuf**, 1963, ceramic, 180 × 135 cm, Fondation Maeght, Saint-Paul-de-Vence

Fig. 6 Joan Miró, *Goddess*, **Déesse**, 1963, ceramic, 157 × 115 cm, Fondation Maeght, Saint-Paul-de-Vence

The labyrinth is part of classical mythology associated with the age-old question of how humans become human. The modernist equivalent is: how do they become free—intrepid, responsible people who have themselves under control? In the Greek myth, Theseus showed how it is done. He set off into the labyrinth where the Minotaur lurked, a powerful, irascible, raging monster with the head of a bull. The hero threaded his way through the maze of passages, found the demon and vanquished it. Having accomplished this, he was able to retrace his steps through the labyrinth on account of Ariadne's ball of thread that he had taken with him and unravelled as he walked through its tortuous passageways.

Numerous versions of the myth exist. The construction of classical and post-classical labyrinths is not always the same, but the basic principle adheres to the notion of the developing personality. The hero needs courage to control his own untamed nature, and he can do this only with the strength of his memory. Ariadne's clew stands for this abstract human ability. Early representations of labyrinths inscribed in rock walls and on Cretan silver coins show a pattern that twists and turns in on itself like a thread. Structure and myth thus coincide. As Hermann Kern showed in his comprehensive book about labyrinths, it was initially a metaphor for an initiation ritual or rite of passage. Man is put to tests that he must pass if he wishes to assert himself later in life.[13] There are psycho-logical as well as social reasons for the necessity of such rites of passage. Only someone who is spiritually sound can take on duties in society as a responsible fellow human—that is at least the principle and purpose of a rite of passage.[14]

'Rite of passage' is a term denoting a process that is both physical and mental. As a labyrinth, the body is a threshold phase for the soul. As a maxim at the beginning of his book, Kern writes:

In a labyrinth, one does not lose oneself
In a labyrinth, one finds oneself
In a labyrinth, one does not encounter the Minotaur
In a labyrinth, one encounters oneself.[15]

According to Victor Turner, 'liminality is frequently likened to death, to being in the womb, to invisibility, to darkness, to bisexuality, to the wilderness, and to an eclipse of the sun or moon. Liminal entities, such as neophytes in initiation or puberty rites, may be represented as possessing nothing.... Their behaviour is normally passive or humble.... It is as though they are being reduced or ground down to a uniform condition to be fashioned anew and endowed with additional powers to enable them to cope with their new station in life.'[16] Some scepticism is in order here. After all, Theseus had to overcome his fear and find a way into the unknown, pressing forward or turning back whenever he encountered a blind alley, so as ultimately to defeat the Minotaur, the demon within. A labyrinth therefore demands that action be taken.

Freud's call to man was likewise for him to control his libido (the Id) through his Ego by getting to know his driving compulsions, especially his frustrations, and learning how to accept them actively by giving his imagination free

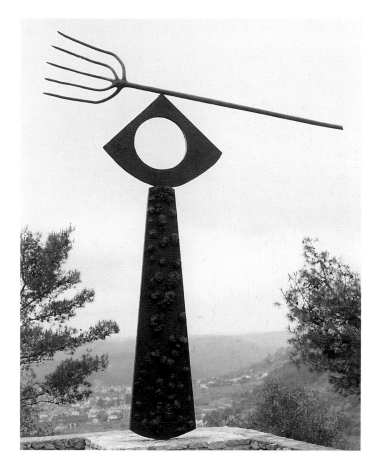

Fig. 7 Joan Miró, *The Pitchfork*, **La Fourche**, 1963, iron and bronze, 507 × 455 × 9 cm
Fondation Maeght, Saint-Paul-de-Vence

rein.[17] The Surrealists, including Miró, picked up on this notion, making it one of their central concepts. Their hope was founded on the idea that it would be viewers who would become familiar with suppressed desires by exercising their fantasies (even if these washed over them like a maze of images), whether in dreams, hallucinations or creative imaginings. They would thereby learn to handle them openly and freely, and thus could live henceforth as free, creative human beings. Their principal theoretician, André Breton, proclaimed this maxim in his first Surrealist manifesto (1924), and the artists and writers around him adhered to it.[18] Yet not all the Surrealists adopted the old motif of the maze, i.e. circuitous paths between hedges or walls containing countless dead ends. Some preferred to invent other kinds of mazes or tortuous paths in the form of associations, unusual combinations of objects—surrealist objects or *poème-objets*—or seren-dipities.[19] The aim remained nonetheless the same, whether the metamor-phosis of the hero in the labyrinth of antiquity, or the transformation of the patient on the couch into a spiritually sound being, or the mutation of the viewer into an imaginative, creative (and therefore free) person at the sight of art depicting surreal scenes. To make this ideal explicit, Breton gave the finest Surrealist periodical of the 1930s, to which Miró also contributed with the first arch sketches for his later labyrinth, the apt name of *Minotaure*.[20]

What then did Miró, who was among the wider circle of younger Surrealists, think of these traditions and models? He called dreams 'counter-worlds'. When asked in 1926 whether his intention was to emphasise his 'taste for

the marvelous ... that issues directly from reality', he replied: 'Absolutely.... I painted without premeditation, as if under the influence of a dream. I com-bined reality and mystery in a space that had been set free.... I was no longer subjected to dream-dictation, I created my dreams through my paint-ings.... I escaped into the absolute of nature. I wanted my spots to seem open to the magnetic appeal of the void, to make themselves available to it.'[21] Even his name had something to do with this. In Spanish *miro* is a form of the verb 'to see', whereas in colloquial French it means 'blind'.[22] Thus Miró's very name contains both light and darkness. In an earlier statement of 1957, he had asked: 'Is it not the essential self in the mysterious light that emanates from the secret source of one's creative work—the thing that finally becomes the whole man? His true reality is there. It is a deeper, more ironical reality, indifferent to the one before our eyes; and yet it is the same reality. It need only be illuminated from below, by the light of a star.'[23]

Miró quickly found a sympathetic viewer in Ernest Hemingway, who not only purchased an early work—*The Farm* (illus. p. 125)—but wrote about it as well, characteristically seeing it as an odyssey or maze. This prompted him to compare the work with James Joyce's novel *Ulysses*, and he was struck by the temporal coincidence of the two works.[24] Could Miró have remembered this when he installed his labyrinth at the Fondation Maeght in 1962–64? He certainly drew on much earlier works, not just in method but also for individual motifs. What then was this method and what opportunities were available to him that seemed appropriate to a labyrinth?

STRATEGY OF ASSOCIATION

First, he used a landscaped garden in which he was able to construct a kind of maze, following the old tradition. Then he installed mythical figures that, like the Minotaur demon of antiquity, have timeless significance for human existence, such as birds, goddesses and eggs. Finally, and most importantly, he built on the force of poetic allusion, which always runs contrary to rational readability. Instead of a 'painting *poème*' (James Sweeney), he also relied on the 'sculpture *poème*', which promises spiritual and mental rewards in the joy of association and the benefits of insight gained if multiple meanings are interpreted by means of association. Fun is thereby transformed into earnest. Only in associations does the actual metamorphosis of ideas and thoughts take place. They derive their power largely from metaphors, which as the Roman orator Quintilian noted are based on the art of *translatio*,[25] translating the finest elements of speech because they are so refreshing and radiant, shedding light of their own and adding to the wealth of expression. They render language that 'most difficult of services, i.e. nothing appears to lack its name', because where there is no expression for something, metaphors are used instead, bringing several realities together. The language of poetry is a coded, visual language, particularly where it has emblematic character, and can be read only by someone who knows how to make use of Ariadne's thread: remembered images, multiple meanings from earlier times, such as myths, legends, sagas and fairy tales, dreams, visual material from prehistory and ethnic peoples or in folk art—which for Miró meant mainly Catalan folk art—everyday utensils, and South Sea masks.[26] Miró was especially drawn

to a 10th/11th-century Gobelin in Girona Cathedral, depicting scenes from the Apocalypse, whose grotesques, especially the rotund beetle with eight legs and a vaginal slit on its back, took his fancy.[27] 'As you can see,' said Miró in 1936, 'I give greater and greater importance to the materials I use in my work. A rich and vigorous material seems necessary to me in order to give the viewer that smack in the face that must happen before reflection intervenes. In this way, poetry is expressed through a plastic medium, and it speaks its own language.'[28] The place, myths and power of association of ancient sources provide the visitor to the labyrinth with ample material for a wealth of blind alleys, out of which only Ariadne's thread can guide him. Miró himself conjured up this thread.

Miró had written about his painting *Harlequin* of 1924–25 (illus. p. 45) a semi-automatic sounding text in 1939 that, in the form of associations, muses about the origin of hallucinations. He thereby drew attention to the value of phantasmagoria, which Odile Redon had already attempted to depict in the 1880s: 'the ball of yarn unraveled by cats dressed up as smoky harlequins twisting around inside me and stabbing my gut during the period of my great hunger that gave birth to the hallucinations recorded in this painting beautiful bloomings of fish in a poppy field marked down on the snow-white page shuddering like a bird's throat against the sex of a woman in the form of a spider.'[29] It is all there: the ball of thread, the bird that touches the spider, which resembles the soft sex, i.e. terms from Miró's arsenal of a secret pictorial codes, which Miró called 'magic' when writing about this picture in 1978:

Fig. 8 Joan Miró, *Labyrinth*, Fondation Maeght, Saint-Paul-de-Vence

Fig. 9 *Minotaure*, no. 3–4 (1933)

'I was trying to capture the magic side of things'.[30] Once you have learnt to read Miró's pictorial language, you can find the way out of the labyrinth of his associative symbols, on the basis of memory and recognition. Do visitors to the park make such connections?

THE STATIONS

If we return to the adventure playground of the soul at the Foundation Maeght that is supposed to liberate the visitor, it is not the great arch that forms the intended start but an area of two 'lower' creatures, the *Stag Beetle* (Fig. 2) and the *Salamander* (Fig. 3), which both appear to address the human in the animal (of the sculptural image) and the animal in the human visitor to the park, as if the equation is to be discovered here and the usual biological hierarchy set aside. Thus prepared, the visitor now proceeds to the arch as the signal for entry (Fig. 8). From a distance it looks like a bull, such as Miró had already painted in his picture *Pastorale* of 1923–24 (illus. p. 126), an almost childlike simplification of form with a thick rump and huge crescent-shaped horns. This bull thus has nothing at all of a dangerous Minotaur about it but, stands trustingly in an otherwise rather dreamlike landscape of grotesques. An abstract version of the bull first appears in a picture dated 1933 and on the earlier-mentioned page of his drawings for issue no. 3–4 of *Minotaure*, which came out the same year (Fig. 9). On that page, Miró evolved a bull made up of three large bones, or elongated cell shapes, which he transformed into an arch and furnished with female and male genitals. The sketched bull's head has horns like those eventually created for the park, but

here they are (logically enough) still connected to a head. In addition there is a series of symbols with amusing variations, such as the bull/man grotesque and a corresponding female grotesque apparently erotically communicating over the lintel.[31]

In *The Bull Fight* of 1945, the bull looks rather like a bloated cell-like arch with the crescent moon of its horns.[32] In ancient Spain, the cult of the bull had had many meanings, which were lent expression in religious rituals. The animal was connected with the cult of the moon in northern Spain, where a matriarchy held sway, as José Maria Blasquez has shown.[33] Erich Neumann even reminds us of a hymn to the moon god of Ur, in which its androgynous nature is described:

Powerful young bull with thick horns,
perfect limbs, with azure beard,
full of strength and opulence.
Fruit engendered of itself, of high stature,
marvellous to look at, with whose opulence no man's gaze can be sated,
womb, universal progenitor who holds a radiant seat among living creatures.[34]

The arch in the labyrinth resembles all kinds of contorted biomorphic cell shapes from pictures of the 1930s. At this time, Miró was kept in Barcelona during the Spanish crisis and subsequent civil war of 1937. His experience of this period was shocking and terrifying.[35] He was plagued by nightmares.[36]

Possibly as a result of these experiences, during this period he developed variants of motifs that he later used for the labyrinth ensemble. Amoebic bodies with female and male genitalia reveal an androgynous world that appears to be proliferating, developing and changing in the mythical sense, such that the macrocosm of the stellar evolution coincides with microcosmic organs. In the gouache painting *The Lovers* of 1935,[37] Miró presents a cell form that likewise possesses both female and male genitalia and is turning into an animal or bird head. A male figure with a pointed nose 'sniffs' at the posterior of the androgynous principal figure. The much later *Arch* (Fig. 4) also contains something in the way of female characteristics, a star, an outstretched bone (which also looks like a crescent moon) and the suggestion of a bird head at the side.

It is not surprising, given his experiences of 1937, that Miró returned to these motifs during the war years of 1944/45 and in a sketchbook steered straight for the figures of the labyrinth. He seemed to be looking for a counter-image in the myth—how could one spiritually escape chaos and horror? Where was a way out? Miró designed this arch on sheet 7, no. 4, of his sketchbook of the time, on 20 September 1944, added the title *Personnage avec un oiseau* and wrote beneath the date 'terra refractaria extra' (extra unruly earth).[38] The lintel was shown this time quite clearly as a broadly grinning face, a typical grotesque, a monster through which the visitor would have to pass. The shape is scarcely reminiscent of a bird.[39] In the final version of 1963, the left eye mutated into a female breast. Miró made small and large maquettes of this arch in 1962–63. At first he had considered a daintier arch, with stumpy arms at the sides and breasts applied in the middle of the lintel and an indistinct figure crouching at the side that was to be linked with the female arch. A second model would have possessed a horizontal vaginal slit in the middle of the lintel, with the breasts to right and left looking like cheeks.[40] From a distance, a phallic nasal bung above the slit would have given the arch a face. This variant was also rejected. In the end, Miró opted for a more indefinite biomorphic face with ceramic incisions and coloured particles right and left on the leg-like supports.

The bone-like open crescent underscores the associations conjured up by the arch. It evokes images of night, death and desire.[41] It acts like a symbol with prophetic meaning, for the bone-like moon looms almost as if in a memorial. Could this be the moon announcing the apocalypse, a sign of eternal repetition of the cycle of growth and decay? The crescent moon is also reminiscent of a scythe, a symbol of harvest, life and death. Miró identified himself with this symbol. In a conversation of 1959, he declared: 'My nature is tragic and taciturn.... When I was young, I went through periods of profound sadness. I am rather stable now, but everything disgusts me: life strikes me as absurd. This has nothing to do with reason; I feel it inside me; I am a pessimist. I always think that everything is going to turn out badly. If there is something humorous in my paintings, it's not that I have consciously looked for it. Perhaps this humor comes from a need to escape the tragic side of my temperament. It's a reaction, but an involuntary one.'[42]

Miró had already intended a major role for the moon in his picture *Motherhood* (Fig. 10), in which he ascribed to the dark half moon an allegorical meaning as the planet Mars. Mars is the god of division, battle and war. For alchemists, division does not have merely a negative meaning, it also includes the separation of incompatible things in a dark, painful process intended to bring about positive effects. According to Gassner, who interpreted the picture in detail, Miró was influenced here by the writings of the mystic Jakob Böhme—*De signatura, or Of the Birth and Description of All Creatures*.[43] Böhme maintained that the moon is, in contrast to the sun, part of the 'primordial dualism' that governs the 'unequal pair of stars' sun and moon, Venus and Mars.

In his arch, Miró drew on ancient ideas of an initiate entering another world, as was proclaimed on the gateway at Mycenae[44] and such as Constantin Brancusi also used in 1935–37 in the *Gateway of the Kiss*, which was incorporated into one of the stages of his great ensemble for the small Romanian town of Tirgu Jiu.[45] There Brancusi also united male and female figures in close embrace in scratched drawings on the architrave and in the symbols of the fusion of the sexes and the eyes on the jambs. The arch or gateway is an ancient motif signifying transition.

Thus attuned to the symbols of the sexual, cosmic world and the meaning of time, the visitor to the park can press on in Miró's labyrinth to the great *Egg* (Fig. 5), which stands in a basin on a small plateau as if waiting for him. On the lead-grey egg Miró painted the symbols of light and darkness, adding the colour of the sky with a blue glazed spot. This mythical egg incorporates the origin of the world. If you add the reflection in the water, substance is here united with the ephemeral and intangible. Appearance and reality then coincide. Miró had already united the determinate with the indeterminate in a clay version including his crescent lunar bird. In this overall view, he contributed more to the motif of the egg than his predecessors Max Ernst or Brancusi, who likewise viewed the egg as a universal motif. In Salvador Dalí's picture *The Metamorphosis of Narcissus* of 1937,[46] a flower even grows out of the egg, such as nature never allowed for. Botany and zoology fuse in the other world into which Narcissus dreams himself. For Dalí, Narcissus will change from the egg into this flower.

In Miró's labyrinth, however, a link must still be established between the egg and the already explored arch. Here the egg could be taken as a symbol of rebirth after the arch had brought us into a new world in which man and woman, life and death and now also light and darkness originate from the same source. Alchemistically speaking, it incorporates with its leaden hue the symbolic colour of Saturn, who stands for the creative spirit, light and darkness. Miró's *Egg* is also furnished with the sign of the solar eclipse. Miró had already fashioned ceramic eggs in 1958 onto which he scratched signs recalling prehistoric rock drawings, for example an animal with a spiralling tail, a symbol of a snake, sperm or even a labyrinth. The egg contains the message 'everything is in everything'. This corresponds to the Platonic notion of *eidos*, which encompasses the natural and mental world of ideas in nuce.

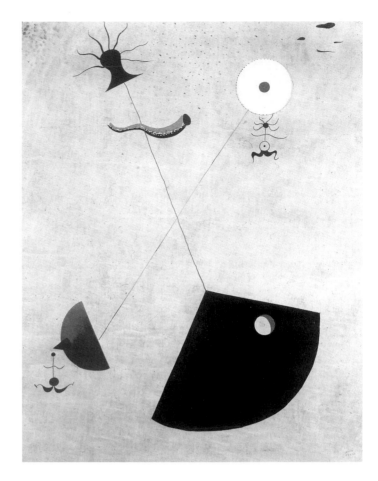

Fig. 10 Joan Miró, *Motherhood*, **Maternité**, 1924, oil on canvas, 92 × 73 cm
The National Gallery of Scotland, Edinburgh

Not far from the mythical egg, the labyrinth initiate encounters Miró's *Goddess* (Fig. 11). This appears to be giving birth to the egg, since her roughly bell-shaped belly displays an eruptively open vagina, from which a large shell-shaped ribbed leaf hangs. Here the organic and vegetable worlds come together, as Dalí had also imagined. Yet Miró had already painted a leaf on a vase in 1922–23, called *Flowers and Butterfly*—once again showing a round body with part of a plant. The picture was painted when Miró first became interested in alchemistic theory among the Surrealists in the rue Blomet in Paris. Miró transformed the once simple vase decoration on his goddess in the labyrinth in a mythical, alchemistic way that is quite astonishing. Incidentally he had already roughly conceived the figure in 1942 in a watercolour (with the aid of chalk) titled *Figure, Bird, Star*, and two years later reduced it in numerous outline sketches.[47] In 1945, he incorporated it into the picture *Dancer Listening to the Organ in a Gothic Cathedral (Danseuse entendant jouer de l'orgue ans une cathédrale gothique)*, and in 1956 made yet another version, but this time as a sculpture.[48]

Alchemists designate a woman as *vas*, a vessel for natural and mental processes of all kinds that will lead the alchemistically minded philosopher to the philosopher's stone. Miró's goddess is strikingly similar to the alchemistic concept. He reduces her head to a phallic knob, similarly the stumpy arms at the side, as if she were derived from Greek amphorae of around 1000 BC, which likewise depict female figures.[49] In his book *The Great Mother* (1957) Jung's pupil Erich Neumann, whom I mentioned earlier, likewise discusses

the vessel nature of women and describes the symbolism associated with it: 'This central symbol is the *vessel*. From the very beginning down to the latest stages of development we find this archetypal symbol as essence of the feminine. The basic symbolic equation woman = body = vessel corresponds to what is perhaps mankind's—man's as well as woman's—most elementary experience of the Feminine.'[50] The principal features are the mouth, breast and womb. Whether or not Miró was familiar with this book, according to Gassner he embraced Böhme's alchemistic ideas. If we accept Gassner's explanations of Böhme's symbolic theories, then Miró's goddess must be a representation of Dione, the mother of Venus, from whom everything issues. According to Böhme, all things 'come from One Mother, and separate into two beings after birth. The desire of Venus goes into the Sun and receives the quality of the Sun in her desire and shines out of the Sun; she has refulgence above all planets and stars which she derives from her Mother, and in her power is her joy, as the laughter that she has within her.... She is the true daughter of the Sun, ... and therefore lies at first below the Sun.'[51] If Miró adopted this notion, he would have wanted to depict the mother of Venus, this mother of beauty and love, and therefore art, too. Forerunners of the labyrinth goddess in his oeuvre are a painted goddess of around 1938 (*Groupe de personnages*), sketches from the war years and terracotta goddesses from 1944–49. In the labyrinth, however, Miró expanded the mother symbol of the *vas* by means of the leaf hanging out of the maw-like vulva like a tongue, which reinterpreted the female element as a universal creativity. Translated, this would be: The *arbor philosophorum*, the philosopher's tree,

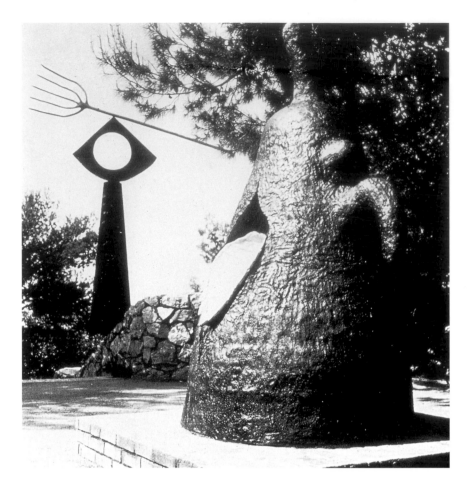

Fig. 11 Joan Miró, *Labyrinth*, Fondation Maeght, Saint-Paul-de-Vence

grows from the female principle. He had already painted a woman with a triangular neck in 1938 (*Portrait IV*) and depicted in her middle section a white leaf issuing from her vulva.[52] It is reminiscent of the alchemistic colour of purity for beginning and end. Like the egg, the goddess would thus also embody an unbroken circle.

Miró had already painted *Motherhood* in 1924, a picture which according to Gassner depicts the female body as a cosmic entity.[53] Miró himself told Werner Schmalenbach: 'For me, that is what I call woman, not a female creature, it is a universe.'[54]

From the 1930s on, the allegory of femaleness, the maternal, the erotic and the beautiful was worshipped by many artists in sculptural idols—despite having previously, as the archetypal avant-garde, vehemently defended themselves against traditions of glorification in Church, state and culture. Aristide Maillol, Henri Laurens, Jean Arp, Henry Moore and many others are notable examples of this. Figures of the opulent, massive and maternal woman epitomised for most of them salvation and may have been employed to discourage the general enthusiasm for war.

This objective is once again made clear by Miró's largest sculpture in the labyrinth, with which he concluded its programme as it was then, in 1964. I say concluded, but this can have been the case only formally. In terms of content, it was not in the least intended so. With the handle, the round hole

in a quarter of a circle and the feather-like form of the pitchfork, a bird was supposed to be evoked, whereby the viewer would see the hole as the eye, the handle as the upper outline of the beak and the tines as a headdress. Two early drawings from the aforementioned sketchbook of 1944, both titled *Personnage et oiseau*, show how Miró still placed the pitchfork next to, but detached from, the bird's body, so that we can regard the later positioning of the pitchfork on the head of the woman-bird as a true enhancement of the motif.[55]

Miró invented his motif of an eyehole in a highly abstract and isolated facial field back in the 1920s. The hollow space and eye symbol thus combine to make a single figure. Together, they allude to the Creation and to visual knowledge. In his picture *Ploughed Earth* of 1923–24 (illus. p. 59), the artist inserted an eye into the crown of a tree, whereas in the *Catalan Landscape (The Hunter)* of the same year (illus. p. 127) trunk and eye are just placed side by side. As Miró already showed in his early work *Motherhood*, he regards the quarter of a circle with a hole in it as a female body, which is furnished with a vulva in the painting. According to this view, the bird eye and vulva would coincide in the labyrinth. Woman and bird would produce a male-female love figure like in Brancusi's kissing arch. In alchemy, social salvation is expected to ensue from the union of the two sexes in an androgynous being. In this utopia, all battles of the sexes are dissolved. But Miró is not content with just uniting man and woman in a common body. The man appears in Miró's works only as a bird, a creature of spatial freedom; the connection is

woman and bird, as the male is already represented by the animal, according to Surrealist custom.[56] In addition, the small, regular bulges made of iron on the bottom section of the figure lead the viewer to believe that it is the trunk of a gnarled plane tree. The 'bird' would thus sit in a tree. It also seems possible that Miró was quoting the similarly regularly arranged burls (as derivatives of thick screw heads) on the doors of the Romanesque church of Sant Pan de Camps in Barcelona's old city and therefore viewed the *Pitchfork* as an exit into the open air.[57] Together, both associations make quite adequate sense of it.

The viewer participates in the utopia of the union of the sexes (*androgyne*) in the labyrinth quite specifically for the first time, in literally being able to see through the eye of the bird into the actual expanse of space. He can thus feel like a bird, in accordance with a first strategy. He can also by association see the eye of the bird as the woman's vulva and become familiar with his own gaze in it as he himself becomes creative, in accordance with a second strategy. Penrose also presented possible associations based on the circle of the eye as an empty shape: 'There is no more evocative trap for catching space than a circular hole such as that in the triangular head of the *Fork*. Wherever it occurs, although essentially no more than a void, the empty circle becomes filled with associations that vary according to its position either as a source of light or as darkness. It may equally be an eye, a mouth, the sun, an empty bottomless well or a crater of a volcano. Its ambiguity is matched by that of a cave and convex surfaces: the convex surface of an eggshell encloses emptiness or the swelling germination of life; but by adding atmospheric colour and sign of movement, Miró can give it the transparent depth of the sky before dawn.'[58] Summing up, Prat saw the work as an exit, like a window into the universe, with the pitchfork holding the sky between its tines.[59] One could put forward a further thesis: on reaching the bird, the initiate finds his way out of the labyrinth into a space with an expansive vista and also into the space of his invisible interior. The bird eye makes him the hero, occupying the role of Theseus.

Miró later repeated the eye, but this time as a dark, sinister hole, in an aquatint etching *Star of the Labyrinth*.[60] The most important feature is that the hole is like a labyrinthine spiral here. Particularly in the function of the bird Miró sticks to the Surrealist maxim: the extraneous Freudian mentor must be abandoned in order for the viewer to become master of his own soul through art. The Freudian concept of happiness achieved through exercising the imagination was thus passed on to the viewer, who was to assert his own claim to be an artist. It is understandable therefore that Miró puts this giant bird woman on a tall plinth—this was after all the quintessence of the Surrealist road to salvation, which he had meaningfully employed in the empirical path of the labyrinth.

AN EXIT FOR THE EYES AND THE IMAGINATION
For the Surrealists, the bird was a symbol of soaring and freedom. Yet none of them had attained such a comprehensive formulation of it as Miró did in the labyrinth at the Fondation Maeght, as the viewer here is not only eye to

eye with the bird but is able to give birth to new imaginings through it. The bird in *Pitchfork* takes the viewer with it into the far realm of his own soul. 'What counts is to bare our soul,' said Miró in conversation with Georges Duthuit in 1936.[61] The actual hole in the female body/head of the bird thus proves to be a vacuum, an epiphany for the future imagination.

Stag Beetle, Salamander, Arch, Egg, Goddess and *Pitchfork* are the stations of a labyrinth in which the viewer finds what is needed to acquire knowledge of the world and his role in it. Miró may have been inspired in this by another Spaniard, the 17th-century playwright Pedro Calderón de la Barca, who wrote about the great theatre of the world ('El gran theatro del Mundo', 1645) and labyrinths ('El laberinto del Mundo' and 'El gran mercado del Mundo') in his *Auto sacramentales*, first published in 1677.[62] Wanderings in the maze of the spiritual labyrinth were likewise seen by Calderón as exercises leading to self-knowledge. The Mexican poet Octavio Paz, who was close to the Surrealists for a while and met Breton in Mexico City in 1930, wrote a book titled *El laberinto de la soledad* (*The Labyrinth of Solitude*) in 1950. Though Miró may have demanded a process of solitary, quiet association from each of his visitors to the labyrinth, he will scarcely have shared the critical view of Paz, who accused his fellow countrymen of holding a nihilist view and said all Mexicans hid behind masks and suspected everyone else because they suspected themselves.

Despair and fear of madness, the actual Dionysian element in the labyrinthine archetype, were suggested in Miró's work not just by the bull and its ossiform crescent-shaped horns, but also by the snake of darkness that could emerge from the egg and the dark maw of the divine vulva. His secret language is coded, never direct and therefore not alarming. Even so, the visitor to the park —as an incarnation of Theseus—must seek a path through the sculptural, symbolic and practical functions by means of the associative possibilities of emblematic clues until he has discovered Ariadne's thread in the form of childlike, mythical motifs. Only then will he be able to find his way out into freedom.

NOTES

1 Hubertus Gassner, 'Ein Zaubergarten voller Zeichen', in *Miró: Später Rebell*, ed. Evelyn Benesch and Ingried Brugger (Vienna: Kunstforum; Wolfratshausen, 2001), pp. 59–79; Gassner does not discuss the labyrinth at the Fondation Maeght.

2 Julien Clay, 'Miró à Saint-Paul de Vence, un haut lieu de l'art moderne', *XXe siècle*, special issue, 'Hommage á Joan Miró' (1972): 65–70; Roland Penrose, *Miró* (London, 1970), pp. 159–60; Jean-Louis Prat, 'Le labyrinthe des reves', in *Joan Miró: Métamorphoses des formes, Collections de la Fondation Maeght*, exh. cat (Saint-Paul-de-Vence, 2001), pp. 9–15, 180–84.

3 See Jacques Dupin, Francesc Català-Roca and Joan Prats, *Joan Miró escultor* (Barcelona, 1972); Alain Jouffroy and Joan Teixidor, *Miró: Sculpture* (Paris, 1973); Teresa Marti, librarian of the Fundació Joan Miró in Barcelona, and curator Teresa Montané confirmed that a monographic study devoted to the labyrinth at the Fondation Maeght in Saint-Paul-de-Vence has not yet been undertaken. In the catalogues on the subject of the sculptural works, the labyrinth is not mentioned, probably because it could not be included in the exhibitions. (Exhibitions devoted to Miró's sculpture include: Walker Art Center, Minneapolis, 1971; Paris, 1974; New York, 1975; Paris, 1978; Granada, 1978; Prato, 1979; Saint-Paul-de-Vence, 1979; St. Pierre, 1979; New York, 1980; Milan, 1981; London, 1981; Karlsruhe, 1983; New York, 1984.) The same applies to the catalogue accompanying the exhibition held at the Fondation Maeght titled 'Sculptures de Miró', with texts by Joan Teixidor and David Sylvester (Saint-Paul-de-Vence, 1973).

4 With a short text by François Wehrlin, without explanations or interpretations, *Derrière le Miroir*, no. 155 (Dec. 1965); cited in *Fondation Maeght—Inauguration* (France, 1965). The year before, the periodical had published the ground plan of the park without the arrows but with a very suggestive statement by Miró about his Tal Coat mosaics: 'On y voit la lumière de la terre et du ciel captée, regner libre à travers ces lignes du ciel ces chemien d'homme.' See Henri Maldiney, 'La Fondation Maeght à Saint-Paul', *Derrière le Miroir*, no. 148 (July 1964): 51–52.

5 See the conversation between Miró and Artigas in Rosamond Bernier, *Joan Miró: Paintings, Gouaches, Sobreteixims, Sculpture, Etchings*, exh. cat. (New York: Pierre Matisse Gallery, 1973).

6 An old photo of around 1962 shows *Déesse* and *L'Arc*; see Prat (note 2), p. 12. In a conversation with the author on 10 April 2001, J.-L. Prat said that there were possibly even more cardboard models. In a letter to the author dated 5 March 2001, Prat also wrote that no other documents existed in the museum concerning the background of the work or correspondence available between Miró and Sert or A. Maeght. Prat was of the opinion that Miró had never made any statements about it. He said Sert had conceived the idea of the labyrinth with the low walls and presented them to the client, Miró's role being solely to fit it out. There does not appear to be any source for this. Was there no discussion between Sert and Miró about how the walled areas should be divided up?

7 Clay (note 2) mentions *Gargouille* (1964), *Personnage* (1972), *Femme à la chevelure défaite* (1963), a model of *l'oiseau lunaire* (executed 1968), *oiseau solaire* (1968), the flat ceramic circular mosaic *cadran solaire* (1968), three small masks for it (1968) for gargoyles and a second *Personnage* (1970). A *Oiseau* (1968) of cast iron was originally envisaged for one corner of the tall tower, but was later brought inside by the museum administration. Miró wanted to make a bronze of it, to protect the original; see Clay (note 2), no. 65, p. 17; other additions were a long mosaic wall (1968) in front of the tower (to provide electricity) and *Totem* (1968), which was pushed against the museum wall. See Prat (note 2), pp. 185, 189.

8 J.-L. Prat in conversation with the author on 10 April 2001.

9 See page with various drawings, including variants of *Arch*, in *Minotaure*, no. 3–4 (12 Dec. 1933): 14.

10 Figures and fountain installations added later are therefore omitted in this analysis. Moreover, only initial locations are discussed.

11 When Miró died, in 1983, the *Stag Beetle* was in a workshop being restored. It was re-incorporated into the park as late as 1990.

12 The arch was conceived as a *Personnage avec oiseau* in 1944–46, and then executed as *L'Arc* in 1962–64. José Pierre and José Corredor-Matheos, *Céramiques de Miró et Artigas* (Paris, 1974), p. 14.

13 Hermann Kern, *Through the Labyrinth: Designs and Meanings over 5,000 Years* (Munich, London and New York, 2000).

14 Arnold van Gennep, *Les Rites de passage* (Paris, 1909).

15 Kern (note 13), p. 23.

16 Victor W. Turner, *The Ritual Process: Structure and Anti-Structure* (Harmondsworth, England, 1969), p. 81.

17 Sigmund Freud, 'Ego and Id' (1923).

18 See André Breton's first Surrealist manifesto in *Manifestoes of Surrealism*, trans. Richard Seaver and Helen R. Lane (Ann Arbor: University of Michigan Press, 1969).

19 See Breton's second Surrealist manifesto, in ibid.

20 See André Masson's bronze sculpture *Minotaure* in *Wahre Wunder*, ed. Siegfried Gohr and Josef Haubrich, exh. cat. (Cologne: Kunsthalle, 2000), p. 302.

21 Interview with Denys Chevalier, *Aujourd'hui: Art et Architecture* (November 1962); quoted from *Joan Miró: Selected Writings and Interviews*, ed. Margit Rowell (London, 1987), p. 264.

22 Ibid., p. 320, note 43 2/3.

23 Joan Miró, 'Déclaration', *XXe siècle* 5, no. 9 (June 1957): 24; quoted from ibid., p. 240.

24 Hemingway, quoted in Clement Greenberg, *Joan Miró* (New York, 1949).

25 *The Institutio Oratoria of Quintilian*, trans. H.E. Butler, vol. III, Loeb Classical Library (London, 1921), bk. VIII, chap. vi, 4–19.

26 Walter Erben, *Joan Miró* (Munich, 1959), no. 30.

27 Greenberg (note 24), p. 19.

28 Joan Miró, 'Où allez-vous, Miró?', interview with Georges Duthuit, *Cahiers d'art* 11, no. 8–10 (1936); quoted from Rowell (note 21), p. 151.

29 Joan Miró, 'Sur le Carnival d'Arlequin', *Verve*, no. 4 (Jan.–March 1939): 85; quoted from Rowell (note 21), p. 164.

30 Lluís Permanger, 'Revelaciones de Joan Miró sobra su obra', *Gaceta ilustrada*, 23 April 1978, pp. 45–46; quoted from Rowell (note 21), p. 291.

31 Miró's pencil drawing *Légende du Minotaure*, dated 30 August 1933, in *Miró: Frühe Zeichnungen*, exh. cat. (Zurich: Galerie Maeght, June–July 1980), Fig. 15.

32 See Hubertus Gassner, *Joan Miró: Der magische Gärtner* (Cologne, 1994), Colour Plate 29.

33 José Maria Blasquez, 'Althispania', in H.W. Haussig, *Wörterbuch der Mythologie: Götter und Mythen im alten Europa*, vol. II (Stuttgart, 1956), pp. 781, 798f.

34 Erich Neumann, 'Über den Mond und das matriachalische Bewusstsein', in idem *Umkreisung der Mitte: Aufsätze zur Tiefenpsychologie der Kulturen II: Zur Psychologie des Weiblichen* (Zurich, 1953–54), p. 77. The author owes this reference to Mareile Karpus.

35 See Gassner (note 32), chap. XI, esp. pp. 287 and 292; Gassner does not relate Miró's periods of crisis to the later labyrinth.

36 Ibid., p. 298.

37 Ibid., Fig. 51, p. 209.

38 'Miró's Sketchbook: Escultera', Fundació Joan Miró, Barcelona, no. 351 from book 3509–3533, illustrated in *Miró in America*, ed. Barbara Rose, exh. cat. (Houston: Museum of Fine Arts, 1982), Fig. 43; see also Miró's variant in *Obra de Joan Miró: Dibiuxos, pintura, escultura, céramica, tèxtils* (Barcelona: Fundació Joan Miró, 1988), no. 1377.

39 See Rose, ibid., p. 42.

40 Jouffroy and Teixidor (note 3), nos. 52–54.

41 Picasso painted bones surrounding Odysseus fishing in the water not with an open joint but with a round node. Only the ears of Odysseus as he listens look like 'open' bone joints.

See *Odysseus and the Sirens* (1946), oil on asbestos cement, Musée Picasso, Antibes, in Frank Elgar and Robert Maillard, *Picasso: Sein Werk* (Munich and Zurich, 1956), illus. p. 219.

42 Joan Miró, 'Je travaille comme un jardinier', *XXe siécle mensuel* 1, no. 1 (Feb. 1959); quoted from Rowell (note 21), p. 247.

43 Quoted from Gassner (note 32), p. 95.

44 Holz believes that Miró would have been able to find a model for the Naveta by Rafael Rubi in the Stone Age gateway of transition on Minorca. See Hans Heinz Holz, 'Mirós Welt mythischer Zeichen', in *Joan Miró*, exh. cat. (Zurich: Kunsthaus, 1987), p. 76, n. 31.

45 Antje von Graevenitz, 'Constantin Brancusi', in *Zeichen des Glaubens—Geist der Avantgarde: Religiöse Tendenzen in der Kunst des 20. Jahrhunderts*, ed. Wieland Schmied, exh. cat. (Berlin: Grosse Orangerie, Schloss Charlottenburg, 1980; Munich and Milan, 1980), pp. 211–19.

46 'Die Metamorphose der Narziss', in *Salvador Dalí: 1904–1989*, texts by Karin von Maur, exh. cat. (Stuttgart: Staatsgalerie; Stutgart 1989), no. 191, p. 240f.

47 Sketch nos. 5/3 in the Fundació Joan Miró, dated '31. Aost 1944' in octavo sketchbook, nos. 3509–3533: inscribed *escultura*; no. 3512, initially described as *Tête* (in 3553: *Escultura*; illustrated in *Obra* [note 38], no. 1396): no. 3767 in octavo sketchbook, nos. 3720–3952: six versions of the goddess and two of the arch; no. 56c, sheet 3525, described as *Femme* of 20 September 1946; likewise: no. 30/15 of the same date, in small lined octavo notebook, where there is once again no. 32/5 b of 28 September 1946; no. 3277 of 5 January 1947 featuring two goddesses; see also sheet nos. 3539 and 3544.

48 Penrose (note 2), Figs. 79, 108.

49 Herbert Kühn, *Die Kunst Alteuropas* (Stuttgart, 1954), Figs. 78, 81. The author is grateful to Mareile Karpus for pointing this out.

50 Erich Neumann, *The Great Mother: An Analysis of the Archetype*, trans. Ralph Manheim, Bollingen Series XLVII (London, 1972), p. 39.

51 Jakob Böhme, chap. 4, quoted from the facsimile of the 1730 edition (Stuttgart, 1957), pp. 29, 40; quoted from Gassner (note 32), p. 98, note 109.

52 *Joan Miró: Catalogue raisonné, Paintings*, ed. Jacques Dupin and Ariane Lelong-Mainaud, vol. 1 (Paris, 1999), no. 587, p. 202f.

53 Gassner (note 32), p. 95.

54 Werner Schmalenbach, *Joan Miró: Zeichnungen aus den späten Jahren* (Frankfurt, Berlin and Vienna, 1982), p. 27.

55 See Rose (note 38), Figs. 42, 45. At that time, the head was obviously intended to be completely three-dimensional. Miró gave it a handle and what appear to be stumpy arms. He envisaged a triangle for the body of the bird, which become merely a head in the final sculpture. The sketches are kept at the Fundació Joan Miró in Barcelona, nos. 3566 and 4003. Another sheet, sheet 5, no. 3551 in folder 3534–3663, shows the figure of the *Fourche* (pitchfork) with a head beside it, so that the interpretation of a head/eye seems appropriate. See similar sheets no. 3593 designated *Tête* in the octavo sketchbook: 3534–3663, and sheet III/67 no. 3607, called *Femme* in the same sketchbook.

56 Miró explained that males rarely had a place in the universe that the woman represented. 'Woman or figure (*personnage*). Never man. Woman or figure or bird', in Schmalenbach (note 54), p. 27.

57 See Miró's *Constellation silencieuse* sculpture, 1970, a kind of door with similar burls bearing a golden egg and a kind of crescent moon, in Prat (note 2), no. 103, p. 19.

58 Penrose (note 2), p. 160.

59 Prat (note 2), p. 180f.

60 Miró, *L'Astre du Labyrinthe*, coloured aquatint, 1968, 75 numbered and signed copies, depicted in *Miró*, exh. cat. (Zurich: Galerie Kornfeld, 1971), no. 30.

61 See Rowell (note 21), p. 152.

62 Pedro Calderón, 'Auto sacramentales' (1677), in idem, *Obras completas*, ed. A. Valbuena and A. Valbuena Briones, 3 vols. (Madrid, 1951–56).

PLATES

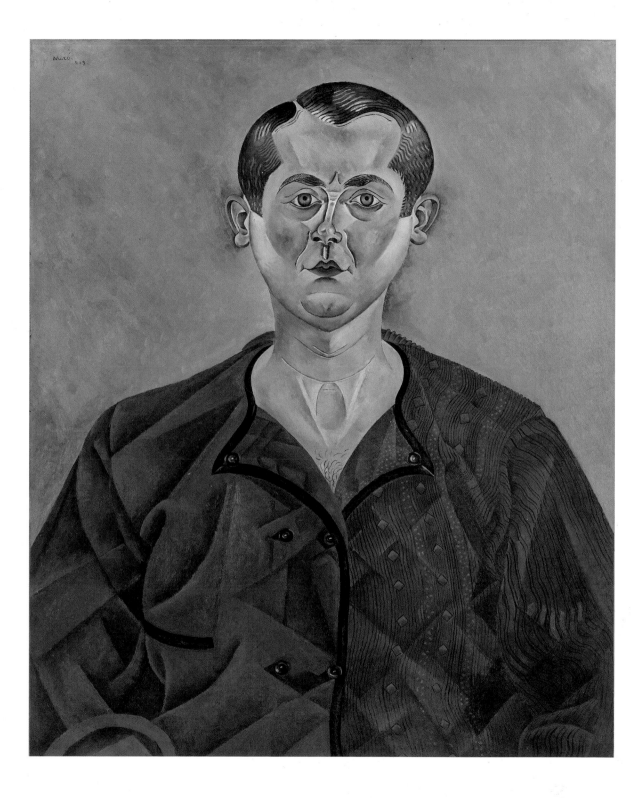

Self-Portrait, 1919 Cat. 4

Portrait of Vicens Nubiola, c. 1917 Cat. 2

Nude with a Mirror, 1919 Cat. 3

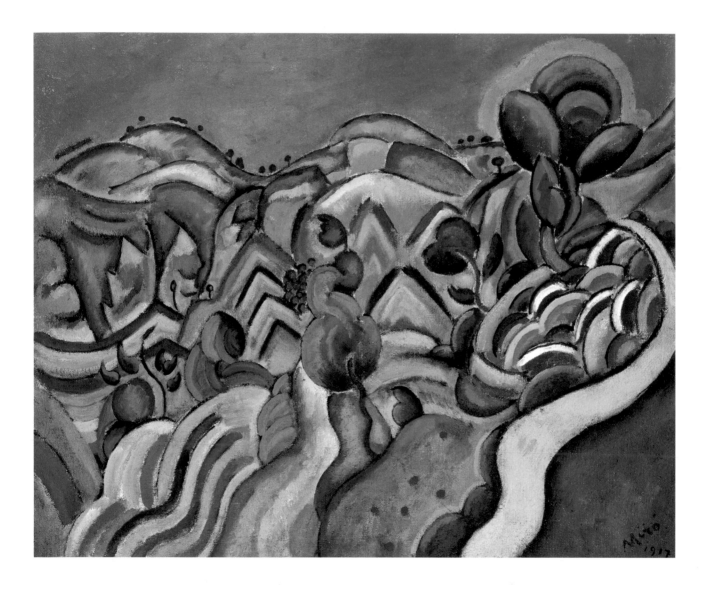

Siurana, the Path, 1917 Cat. 1

The Farm, 1921–22 Cat. 5

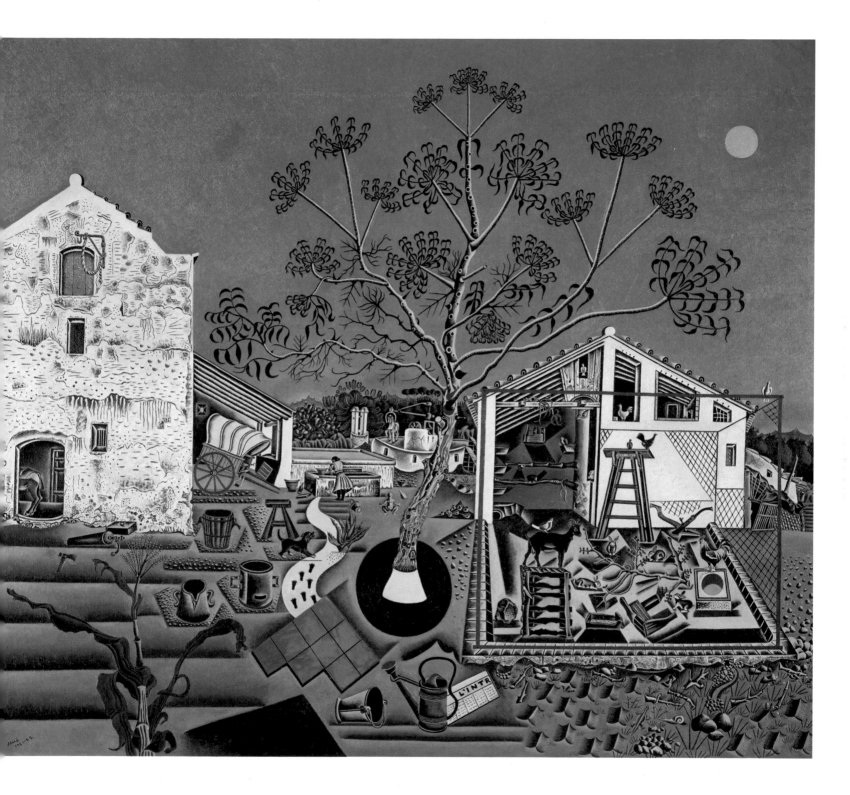

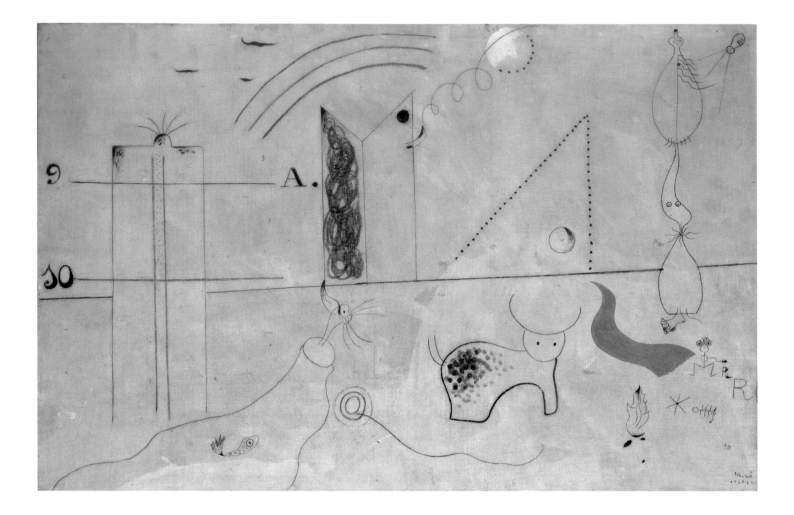

Pastorale, 1923–24 Cat. 6

Study for *Pastorale*, 1923–24 Cat. 62

Catalan Landscape (The Hunter), 1923–24 Cat. 7

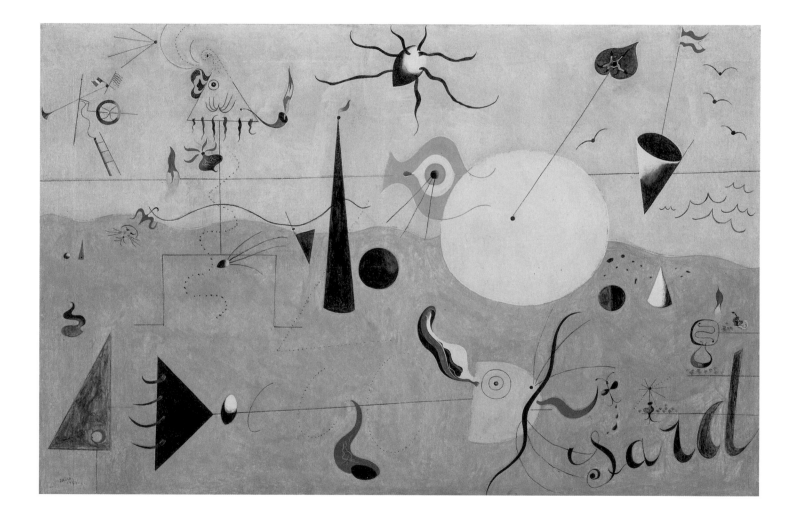

Toys, 1924 Cat. 8

The Family, 1924 Cat. 67

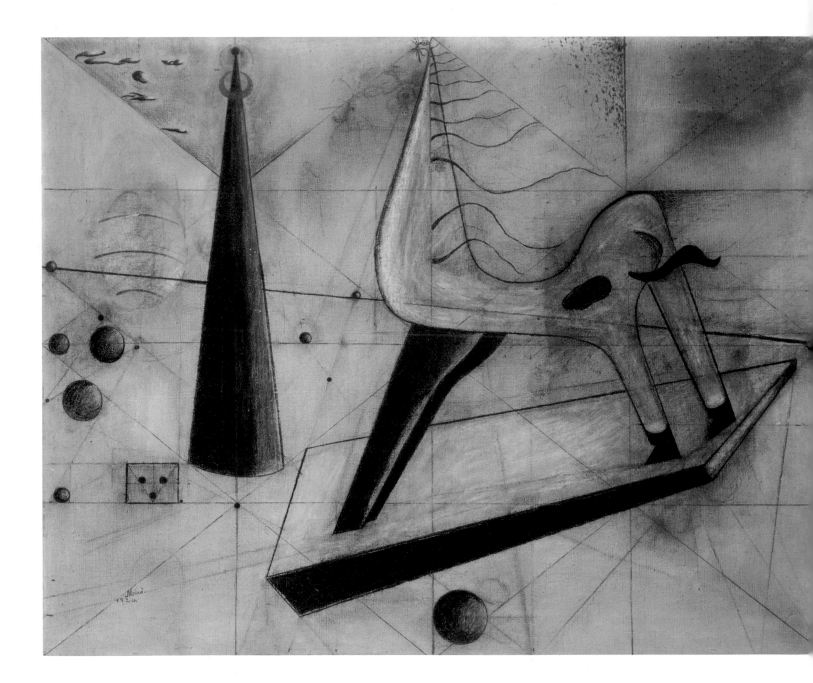

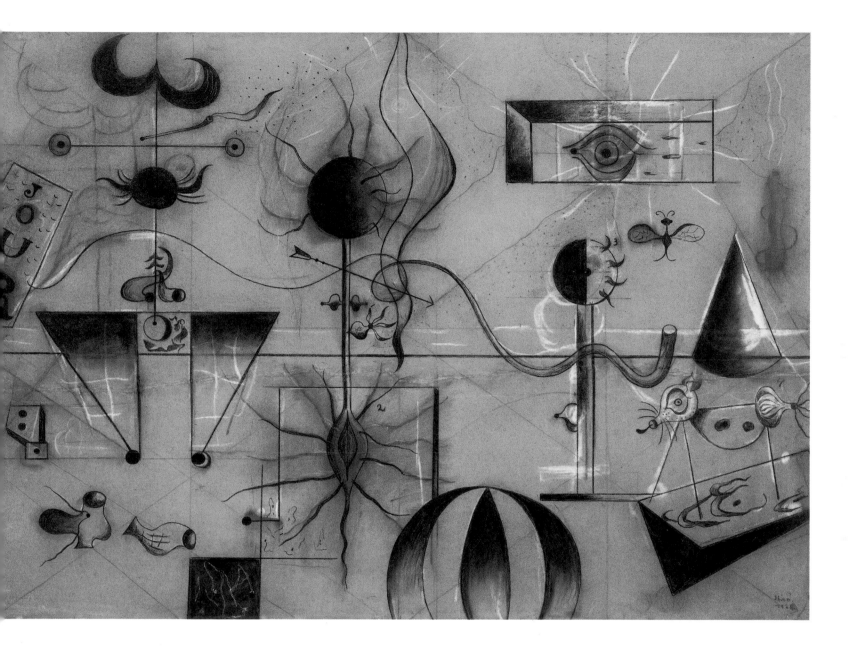

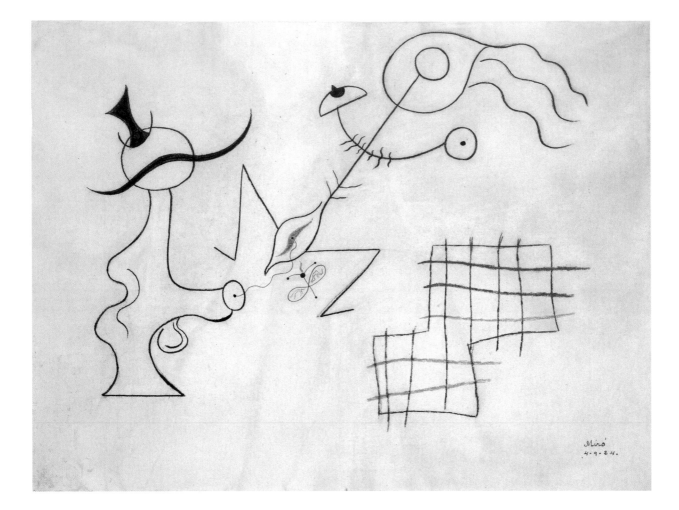

Untitled, 1924 Cat. 64

The Wind, 1924 Cat. 63

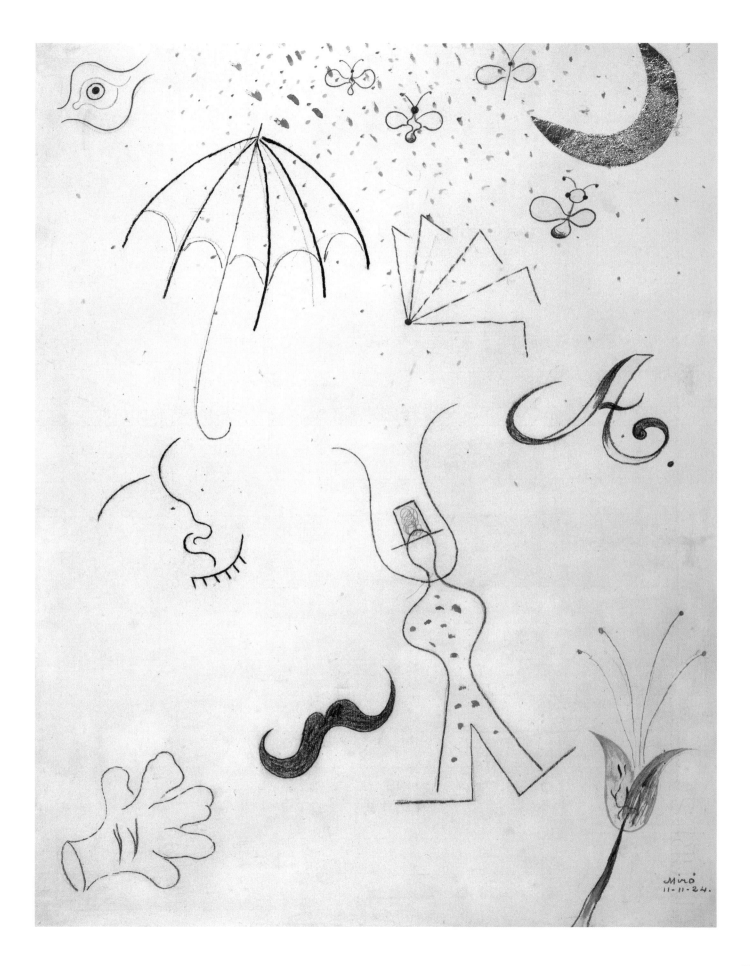

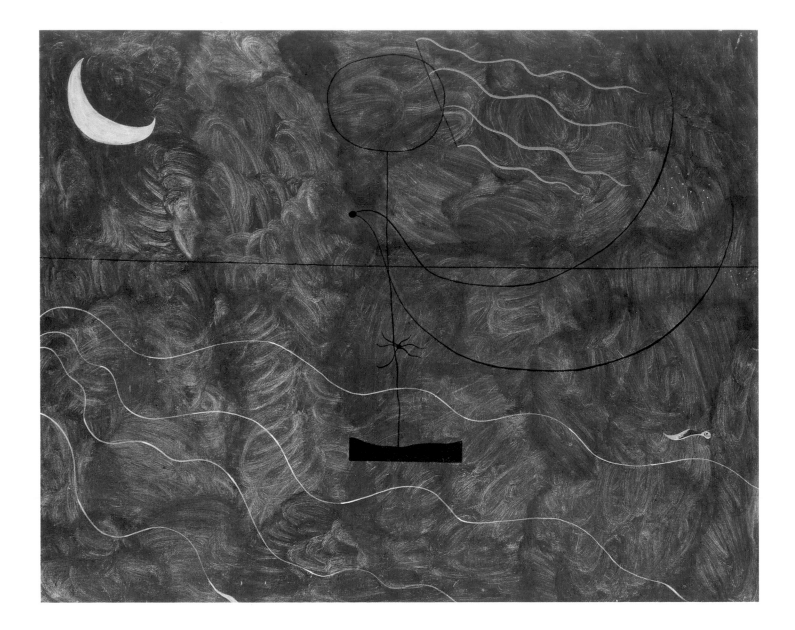

Bather, 1924 Cat. 9

The Gentleman, 1924 Cat. 10

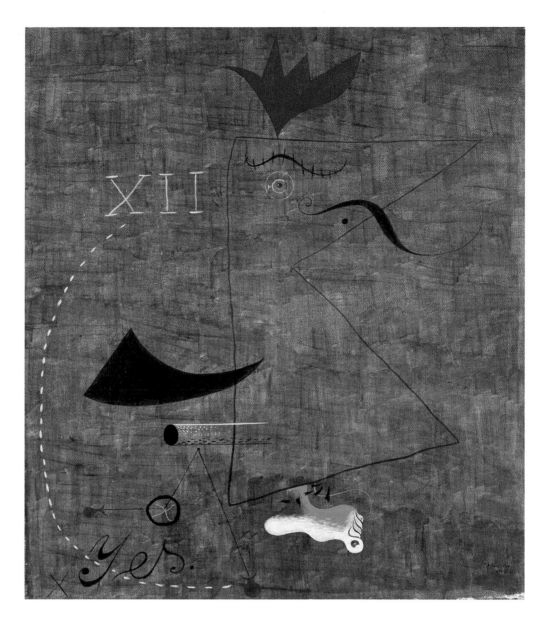

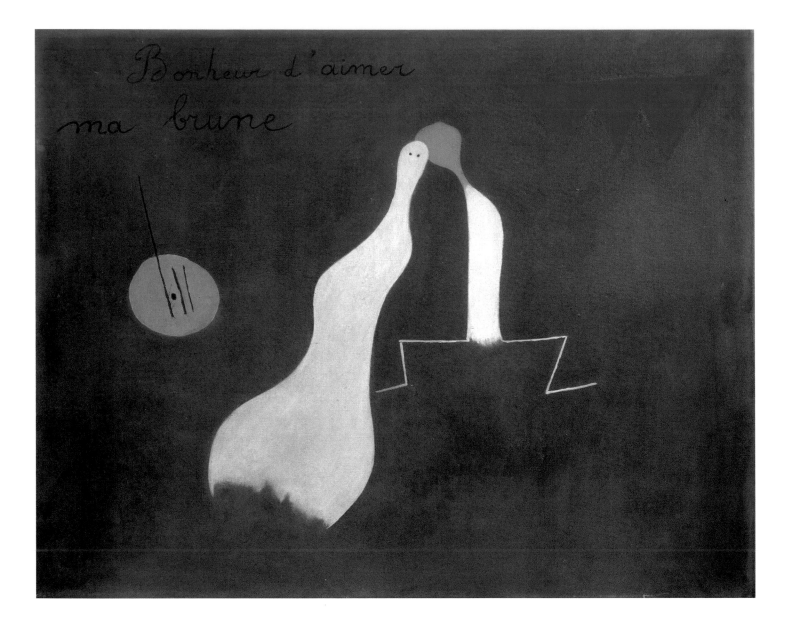

'The happiness of loving my brunette', 1925 Cat. 11

Painting, 1925 Cat. 12

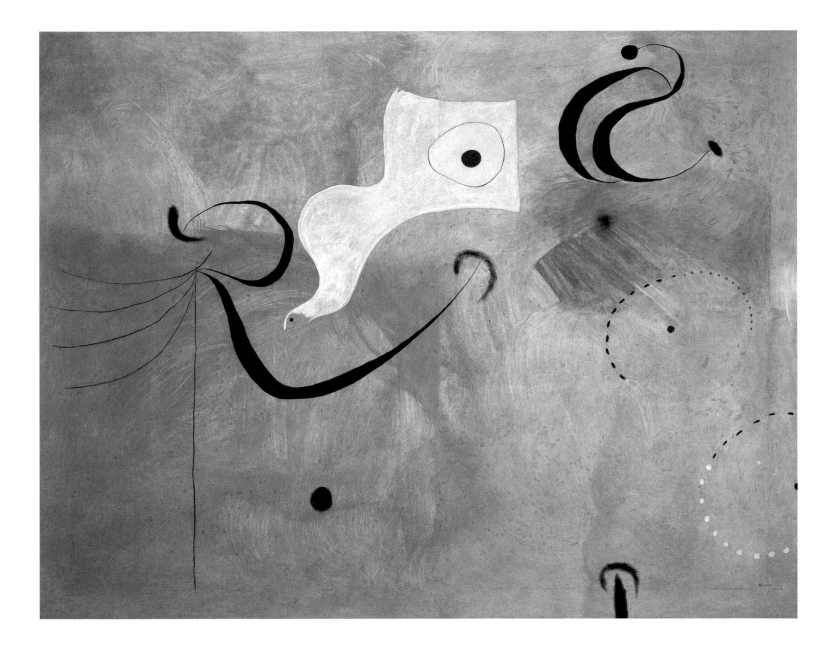

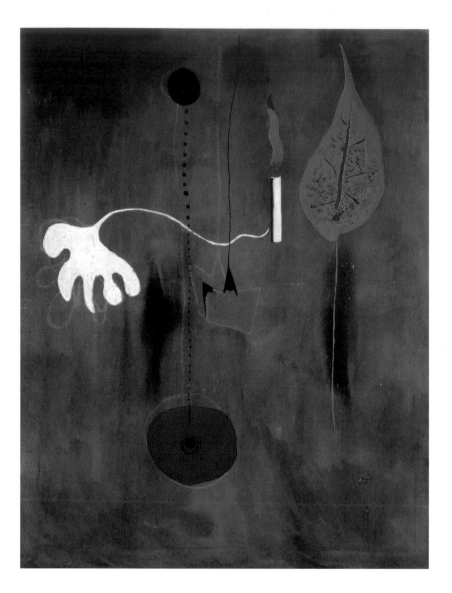

Painting (Man with a Candle), 1925 Cat. 14

Painting (The Sum), 1925 Cat. 13

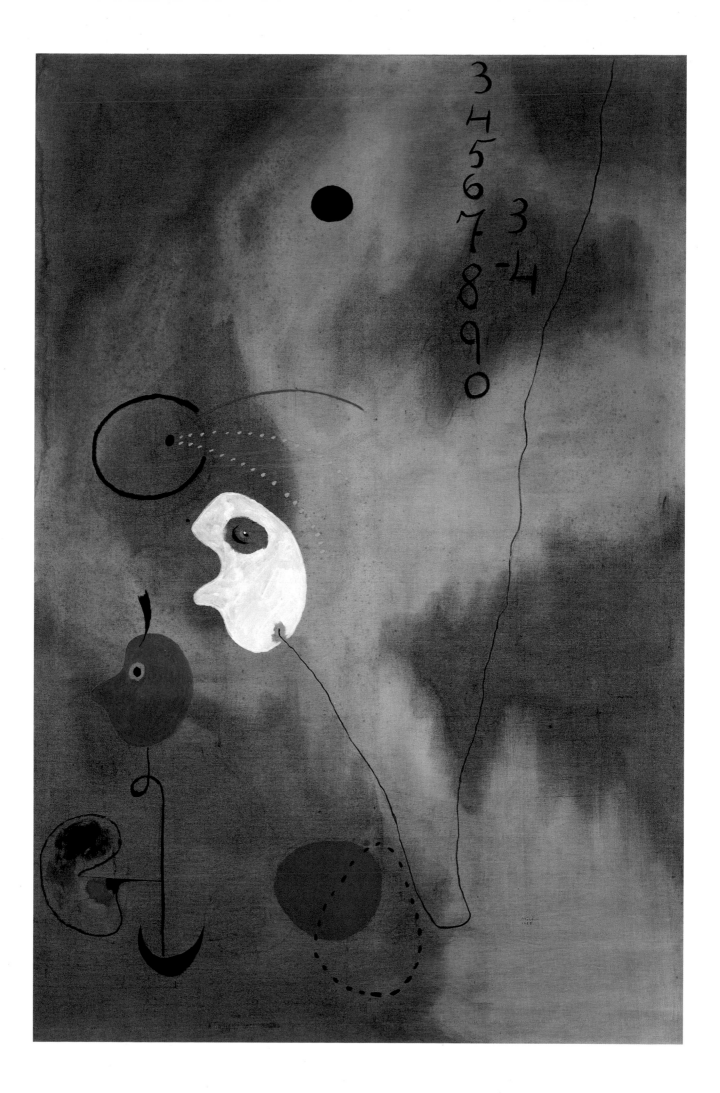

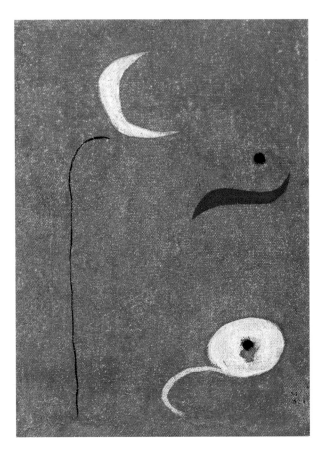

Painting, 1926 Cat. 17

Landscape, 1926 Cat. 18

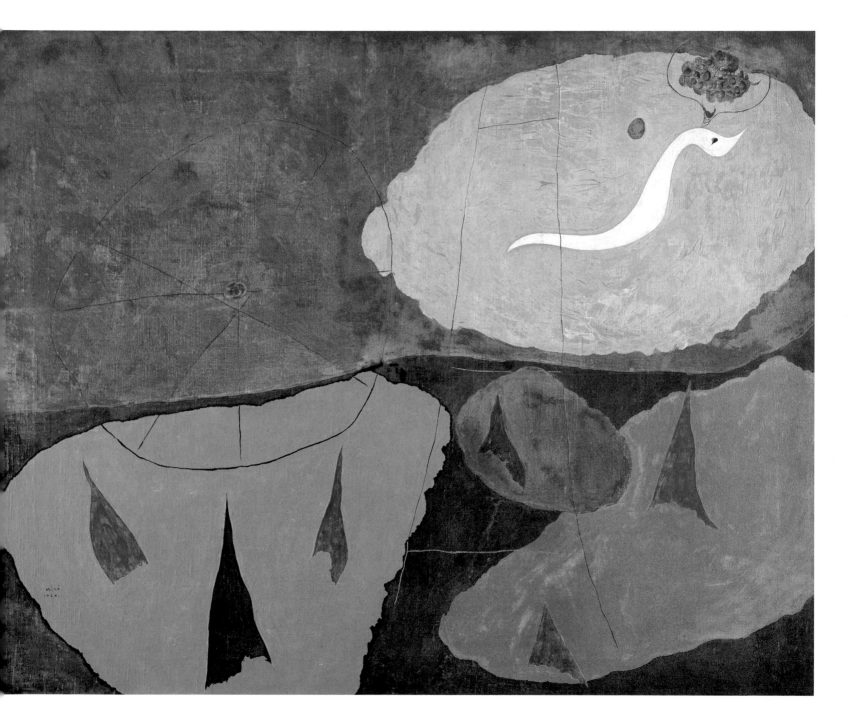

Composition in Brown and White (Painting), 1927 Cat. 20

'Love', 1926 Cat. 15

Study for *The Potato*, 1928 Cat. 73

udy for a composition, 1929 Cat. 76

udy for a composition, 1929 Cat. 77

udy for a composition, 1929 Cat. 78

Study for a composition, *c.* 1927 Cat. 71

Study for *The Lovers*, 1928 Cat. 72

Study for *Still Life with a Lamp*, 1928 Cat. 74

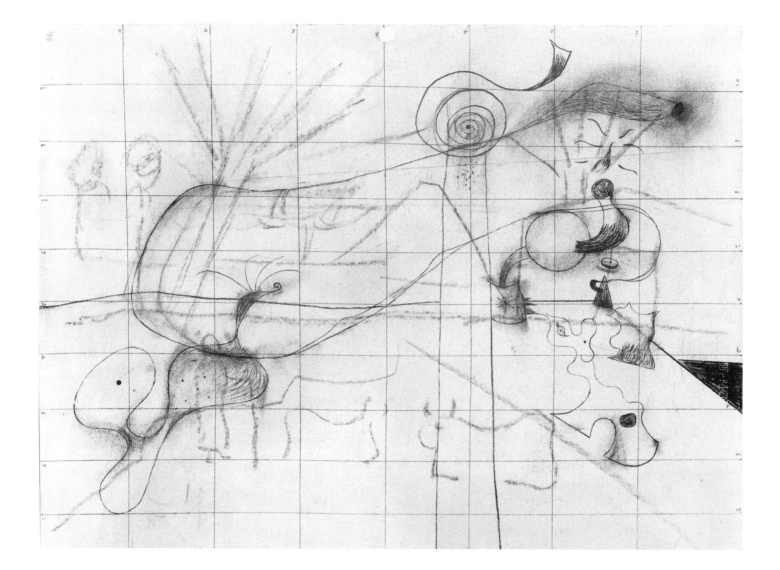

Study for a composition, *c.* 1927 Cat. 70

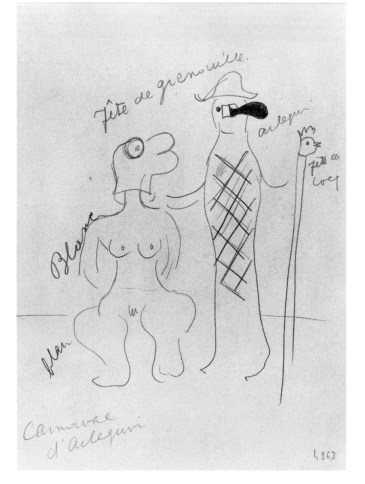

Untitled, undated Cat. 66

Harlequin's Carnival, undated Cat. 65

Hand Catching a Bird, 1926 Cat. 68

Painting (The King's Jester), 1926 Cat. 16

Painting, 1927 Cat. 19

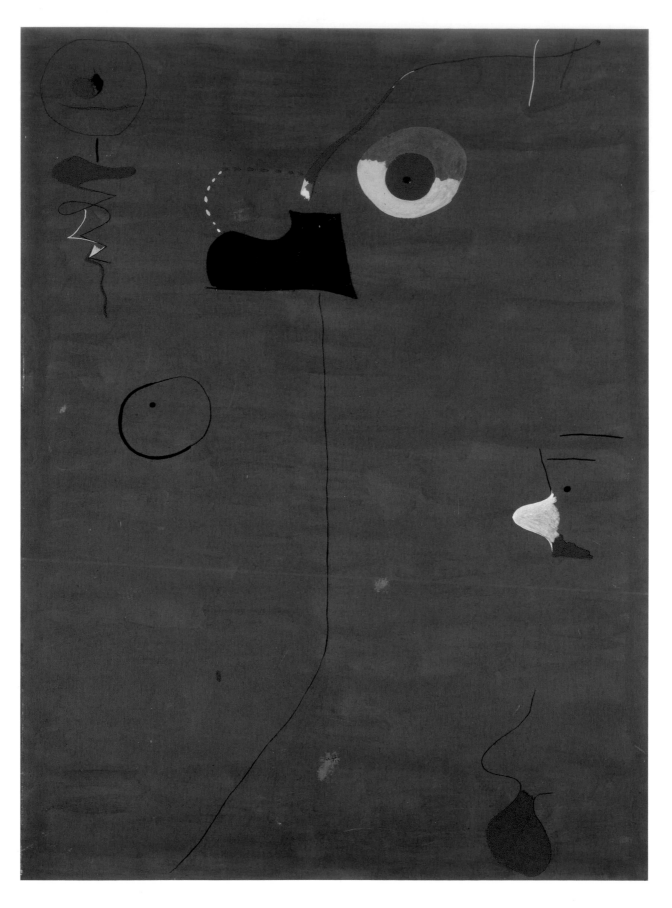

Painting (Fratellini), 1927 Cat.

Painting, 1927 Cat. 21

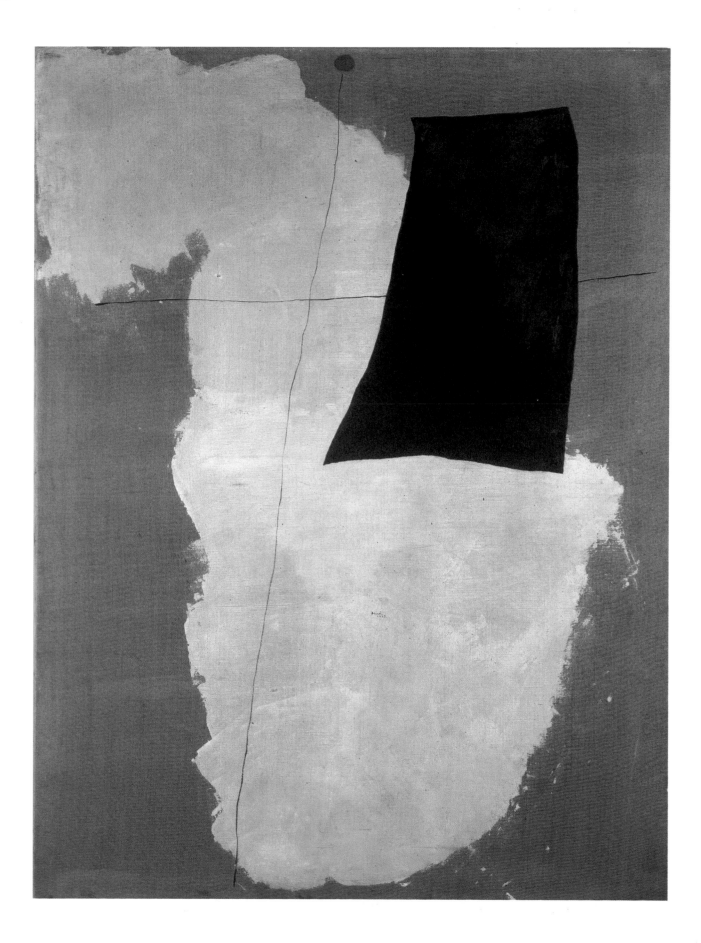

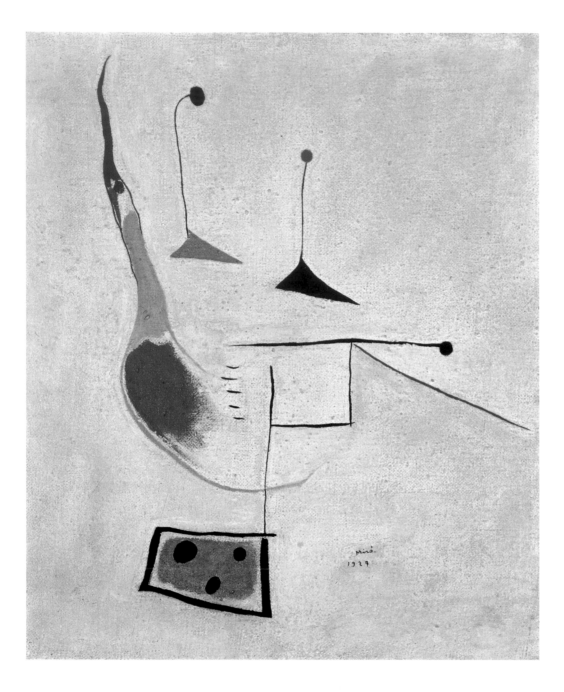

Painting on White Ground, 1927 Cat. 23

Painting (The Circus Horse), 1927 Cat. 24

Study for *The Circus Horse*, 1929 Cat. 79

Study for *The Circus Horse*, 1929 Cat. 80

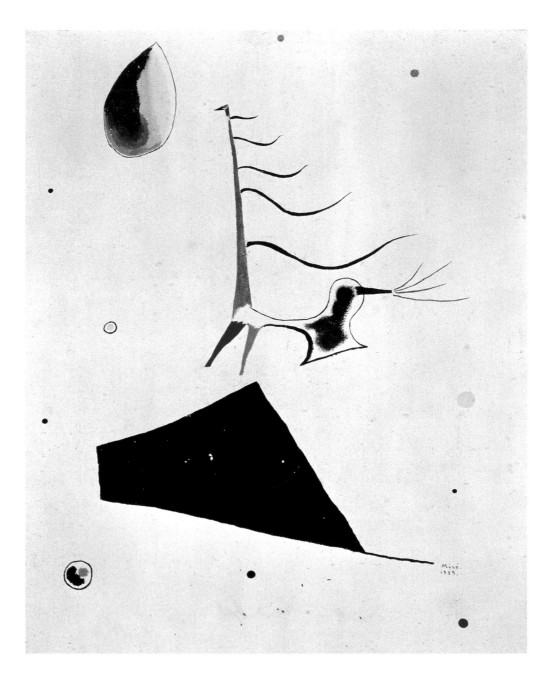

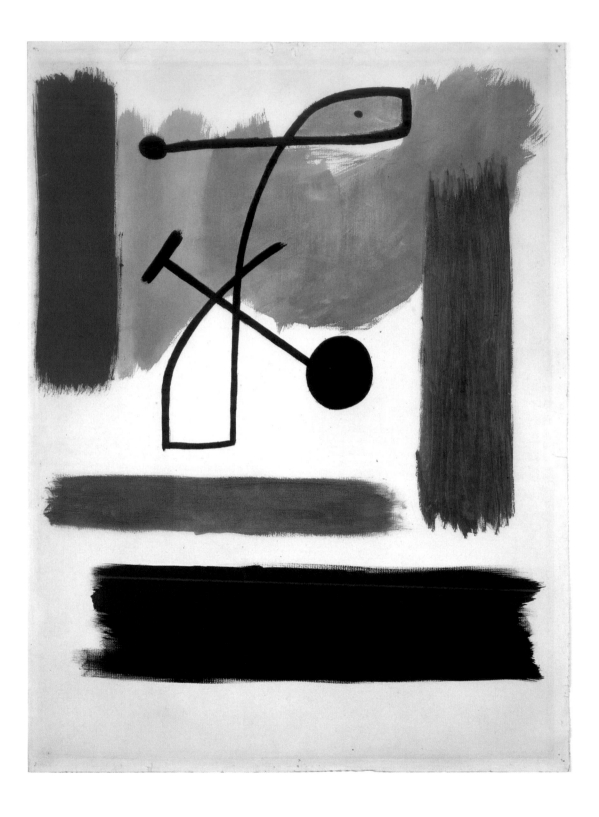

Woman Walking down the Street, 1931 Cat. 26

Composition, 1930 Cat. 25

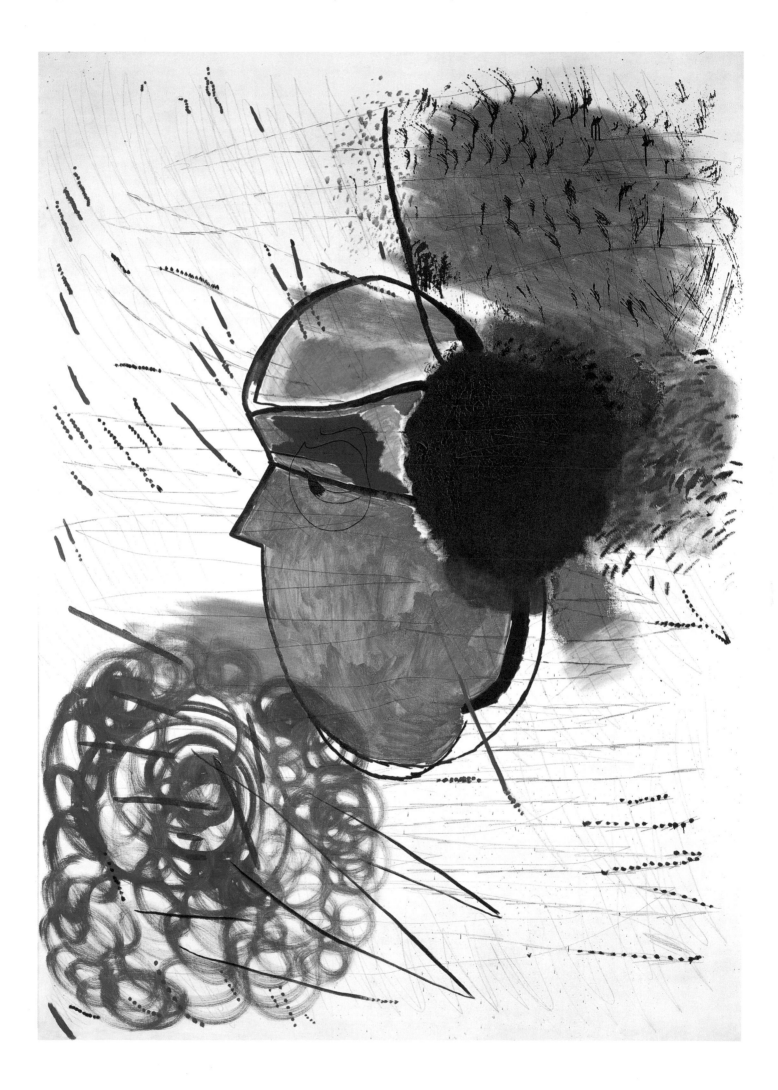

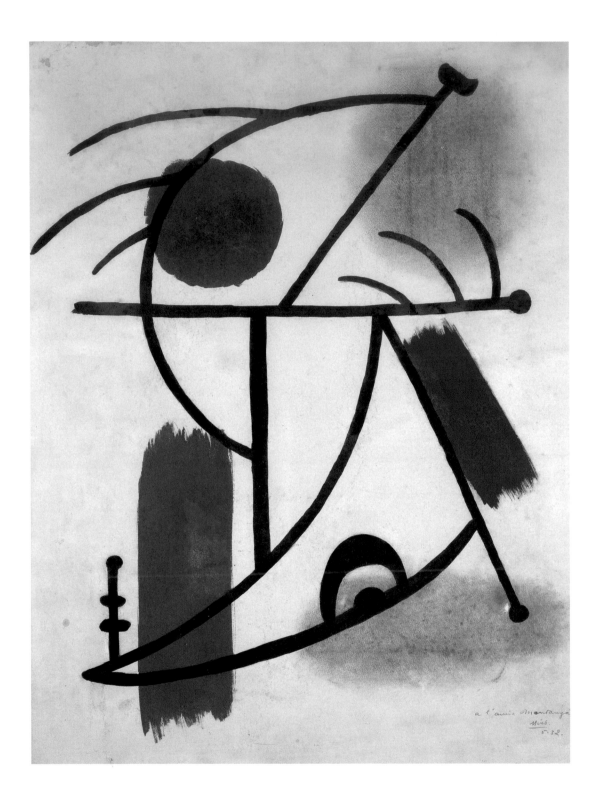

Painting, 1931 Cat. 27

Painting, 1932 Cat. 29

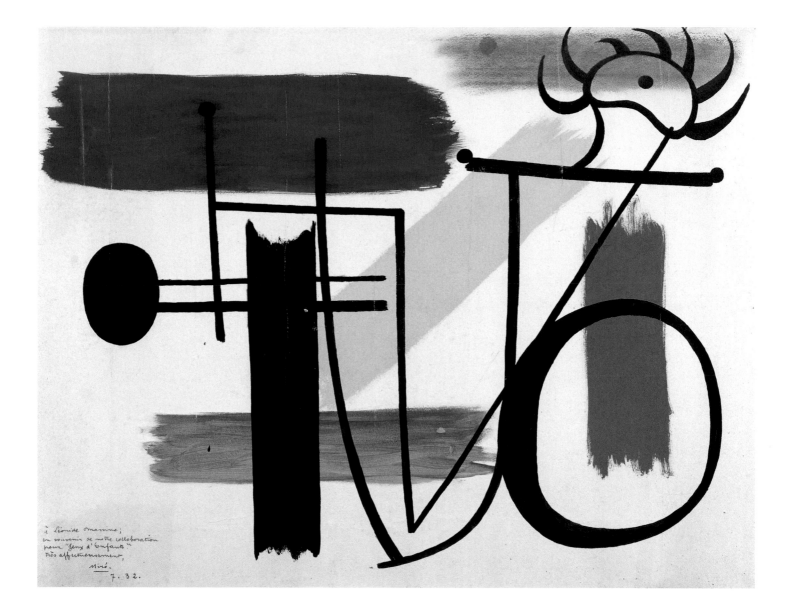

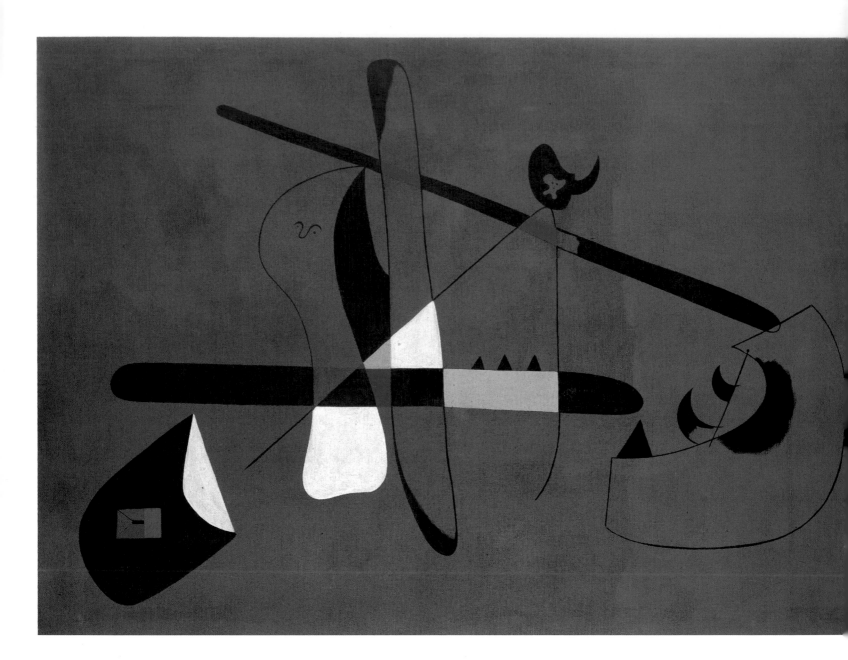

Painting, 1933 Cat. 30

Collage for *Painting*, 1933 Cat. 97

Collage for *Painting*, 1933 Cat. 95

Collage for *Painting*, 1933 Cat. 96

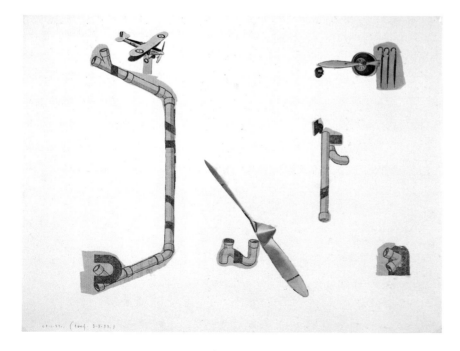

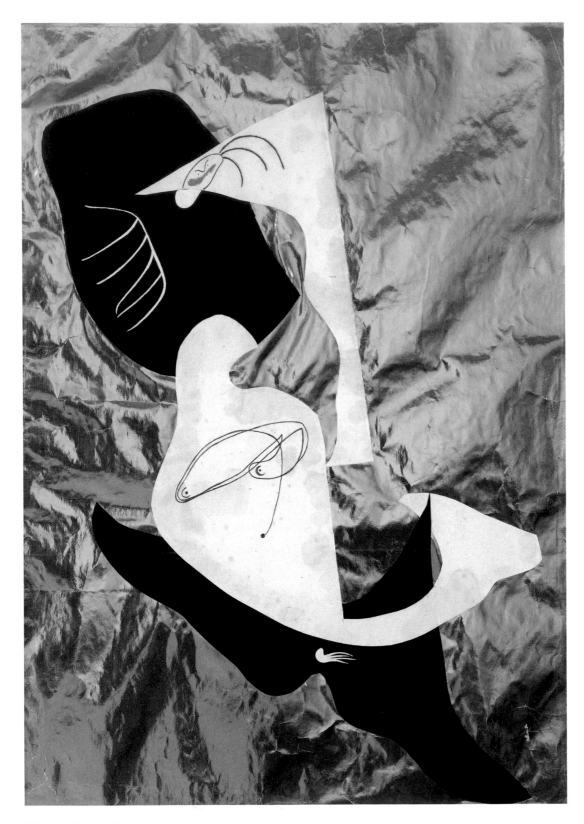

Collage drawing, 1934 Cat. 103

Collage, 1929 Cat. 81

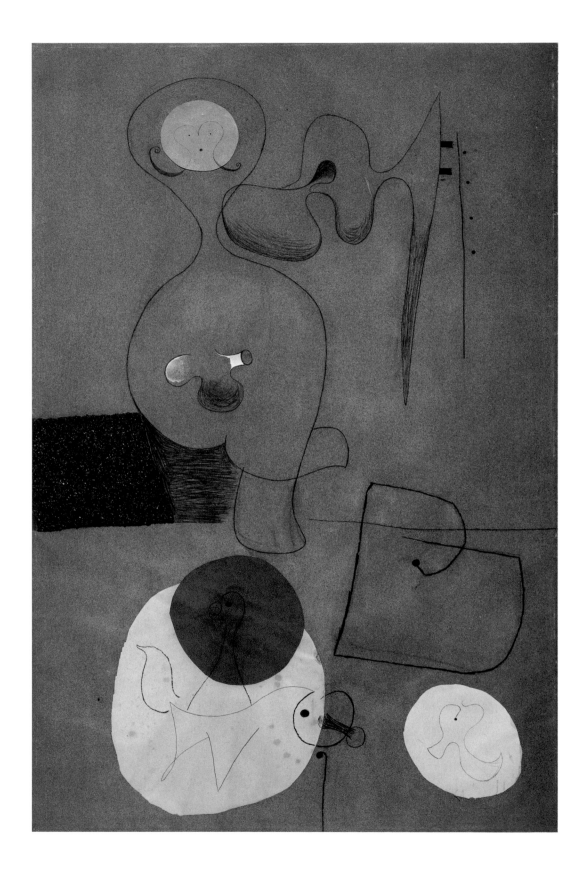

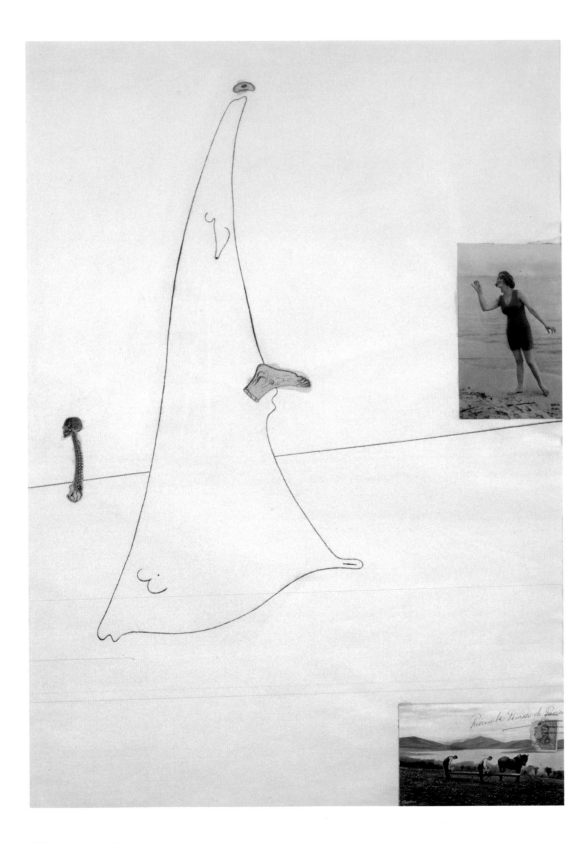

Collage drawing, 1933 Cat. 101

Snail Woman Flower Star, 1933 Cat. 102

Minotaur, 1934 Cat. 104

Metamorphosis, 1936 Cat. 108

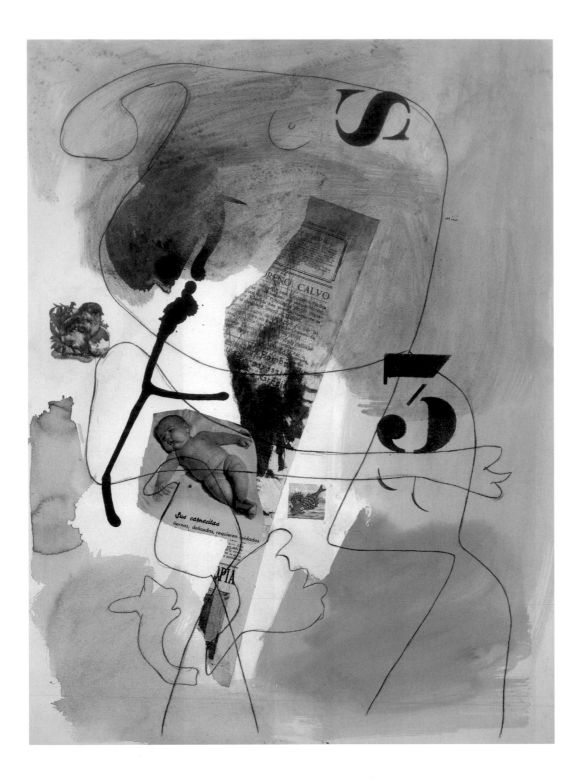

Metamorphosis H, 1936 Cat. 107

Collage drawing, 1933 Cat. 100

NEW PATHS IN PAINTING

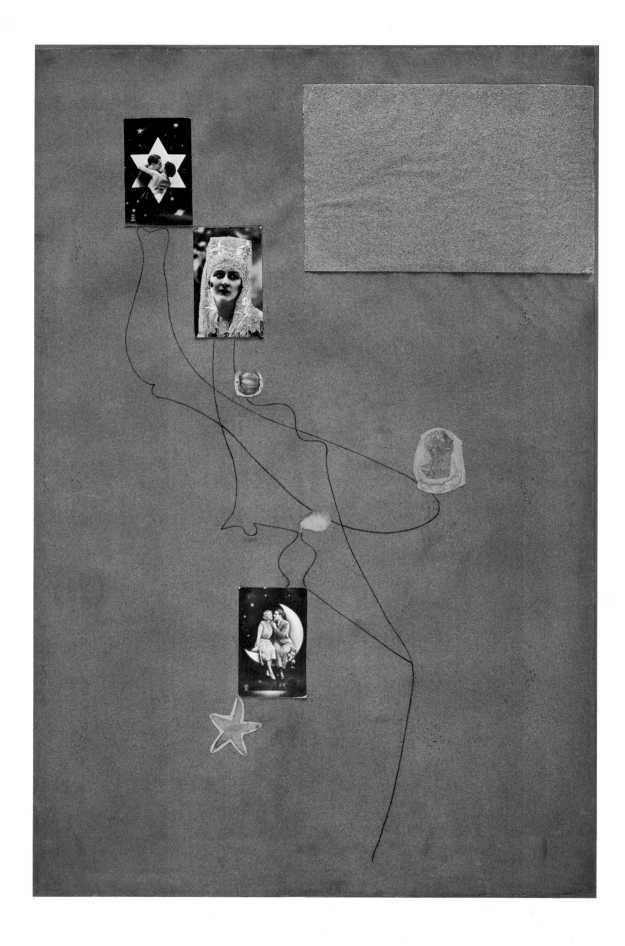

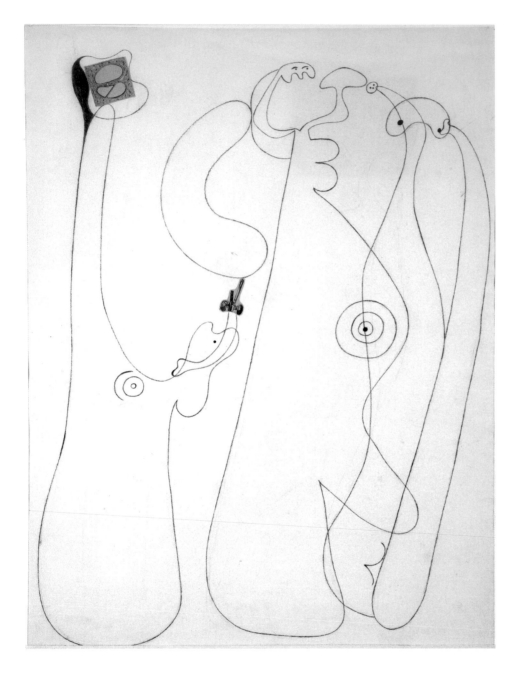

Collage drawing, 1933 Cat. 98

Collage drawing (*The Origin of the Human Animal*), 1933 Cat. 99

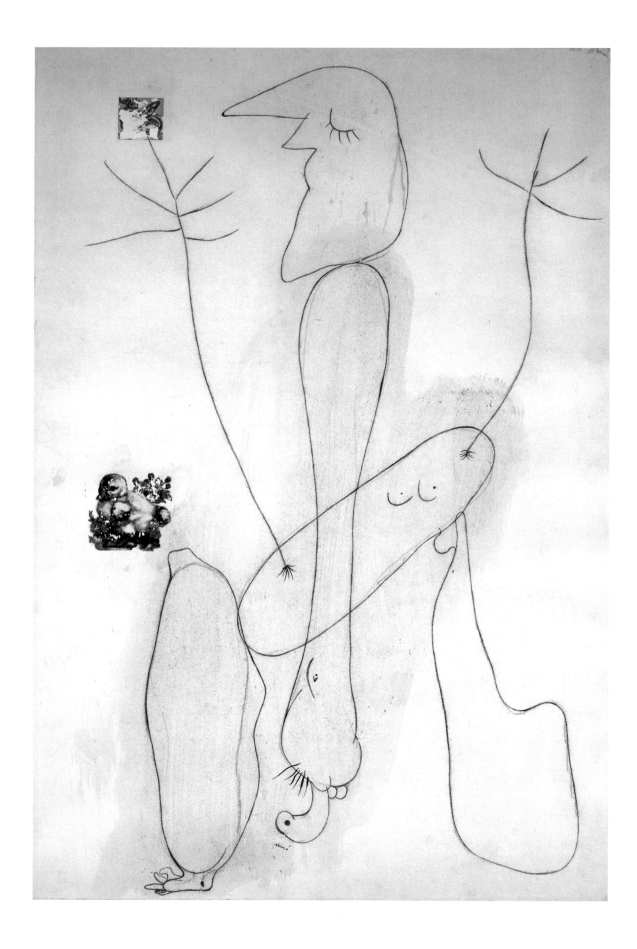

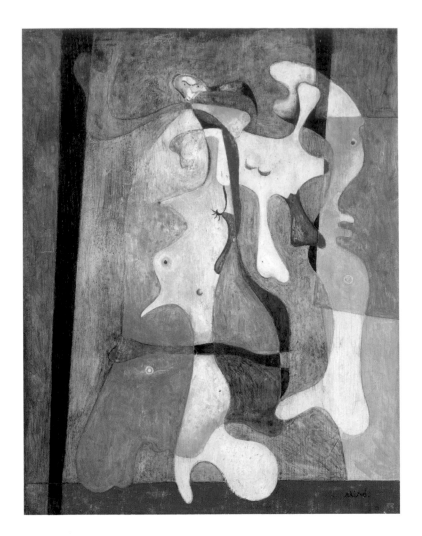

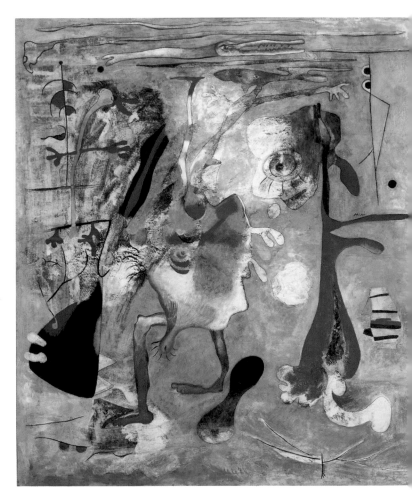

Women, 1932 Cat. 28

Painting, 1935 Cat. 38

Two Women Bathing, 1936 Cat. 41

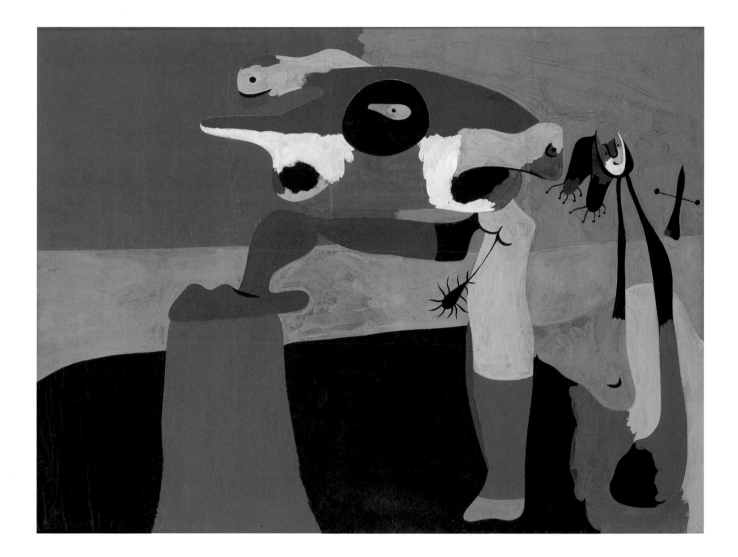

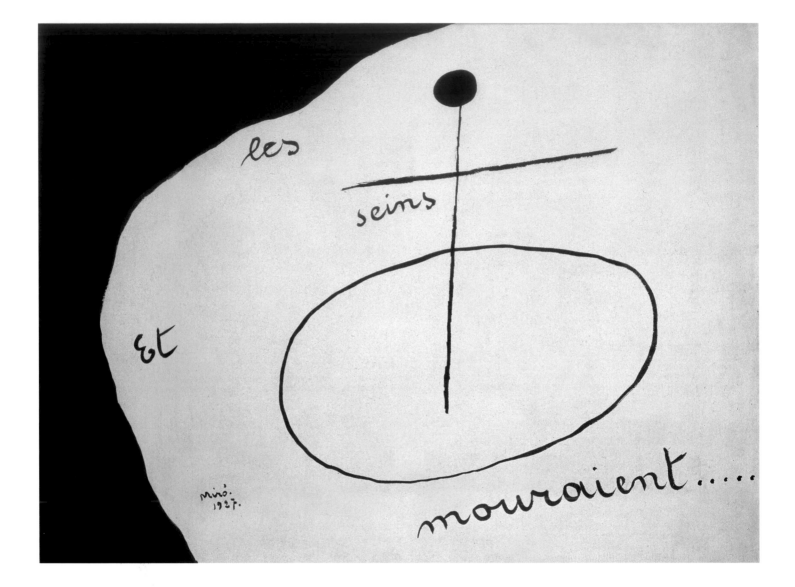

'And the breast died', 1927 Cat. 69

Figure, 1930 Cat. 94

Figure, 1930 Cat. 92

Untitled, 1930 Cat. 93

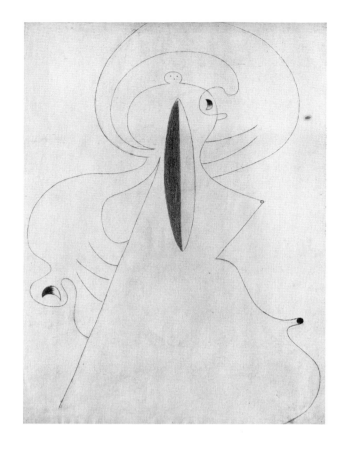

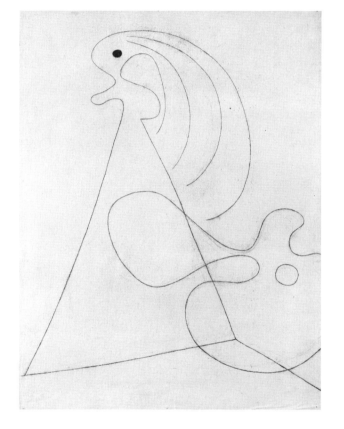

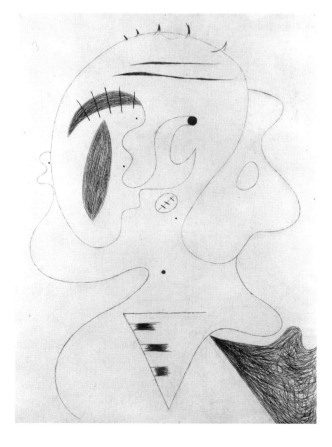

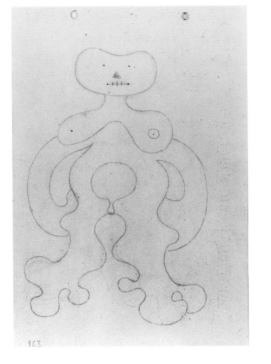

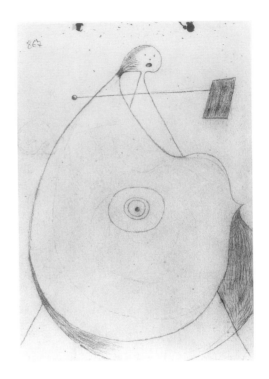

SKETCHBOOK (10 SHEETS OF 27)

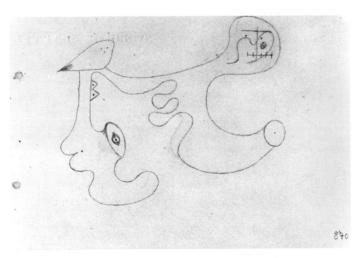

Woman, 1930 Cat. 85

Figure, 1930 Cat. 88

Man and Woman, 1930 Cat. 89

Woman, 1930 Cat. 90

Figure, 1930 Cat. 86

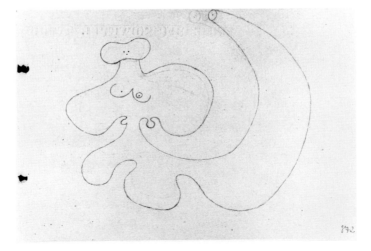

Woman, 1930 Cat. 84

Woman, 1930 Cat. 87

Figure, 1930 Cat. 82

Woman, 1930 Cat. 83

Woman, 1930 Cat. 91

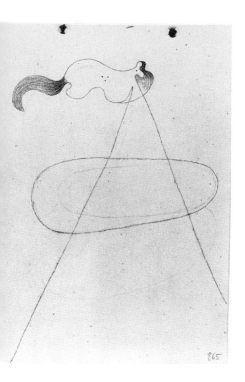

'Snail woman flower star', 1934 Cat. 33

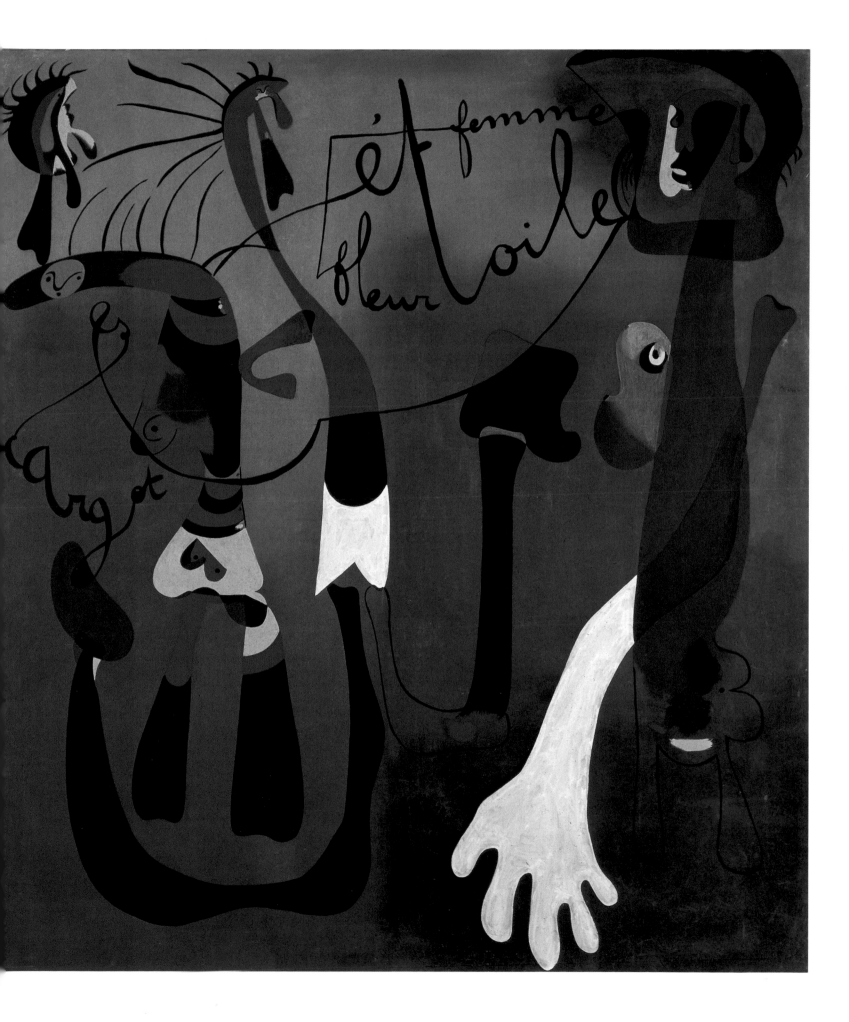

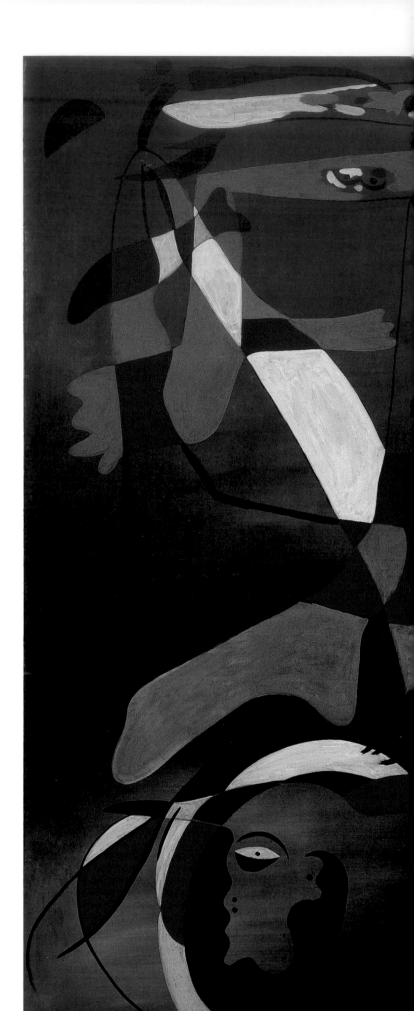

'Swallow love', 1933–34 Cat. 34

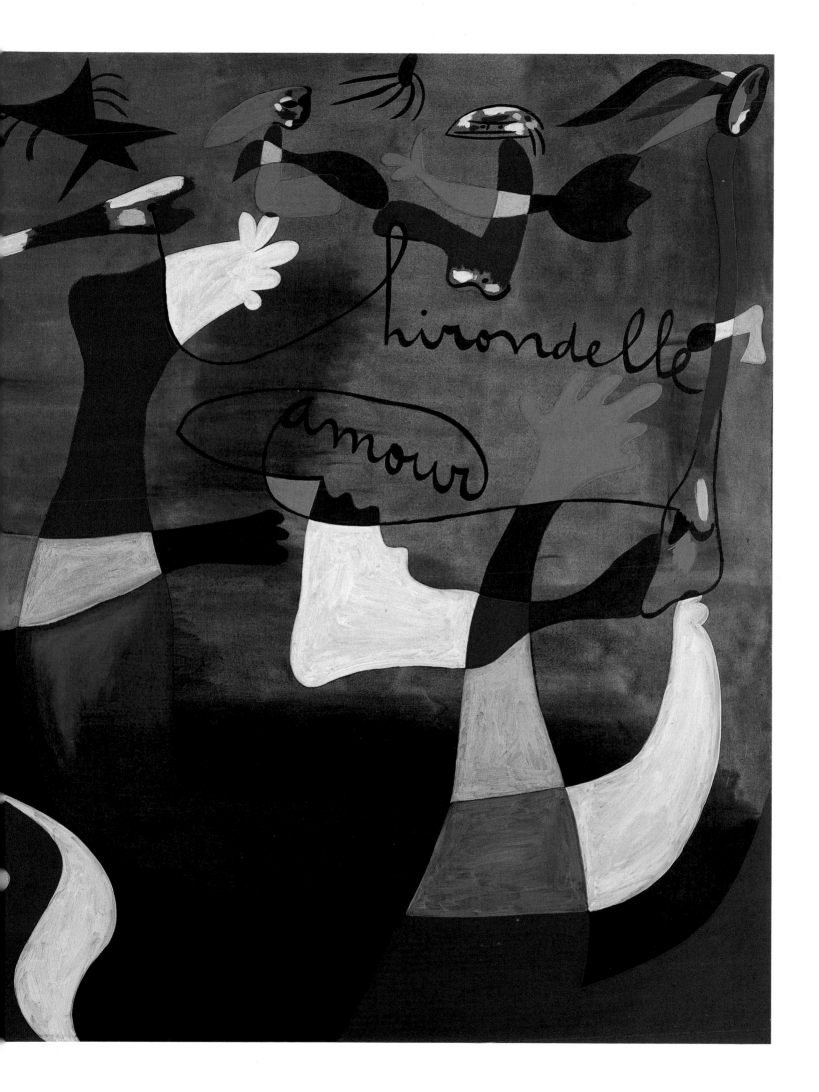

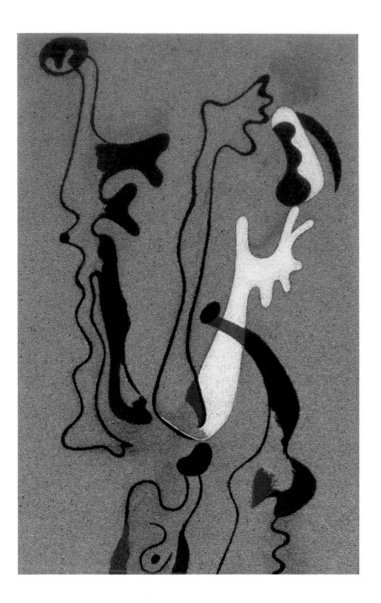

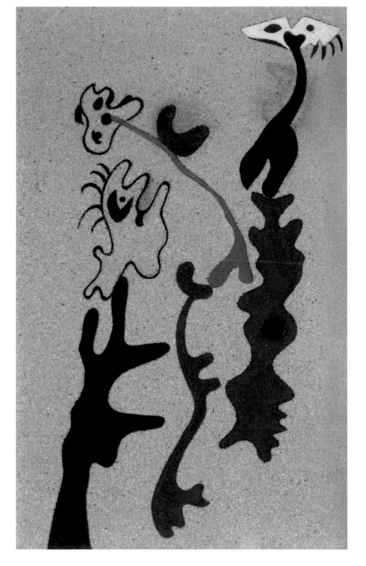

Painting, 1933 Cat. 32

Painting, 1933 Cat. 31

Signs and Figurations, 1936 Cat. 39

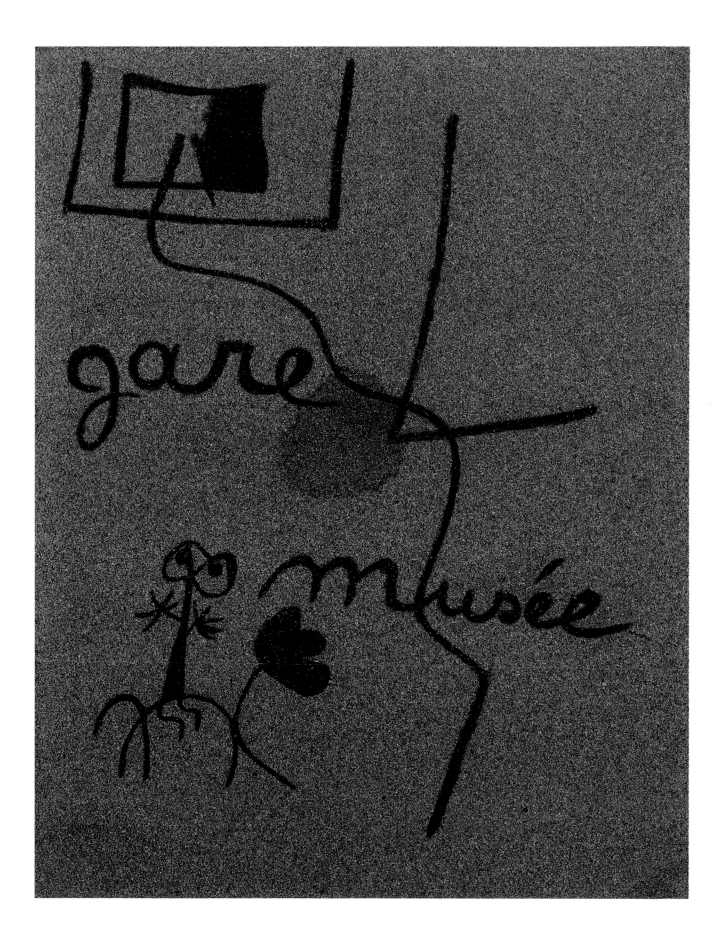

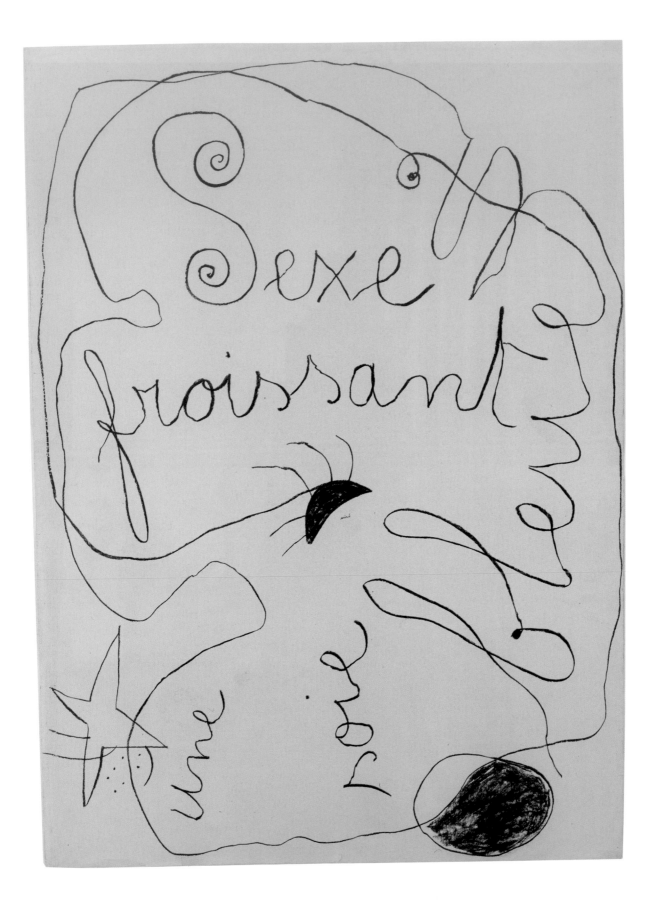

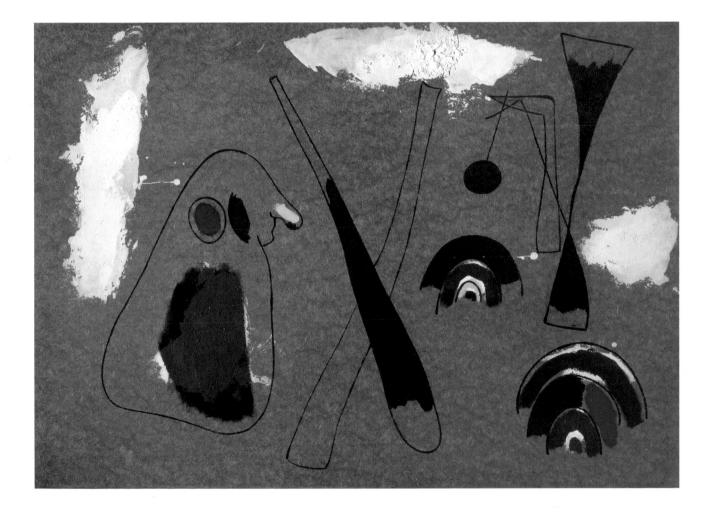

'*Sex, crumpling blue silk*', 1937 Cat. 110

Painting, 1936 Cat. 40

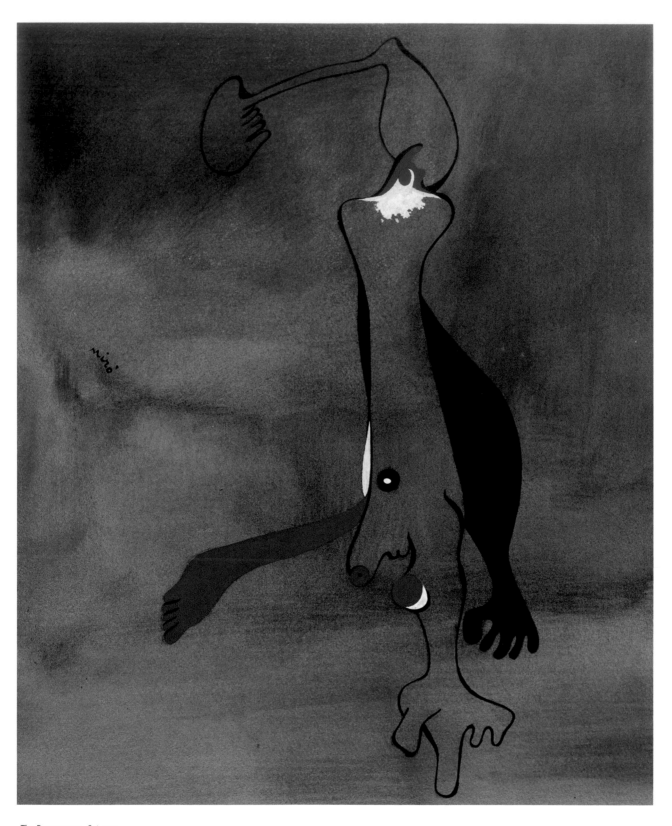

The Dancer, 1935 Cat. 105

Seated Woman, 1935 Cat. 106

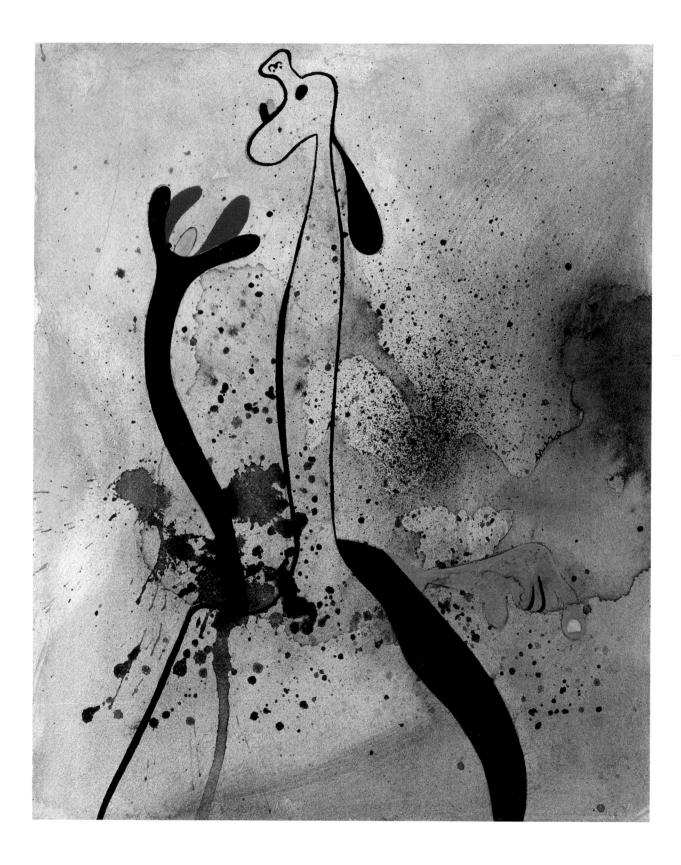

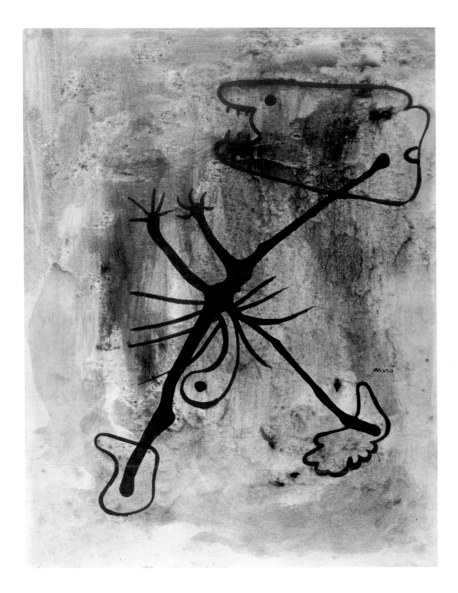

Figure in a State of Metamorphosis, 1936 Cat. 109

The Adulterer, 1928 Cat. 75

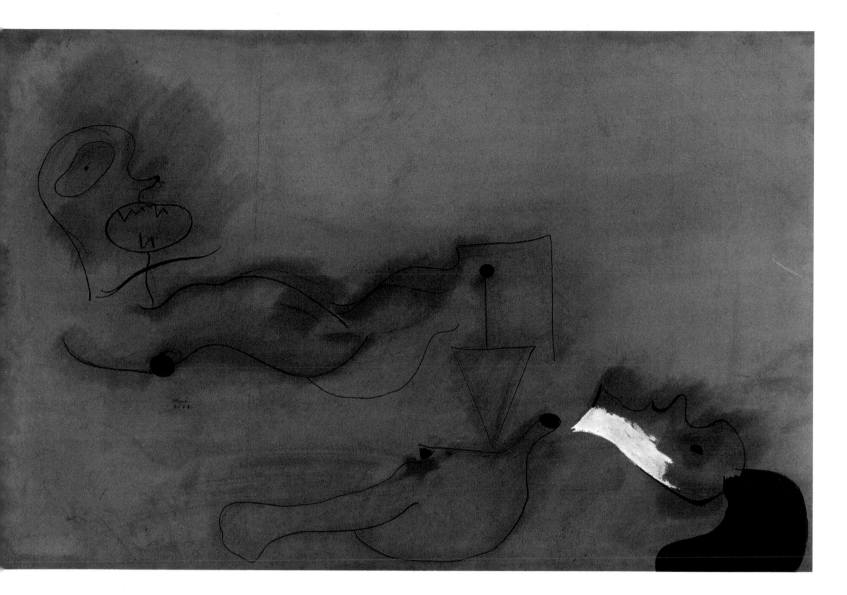

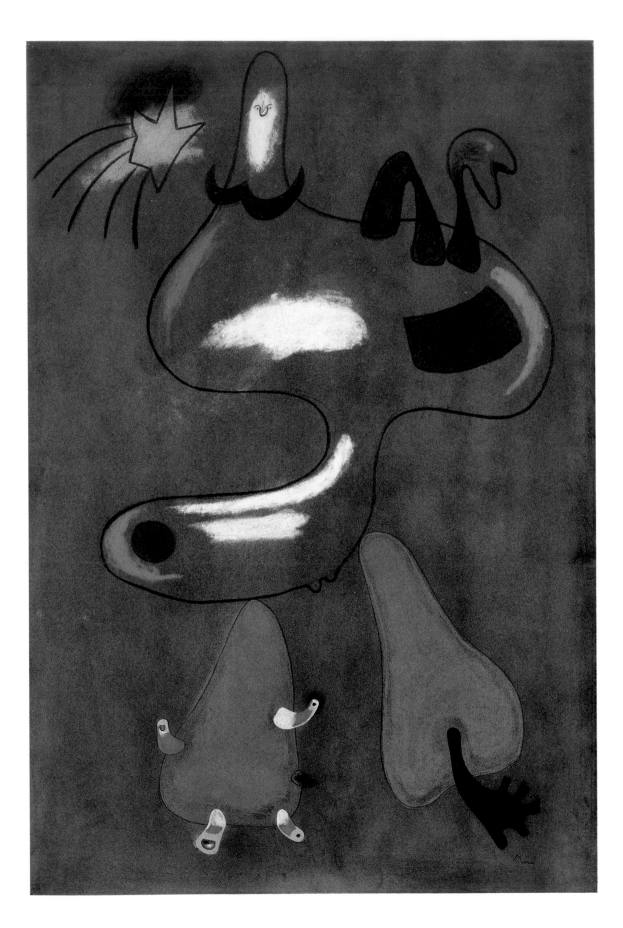

Figure, 1934 Cat. 35

The Lovers, 1934 Cat. 36

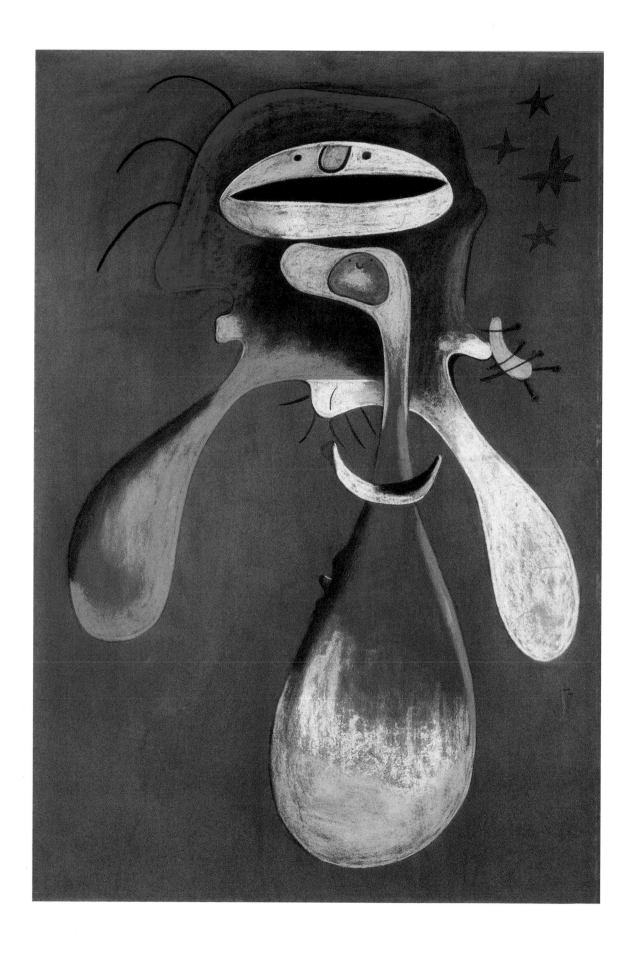

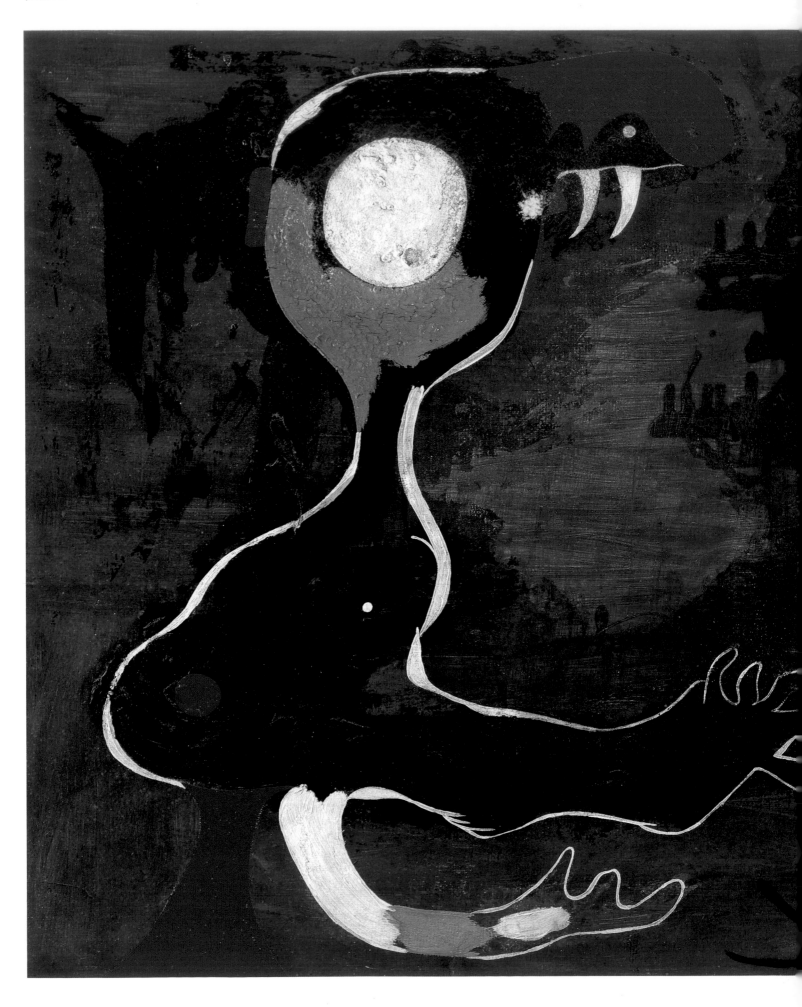

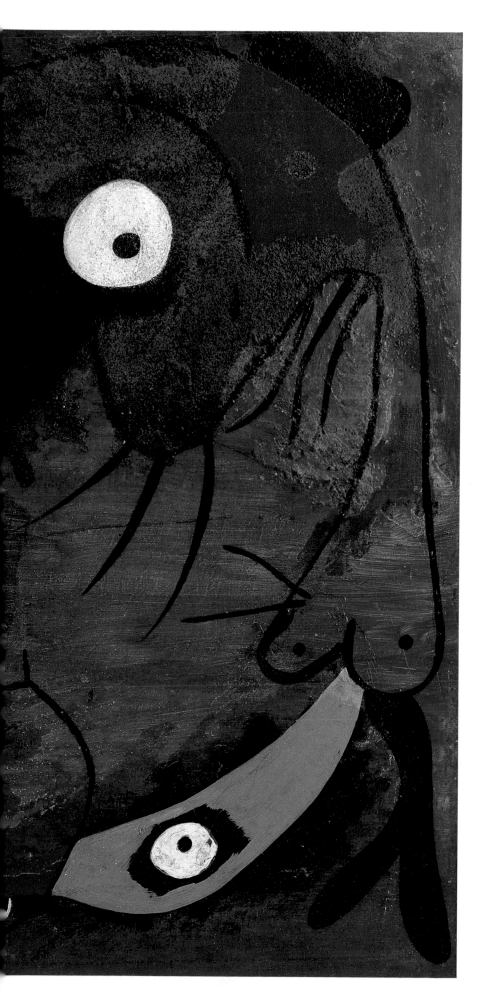

Two Women, 1935 Cat. 37

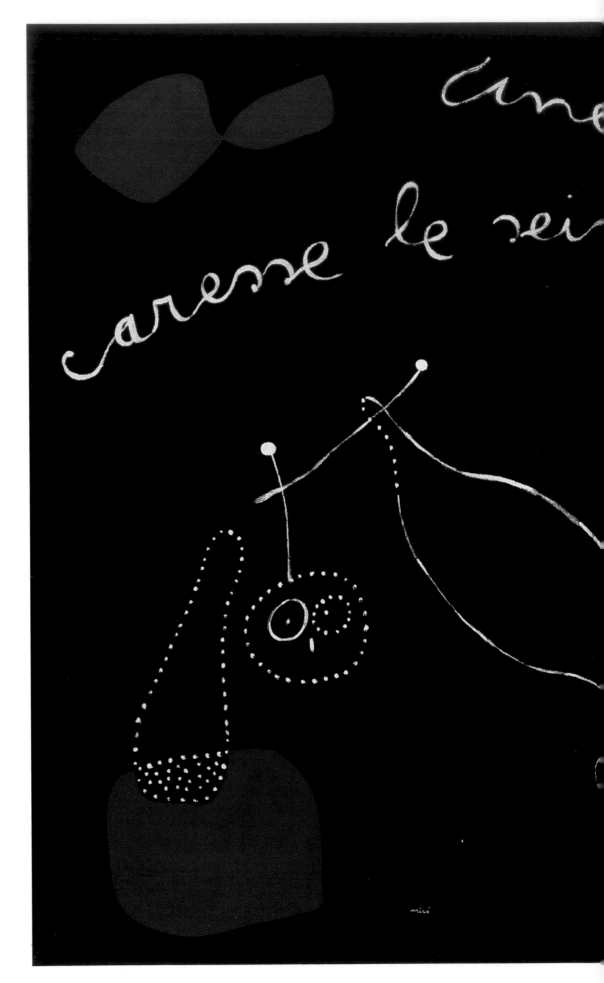

'A star caresses the breast of a black woman',
1938 Cat. 42

Woman and Snake, 1942 Cat. 112

Women and Birds in front of the Sun, 1942 Cat. 115

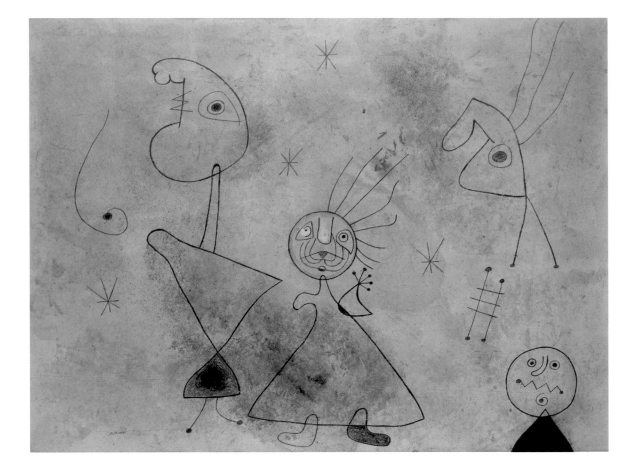

Woman Dreaming of Escape, 1942 Cat. 114

*The Snake with Red Poppies Moving through a Field of Violets Inhabited by
Lizards in Mourning*, 1947 Cat. 45

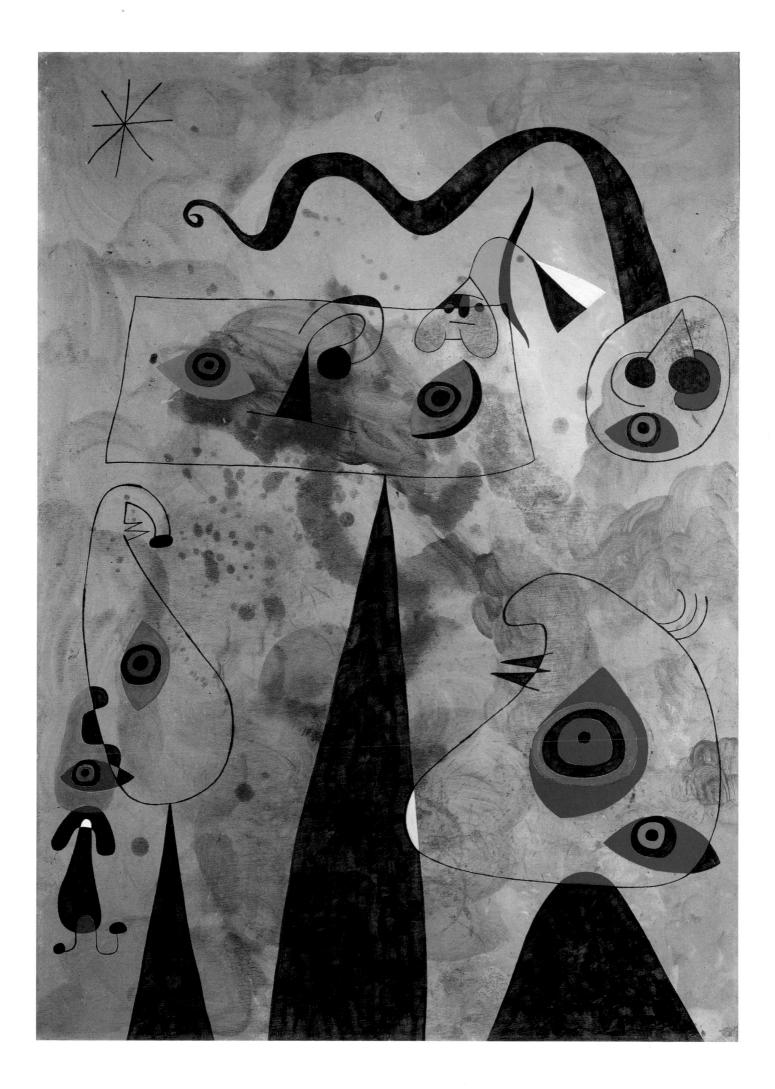

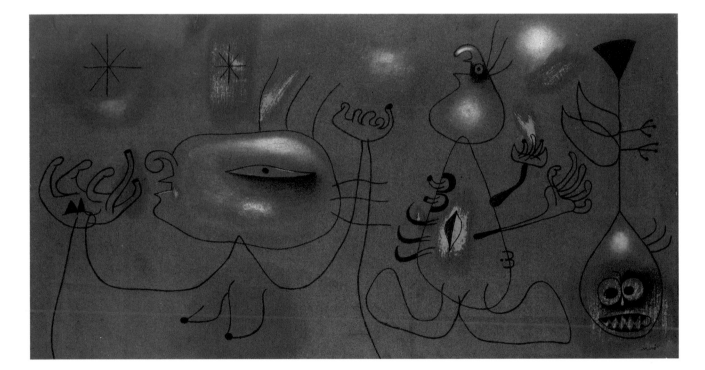

Woman, Bird, Star, 1942 Cat. 113

Figure, Bird, Star, 1942 Cat. 111

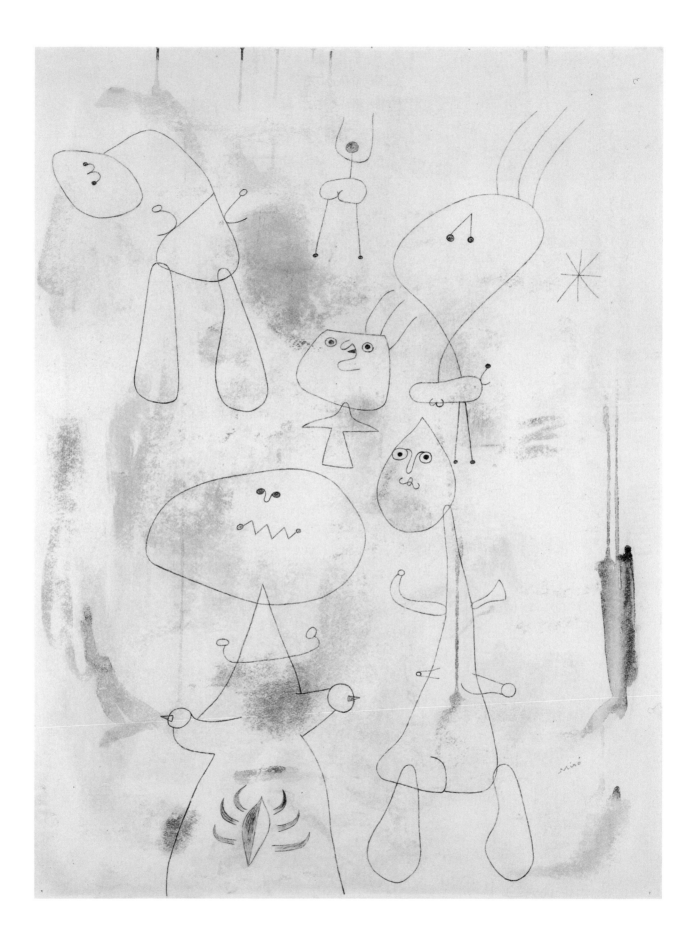

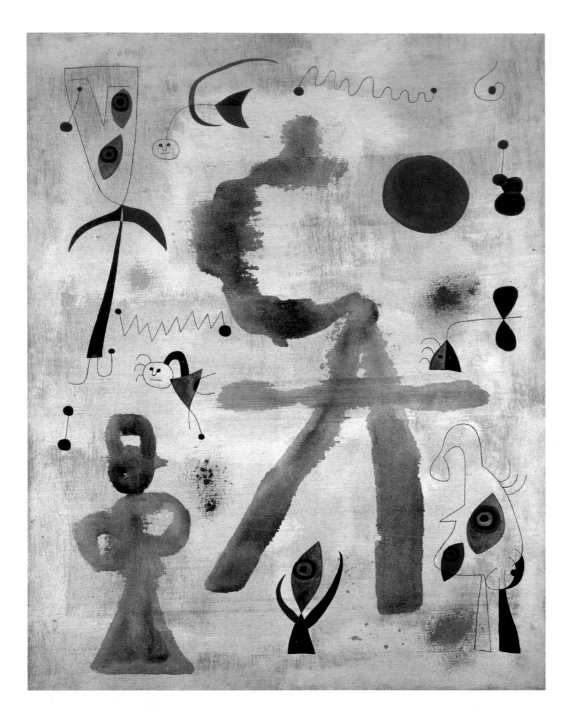

Figures and Birds in front of the Sun, 1946 Cat. 44

Woman Dreaming of Escape, 1945 Cat. 43

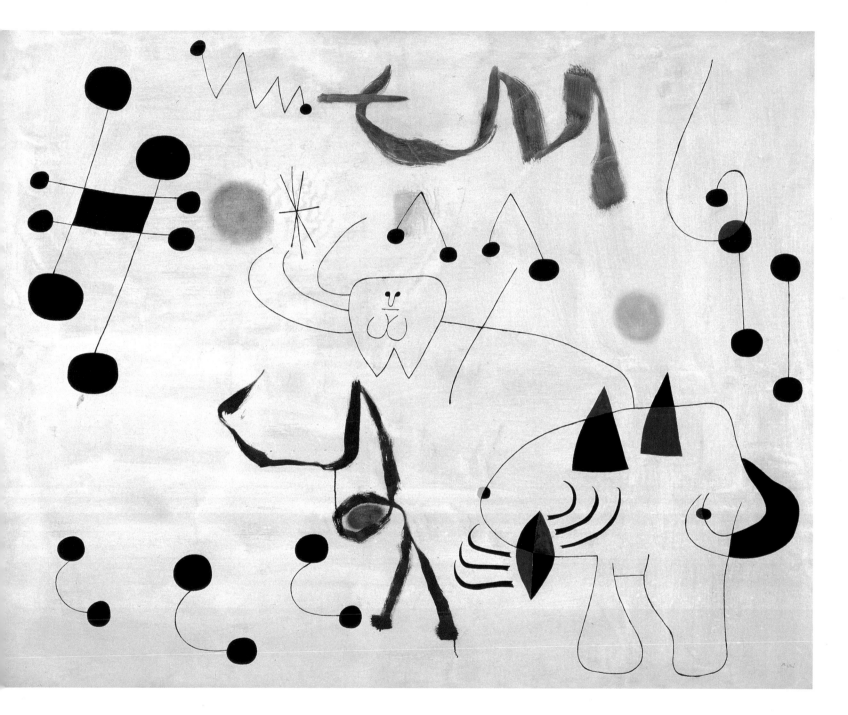

Head, 1949 Cat. 119

Figure, 1949 Cat. 118

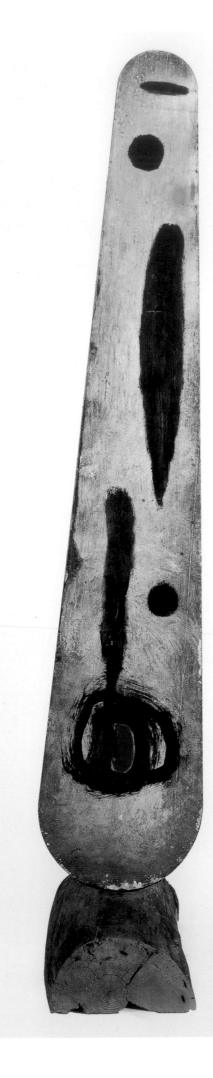

The Ironing Board, 1953 Cat. 48

Painting Object, 1953 Cat. 47

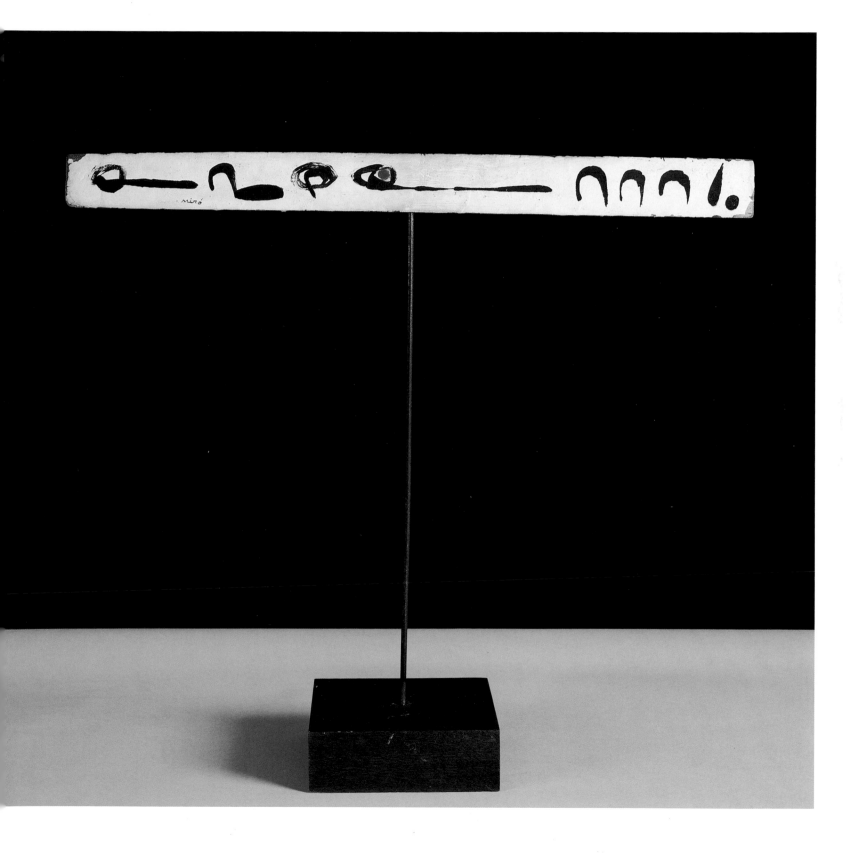

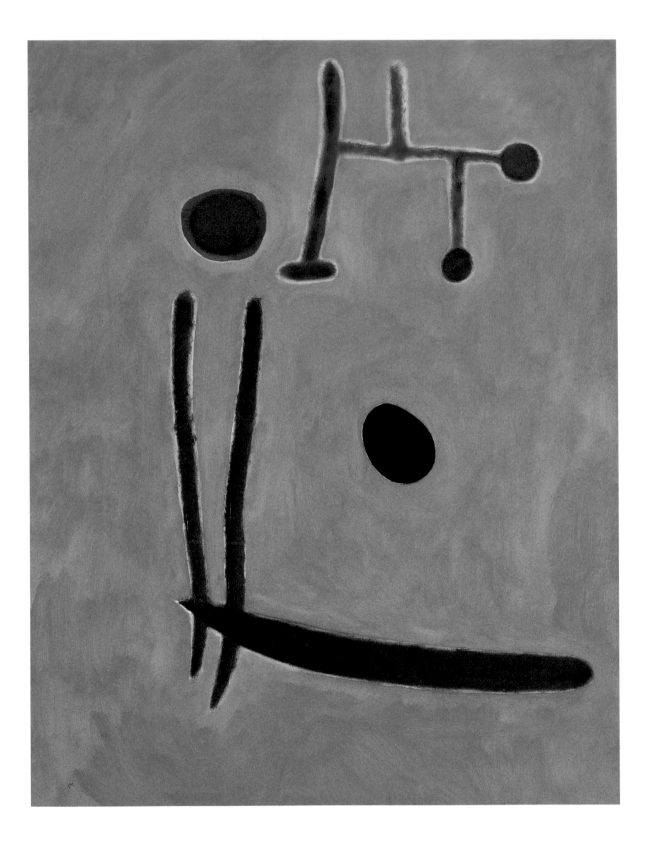

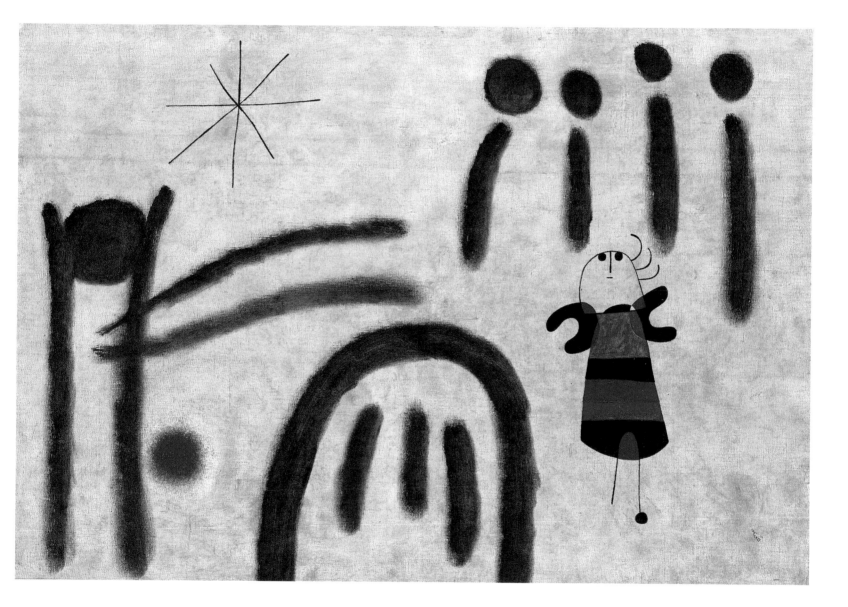

Birds in Space, 1960 Cat. 50

The Little Fair-haired Girl at the Amusement Park, 1950 Cat. 46

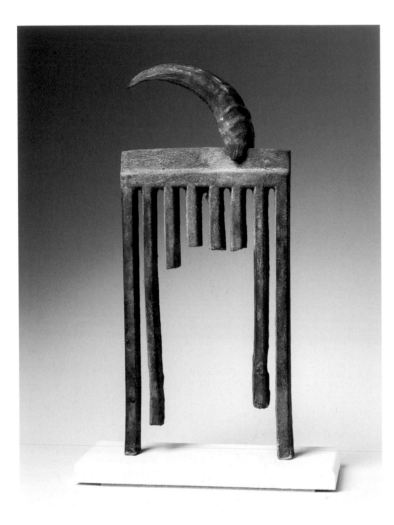

Woman, 1967 Cat. 121

Woman, 1946 Cat. 117

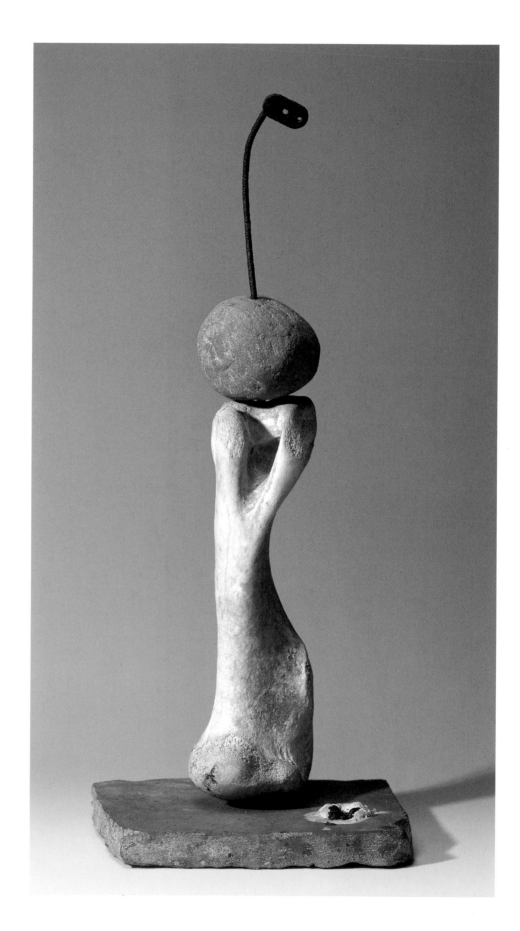

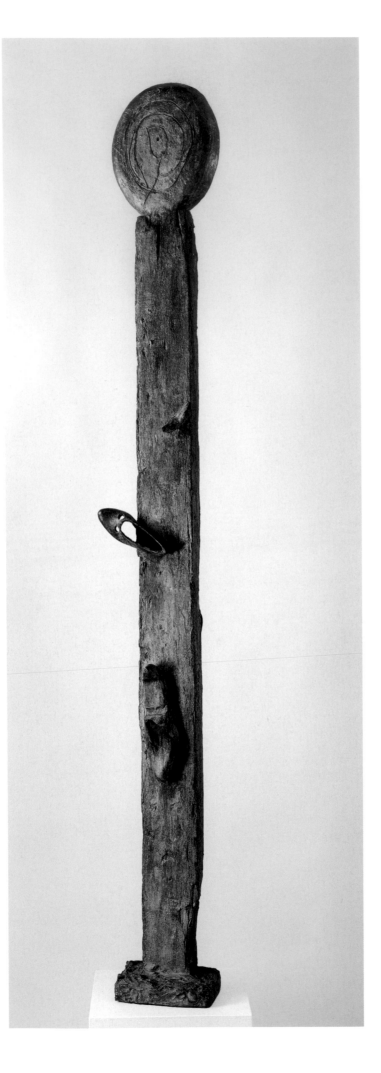

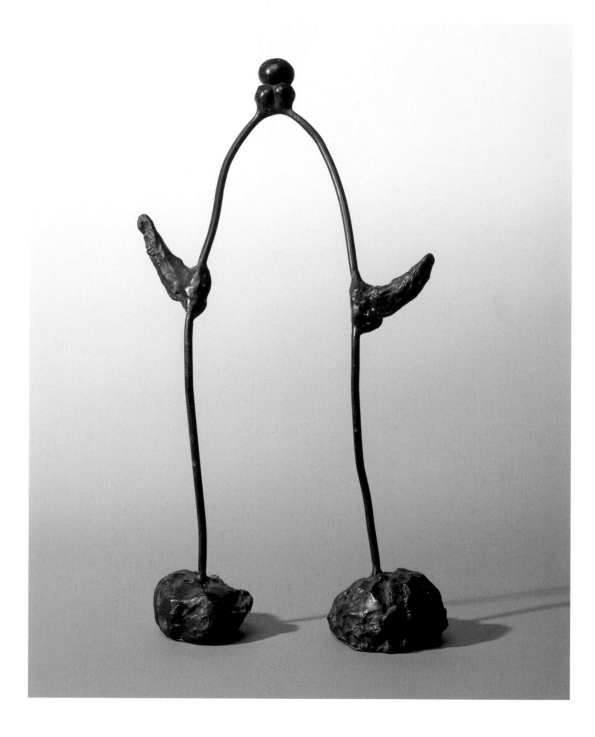

Totem, N1, 1972 Cat. 124

Woman, 1970 Cat. 123

Man and Woman, 1969 Cat. 122

The Caress of a Bird, 1967 Cat. 120

Blue I, 1961 Cat. 51

Blue II, 1961 Cat. 52

Blue III, 1961 Cat. 53

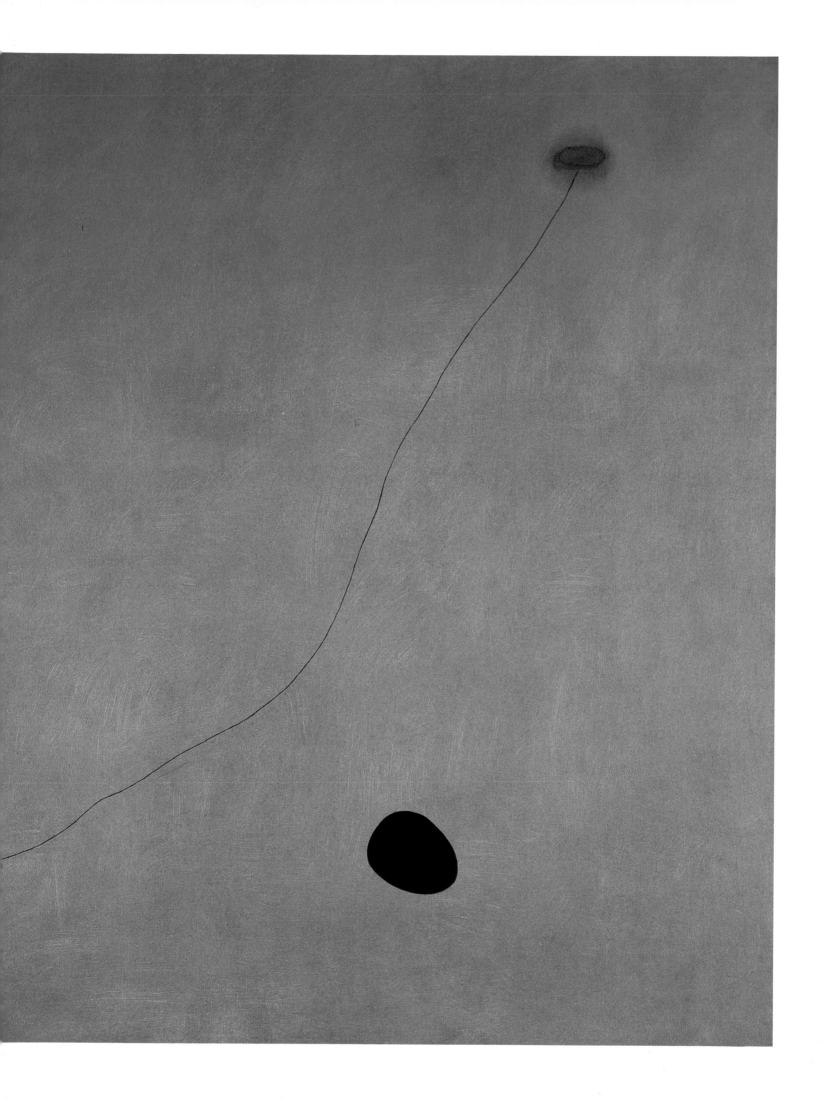

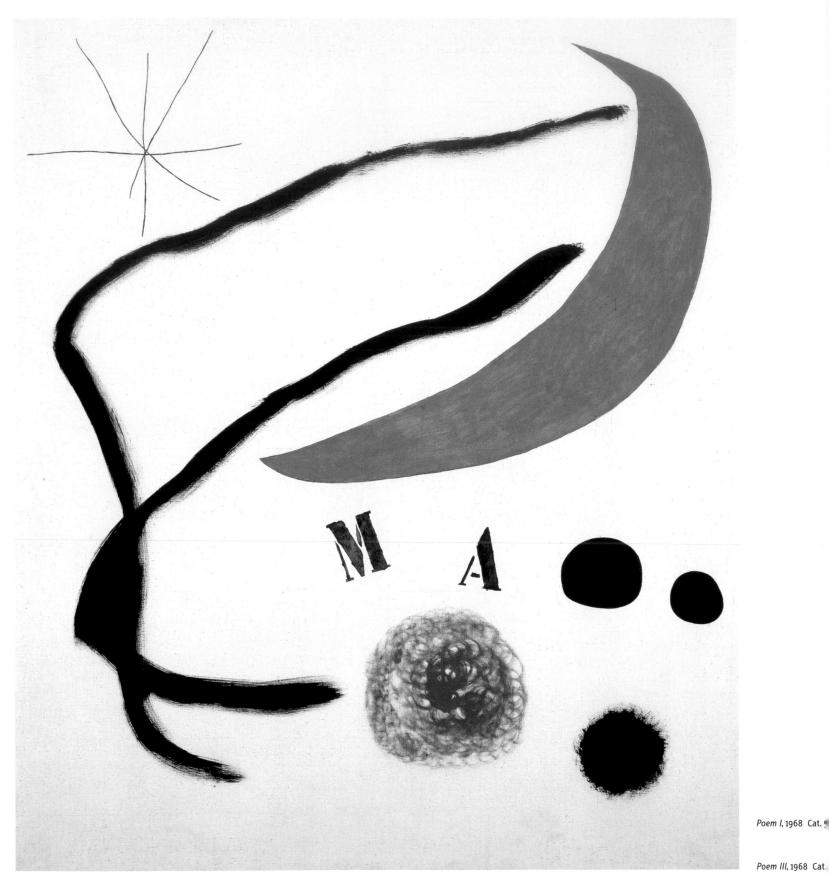

Poem I, 1968 Cat.

Poem III, 1968 Cat

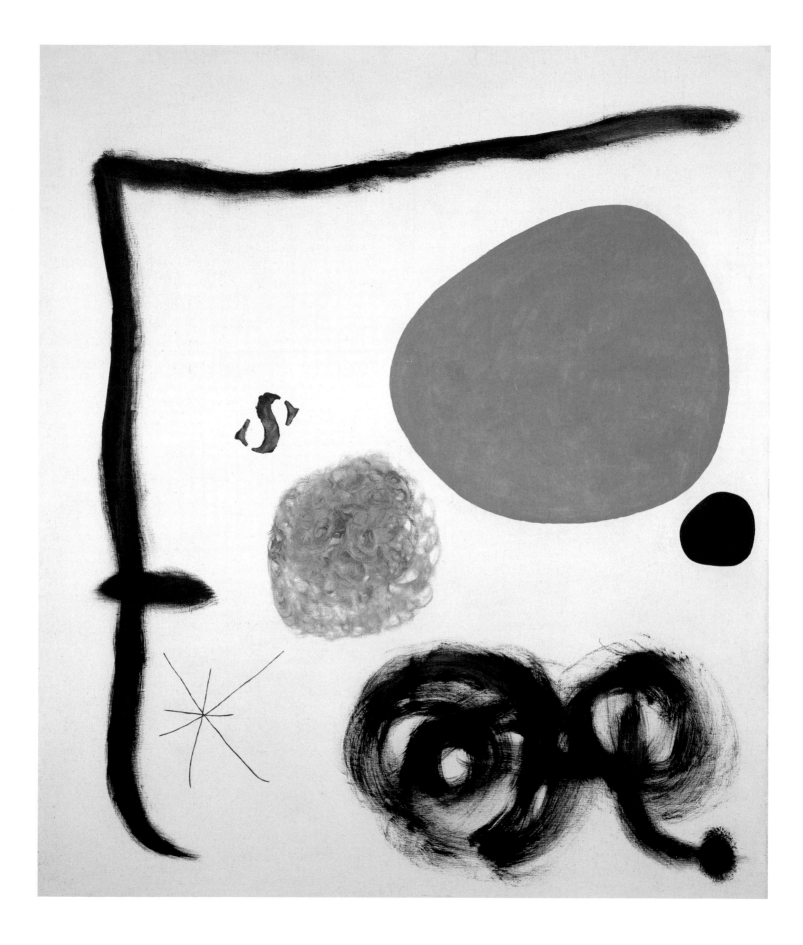

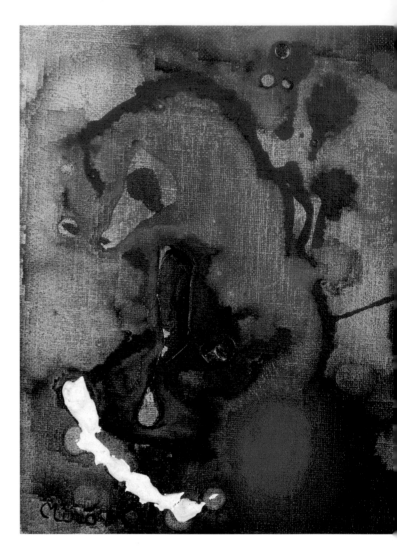

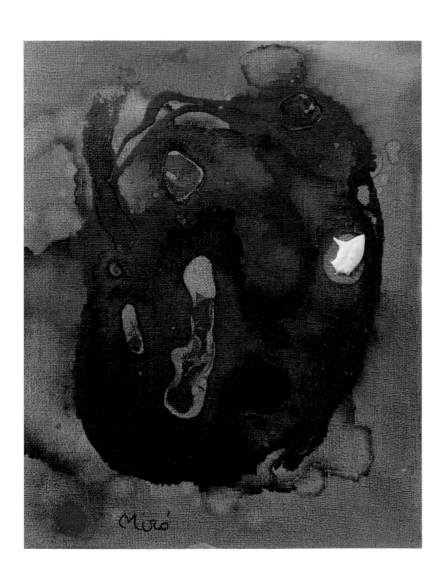

White Accent III, 1963 Cat. 54

White Accent V, 1963 Cat. 55

Untitled, 1964 Cat. 116

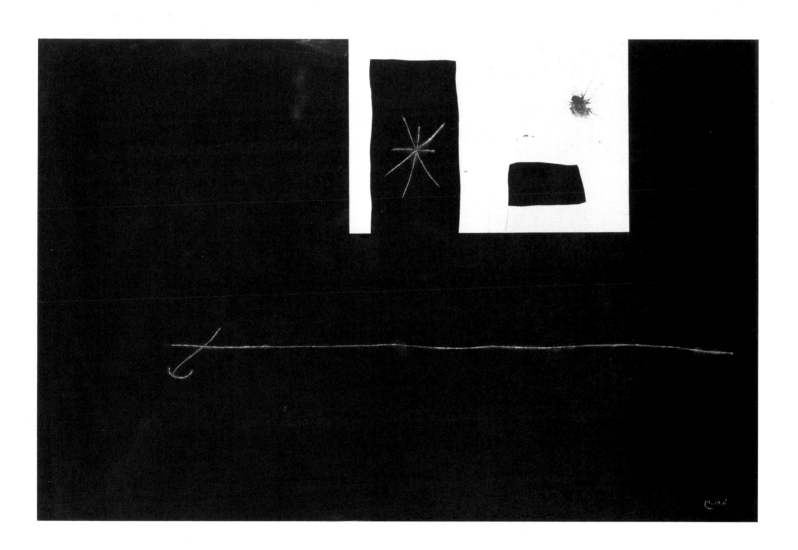

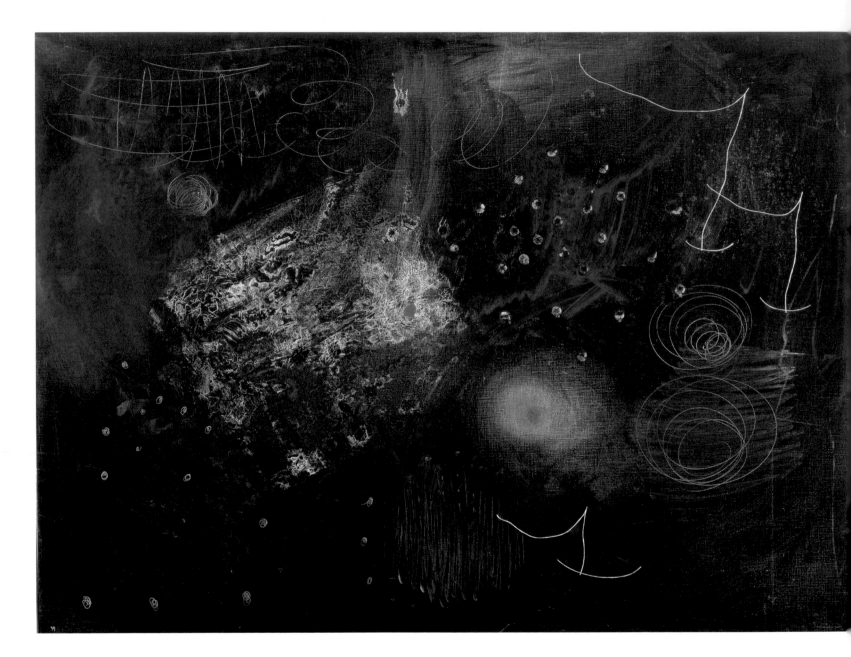

Three Birds in Space, 1959 Cat. 49

The First Spark of Day, 1966 Cat. 56

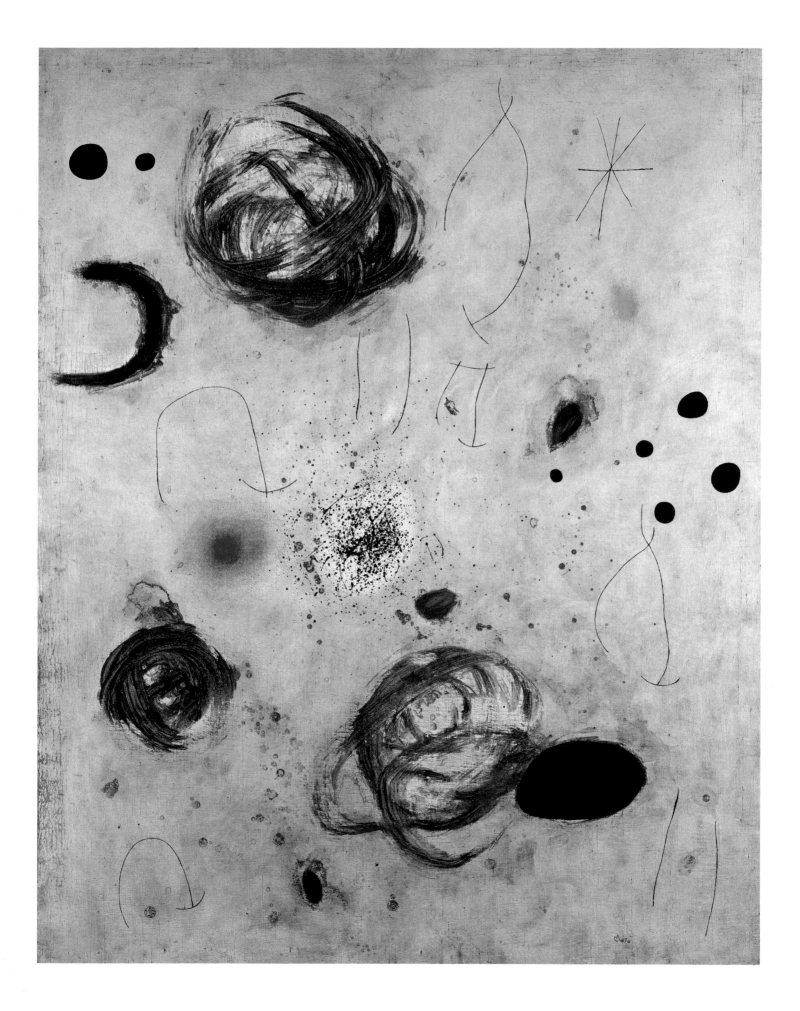

Red Accent in the Silence, 1968 Cat. 57

Letters and Numbers Attracted by a Spark, 1968 Cat. 60

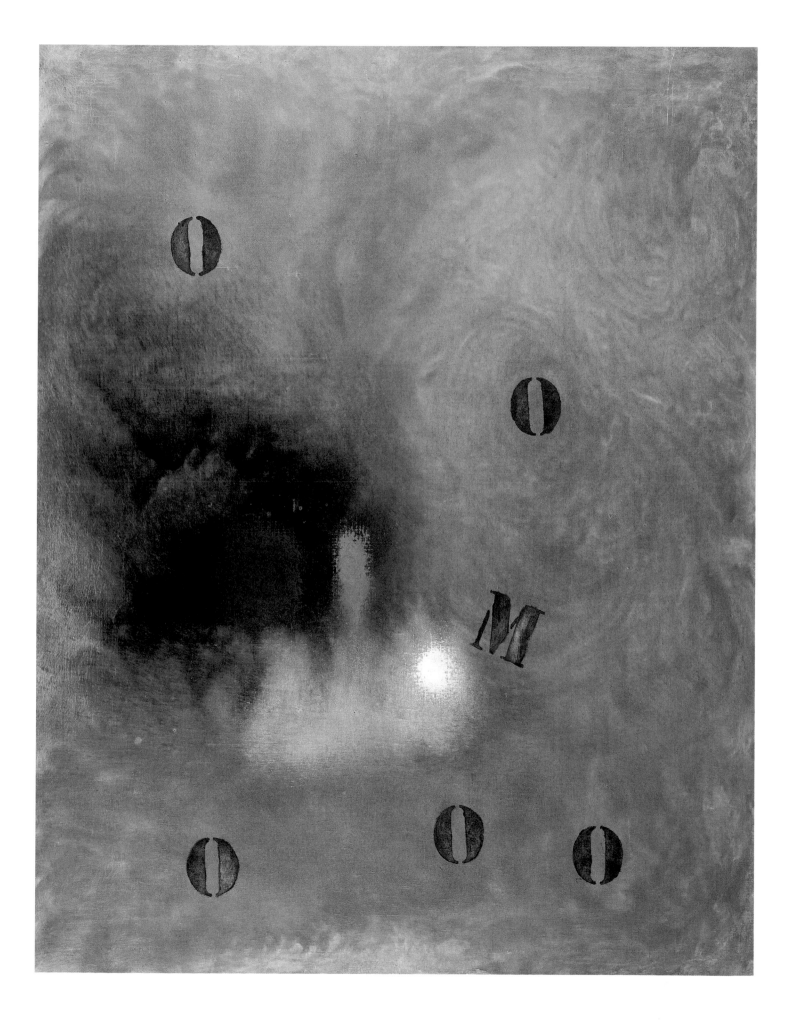

Woman and Birds in a Landscape, 1970–74 Cat. 61

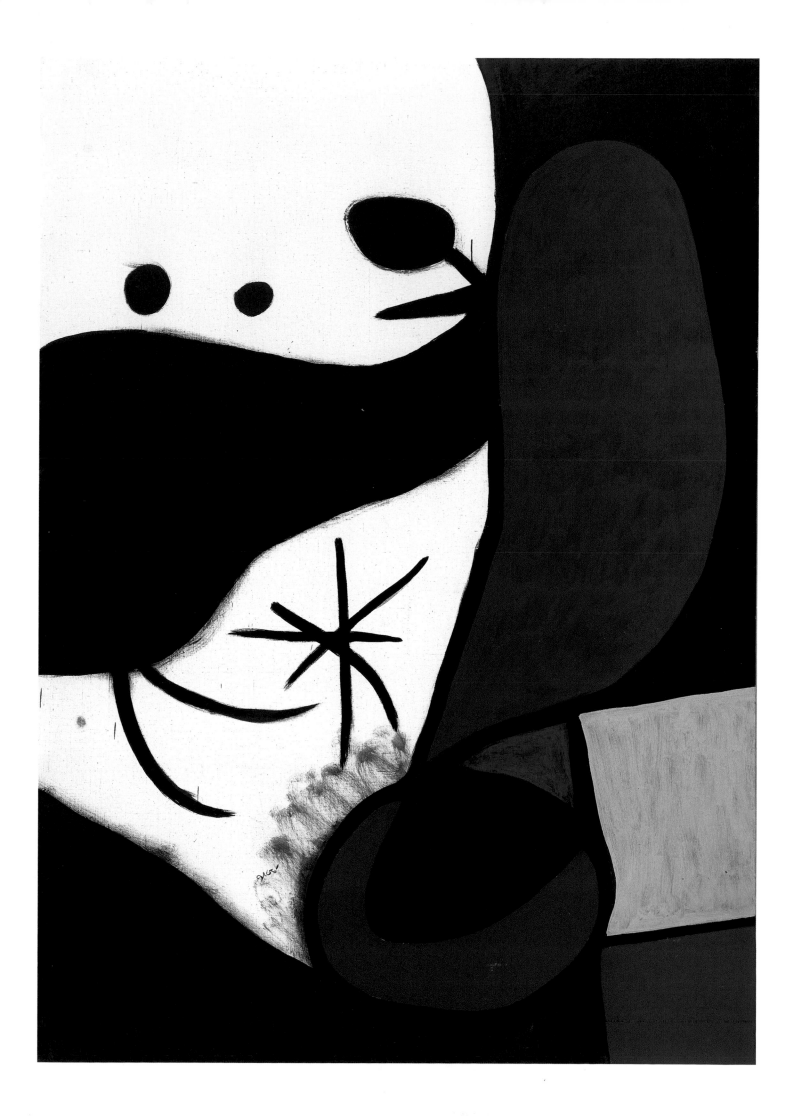

BIOGRAPHY

1893
Joan Miró is born on 20 April at No. 4, Passatge del Crèdit in Barcelona. His father, Miquel Miró i Adzerias, is a goldsmith and watchmaker from Cornudella near Tarragona; his mother, Dolors Ferrà i Oromí, hails from Palma de Mallorca. He grows up in Barcelona, Cornudella and Palma de Mallorca.

1901
First drawings.

1906
First surviving sketchbook, with landscape drawings of Cornudella and Majorca.

1907
Miró attends business school and, at the same time, La Llotja art academy (until 1910), Barcelona, where Pablo Picasso had studied. His teachers are Modest Urgell (landscape painter) and Josep Pascó (applied art).

1910
Miró joins the firm of Dalmau i Olivares (ironware and chemicals) to learn bookkeeping.

1911
He goes down with typhoid. To recuperate, he spends a long period in Mont-roig del Camp, where his parents have just bought a farmhouse. He exhibits two paintings at the sixth Exposición Internacional de Arte in Barcelona, his first show.

1912
Studies at Francesc Galí's art school (until 1915), where he meets Joan Prats, Josep Francesc Ràfols, Enric Cristòfol Ricart and Josep Llorens Artigas, who become lifelong friends. Together they visit an exhibition of Cubist painting at the Dalmau Gallery, Barcelona.

1913
Miró enrols at the Circol Artístic de Sant Lluc in Barcelona, where he attends drawing classes.

1916
Miró becomes acquainted with art dealer Josep Dalmau. During World War I, when Spain was neutral, the Dalmau Gallery was a meeting place for such exiled French artists as Albert Gleizes, Marie Laurencin and Francis Picabia.

1917
Miró meets Francis Picabia, publisher of the Dadaist periodical *391*, in Barcelona. Miró devours avant-garde literature, such as Pierre Reverdy's newspaper *Nord-Sud*, Albert Birot's *SIC* and Guillaume Apollinaire's poetry (*Le Poète assassiné*).

1918
Miró, Artigas, Ràfols and Ricart join the progressive Agrupació Courbet association of artists. Miro's first solo exhibition in Barcelona, featuring 64 works, is held at the Dalmau Gallery.

1919
The artist works on landscapes in Mont-roig, and paints *Nude with a Mirror* (illus. p. 123) and *Self-Portrait* (illus. p. 121). The Agrupació Courbet breaks up towards the end of the year.

1920
In late February, Miró makes his first trip to Paris. He and Ricart call on Pablo Picasso at his studio. In mid-June, he returns to Mont-roig and later Barcelona. He continues in this rhythm—spending some months each year in Paris and then returning to Catalonia—until 1932. Two pictures are shown in the Catalan section of the Salon d'Automne in Paris. Miró also takes part in the 'French Avant-garde' exhibition in Barcelona along with Pablo Picasso, Gino Severini, Paul Signac, Henri Matisse, Juan Gris and Georges Braque. His works reflect Cubist influences.

1921
Miró moves in to Pablo Gargallo's studio at 45, rue Blomet in Paris. He meets André Masson, who works in the studio next door, and becomes friends with Max Jacob. His first solo exhibition in Paris, at the Galerie La Licorne, organised by Josep Dalmau, is a commercial failure. Back in Mont-roig, he begins work on *The Farm* (illus. p. 125). He finishes this key early work of his poetic realism phase the following year in Barcelona and Paris.

1923
Through André Masson, Miró gets to know Michel Leiris and probably Georges Limbour, Robert Desnos, Raymond Queneau, Armand Salacrou and Antonin Artaud. In Mont-roig, he starts work on *Catalan Landscape (The Hunter)* (illus. p. 127) and *Pastorale* (illus. p. 126) among others. They mark a shift away from accurate, detailed depiction towards a fantastic, enigmatic coded idiom.

1924
Intellectuals, poets, writers and artists such as Max Jacob, Michel Leiris, Georges Limbour, Benjamin Péret, Armand Salacrou, Roland Tual and Joan Miró now regularly meet at the rue Blomet. Miró works on pictures with grey grounds, such as *The Family* (illus. p. 129) or *Toys* (illus. p. 128). At the end of the year, André Breton's *Manifeste du surréalisme* is published, his first Surrealist manifesto.

1925
Louis Aragon and Paul Eluard visit Miró in the rue Blomet. Miró meets André Breton there for the first time, who later acquires the *Catalan Landscape* (*The Hunter)* (illus. p. 127) and *Motherhood* (illus. p. 115). The signatures of the artists in the Surrealist group around Breton and from the rue Blomet feature on the invitation card to Miró's second solo exhibition in Paris, which is organised by Jacques Viot at the Galerie Pierre. An essay by Benjamin Péret appears in the catalogue. Miró takes part in the joint exhibition 'La Peinture surréaliste' in Paris with Max Ernst, Jean Arp, André Masson, Giorgio de Chirico, Paul Klee and Man Ray. Ernest Hemingway buys *The Farm* (illus. p. 125). In Mont-roig in the summer, Miró begins the series of *Dream Pictures*, which preoccupies him until 1927.

1926
In Paris, Miró moves in to a new studio, at 22, rue Tourlaque in Montmartre. Max Ernst, Jean Arp and probably Paul Eluard are now his neighbours. He collaborates with Max Ernst on the stage sets of *Romeo and Juliet* for Serjei Diaghilev's *Ballets Russes*. Breton and various other Surrealists protest against the performance, which in their view is a bourgeois event. At the Brooklyn Museum in New York, Miró takes part in his first exhibition of contemporary art, the 'International Exhibition of Modern Art'.

1927
Miró does his first book illustrations, for *Gertrudis* by the Catalan poet J.V. Foix. Henceforth he is frequently asked to illustrate the works of novelists and poets.

1928
Pierre Loeb organises a solo exhibition at the Galerie Bernheim & Cie. in Paris, featuring 41 works. This is the artist's first financially successful and critically acclaimed show. André Breton publishes *Le Surréalisme et la peinture* with commentaries on Miró, Jean Arp and Yves Tanguy. Miró travels to Belgium and Holland. The result is the *Dutch Interiors*.

1929
On 12 October Miró and Pilar Juncosa get married in Palma de Mallorca. After the wedding, the couple move into a flat in Paris. The journal *La Revolution surréaliste* publishes Breton's *Second Manifeste du surréalisme*.

1930
Looking for new forms of expression, Miró experiments intensively with materials alien to painting, such as various *objets trouvés*, wood, sand, clay, aluminium and paper. On 17 July Miró's only child, his daughter Maria Dolors, is born. The artist produces his first lithographs for Tristan Tzara's *L'Arbre des voyageurs*, the first of his many prints. In parallel, he works in Mont-roig on a series of works on Ingres paper (illus. pp. 154, 156, 157). Miró also completes his first sculpture object this year. In October, the Valentine Gallery puts on his first solo exhibition in New York.

1932
Miró now lives and works mainly at 4 Passatge del Crèdit in Barcelona, paying only brief visits to Paris. He designs the stage sets, costumes and props for *Jeux d'enfants*, performed by the *Ballets Russes*. Through Joan Prats, he makes the acquaintance of architect Josep Lluis Sert. Alexander Calder visits Miró in Mont-roig and puts on a circus performance with the latter's wire figures (illus. p. 18). Miró conceives small-scale works on wood (illus. p. 170).

1933
Miró works on 18 paintings based on collages he prepares (illus. pp. 158, 159). He takes part in the 'Exposition surréaliste' at the Galerie Pierre Colle, Paris. In Mont-roig, Miró works on collages with post cards, newspaper cuttings, etc. (illus. pp. 162, 163).

1934
The avant-garde periodical *Cahiers d'art* devotes an issue to Miró, and Yvonne Zervos organises the *Joan Miró* exhibition at *Cahiers d'art*'s gallery. The artist works on cartoons for tapestries (illus. pp. 177, 178–79). Towards the end of the year, he begins work on a first series of pastel pictures on velvet paper (illus. pp. 188, 189).

1935
Miró designs the cover of issue 7 of *Minotaure*, founded in 1933, which acts as the mouthpiece of the Surrealist movement until 1939. He begins to work on Masonite (illus. p. 183). A trip through Germany takes him to Cologne, Hamburg, Berlin, Dresden (where he meets the German art historian Will Grohmann) and Stuttgart.

1936
The Civil War in Spain prompts the artist to remain in France. Miró takes part in the 'Exposition surréaliste d'objets' at the Galerie Charles Ratton, Paris. At the turn of the year, he is represented at the 'Fantastic Art, Dada, Surrealism' exhibition at the Museum of Modern Art, New York.

1937
Miró attends the Académie de la Grande Chaumière, where he executes life drawings of the same name. For the Spanish Pavilion at the World Exhibition in Paris, Miró designs the now lost large-scale mural *The Reaper* (illus. p. 86). Picasso's *Guernica* is likewise displayed there.

1938
Miró collaborates with painter and graphic artist Louis Marcoussis on etchings subsequently printed at the workshops of Roger Lacourière and at the Stanley W. Hayter Studio in Paris. He spends the summer in Varengeville-sur-Mer, Normandy. André Breton and Paul Eluard invite him to the 'Exposition internationale du surréalisme' at the Galerie des Beaux-Arts, Paris.

1939
In Normandy, he produces the *Varengeville* series of small-scale works, in which the artist applies oils directly to untreated sacking.

1940
In Varengeville, Miró begins a series of 23 gouaches entitled *Constellations*, which he continues in Palma de Mallorca and completes in 1941 in Mont-roig. Since the German army is marching towards Paris and Spain has been under Franco's control since 1939, the artist and his family retreat to Palma de Mallorca. In Barcelona, Joaquim Gomis begins his photographic studies of Miró, which he continues into the 1960s.

1941
The first large Miró retrospective is mounted at the Museum of Modern Art, New York. The curator, James Johnson Sweeney, publishes a monograph to accompany the exhibition.

1942
At the end of the year, Miró returns to the Passatge del Crèdit in Barcelona.

1944
Miró works on ceramics together with Josep Llorens Artigas. The two friends later produce quite a number of sculptures and ceramic murals together. In addition, Miró has 50 lithographs from the *Barcelona* series printed at the Miralles workshop in Barcelona (illus. pp. 90–105); Joan Prats edits the series. Miró returns to painting, which he has put aside for four years.

1946
Miró has his first bronze sculpture cast at the Gimeno foundry in Barcelona.

1947
Miró is commissioned to do his first monumental mural in the restaurant of the Terrace Plaza Hotel in Cincinnati, Ohio. During the several months he spends in New York, he often works in Stanley W. Hayter's Studio 17. He becomes acquainted with Jackson Pollock. Thomas Bouchard films Miró at work in Studio 17 and in Carl Holty's studio. André Breton and Marcel Duchamp show works by Miró at 'Le Surréalisme en 1947: Exposition internationale du surréalisme', an exhibition mounted by the Galerie Maeght, Paris.

1949
Miró produces 90 colour lithographs illustrating Tristan Tzara's *Parler seul* sequence of poems. Henceforth his work is characterised by his use of gestural and impulsive symbols and colours, on the one hand, and precise figures, letters and pictorial symbols, on the other.

1950
In autumn, Miró moves into a flat in the Carrer de Folgaroles in Barcelona.

1953
In Barcelona, Thomas Bouchard continues work on his film *Around and About Miró*, which he began in New York in 1947.

1954
Miró is invited to the Venice Biennale, where he is awarded the Grand Prix for graphic art. A new period of intensive collaboration with Artigas begins, and by 1956 the two of them produce more than 200 works at Artigas's studio in Gallifa, Barcelona. A Miró retrospective is held at the Kaiser Wilhelm Museum, Krefeld.

1955
He paints a series of pictures on card. After this, he gives up painting once again. Miró takes part in the first documenta in Kassel, as well as in subsequent ones, in 1959 and 1964.

1956
Miró gives up his studio in the Passatge del Crèdit and settles in Palma de Mallorca, where Josep Lluis Sert has designed him a studio, which the artist fits out over the next two years. Miró and Artigas begin work on two monumental ceramic walls for the UNESCO building in Paris. The following year, he and Artigas visit the caves of Altamira in connection with this work.

1958
A volume of Paul Eluard's *A Toute Epreuve*, with 80 woodcuts by Miró, is launched at an exhibition at the Galerie Berggruen, Paris.

1959
Miró returns to painting. The Museum of Modern Art, New York, and the Los Angeles County Museum mount a comprehensive retrospective of the artist's work. Miró is awarded the 1958 Guggenheim Award for the murals of the UNESCO building in Paris. Joaquim Gomis's photographic record *The Miró Atmosphere* is launched at the Pierre Matisse Gallery, New York.

1960
Miró acquires the 17th-century villa Son Boter, directly beside his house and studio in Palma. It provides further studio space.

1961
Jacques Dupin's biography of Miró and the *Constellations* album with a text and poems by André Breton appear.

1962
Retrospective at the Musée National d'Art Moderne, Paris.

1964
The building designed by Josep Lluis Sert for the Fondation Maeght is opened in Saint-Paul-de-Vence. Miró installs the *Labyrinth* in the adjoining garden, with sculptures jointly conceived by him and Josep Llorens Artigas. Roland Penrose organises a retrospective at the Tate Gallery in London. Miró goes to London for the exhibition.

1966
First monumental bronze sculptures—the *Solar Bird* and *Lunar Bird*. Miró pays his first visit to Japan to attend his large retrospective at the National Museum of Art in Tokyo.

1969
The 'Miró Otro' exhibition is put on at the Architect's College in Barcelona, for which he paints a piece of glass measuring 70 square meters. At the end of the exhibition, the work is destroyed by the artist. Retrospective at the Haus der Kunst, Munich.

1970
Ceramic murals for the Japanese pavilion at the World Exhibition in Osaka and for Barcelona Airport.

1972
Miró and Josep Royo begin work in Tarragona on the *Sobreitexims*, during which he sprinkles petrol on handmade tapestries he designed himself, sets fire to them, puts it out and reworks them.

1975
The Fundació Joan Miró, Centre d'Estudis d'Art Contemporani in Barcelona, which was founded in 1972, opens its doors to the public in a building designed by Josep Lluis Sert. The foundation possesses about 200 paintings, 50 sculptures, 5,000 drawings and all of Miró's prints.

1977
Following illustrations for *Ubu roi*, Miró makes puppets, masks and curtains for *Mori el Merma* (Death to the Tyrant), a play performed in 1978 by the Catalan La Claca company in Barcelona. La Claca was banned during the Franco regime.

1978
The Museo Español de Arte Contemporáneo in Madrid puts on a retrospective. King Juan Carlos and Queen Sofia decorate Miró with the Gran Cruz de Isabella la Catolica.

1980
King Juan Carlos confers the Medalla de Oro de las Bellas Artes españolas on Miró.

1983
Numerous exhibitions and events are held to celebrate Miró's ninetieth birthday, including those at the Museum of Modern Art, New York, and the Fundació Joan Miró, Barcelona. On 25 December Miró dies in Palma de Mallorca. He is buried in the Montjuïc cemetery in Barcelona.

1992
The Fundació Pilar i Joan Miró, set up by the artist himself, is opened in Palma de Mallorca.

James Johnson Sweeney. 'Joan Miró: Comment and Interview'. *Partisan Review* 15, no. 2 (February 1948).

Rosamond Bernier. 'Miró céramiste'. *L'Œil*, no. 17 (1956).

Ernst Scheidegger (ed.). *Joan Miró: Gesammelte Schriften, Fotos, Zeichnungen.* Zurich, 1957.

Joan Miró. 'Ma Dernière Œuvre est un mur'. *Derrière le Miroir*, no. 107–9 (June–August 1958).

Edouard Roditi. 'Interview with Joan Miró'. *Arts* 33, no. 1 (October 1958).

Yvon Taillandier. 'Je travaille comme un jardinier'. Interview with Joan Miró. *XXe Siècle Mensuel* 1, no. 1 (February 1959).

Joan Miró. 'Cómo hice los murales para la UNESCO'. *Blanco y negro*, no. 2457 (June 1959).

Rosamond Bernier. 'Propos de Joan Miró'. *L'Œil*, no. 79–80 (July–August 1961).

Denys Chevalier. 'Miró'. *Aujourd'hui: Art et Architecture* 7, no. 40 (November 1962).

Baltasar Porcel. 'Joan Miró o l'equilibri fantàstic'. *Serra d'Or* 8, no. 4 (April 1966).

Bruno Friedman. 'Espíritu creador en el arte y en la ciencia: Entrevista con Joan Miró'. *Impacto: Ciencia y sociedad* 19, no. 4 (October–December 1969).

Yvon Taillandier. 'Miró: Maintenant je travaille par terre...'. *XXe Siècle* 36, no. 43 (December 1974).

Gaëtan Picon (ed.). *Joan Miró: Carnets catalans, Dessins et textes inédits.* Geneva, 1976.

Georges Raillard. *Miró: Ceci est la couleur de mes rêves.* Paris, 1977.

Santiago Amón. 'Tres horas con Joan Miró'. *El País Semanal* (June 1978).

Daniel Marchesseau. 'Interview de Joan Miró par Daniel Marchesseau à Saint-Paul-de-Vence', 14 October 1978. *L'Œil*, no. 281 (December 1978).

Lluís Permanyer. 'Revelaciones de Joan Miró sobre su obra'. *Gaceta ilustrada*, no. 1124 (April 1978).

Miguel Fernández-Braso. 'En el taller de Miró'. *Guadalimar*, no. 54 (November 1980).

Michael Gibson. 'Miró: When I see a tree... I can feel that tree talking to me'. *Art News* 79, no. 1 (January 1980).

Duncan Macmillan. 'A Conversation with Joan Miró: Catalan'. *Artscanada* 37, no. 3 (December 1980/January 1981).

Margit Rowell (ed). *Joan Miró: Selected Writings and Interviews.* The Documents of Twentieth Century Art. London, 1987.

——. *Joan Miró: Ecrits et entretiens.* Paris, 1995.

BIBLIOGRAPHY

Catalogues and catalogues raisonnés

Jacques Dupin. *Joan Miró: Leben und Werk.* Cologne, 1961.

Joan Miró: Lithographs. IV vols. Paris, 1972–82.

Miró in the Collection of The Museum of Modern Art. Ed. William Rubin. Exh. cat. New York, The Museum of Modern Art, 1973.

Obra de Joan Miró. Barcelona, Fundació Joan Miró, 1988.

Joan Miró: Campesino catalán con guitarra, 1924. Exh. cat. Madrid, Museo Thyssen-Bornemisza, 1997.

Miró: La Collection du Centre Georges Pompidou, Musée National d'Art Moderne. Exh. cat. Paris, Musée National d'Art Moderne, Centre Georges Pompidou, 1999.

Joan Miró, Catalogue raisonné: Paintings. Ed. Jacques Dupin and Ariane Lelong-Mainaud. Vol. Iff. (vols. I–IV published so far). Paris, 1999ff.

Joan Miró: Métamorphoses des formes, Collections de la Fondation Maeght. Exh. cat. Saint-Paul-de-Vence, Fondation Maeght, 2001.

Sources

Joan Miró. 'Comentaris'. *La Publicitat* (14 July 1928).

Georges Duthuit. 'Où allez-vous, Miró?'. *Cahiers d'art* 11, no. 8–10 (1936).

Monographs

Shuzo Takiguchi. *Miró.* New York, 1940.

Michel Leiris. *The Prints of Joan Miró.* New York, 1947.

Clement Greenberg. *Joan Miró.* New York, 1948.

Raymond Queneau. *Joan Miró ou le poète préhistorique.* Paris, 1949.

Jacques Prévert and G. Ribemont-Dessaignes. *Joan Miró.* Paris, 1956.

Walter Erben. *Joan Miró.* Trans. Michael Bullock. London, 1959.

Roland Penrose. *Miró.* London, 1970.

Jacques Dupin, Francesc Català-Roca and Joan Prats. *Miró escultor.* Barcelona, 1972.

Margit Rowell. *Joan Miró: Peinture-Poésie.* Paris, 1976.

Werner Schmalenbach. *Joan Miró: Zeichnungen aus den späten Jahren.* Frankfurt, Berlin and Vienna, 1982.

Rosa Maria Malet. *Miró.* Barcelona, 1983.

Guy Weelen. *Miró.* Cologne, 1984.

Rober S. Lubar. 'Joan Miró before *The Farm*, 1915–1922: Catalan Nationalism and the Avant-garde'. Ph.D. diss. New York University, 1988.

Victoria Combalía. *El descubrimiento de Miró: Miró y sus críticos 1918–1929*. Barcelona, 1990.

Rosa Maria Malet. *Miró*. Barcelona, 1992.

Domènec Corbella i Llobet. *Entendre Miró, anàlisi del llenguatge mironià a partir de la Sèrie Barcelona 1939–44*. Barcelona, 1993.

Pere Gimferrer. *Las raices de Miró*. Barcelona, 1993.

Ernst Scheidegger. *Joan Miró in Catalonia: Traces of an Encounter*. Paris, 1993.

Hubertus Gassner. *Joan Miró: Der magische Gärtner*. Cologne, 1994.

Barbara Catoir. *Miró on Mallorca*. Munich and New York, 1995.

Victoria Combalía. *Picasso—Miró: Miradas cruzadas*. Madrid, 1998.

Pilar Cabañas. *La fuerza de Oriente en la obra de Joan Miró*. [Madrid], 2000.

Catalogues of solo exhibitions
1918—Barcelona, Dalmau Gallery, *Joan Miró*

1921—Paris, Galerie La Licorne, *Peintures et dessins de Joan Miró*

1941—New York, The Museum of Modern Art, *Joan Miró*, ed. James Johnson Sweeney

1954—Krefeld, Kaiser Wilhelm Museum, and Stuttgart, Württembergische Staatsgalerie, *Joan Miró*, text by Will Grohmann and Paul Wember

1957—Krefeld, Kaiser Wilhelm Museum, and Berlin, Haus am Waldsee, etc., *Miró: Das graphische Werk*, ed. Paul Wember

1959—Paris, Galerie Berggruen, *Joan Miró: Constellations*

1972—New York, Solomon R. Guggenheim Museum, *Joan Miró: Magnetic Fields*, ed. Rosalind E. Krauss and Margit Rowell

1972—Zurich, Kunsthaus, *Miró: Das plastische Werk*

1973—Hamburg, Kunstverein, *Joan Miró: Das graphische Werk*

1974—Paris, Grand Palais, *Joan Miró*

1980—St. Louis, MO, Washington University Gallery of Art, etc., *Joan Miró: The Development of a Sign Language*, text by Sidra Stich

1985—New York, Pierre Matisse Gallery, *Miró—Artigas: Terres de Grand Feu*. New York and Zurich

1986—Zurich, Kunsthaus, and Düsseldorf, Städtische Kunsthalle, *Joan Miró*

1987—Cologne, Museum Ludwig, *Miro: Der Bildhauer*, ed. Gloria Moure

1988—Frankfurt, Schirn Kunsthalle, *Miró: Gemälde, Plastiken, Zeichnungen und Graphiken*, Munich

1988—Rivoli, Castello di Rivoli Museo d'Arte Contemporanea, *Joan Miró: Viaggio delle figure*, ed. Rudi Fuchs et al., Milan

1988—Barcelona, Fundació Joan Miró, *Impactes: Joan Miró 1929–1941*

1989—Hanover, Kestner Gesellschaft, *Joan Miró: Arbeiten auf Papier 1901–1977*, ed. Carl Haenlein

1990—Munich, Kunsthalle der Hypo-Kulturstiftung, *Joan Miró: Skulpturen*

1993—Madrid, Museo Nacional Centro de Arte Reina Sofia, *Joan Miró Campo de Estrellas*, text by Margit Rowell

1993—New York, The Museum of Modern Art, *Joan Miró*, ed. Carolyn Lanchner

1993—Barcelona, Sala d'exposicions Portal de Santa Madrona, *Joan Miró: L'arrel i l'indret*

1994—Barcelona, Fundació Joan Miró, *Miró en escena*

1996—Las Palmas de Gran Canaria, Centro Atlántico de Arte Moderno, *Joan Miró: Territorios creativos*

1996—Palma de Mallorca, Palma Town Hall, *Palma territori Miró*

1996—Palma de Mallorca, Fundació Pilar i Joan Miró, *Poesia a l'espai: Miró i l'escultura*

1997—Vaduz, Staatliche Kunstsammlung Liechtenstein, *Joan Miró: Skulptur, Graphik, Malerei*

1998—Stockholm, Moderna Museet, *Joan Miró: Creator of New Worlds*

1998—Palma de Mallorca, Fundació Pilar i Joan Miró, *Miró—Antigas: Ceramiques*

1999—Dortmund, Museum am Ostwall, *Joan Miró: Werke aus Mallorca*, ed. Tayfun Belgin

2000—Ludwigshafen, Wilhelm Hack Museum, *Miró: Mein Atelier ist mein Garten*, ed. Richard W. Gassen, Ostfildern-Ruit

2001—Vienna, Kunstforum, *Miró: Später Rebell*, ed. Evelyn Benesch and Ingried Brugger, Wolfratshausen

2001—Barcelona, Fundació Joan Miró, *Joan Miró: Desfilada d'obsessions*

Essays and further reading
André Breton. 'Surrealism and Painting' (1928). *Surrealism and Painting*, trans. Simon Watson Taylor. London, 1972.

Michel Leiris. 'Joan Miró'. *Documents* 1, no. 5 (October 1929).

Hilton Kramer. 'Miró's Paradox: What Happened after the "Death of Painting"?'. *New Criterion* 7, no. 5 (1989): 1–6.

Rory Doepel. 'Miró's Literary Sources with Particular Reference to Alfred Jarry's Surmâle'. *South African Journal of Art and Architectural History* 1, no. 4 (December 1990): 131–46.

Rosalind Krauss. 'Michel, Bataille et moi'. *October 68* (1994): 3–20.

Jonathan Fineberg, 'Miró und die Reime der Kindheit', in *Mit dem Auge des Kindes*. Ed. Helmut Friedel and Josef Helfenstein. Exh. cat. Munich, Lenbachhaus, 1995, pp. 148–61.

Christopher Green. 'The Infant in the Adult: Joan Miró and the Infantile Image', in *Discovering Child Art: Essays on Childhood, Primitivism and Modernism*. Ed. Jonathan Fineberg. Princeton, NJ, 1998, pp. 210–34.

Charles Palermo. 'Tactile Translucence: Miró, Leiris, Einstein'. *October 97* (2001): 31–50.

Peter Bürger, 'Befreiung und "refus": Miró und der Surrealismus', in *idem, Das Altern der Moderne*. Frankfurt, 2001, pp. 123–34.

Robert S. Lubar. 'La Méditerranée de Miró', in *Paris–Barcelone de Gaudí à Miró*. Exh. cat. Paris, Galeries nationales du Grand Palais, and Barcelona, Museu Picasso. Paris, 2001, pp. 399–421.

Joaquim Gomis
James Johnson Sweeney, Joaquim Gomis and Joan Prats. *Atmósfera Miró*. Barcelona, 1959.

Yvon Taillandier, Joaquim Gomis and Joan Prats. *Creación Miró 1961*. Barcelona, 1962.

Roland Penrose, Joaquim Gomis and Joan Prats. *Joan Miró: Creación en el espacio de Joan Miró*. Barcelona, 1966.

James Johnson Sweeney, Francesc Català-Roca, Joaquim Gomis and Joan Prats. *Joan Miró*. Barcelona, 1970.

Joaquim Gomis: Fotografies 1941–1981. Text by Daniel Giralt-Miracle. Barcelona, 1994.

Joaquim Gomis. Exh. cat. Eivissa, Església de l'Hospitalet, 2000.

LIST OF WORKS

Numbers preceded by 'CR' are those given in *Joan Miró, Catalogue raisonné: Paintings*, ed. Jacques Dupin and Ariane Lelong-Mainaud, vol. Iff. (vols. I–IV have appeared thus far), Paris, 1999ff.

PAINTINGS

Siurana, le sentier
1 *Siurana, the Path*, 1917
Oil on canvas, 60.6 × 73.3 cm
Museo Nacional Centro de Arte Reina Sofia, Madrid
(CR 33)
Illus. p. 124

Portrait de Vicens Nubiola
2 *Portrait of Vicens Nubiola*, c. 1917
Oil on canvas, 103.5 × 113 cm
Museum Folkwang, Essen
(CR 54)
Illus. p. 122

Nu au miroir
3 *Nude with a Mirror*, 1919
Oil on canvas, 113 × 102 cm
Kunstsammlung Nordrhein-Westfalen, Düsseldorf
(CR 71)
Illus. p. 123

Autoportrait
4 *Self-Portrait*, 1919
Oil on canvas, 73 × 60 cm
Musée National Picasso, Paris
(CR 72)
Illus. p. 121

La Ferme
5 *The Farm*, 1921–22
Oil on canvas, 132 × 147 cm
National Gallery of Art, Washington, DC
Gift of Mary Hemingway, 1987.18.1
(CR 81)
Illus. p. 125

Pastorale
6 *Pastorale*, 1923–24
Oil and charcoal on canvas, 60 × 92 cm
Museo Nacional Centro de Arte Reina Sofia, Madrid
(CR 89)
Illus. p. 126

Paysage catalan (Le Chasseur)
7 *Catalan Landscape (The Hunter)*, 1923–24
Oil on canvas, 64.8 × 100.3 cm
The Museum of Modern Art, New York, Purchase 1936
(CR 90)
Illus. p. 127

Les Joujoux
8 *Toys*, 1924
Oil and charcoal on canvas, 74 × 92 cm
Moderna Museet, Stockholm
(CR 95)
Illus. p. 128

Baigneuse
9 *Bather*, 1924
Oil on canvas, 72.5 × 92 cm
Musée National d'Art Moderne, Centre Georges Pompidou, Paris
(CR 104)
Illus. p. 132

Le Gentleman
10 *The Gentleman*, 1924
Oil on canvas, 52.5 × 46.5 cm
Öffentliche Kunstsammlung, Kunstmuseum, Basle
Gift of Marguerite Arp-Hagenbach, 1968
(CR 107)
Illus. p. 133

'Bonheur d'aimer ma brune' (peinture-poème)
11 *'The happiness of loving my brunette'* (painting-poem), 1925
Oil on canvas, 73 × 92 cm
Private collection
(CR 128)
Illus. p. 134

Peinture
12 *Painting*, 1925
Oil on canvas, 89 × 116 cm
Rosamond Bernier, New York
(CR 154)
Illus. p. 135

Peinture (L'Addition)
13 *Painting (The Sum)*, 1925
Oil on canvas, 195 × 129.2 cm
Musée National d'Art Moderne, Centre Georges Pompidou, Paris
(CR 168)
Illus. p. 137

Peinture (Personnage à la bougie)
14 *Painting (Man with a Candle)*, 1925
Oil on canvas, 116 × 89 cm
The Berardo Collection, Sintra Museum of Modern Art, Lisbon
(CR 181)
Illus. p. 136

'Amour' (peinture-poème)
15 *'Love'* (painting-poem), 1926
Oil on canvas, 146 × 114 cm
Museum Ludwig, Cologne
(CR 189)
Illus. p. 141

Peinture (Le Fou du roi)
16 *Painting (The King's Jester)*, 1926
Oil, charcoal and pencil on canvas, 114 × 146 cm
Milwaukee Art Museum
Gift of Mr. and Mrs. Maurice W. Berger
(CR 192)
Illus. p. 148

Peinture
17 *Painting*, 1926
Oil on canvas, 23.5 × 18 cm
Colección Alorda-Derksen, Barcelona
(CR 199)
Illus. p. 138

Paysage
18 *Landscape*, 1926
Oil on canvas, 81 × 100 cm
Staatliche Kunsthalle, Karlsruhe
(CR 217)
Illus. p. 139

Peinture

19 *Painting*, 1927
Tempera and oil on canvas, 97 × 130 cm
Tate Gallery, London, purchased 1971
(CR 243)
Illus. p. 149

Composition en brun et blanc (peinture)

20 *Composition in Brown and White (Painting)*, 1927
Oil, tempera and pencil on canvas, 130 × 195 cm
Staatsgalerie, Stuttgart
(CR 254)
Illus. p. 140

Peinture

21 *Painting*, 1927
Oil on canvas, 129 × 97 cm
Musée d'Art Moderne de Lille Métropole,
Villeneuve d'Ascq
(CR 257)
Illus. p. 151

Peinture (Fratellini)

22 *Painting (Fratellini)*, 1927
Oil on canvas, 130.2 × 97.1 cm
Philadelphia Museum of Art, A. E. Gallatin
Collection, 1952
(CR 265)
Illus. p. 150

Peinture en blanc

23 *Painting on White Ground*, 1927
Oil on canvas, 55 × 46 cm
Museo Thyssen-Bornemisza, Madrid
(CR 292)
Illus. p. 152

Peinture (Le Cheval de cirque)

24 *Painting (The Circus Horse)*, 1927
Oil on canvas, 61 × 50 cm
Helly Nahmad, Monte Carlo
(CR 303)
Illus. p. 153

Composition

25 *Composition*, 1930
Oil on canvas, 230 × 165 cm
Musée de Grenoble
(CR 318)
Illus. p. 155

Femme se promenant dans la rue

26 *Woman Walking down the Street*, 1931
Oil on Ingres paper, 63 × 46 cm
Private collection, Barcelona
(CR 369)
Illus. p. 154

Peinture

27 *Painting*, 1931
Oil on Ingres paper, 62 × 48 cm
Colección El Conventet, Barcelona
(CR 378)
Illus. p. 156

Femmes

28 *Women*, 1932
Oil on wood, 41 × 33 cm
Colección Niki et Celia Bosch, Barcelona
(CR 394)
Illus. p. 170

Peinture

29 *Painting*, 1932
Oil on Ingres paper, 46 × 63 cm
Private collection, Turin
(CR 412)
Illus. p. 157

Peinture

30 *Painting*, 1933
Oil on canvas, 98 × 130 cm
Galerie Jan Krugier, Ditesheim & Cie., Geneva
(CR 423)
Illus. p. 158

Peinture

31 *Painting*, 1933
Oil on sandpaper, 37 × 23 cm
Private collection, courtesy Galerie Odermatt-
Vedovi, Paris
(CR 435)
Illus. p. 180

Peinture

32 *Painting*, 1933
Oil on sandpaper, 37 × 23 cm
Private collection
(CR 436)
Illus. p. 180

'Escargot femme fleur étoile' (peinture-poème)

33 *'Snail woman flower star'* (painting-poem), design
for a tapestry, 1934
Oil on canvas, 195 × 172 cm
Museo Nacional Centro de Arte Reina Sofia,
Madrid
(CR 462)
Illus. p. 177

'Hirondelle amour' (peinture-poème)

34 *'Swallow love'* (painting-poem), design for a tapes-
try, 1933–34
Oil on canvas, 199.3 × 247.6 cm
The Museum of Modern Art, New York
Gift of Nelson A. Rockefeller, 1976
(CR 463)
Illus. pp. 178–79

Figure

35 *Figure*, 1934
Pastel on paper on canvas, 107 × 72 cm
Musée des Beaux-Arts, Lyons
(CR 472)
Illus. p. 188

Les Amoureux

36 *The Lovers*, 1934
Pastel and sand on paper on canvas, 107 × 72 cm
Private collection (formerly André Breton
Collection)
(CR 473)
Illus. p. 189

Deux Femmes

37 *Two Women*, 1935
Oil on card, 75 × 105 cm
Sprengel Museum, Hanover
(CR 493)
Illus. pp. 190–91

Peinture

38 *Painting*, 1935
Oil on Masonite, 76 × 65 cm
Sammlung Welle, courtesy Galerie Michael Haas,
Berlin
(CR 502)
Illus. p. 170

Signes et figurations

39 *Signs and Figurations*, 1936
Oil on sandpaper, 135 × 100 cm
Galerie Lelong, Paris
(CR 522)
Illus. p. 181

Peinture

40 *Painting*, 1936
Mixed media on Masonite, 78 × 108 cm
Colección Carmen Thyssen-Bornemisza en depósi-
to en el Museo Thyssen-Bornemisza, Madrid
(CR 536)
Illus. p. 183

Deux Baigneuses

41 *Two Women Bathing*, 1936
Gouache on paper, 49 × 65 cm
Colección El Conventet, Barcelona
Illus. p. 171

**'Une étoile caresse le sein d'une négresse' (pein-
ture-poème)**

42 *'A star caresses the breast of a black woman'*
(painting-poem), 1938
Oil on canvas, 130 × 195 cm
Tate Gallery, London, purchased 1983
(CR 580)
Illus. pp. 192–93

Sans titre

66 Untitled (study for an illustration for an unpub-
lished book by Robert Desnos), undated
Pencil on paper, 26.8 × 20.5 cm
Fundació Joan Miró, Barcelona
Illus. p. 146

La Famille

67 *The Family*, 1924
Charcoal, chalk and coloured pencil on sandpaper,
74.9 × 104.1 cm
The Museum of Modern Art, New York
Gift of Mr. and Mrs. Jan Mitchell
Illus. p. 129

Main attrapant un oiseau

68 *Hand Catching a Bird*, 1926
Pencil on paper, 48 × 63 cm
Collection Valerio Adami, Paris
Illus. p. 147

'Et les seins mouraient'

69 *'And the breast died'*, 1927
Indian ink on card, 50 × 64.5 cm
The Berardo Collection, Sintra Museum of Modern
Art, Lisbon
Illus. p. 172

Etude de composition

70 Study for a composition, *c.* 1927
Charcoal on paper, 15.5 × 21.5 cm
Fundació Joan Miró, Barcelona
Illus. p. 144

Etude de composition

71 Study for a composition, *c.* 1927
Charcoal on paper, 15.5 × 21.5 cm
Fundació Joan Miró, Barcelona
Illus. p. 144

Dessin préparatoire de 'Les Amoureux'

72 Study for *The Lovers*, 1928
Charcoal on paper, 15.7 × 21.5 cm
Fundació Joan Miró, Barcelona
Illus. p. 144

Dessin préparatoire de 'La Pomme de terre'

73 Study for *The Potato*, 1928
Charcoal on paper, 18 × 13.6 cm
Fundació Joan Miró, Barcelona
Illus. p. 142

Dessin préparatoire de 'Nature morte à la lampe'

74 Study for *Still Life with a Lamp*, 1928
Charcoal on paper, 50 × 65.1 cm
Fundació Joan Miró, Barcelona
Illus. p. 145

L'Adultère

75 *The Adulterer*, 1928
Oil paint, sand, crayon, tempera on paper, 72 × 107
cm
Museum am Ostwall, Dortmund
Illus. p. 187

Etude de composition

76 Study for a composition (illustration for Robert
Desnos's book entitled *Les Pénalités de l'enfer ou
les Nouvelles Hébrides*, 1925), 1929
Charcoal on paper, 11.4 × 15.8 cm
Fundació Joan Miró, Barcelona
Illus. p. 143

Etude de composition

77 Study for a composition (illustration for Robert
Desnos's book entitled *Les Pénalités de l'enfer ou
les Nouvelles Hébrides*, 1925), 1929
Charcoal on paper, 15.4 × 11.8 cm
Fundació Joan Miró, Barcelona
Illus. p. 143

Etude de composition

78 Study for a composition (illustration for Robert
Desnos's book entitled *Les Pénalités de l'enfer ou
les Nouvelles Hébrides*, 1925), 1929
Charcoal on paper, 11.8 × 15.4 cm
Fundació Joan Miró, Barcelona
Illus. p. 143

Dessin préparatoire de 'Le Cheval de cirque'

79 Study for *The Circus Horse*, 1929
Pencil on paper, 27 × 20 cm
Arp Museum, Rolandseck
Illus. p. 153

Dessin préparatoire de 'Le Cheval de cirque'

80 Study for *The Circus Horse*, 1929
Pencil on paper, 20 × 27 cm
Arp Museum, Rolandseck
Illus. p. 153

Collage

81 Collage, 1929
Ink, charcoal, pastel, paper on paper, 108 × 71 cm
Musée National d'Art Moderne, Centre Georges
Pompidou, Paris
Illus. p. 161

SKETCHBOOK (10 SHEETS OF 27)

Personnage

82 *Figure*, 1930
Charcoal on paper, 23.6 × 15.8 cm
Fundació Joan Miró, Barcelona
Illus. p. 175

Femme

83 *Woman*, 1930
Charcoal on paper, 23.6 × 15.8 cm
Fundació Joan Miró, Barcelona
Illus. p. 175

Femme

84 *Woman*, 1930
Charcoal on paper, 23.6 × 15.8 cm
Fundació Joan Miró, Barcelona
Illus. p. 175

Femme

85 *Woman*, 1930
Charcoal on paper, 23.6 × 15.8 cm
Fundació Joan Miró, Barcelona
Illus. p. 174

Personnage

86 *Figure*, 1930
Charcoal on paper, 23.6 × 15.8 cm
Fundació Joan Miró, Barcelona
Illus. p. 175

Femme

87 *Woman*, 1930
Charcoal on paper, 23.6 × 15.8 cm
Fundació Joan Miró, Barcelona
Illus. p. 175

Personnage

88 *Figure*, 1930
Charcoal on paper, 23.6 × 15.8 cm
Fundació Joan Miró, Barcelona
Illus. p. 174

Homme et femme

89 *Man and Woman*, 1930
Charcoal on paper, 15.8 × 23.6 cm
Fundació Joan Miró, Barcelona
Illus. p. 174

Femme

90 *Woman*, 1930
Charcoal on paper, 15.8 × 23.6 cm
Fundació Joan Miró, Barcelona
Illus. p. 174

Femme

91 *Woman*, 1930
Charcoal on paper, 23.6 × 15.8 cm
Fundació Joan Miró, Barcelona
Illus. p. 175

SCULPTURE

Femme
117 *Woman*, 1946
Bones, stone, iron, ceramics and oil, 51.5 × 23.5 × 19 cm
Fundació Joan Miró, Barcelona
Illus. p. 209

Figure
118 *Figure*, 1949
Bronze, 8 copies, 19 × 27 × 23 cm
Fundació Joan Miró, Barcelona
Illus. p. 203

Tête
119 *Head*, 1949
Bronze, 8 copies, 23.5 × 24.4 × 19.5 cm
Fundació Joan Miró, Barcelona
Illus. p. 202

La Caresse d'un oiseau
120 *The Caress of a Bird*, 1967
Bronze, painted, 4 copies, 310 × 112 × 32 cm
Fondation Marguerite et Aimé Maeght, Saint-Paul-de-Vence
Illus. p. 213

Femme
121 *Woman*, 1967
Bronze, 5 copies, 43 × 18 × 1.5 cm
Fondation Marguerite et Aimé Maeght, Saint-Paul-de-Vence
Illus. p. 208

Monsieur et Madame
122 *Man and Woman*, 1969
Bronze, painted, 4 copies, 100 × 31 × 31 cm and 68 × 38 × 38 cm
Fondation Marguerite et Aimé Maeght, Saint-Paul-de-Vence
Illus. p. 212

Femme
123 *Woman*, 1970
Bronze, 58 × 34 × 12 cm
Fundació Joan Miró, Barcelona
Illus. p. 211

Totem, N1
124 *Totem, N1*, 1972
Bronze, 4 copies, 210 × 31 × 20 cm
Galerie Lelong, Paris
Illus. p. 210

PRINTS

Barcelona-Série
125 *Barcelona* series, 1944
Lithographs, 50 sheets, 4 numbered copies
Sheet size: 33.8 × 47.3 cm to 70.3 × 53 cm
Courtesy of the Fogg Art Museum, Harvard University Art Museums, Cambridge, MA
Gift of the artist
Illus. pp. 90–105

PHOTOGRAPHIC ACKNOWLEDGEMENTS

Maurice Aeschimann, Geneva: p. 164

Jörg P. Anders, Berlin: p. 207

Muriel Anssens: p. 151

Jaume Blassi, Barcelona: pp. 126 bottom, 143–46, 159, 174–75, 201–3, 209, 218, 227

Martin Bühler: p. 133

CNAC/MNAM: p. 136

CNAC/MNAM Philippe Migeat: p. 161

Faujour: p. 168

Galerie Maeght, Paris: pp. 204–5, 219–22, 224–25

Gasull, Barcelona: pp. 130, 138

Claude Germain: pp. 208, 213

Fabrice Gibert: pp. 162, 165, 181, 210, 194

Joaquim Gomis, Barcelona: frontispiece, pp. 11–37, 89, 108 right, 109–11, 229

Dominique Haim: p. 198

Michael Hering, Sprengel Museum Hannover: p. 160

Walter Klein, Düsseldorf: p. 123

Tord Lund, Stockholm: p. 128

David Mathews and Allan Macintyre (© President and Fellows of Harvard College, Cambridge): pp. 90–105

Wolfgang Morell: p. 153 bottom right

Museo Nacional Centro de Arte Reina Sofia, Photographic Archive, Madrid: pp. 124, 126, 177, 195

The Museum of Modern Art, New York: pp. 127, 129, 167, 169, 178–79

Board of Trustees, National Gallery of Art, Washington, DC: p. 125

Öffentliche Kunstsammlung, Basle: p. 173

Christian Poit, Geneva: p. 182

Rheinisches Bildarchiv, Bonn: p. 141

R-M-N, Ojéda/Le Mage: p. 188

R-M-N, J.G. Berizzi: p. 121

R-M-N, Bertrand Prévost: pp. 214–17

Rocco Ricci: p. 200

Mario Sarotto, Turin: pp. 157, 180 left

Jean-François Tomasian: p. 132

This book was published on the occasion of the exhibition
'Joan Miró: Snail Woman Flower Star', held from
13 July to 6 October 2002 at the museum kunst palast, Düsseldorf

© Prestel Verlag, Munich · Berlin · London · New York,
and the museum kunst palast, Düsseldorf, 2002

© Successió Miró / VG Bild-Kunst, Bonn, 2002
© Succession Picasso / VG Bild-Kunst, Bonn, 2002
© Joaquim Gomis Archive, Barcelona, 2002

Front cover: Joan Miró, '*Escargot femme fleur étoile*', 1934 (see illus. p. 177)
Frontispiece: Joaquim Gomis, portrait of Joan Miró in front of an early version
of the painting *Le Port*, 1945

Photographic acknowledgements: p. 239

Die Deutsche Bibliothek lists this publication in the Deutsche Nationalbibliografie;
detailed bibliographic data is available on the Internet at *http://dnb.ddb.de*

Prestel Verlag
Königinstrasse 9, 80539 Munich
Tel. ++49 89 381709-0; Fax ++49 89 381709-35

4 Bloomsbury Place, London WC1A 2QA
Tel. ++44 (0)20 7323 5004; Fax ++44 (0)20 7636 8004

175 Fifth Avenue, Suite 402, New York, New York 10010
Tel. ++1 (212) 995-2720; Fax ++1 (212) 995-2733

www.prestel.com

Translated from the German by Paul Aston
Copy-edited by Michele Schons
Designed and typeset by WIGEL, Munich
Lithography by ReproLine, Munich
Printed by sellier Druck, Freising
Bound by MIB Conzella, Pfarrkirchen

Printed in Germany on acid-free paper

ISBN 3-7913-2785-2 (English edition)
ISBN 3-7913-2806-9 (German edition)